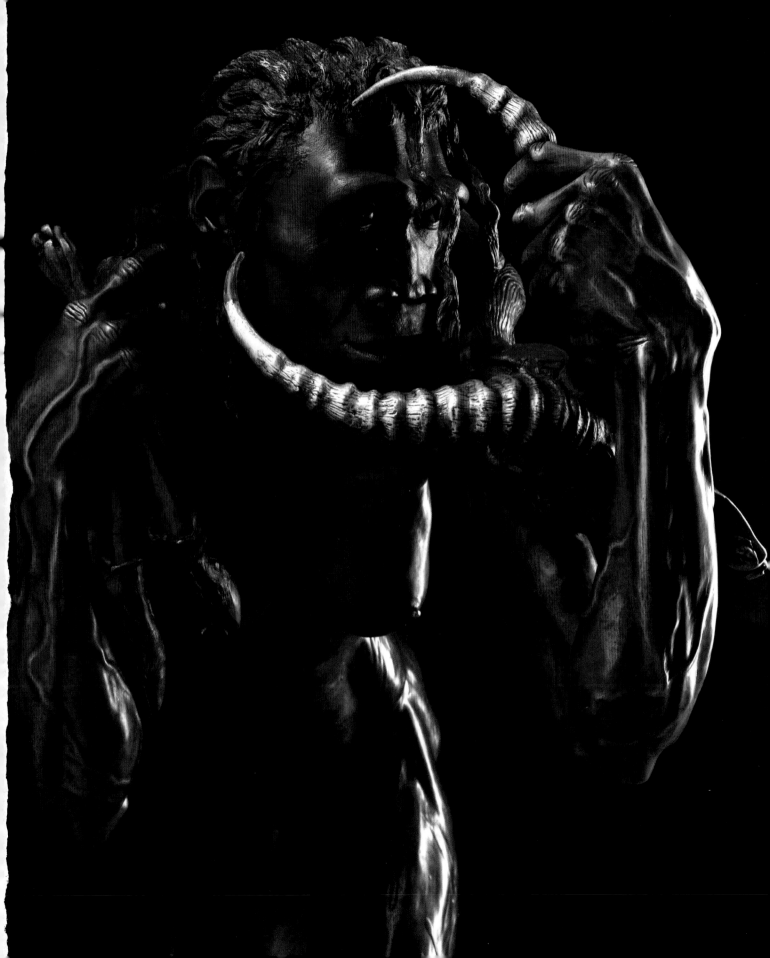

SHAPING HUMANITY

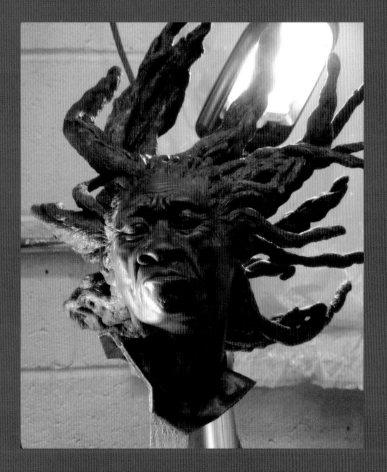

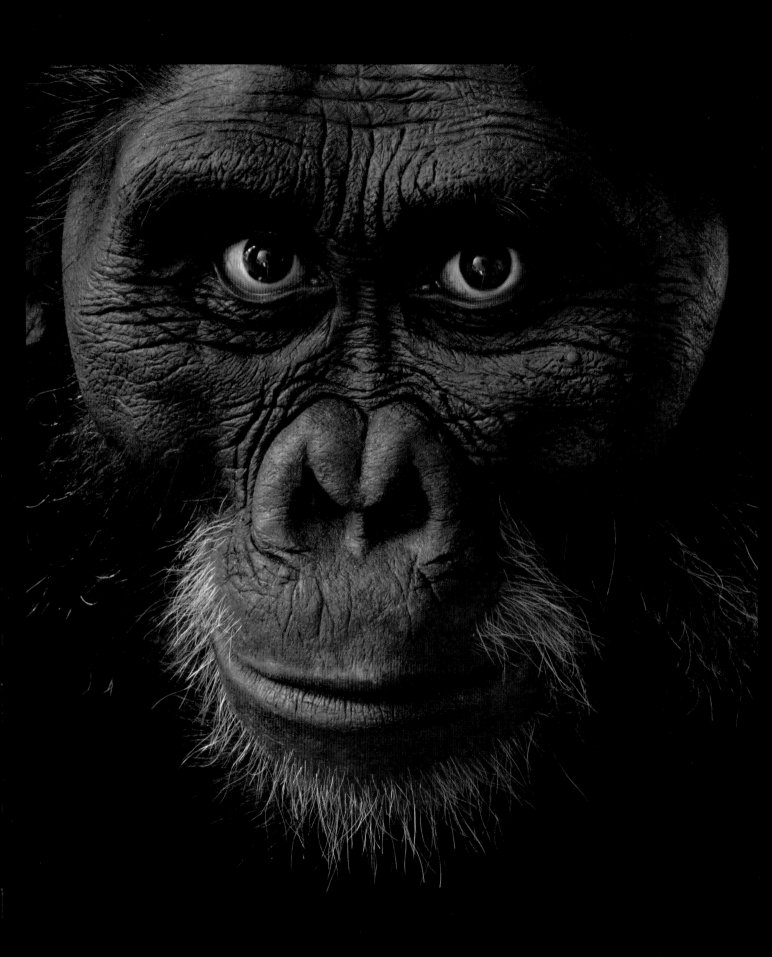

SHAPING HUMANITY

How Science, Art, and Imagination

Help Us Understand Our Origins

JOHN GURCHE

Yale

UNIVERSITY PRESS

NEW HAVEN AND LONDON

Published with assistance from the Louis Stern Memorial Fund.

Yale University Press books may be purchased in quantity for educational, business, or promotional use.

For information, please e-mail sales.press@yale.edu (U.S. office) or sales@yaleup.co.uk (U.K. office).

Designed by James Johnson.

Set in Scala type by BW&A Books, Inc.

Printed in China.

Library of Congress Cataloging-in-Publication Data

Gurche, John

Shaping humanity : how science, art, and imagination help us understand our origins / John Gurche.

p. cm.

Includes bibliographical references and index.

ISBN: 978-0-300-18202-6 (hardcover : alk. paper)

1. Fossil hominids. 2. Human beings—Origin. 3. Human evolution. I. Title.

GN282 .G87 2013

569.9—dc23

2013016699

A catalogue record for this book is available from the British Library.

This paper meets the requirements of ANSI/NISO Z39.48-1992 (Permanence of Paper).

10 9 8 7 6 5 4 3 2 1

In Memory of Chip Clark,
and dedicated to Blythe, Loren, and Meave,
who will help write the next chapter

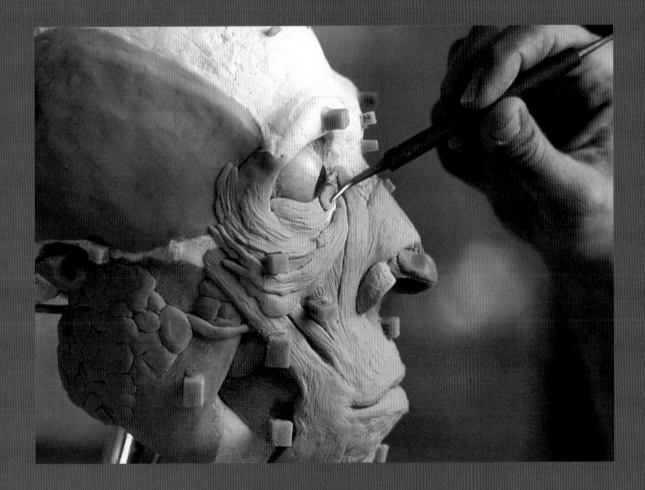

CONTENTS

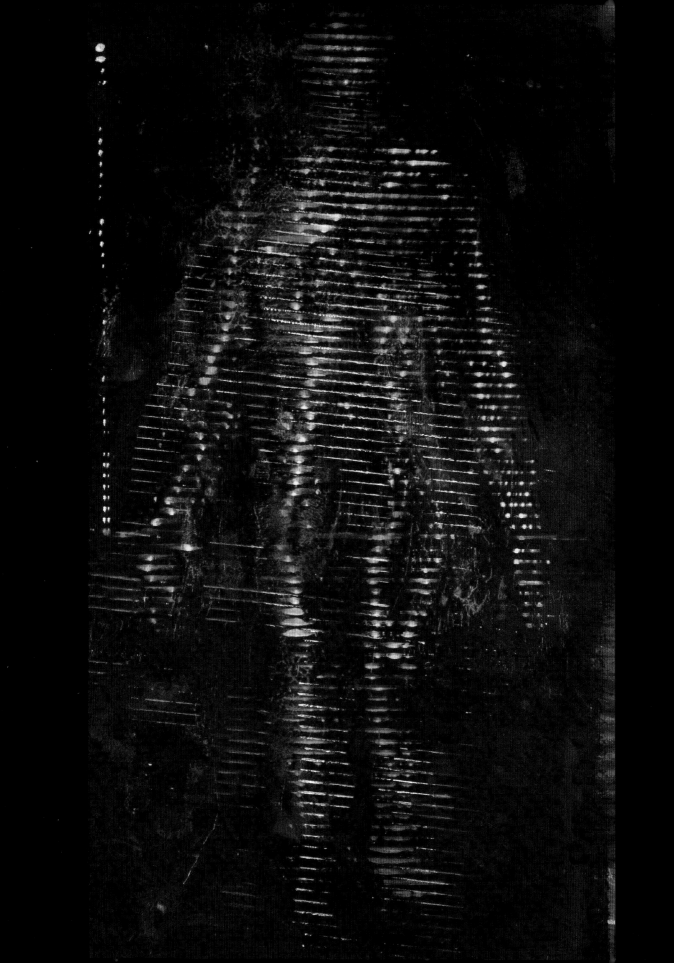

PREFACE

Two very different processes arrive at the same endpoint: a human shape. One is guided by a sense of aesthetics. The other is blind. The two modes are sculpture and organic evolution, the processes explored in this book.

Charles Darwin expressed a sentiment that resonates with many of us when he said in the last sentence of *On the Origin of Species:* "There is grandeur in this view of life, with its several powers, having been originally breathed into a few forms or into one, and that, whilst this planet has gone cycling on according to the fixed law of gravity, from so simple a beginning endless forms most beautiful and most wonderful have been and are being, evolved." It is as if nature, in shaping a myriad of life forms on our world, has operated with a powerful sense of aesthetics. Consider how strange this idea is. We know that the evolutionary forces which shape organisms work with nothing like aesthetic considerations (sexual selection excepted). Evolution is blind to any concept of beauty, and it has no goals or purpose. It does not strive toward an end. It is only that forms with less optimal function in their local environments are less likely to survive and reproduce, so that traits that optimize survival and reproduction are more likely to be passed on.

And yet the results we humans find breathtaking, and this is a paradox. How can we explain our intense response to an art form created blind, with no guiding sense of aesthetics? If we can reject the idea that nature is tailored with such a guiding principle, we are left with only one other choice: that our sense of aesthetics is tailored to nature.

Humans evolved aesthetic sensibilities as they became a symbol-using animal. The human arts provide a conduit for ideas and states of mind, many of which are not easily expressed verbally. They include attempts to capture or interpret certain aspects of nature. Organic form and, particularly, the human form are especially powerful for us. How exciting, then, to discover a process that molds one organic form into another. And what an irresistible focus for an artist, dealing with life forms making the transition from organic forms we don't respond to as human to those we do.

This is my bias, anyway. I am aware that not all artists feel this way. When my son Loren was four

years old, he walked into the studio of an artist friend of mine, looked around, and, having seen only my studio previously, asked: "Where are all your skulls?" That sums up my feelings pretty well.

This book is about dealing with the evolutionary process in art. Specifically, it is about the challenges and triumphs of telling the human evolutionary story with sculpture for the new Hall of Human Origins at the Smithsonian Institution, which opened in 2010. It follows the behind-the-scenes processes that shaped this work, including the research, arguments, and inspirations behind the sculpture in the hall today. It includes eleventh-hour course corrections, concepts that were abandoned, and occasional times when our efforts unintentionally ventured into the realm of the absurd. It is a human story, and one in which I am happy to have been a participant.

Each of the chapters in this book covers a different species, and chapters are arranged in roughly chronological order. Each chapter begins with what science has been able to reveal about a particular species. What role did it play in the evolution of humanity? An important part of each of these accounts is to cover in brief the history of ideas that have influenced our understanding of an ancestor and the debates that are still alive today.

The study of the fossil remains of human ancestors has revealed that human evolution was a mosaic affair; some features and capacities we consider human arrived early in the process, and some very late. Thus the evolutionary story of each species of human ancestor concerns different adaptations. For example, the adaptive tale of the earliest known hominins, between six and seven million years ago, involves the transition to bipedal locomotion from the quadrupedal locomotion of ancestral apes. The story of the first members of the genus *Homo*, about four million years later, involves the first significant enlargement of the brain. Like characters in an epic novel, each species has its own unique evolutionary story to tell.

This is not to imply that early human ancestors were unfinished humans. At no point in this process did evolution have today's humanity as something it was striving for, and evolution should not be viewed as progress. If an adaptation, such as increases in brain size, continued to convey advantages for a long time, this may look deceptively like progress toward an end. However, at any one point in time, evolution is only a here-and-now adaptation to local conditions. The view of ancestors as players in the human evolutionary narrative represents reality in the sense that different characteristics we consider human were added at different times, but this view is a construct that can be erected only in retrospect, from any arbitrary point in time.

Against the background of our current understanding of a species, the next section of each chapter chronicles the Smithsonian team's and my thinking concerning each sculpture, including discussions and disagreements. What aspects are most important to depict for a particular species? How can we make the character and emotional tone of each sculpture reflect its adaptive package? And how can we best represent the human condition and its coming-to-be in the series as a whole? There are metaphors

here for those who would read them; in many cases qualities of the sculpted individual's character or its pose that reflect the adaptive story of each species as we presently understand it.

Following these sections, each chapter of the book follows the anatomical detective work of reconstructing an ancestor from clues in the bones, and the nuts-and-bolts stories of creating the sculptures. These include stop-the-presses moments when a newly published scientific discovery created a change in our understanding of a particular species while a sculpture of it was in progress.

This book is a very personal one. Art is by nature personal, so an honest book about its creation cannot be otherwise. A primary goal of both the new hall and this book is that of fostering a deep personal connection with human ancestors and with the process that created us. *Shaping Humanity* is specifically about one way of making such a connection—through sculpture. The book is also about the view of humanity that emerges from this kind of connection: when our history is viewed in the context of the larger evolutionary time-stream, humans emerge as a rather fantastic development. This perspective was for me greatly enhanced by working intensely on the Smithsonian project, and spending several months with each human ancestor. So in the book, I have included discussion of the development of the sculptures as a way to tell the human story and foster this kind of connection, and also passages that deal, sometimes impressionistically, purely with the connection itself.

An awareness of the evolutionary context for human life greatly enriches our experience of being alive. This story is your story.

ACKNOWLEDGMENTS

The work at the core of this book was not a solo effort, and I have many to thank for their help and cooperation. Foremost among them are the members of the Smithsonian team of scientists, artists, and exhibit design people who created the new David H. Koch Hall of Human Origins. I worked closely with a number of these, including Rick Potts, Briana Pobiner, Matt Tocheri, Linda McNamara, Sharon Barry, Jenny Clark, Fang-Pin Lee, Stephen Petri, Junko Chinen, Kathleen Gordon, Mike Lawrence, Michael Mason, Paul Rhymer, and Chip Clark. I am grateful to these individuals for help and support, critiques, friendship, and, not infrequently, laughter.

The reconstruction of human ancestors is based on the work of paleoanthropologists and scientists in other fields, working together to uncover information about the human past. My work is impossible without theirs, and I am very grateful to the researchers in these various fields. In addition, I have a number of scientists to thank individually for their help with my work in reconstructing the human ancestors featured in this book. They have offered helpful comments, provided data, and participated in discussions that influenced the course of my efforts. My thanks go to David Begun, Kay Behrensmeyer, Lee Berger, Alison Brooks, Jenny Clark, Dean Falk, Bob Franciscus, Trent Holliday, Ralph Holloway, Nina Jablonski, Bill Jungers, Bruce Latimer, Meave and Richard Leakey, David Leslie, Ginesse Listi, Owen Lovejoy, Mary Manheim, Rick Potts, Brian Richmond, Philip Rightmire, Chris Ruff, Peter Schmid, Randy Susman, Matt Tocheri, Erik Trinkaus, Alan Walker, Carol Ward, Tim White, and John Yellen.

Thanks to Yoel Rak, Marcia Ponce de León, and Christoph Zollikofer for their digital reconstruction of the A.L. 444-2 skull, and to Bill Kimbel for his 1995 tutorial on the fossil.

I am grateful to Richard and Meave Leakey, and Emma Mbua at the Kenya National Museums; Ron Clarke, the late Phillip Tobias, and the late Alan Hughes at the University of the Witwatersrand; Lee Berger, Wilma Lawrence, and Bonita de Klerk at the Institute for Human Evolution at Wits; David Hunt at the Smithsonian Institution's Museum of Natural History, the staff of the Transvaal Museum, and that of the Powell-Cotton Museum for providing access to and allowing study of specimens in their care.

For including me on her great ape dissection teams and for stimulating anatomical discussions, I am indebted to Adrienne Zihlman. Thanks also go to Robyn McFarland, Carol Underwood, Debra Bolter, and Gary Staab for their anatomical expertise and help with dissections. I am grateful to Bob Martin, Mary Marzke, and Linda Winkler for allowing me to dissect specimens in their care at the University of Zurich, the University of Arizona, and the University of Pittsburgh at Titusville, respectively.

Thanks to Patti Booth Taylor for her modeling, her fitness expertise, and her enthusiasm. And to Bea Kolkman for her cooperation and impish behavior. Thanks also to hand models Patti Stoiko and Ted Oberhaus.

I had several paid assistants who were indispensable. These included J. J. Manford, Bryan Root, Erica Pollock, and Loren Gurche.

Thanks to the New Old Guys, who meet for coffee every morning in Trumansburg, New York, and who occasionally swarmed my studio to offer critiques on the sculptures. Artist Dan Burgevan was particularly helpful.

I am grateful to Gary Siegel and the staff of the New Arts Foundry for their artistry and attention to detail.

In addition, I want to thank those who have helped specifically with this book. Their help should not be taken as endorsement. I had final say about what went into the book and any errors in the book or the work behind it are strictly my own. These include Kris Carlson, Libby Cowgill, Michael Dineen, Dean Falk, Andrew Hill, Trent Holliday, Bill Jungers, Brian Richmond, Pat Shipman, Peter S. Ungar, Carol Ward, Tim White, and John Yellen.

I thank Jean Thomson Black and Jeffrey Schier for their editing and advice. Thanks also to the other staff members at Yale University Press. Thanks to Don Hurlbert for help with photographic equipment.

My family was involved with many aspects of the creation of the Smithsonian sculptures, everything from discussions and sculpture critiques to donating their hair, helping with hominin accoutrements, and modeling as early hominins. To Blythe Gurche, Loren Gurche, and Meave Gurche go my gratitude and my love.

My love and deepest thanks to Patti Stoiko for her encouragement of this project. For a lifetime of inspiring discussions about nature and humanity's place in it, I thank Charley Gurche. For his insightful perspectives about the human future, I want to thank the late Michael Stoiko. My love and gratitude go to Jack and Suzanne Gurche for their abundant love and encouragement.

This list would not be complete without thanking three individuals for their inspiring influence; one an artist, one a scientist, and one who was both. Thank you Stanley Kubrick, Larry Martin, and Loren Eiseley.

Finally, for his support, friendship and love, and help on many fronts, I want to thank Rick Potts.

SHAPING HUMANITY

PROLOGUE

He had not been sick, was not injured in any way. So the sight of him face down in the marsh was a shock to his family. Surely this could not be so. Surely the stillness and seeming lifelessness of his body could not mean the end of his story. In truth it did not, although the future of his story was far beyond his family's power to imagine.

Alive! He is well and alive! Not dead, please not dead.

They call to him. The gentle rocking of his body is his only response. They wade out to him. In the quiet the buzzing of flies is obscenely loud.

No breath, no life. Move, please move. They roll him onto his back and see his face, and then they know. Moments later they are startled by a wailing sound that they find to be their own. They carry his body ashore.

Some time later, they become aware that the shadows have lengthened into long stripes. The people do not know how long they have been here, but it is time to go. The lions will be waking now. Although the stone hand axe the man carried will remain in the marsh, his body will be gone tomorrow. It does not occur to them to move it.

The man persisted as a memory for a short time among his people, day by day, year following year, until there was no one left alive who remembered him. Long before this time his body had been dragged off and partially consumed by hyenas, and much of it had been decomposed by organisms which could use its nutrients for purposes of their own.

His bones were buried by overwashing sediment and lay undisturbed for generation upon generation, encased in earth under the hurrying clouds. Bone that had once been alive was, little by little, replaced with groundwater minerals. Thousands of generations passed: birth cries and love, struggle and bright flashes of pain, until there was no member of his species still alive.

His bones remained still, in their bed of silt, as the surface of the land shifted above them. Rains swept away sediment, floods scoured the surface, cutting into earth until, one and a half million years after his death, the water opened a window and the sun once again warmed the bone of his cheek.

❊ ❊ ❊

Something is moving in the distance: back and forth, back and forth, scanning the surface, a figure coming closer, silhouetted against a brilliant blue sky. Closer. An unintelligible shout, and a hand reaches down to touch the bone of the cheek. A stream of sounds—like a complicated birdsong but in a lower register, and then a second figure appears, bending low over the bones.

These are the man's descendants of fifty thousand generations. They look different, with their domed heads and delicate flat faces. They are quick and curious, prying into everything, turning every stone. They chatter incessantly in rapid-fire streams of tongue-bending, tube-modified sound, punctuated by a series of pops, clicks, and hisses.

These inheritors have swarmed the globe and colonized virtually every environment on earth. They change everything they put their hands to. Too restless and curious to stop at their own world, they have set foot upon the earth's moon, and have sent fantastic descendants of the dead man's hand axe on journeys deep into space to look in upon other worlds. While the bodily shape of the man's descendants has changed only subtly from his, the hand axe's descendants bear no visible resemblance to their ancestor. They are composed of geometric shapes of light and ore and structural petrochemical. With them, the earth's inheritors extend their eyes, ears, and consciousness far beyond the home planet's living envelope.

These inquisitive descendants have also devised lenses that allow them to peer through immense distances backward in time, and strange lanterns with which to illuminate the shapes of their ancestors. *We are those descendants and, at a distance of one and a half million years, we are straining to see you.*

Who are you? We beings from your future are using every method we can devise to bring you into focus and answer this question. We want to know you, to see your face, even to experience the world through your senses. We measure you. We generate long chains of words and numbers in our effort to understand you. Past events leave residues you have not dreamed of. Past moments can be partially accessed, and, in a limited way, we can unfold them and study them.

We sift through the debris you cast off, trying to understand the way you lived. We hold the tools that you made and feel a connection with you. Did you give a thought to the distant future of the artifact you were making? Could you have imagined that it would last for uncountable years, outlasting even your lakeside homeland?

We would so like to know about your life, what you think about when you gaze into a starry night sky. Do you wonder about your people's future, about whether there will be heirs to inherit your world and your ways? We can answer: Yes, for we are they.

Our ways are different now. If you could meet us, how unimaginably strange we would seem to you. We and our technology are more closely connected than in your time. And we as individuals are linked in ways you cannot dream of. If you could see us without fear, you might grasp in some way the geometries of our lives.

We look into your empty eye sockets and wonder what you saw. We probe inside the space within your skull in our attempts to learn about your thoughts. We can see that in some ways you are like us. In other ways, you are still very much like the animals that came before you, and you conduct the affairs of your lives and your world as an animal would. If we could experience your thoughts, would they be those of an uncomprehending animal? We have found signs of your consciousness, and in this mirror of awareness we think we see a bit of ourselves. We view ourselves as part of a larger evolutionary stream of ancestors and descendants, of which you are also a part. We cannot help feeling a powerful kinship with you. You are, after all, our physical and symbolic link to the rest of creation.

We humans have a powerful need to understand our beginnings and our relationship to the larger cosmos. Testament to the universal nature of this need is the fact that all human cultures have mythologies that address it. Many of us have times during our lives when the yearning is especially strong to experience a connection with our origins and our links to the rest of nature as fully as possible.

For most of human history, religions have addressed this kind of yearning, often aided by art as a conduit for symbolic concepts and religious awe. The origins myths they have supplied are often beautiful, and the associated imagery compelling. Earth's human cultures have produced thousands of these, many of them mutually exclusive. Today, we have the good fortune to be living at a time when a powerful methodology of testable inquiry is revealing details of the way it actually happened. The origins story revealed so far is fantastic beyond the powers of mere human

imagination. It is the story of a small corner of the universe becoming aware.

Gaining an understanding of human origins through scientific study is one way of experiencing a link to the human past. Other kinds of experience—holding in your hands the skull of an ancient ancestor, for example—fulfill the yearning for a connection in ways that transcend measurement and analysis. I have found personally that one of the more potent ways of making contact is to use the best science available to create art about our origins.

In 1984, the Smithsonian Institution started a project to tell the story of human origins in a large, ambitious new hall at the National Museum of Natural History, an exhibit which later became known as "What Does It Mean to Be Human?" Primary art for the new hall would be a series of sculptures of human ancestors created by myself. Later another phase of work was added, to produce one-quarter-scale drawings

of full-figure reconstructions for a number of early hominid species, and from these several more hominid reconstruction projects evolved, which have appeared in *National Geographic* and elsewhere.

In the late 1980s, progress on the new Smithsonian hall stalled, an interruption that lasted for what turned out to be twenty-three years. It was immensely disappointing at the time. It was also immensely fortuitous in the long view. In the interval I was able to do research in dissection rooms and fossil labs around the world, and to formulate a powerful methodology for the reconstruction of human ancestors. The research behind hominin reconstruction involves the use of anatomical clues preserved in a fossil to re-create a fleshed-out form for an extinct hominid. Anatomical relationships found in living relatives can be used as a primer for reading the bones of extinct species. The work included numerous dissections of every species of living great ape, including humans, and took me into fossil vaults to study remains of human ancestors. By the time work on the hall resumed in 2007, I was ready.

This book tells the stories of the creation of fifteen hominin sculptures for the Smithsonian's new David H. Koch Hall of Human Origins, which opened in March of 2010. Aesthetically and scientifically, the challenge was: how to build into the sculptures strong personalities that would reflect their species' adaptive narratives? Together these stories trace the outline of the larger story of human history as suggested by the fossil record known so far.

The sculptures represent eight species of human ancestors and evolutionary cousins. It is not by any means a complete list, but most other extinct hominin species known at present are dealt with at least briefly in this book. It would be very shortsighted to think that we have now found all of the hominin species that existed. The work represents an effort to understand and communicate about the forces that shaped humanity and our history as we presently understand it. The future will bring surprises.

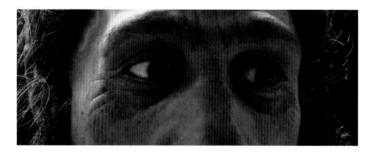

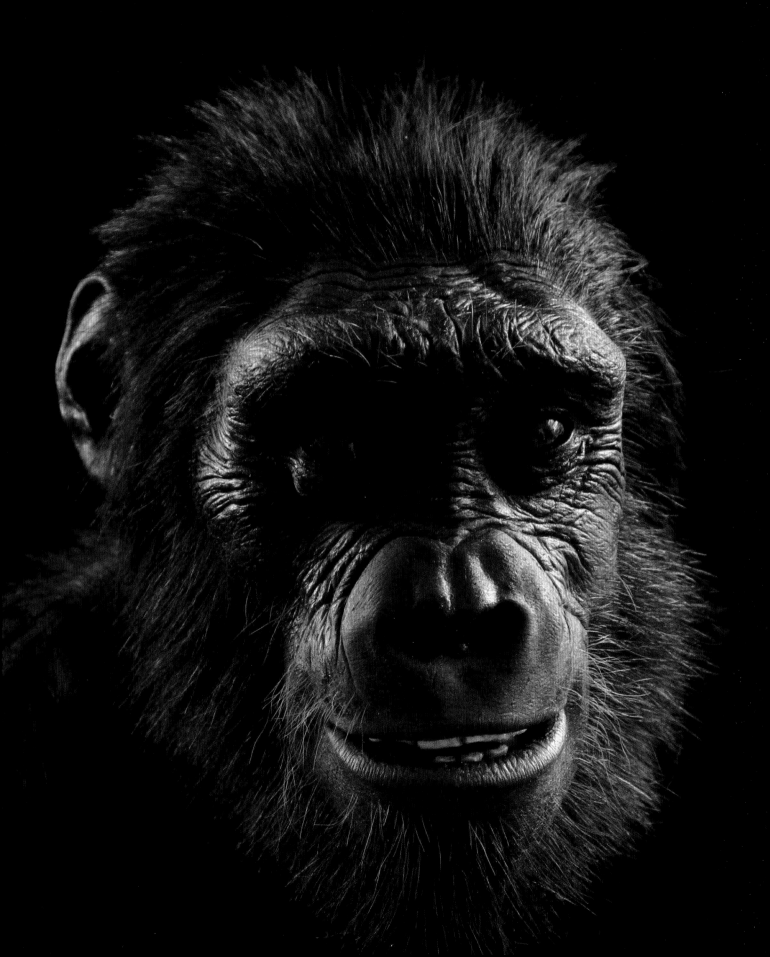

Chapter 1

BEGINNINGS

Sahelanthropus tchadensis (6 to 7 million years ago)

Discovery

There is a windy desert in central Africa where blowing sand sometimes reduces visibility to almost nothing. People, if they can be seen at all, appear only as dim shapes at such times. With increasing distance, the shapes become fainter, until at last they disappear entirely. In July 2001, this inhospitable desert yielded a secret. It was a primate skull, about the size of a chimpanzee's, capped by black manganese–stained sediment like a bizarre mop of hair. It was found in what is now northern Chad by members of a French/Chadian team, among fossils from animal species known from other sites to have lived between six and seven million years ago, and so was older than any known human fossil.

The skull seemed to be unique, exhibiting an odd mix of features not seen in any previously known specimen. It appeared apelike in many ways, possessing a small brain, an inclined plane on the base of the skull where neck muscles once attached, and a large brow ridge like a gorilla's. Two of its features in particular caught the attention of the discovery team, as they were unlike those of apes. The foramen magnum, the hole where the spinal cord emerges from the base of the skull, appeared to be farther forward than its position in apes, which is toward the back of the skull. This feature suggested to the team that the head was balanced on a more vertical neck, as it is in upright-walking humans. Secondly, the canine teeth were small; they were of a reasonable size perhaps for a female ape, but the massive brow ridge suggested that the skull was from a male. A reduction in the size of the canine teeth in males is a humanlike characteristic. If this were a male, the team reasoned, such a reduced canine tooth pointed to a close relationship with humans. The discovery team saw indications that the canine teeth were functionally different than those of apes. The canine teeth of this skull are worn blunt at the tips as in humans, unlike the sharpening wear produced on the upper canine teeth of chimpanzees and gorillas as they hone against the lower premolars.

These features are characteristic of hominins (animals that are more closely related to humans than to our closest living relatives, the chimpanzees). Could this new skull be from a human ancestor, so far back in time? The age of the find is very close to the time when the human and chimpanzee lineages diverged, as indicated by genetic studies. It is twice as old as the celebrated fossil "Lucy," and more than two million years older than the oldest known australopith (an informal name for a group consisting of members of the genus *Australopithecus* and those of *Paranthropus*). Even a casual glance at the skull confirms that it lacks the large jaws and chewing teeth which characterize australopiths. It was apparent to the team that this skull represents something else entirely. Based on the small canine teeth, the forward position of the foramen magnum, and a number of traits resembling later hominins, a thirty-eight-member international team, led by the Université de Poitiers' Michael Brunet, proposed in a 2002 article in *Nature* that it represents a new species of human ancestor. They called it *Sahelanthropus tchadensis,* which translates as "Man from the Sahel Region of Chad."

The Debate

There was bound to be controversy. As we pursue the shapes of our ancestors back through time, they become less distinct. At present we see only dim shapes of those that might be our earliest ancestors and, peering further back into the time of our last common ancestor with the chimpanzee lineage, the shapes disappear entirely; visibility has been reduced to nothing. Inferences have been made about this last common ancestor from the study of later species, but it has yet to be discovered.

As we travel back in time, approaching that common ancestor, the hominins we meet will have ever greater resemblances to it. If we could trace the chimpanzee line back similarly, the same would apply, so that members of the two lineages would increasingly resemble each other the further back we go until, as we reach the common ancestor, they leap into one shape. This means that the early members of both lineages will be difficult to tell apart. Anatomical signals that indicate that an ancestor was on the hominin side of the split, or on the chimpanzee side, will be fainter and more debatable.

In the case of *Sahelanthropus,* the announcement suggesting hominin status for the find met with immediate controversy. Was the foramen magnum in this cranium (meaning the skull minus the lower jawbone), major pieces of which had been moved out of alignment during the fossilization process, really far enough forward to indicate a more vertically held neck? Were the canine teeth small enough to qualify *Sahelanthropus* as a hominin? Three months after the announcement of *Sahelanthropus,* a team of four authors published a brief letter to *Nature* titled "*Sahelanthropus* or *Sahelpithecus*?" which roughly translates as "Man of the Sahel or Ape of the Sahel?"

These authors pointed out a number of primitive features in which *Sahelanthropus* resembles apes and not hominins. They questioned, among other things, the original team's methods of assessing the foramen magnum position in

the *Sahelanthropus* skull. They also judged the plane where neck muscles once attached to be angled toward the rear of the skull like that of an ape, instead of more horizontal like that of most hominins. To them, the pattern of crests indicated in the initial description and photographs of the skull appeared to be more like the pattern of a small, quadrupedal ape with powerful chewing muscles.

The critics noted that the one measurement of the upper canine tooth given in the paper announcing *Sahelanthropus* fits within the ranges for both chimpanzees and female gorillas, and is near the chimpanzee mean. To these authors, part of the wear pattern originally described for the canine of *Sahelanthropus* sounded like honing wear typical of apes. They suggested that, in any case, if the tooth is small in some dimensions it is more likely to be because the skull is that of a female ape. Although male apes and humans have, on average, larger brow ridges than females (and those of the *Sahelanthropus* skull were reported to be thicker than the entire range for gorillas of much larger body size), the critics considered canine size to be a more reliable indicator of sex than brow ridge size, and concluded that female status for the skull cannot be ruled out.

It's worth noting that two of the four authors of this letter disputing hominin status for *Sahelanthropus* are members of a team that had found, a year before the *Sahelanthropus* skull was discovered, a set of six-million-year-old remains that they named *Orrorin tugenensis* and proposed as the oldest known hominin. Assuming both finds are hominins, theirs could claim the title of "oldest hominin" for a period of exactly sixteen

months before it was unseated by *Sahelanthropus*. This doesn't invalidate their claims against *Sahelanthropus*'s proposed hominin status, but it does identify a potential source of vested interest.

The other two authors of the paper were the University of Michigan's Milford Wolpoff, and his former student John Hawks, now of the University of Wisconsin at Madison. Their involvement in the discussion brings up a debate that has had a strong effect on the field of human origins. Should the fossil record of human ancestors be divided into fewer species, representing a simple family tree with only a few branches, or is it more appropriate to divide it into many species, representing a bushier tree with many branches? Milford and some of his students see the human tree as a simpler one. Since they tend to "lump" fossils into fewer species, they are often referred to as "lumpers." Each species they recognize incorporates a significant amount of physical variation, some of which the other camp sees as too great to fit within the range of one species. Since this latter group tends to split the fossil record into a greater number of species, this school is often referred to as "splitters."

This difference in ways of seeing the fossil record has had a large influence on many of the debates in paleoanthropology. When a new species has been named for a fossil, the lumpers are more likely to view it as a representative of an existing species. For them the differences others are seeing between the new fossil and previously known forms may be taxonomically insignificant, being on the order of individual variation within a living primate species. Or the differences may be the result of a pathology or distortion during

fossilization. Most of the issues debated for the species represented in this book are touched in one way or another by this difference of opinion.

In the case of *Sahelanthropus,* removing it from the hominins has the effect of reducing the number of species that are candidates for human ancestry. Others have suggested that all three genera proposed as earliest hominins may in fact represent a single genus. Either possibility would simplify the family tree of humans and their relatives.

The debate began to heat up. In a reply to their critics, Brunet and colleagues chided them for using primitive characters to elucidate relationships, as it is now standard practice to use derived (newly evolved) characters which are uniquely shared instead. They pointed out that some primitive characters would be expected in a hominin of this antiquity. The critics were mistaken in their assessment of an angled plane for the neck muscles; when distortion is removed the angle is outside the range of chimpanzees and within the range of early hominins. The reply restated the original team's claim that in relative size, morphology (form), and wear, the canine tooth is evolved in a hominin direction.

A stronger case was made in 2005 for *Sahelanthropus* having the kind of vertically positioned neck associated with upright walking. A Swiss team, Christoff Zollikofer and Marcia Ponce de León of the University of Zurich, made high resolution scans of the skull and digitally separated the various pieces that had been pushed out of alignment during fossilization, then restored them to their original position. The virtual skull that resulted has a foramen magnum that is

clearly at the base of the skull, facing downward, rather than one farther back which faces more rearward as in chimps, gorillas, and other apes. The reconstructed skull also features a plane for the attachment of neck muscles that is less angled than in the original fossil, so that it is more similar to hominins than to living African apes. And, as if all of this was not already confusing enough, the reconstruction revised the brow ridge thickness by subtracting two millimeters. This put it within the size range of both male and female gorillas, making sexual attribution for the skull much less certain. If the skull is that of a female, canine size can no longer be used as a hominin character for it.

Papers from both teams came out during the next two years. A geometric shape analysis performed by the supporters of *Sahelanthropus's* hominin status found that the skull sorted with those of hominins and not with recent African apes. The critics pointed out the extensive overlap in the size of the brow ridges in male and female apes, and again questioned the proposed male status for the skull. They argued that females of several species of Miocene ape have canine teeth with size and wear similar to those described for *Sahelanthropus,* including wear at the tips and poorly developed canine/premolar honing (sharpening).

They also maintained that, although primitive features of the neck muscles' plane are of limited use in determining relationships, they are informative about posture and locomotion. In their view, features of the long, somewhat angled plane reflect unusually powerful neck muscles, used in a way that differs from known hominins.

They saw no clear indication of bipedal locomotion (walking on two legs).

As I began the reconstruction of *Sahelanthropus,* these issues were not resolved. I did not necessarily need them to be resolved, as my job had less to do with *Sahelanthropus*'s relationships than it did with interpretation of the skull regarding implications for soft tissue anatomy. I base my estimation of soft tissue anatomy on anatomical clues whenever possible and try to avoid using the weaker basis of taxonomic classification or phylogenetic relationships, so that if *Sahelanthropus* is thrown out of the hominins tomorrow, the reconstruction will remain the same. The Smithsonian team and I decided to accept the skull as reconstructed by the Swiss team as the basis for my reconstruction.

Later, when the head reconstruction was in progress, a 2011 article in *Nature* blew the whole argument into the stratosphere. George Washington University's Bernard Wood and New York University's Terry Harrison suggested that all bets were off in determining hominin status for *Sahelanthropus* and for three other early hominin candidates. They emphasized that a number of late Miocene apes also developed small canine teeth with reduced canine/premolar honing, which they suggested is related to diet. They also named several nonbipedal species of living primates which have a forward-positioned foramen magnum and suggested that this feature is related to differences in facial length and carriage of the head and can't be used as an indicator of bipedal walking. In addition, they questioned the postcranial (below the head) evidence for bipedalism in the three

other species proposed to be among the earliest hominins.

Can there be any resolution to these debates? I have included details of this discussion to show how difficult it can be, even for experts, to decide on the hominin or ape status of a fossil this close in time to the splitting of human and chimpanzee lineages. There may not be consensus either on this or on the issue of upright walking for these species until more postcranial bones are found and analyzed in scientific publications.[1] Many researchers have provisionally accepted *Sahelanthropus* as a human ancestor that lived between six and seven million years ago, not long after the last common ancestor of chimpanzees and humans. Most are awaiting the discovery of more remains before committing more solidly.

The Plateau

There are now three candidates for oldest hominin: *Ardipithecus kadabba* (which has been dated to 5.8 million years old), *Orrorin tugenensis* (6 million years old), and *Sahelanthropus tchadensis* (between 6 and 7 million years old). The first two of these species are known only from teeth, jaws, and postcranial bones. In both cases they are argued to be upright walkers based on features of the hind limb bones. All three feature canine teeth that are reduced, at least in comparison to those of male apes, and show reduced honing function.

Some anthropologists believe that these three represent a common adaptive plateau (a broad grouping of related organisms with similar adaptations), the first for hominins after their last

common ancestor with chimpanzees.[2] Inferences about this plateau have been made by Berkeley's Tim White and colleagues based on a 2009 study of the fairly complete skeleton of a later hominin: *Ardipithecus ramidus*—"Ardi"—dated to 4.4 million years ago. If its discoverers are correct, this adaptive plateau included the first changes in the evolutionary development of a biped for a creature that was still a quadruped in the trees. The reconstructed pelvis suggests that these changes included the evolution of a vertically short pelvis with blades that faced somewhat to the side. In human locomotion, this orientation allows muscles of the hip to stabilize the trunk over the standing leg while the other leg leaves the ground to swing forward.

Although no vertebrae from Ardi's lower spine were found, the team inferred that the skeleton had a long lumbar (lower back) section of the spine with a humanlike backward curve, allowing the positioning of the upper body's center of gravity over the hips, farther back than is possible with a great ape's spine, which is short, strait, and stiff in this area. Other areas of the Ardi skeleton, especially the foot, are still very apelike,[3] and some have questioned the anatomical basis for *Ardipithecus*'s proposed status as a biped.

A reduction in the size of the canine teeth in males is part of this hypothesized adaptive plateau, and this suggests to some that social changes were part of the picture. It is very unusual for the main weapon used in intimidation and fighting among males—large canine teeth—to be abandoned in a primate species. Beyond dietary considerations, there are two possible explanations. Perhaps males were using other

means, such as handheld weapons, to intimidate and fight with other males, making large canine teeth obsolete (Darwin favored this explanation in speculating on the reduction of canine teeth in humans). Or possibly these species adopted a social organization in which competition among males was reduced. Smaller male canine teeth and low sexual dimorphism (difference according to sex) in body size in *Ardipithecus ramidus* have led the team working on this species to suggest that competition among males was reduced in comparison to levels seen in some of the living great apes (in living apes, higher levels of competition among males are associated with larger male body size in relation to that of females, resulting in higher levels of body size dimorphism). One possibility for a low-competition social organization is a monogamous mating system, and the *Ardipithecus ramidus* team suggests that such a system, with a male provisioning his mate and their young, might have characterized the earliest hominins. This system selected for a style of locomotion that would free the hands for carrying, so this theory links the two outstanding human features that are seen among early hominins: reduced canine teeth in males and indications of bipedal locomotion. New fossils will clarify the degree to which any of this applies to *Sahelanthropus*.

Some Old Theories Laid to Rest

If the three contenders for oldest hominin are actually human ancestors, they offer some new insights and throw out some old theories about human origins. For decades, many have visualized the earliest hominins in a savanna

setting, with bipedalism emerging as apes were forced to adapt to more open habitats following the breakup of vast forested tracts as a result of climate change. Since all three candidates for earliest known hominin are associated with evidence of a forested setting, this view is no longer tenable unless bipedalism could have arisen as a forest dweller's method of traversing areas between forest patches. At present, this is still hypothetical.

Another popular theory, which has been called "east side story," hypothesized that hominins originated east of the Great Rift Valley in Africa, while today's African apes evolved west of it. The recovery of *Sahelanthropus,* potentially the most ancient hominin, from central Africa—as well as an earlier discovery of an australopith in Chad by Brunet's team—show that this region is part of the human story as well. Taken together with evidence from east and South Africa, these findings suggest that hominins were more geographically widespread than previously appreciated.

One important implication of studies of the candidate earliest hominins is the lack of support from the fossils for the common assumption that our last common ancestor with chimpanzees was chimpanzee-like. Since Darwin's time anthropologists have suspected that African apes (gorillas and chimpanzees) are our closest relatives among living animals. Many considered chimpanzees and gorillas to be more closely related to each other than either was to any other species. A surprise came in the 1980s with genetic studies that indicated that the closest living relatives of chimpanzees were not gorillas, but

humans. This meant that humans and apes could no longer be put on separate branches of the tree. The human family tree is instead nested within that of the great apes. By any reasonable definition, humans are great apes.

Because chimpanzees are our closest living relatives, many scientists have, to various degrees, expected that as we trace human ancestors further back in time, their anatomy will have ever-increasing similarities to a chimp's. Chimpanzees have been used as a sort of proxy for the last common ancestor of the chimp and human lines. Remains of this last common ancestor still have yet to be found, but one lesson from the four oldest proposed hominin species is that none is extremely chimpanzee-like. The earliest known fossil hominins appear to demonstrate the inappropriateness of the chimpanzee model that many have used as a stand-in for the last common ancestor of humans and chimpanzees; the chimpanzee line has evolved as well, so it can't be used as a sort of "living fossil."

This work has implications for the reconstruction of early hominins. Simply assuming that soft tissue anatomy in the earliest hominins would necessarily have been chimpanzee-like is obviously a bad idea. It must be based instead on soft tissue/bone relationships that are similar in African apes and humans, or on soft tissue dimensions that vary predictably with body weight in living members of this group.

Raising the Dead

For all of the Smithsonian sculptures, the team and I gave a lot of thought to what might be important to show for each species. This process

was sometimes inspiring and sometimes painful. I spent many hours in coffee shops filling sketchbooks with drawings of figures representative of some aspect of the human experience. I was concerned primarily with "finding" poses that were powerful aesthetically and could strongly evoke some aspect of being human, even on subconscious levels. At the same time, I had to keep in mind what is important to communicate about each particular ancestor—what the bones (and, for some, the archeology) of a particular ancestor are telling us about its chapter in human history. These ideas were then scrutinized, discussed, augmented, folded, spindled, and mutilated by the Smithsonian team, led by Rick Potts, head of the Human Origins Program.

Since *Sahelanthropus* is, so far, known only from a skull, several fragmentary mandibles, and teeth, we were limited to what we could say in a sculpture of the head. But at least it seemed pretty clear what the issues were. Is this a hominin? Is it a biped? Do the small canine teeth indicate social changes in its lineage? What about the argument that it may be a female ape?

Happily, much of the anatomy relevant to these questions can be represented in a head reconstruction. With a slightly opened mouth, the worn tips of the canine teeth would just be visible, so this kernel of evidence relevant to arguments about hominin status and social organization would be represented, even to the extent of showing tooth wear that may indicate functional differences from the way that ape canines are usually used. The large brow ridge, relevant to the assessment of sex in the skull, which in turn has strong implications for the question of

Sahelanthropus's hominin status, would also be quite visible, as would the degree of verticality in the neck, hinting at upright posture.

In order to begin building a face in clay, I would first need a physical skull. A cast of the original skull was definitely out, because of its distorted condition. It became evident to the team that the best option was to translate the published virtual reconstruction of the skull into a three-dimensional physical skull. The Smithsonian hired a digital 3-D graphics and prototyping company to translate the published orthographic (without perspective or parallax distortion) views of the virtual skull reconstruction into a hard copy. Measurements published by the Swiss team were also on hand to make sure the skull was dead-on. This turned out to be a long process, and the skull was not ready in time for the hall's opening. As a result, this "first" human ancestor was the last to be completed for the hall and was unveiled to the public in early 2011, as part of the one-year anniversary celebration of the hall's opening.

The virtual reconstruction created by the Swiss team and duplicated for this project is a beautiful skull. Its cranial capacity (size of the brain's cavity) is one of the smallest known for any adult hominin and, relative to estimated body size, is like that of living apes. The skull looks in many ways like that of a generalized African ape, with small, slightly blunt canine teeth and a large brow ridge. I was very curious to see the results of my anatomical methods for creating a face for this skull.

Over a two-month period, the reconstruction progressed like a dissection in reverse. It

was reminiscent of a time years ago, when I first dissected the face of a great ape (an adult female orangutan). After those long sessions, once I finally lay down to sleep I would be bombarded by afterimages, which inexplicably were sequencing in reverse, so that what I saw on the interior of my eyelids was a face being constructed. My work on the *Sahelanthropus* head now progressed similarly, though over a period of many weeks. Art and science marble together intimately in this kind of work; the individual decisions about anatomy are mostly science-based, and this feeds a powerful aesthetic. The process allows a degree of confidence that the face developing before you is close to the original, and this can be extremely moving. As the weeks progress, hundreds of individual anatomical decisions slowly come together to reveal a face that carries connotations of identity that cannot be expressed numerically.

Clues in the Quest for a Face

Can a long-dead face really be brought back? Perhaps not so that an individual's family would recognize him, but the skull offers many clues that can help us get close. The comparative anatomy of closest living relatives can tell us about relationships between bone and soft tissue that might allow estimation of soft tissue in extinct forms. For example, the average ratios of eyeball diameter to some of the dimensions of the orbit (eye socket) are very similar in humans, chimps, and gorillas, so the most consistent of these can be used to make reasonable predictions of eyeball size for their extinct relatives.[4] I found that the ratio of eyeball diameter to one measure of transverse (side to side) orbital breadth is similar

in a small sample of great apes and humans.[5] The estimated size of the eyes that once fit into the *Sahelanthropus* skull's eye sockets is similar whether human ratios are used to predict them, or ratios from either species of chimpanzee.

I made the eyes for the *Sahelanthropus* sculpture, as I did for all of the reconstructions, out of acrylic plastic. Making my own eyes allows me to custom-size the eyes precisely to match the diameters predicted by eyeball/eye-socket size relationships among living forms. For some hominins, the predicted size is outside of the range of the usual commercially available artificial eyes. I used to purchase artificial eyes, and when I would sometimes ask for a size outside the range common in living humans the response on the other end of the phone would first be silence, and then, in a somewhat suspicious tone, the question "Who is this eye for?"

Making an acrylic eye is about a thirty-step process, replete with headaches. Each step must be fused seamlessly with the previous work, and the process can go wrong at many points. Even after doing it for a couple of decades, I have only about a 50 percent success rate for eyes that are good enough to include in a reconstruction. If something goes wrong they get tossed into the Halloween box.[6] The great thing about the process is that I can work to maximize those physical qualities that give the illusion of life. There must be a sentience in the eyes, a feeling that there is someone in there. Even chimpanzees and gorillas have this window of the soul quality—if you get up close and look into the eyes of an ape, you see a presence there; there's someone home. The eyes, more than any other area, must carry the

illusion of life, or the sculpture will be dead, a silicone and acrylic anatomical model with no life or magic. As with writing fiction, you have to begin by fooling yourself if you expect to fool others. So the process can have its weird moments: you look up from your sheet of calculations and you catch the creation watching you. Although rationally you know otherwise, you feel at times that what is taking shape under your fingers is no longer just inanimate plaster and clay. These are signs that your effort to build a soul behind the eyes is succeeding. If people react to your sculptures by feeling a little creeped out because they sense a living presence there, you know you've done well.

During one of my trips to Washington, D.C., Rick Potts and I were driving somewhere in his car, and he asked me how I was planning to color the sclerae (the "whites" of the eyes in humans) for the *Sahelanthropus* reconstruction. All three living species of African ape (gorillas, chimpanzees, and bonobos) commonly have darkly pigmented sclerae, unlike humans. When, on rare occasions, one of them lacks it, the effect is startling. One of the wild chimpanzees (known as Mr. Worzel) that primatologist Jane Goodall studied at Gombe Stream National Park in Tanzania had nonpigmented sclerae, and he stood out among his peers for having eyes that eerily resembled human eyes. A captive albino gorilla named Snowflake, who occasionally appeared in *National Geographic*, also had white sclerae, and, again, the human look of his gaze was notable. Eyeballs do not fossilize. Was there a way to address this issue for Sahelanthropus?

The simplest explanation for the occurrence of darkly pigmented sclera in all three species of

African ape is that they inherited this trait from a common ancestor. If this is true, then all of the ancestors of the three species subsequent to this common ancestor would possess this trait, including the last common ancestor of chimpanzees and humans, which lived some time after the gorillas split from the chimp/human line. This means that at some time in human history there was a shift from darkly pigmented sclera to the largely de-pigmented sclera we see in living humans. We can't know the timing of this shift with any certainty, but if we could understand its evolutionary significance, we could make an educated guess.

I knew that assessing another's gaze direction plays an important role in social interaction for many primate species. De-pigmented sclerae allow greater accuracy in such assessments. The communication advantages to having a social group–mate perceive the subtleties of your gaze would apply especially in cooperative group endeavors. Studies of gaze signal behavior in primates have found that humans are adapted for gaze signal enhancement. However, if you are hiding from predators or enemies in a wooded setting, you don't want white headlights peeping out from the shadows. You also might not want an enemy to know whether you are looking at him; because aggressive feelings and the intention to attack are accompanied by direct eye contact in many species of primates, you might want to camouflage the direction of your gaze.

Rick told me about a recent study that reported that human infants follow the direction of the gaze of their mother's eyes, while chimpanzees are less likely to follow another's eyes and

rely on other cues instead. This behavior would certainly be facilitated by de-pigmented sclera.

I hadn't realized it at the time, but an experience a year earlier was connected to an additional social factor relevant to our discussion. During a Thanksgiving visit to my parents in Kansas City, my old friend Dave Philips showed me a movie he thought might scare me. I doubted that possibility; I hadn't been really scared by a movie since childhood. But the movie, *The Grudge,* disturbed me more than any I had seen since I was seven. After it was over I had to linger at Dave's house while he "talked me down." Finally returning to my parents' house, I couldn't fall asleep for hours. The movie left me with a sense of dread that I couldn't explain. Only later did I read about a study concluding that seeing a large expanse of white sclera in the facial expression of another person (as in a look of terror) can generate a signal of danger in the human brain, and that sometimes this response is unconscious. It struck me then that *The Grudge*'s central image of a bulging eye showing lots of white and peeping out of a mass of Japanese hair could account for my unusual reaction to the film. It's not difficult to see the advantages to a social species of reacting to another's look of terror (it's harder to explain why we crazy humans willingly expose ourselves to such terrors for fun).

The balance between the negatives and positives of having a discernible gaze direction must have tipped at some point in human evolution as the latter became more important. The question was, when? When could social behaviors like this have become more important than concealing an aggressive stare or allowing camouflage in a forested setting? Perhaps when more open country settings, where concealment and hiding are less effective, were included among our ancestors' habitats? If so, the shift to de-pigmented sclera would have occurred after the time of *Sahelanthropus,* as all four of the proposed hominin species older than 4.2 million years are associated with indications of wooded habitats. If the shift is more appropriately timed with social changes, there are hints of these scattered throughout the hominin record, but they are sketchy and it is difficult to know when subtle communication in cooperative social ventures, reaction to another's terror, and infants' ability to follow their mother's gaze began to outweigh the other factors.

In the end Rick and I agreed that since *Sahelanthropus* lived so soon after the time of the presumed common ancestor of chimps and humans, which was very likely to have had darkly pigmented sclera, and since it lived in a forested setting in which having dark sclerae offers advantages, a good guess would be that *Sahelanthropus* also possessed this trait. Both inclusion of more open habitats and humanlike social changes were probably far in *Sahelanthropus*'s future. If *Sahelanthropus* was not a hominin, it is even more likely to have had dark sclera like those we see in living African apes. The eyes I made for *Sahelanthropus* were given dark sclerae and placed within the eye sockets according to ape/human commonalities in eye position. Once the eyes were in place, it was evident that the wide pillar between the eye sockets in the *Sahelanthropus* skull would result in widely spaced eyes in the face, lending it a gorilla-like look.

A broken midline crest along the back of the

upper part of the *Sahelanthropus* skull offers a clue about the anatomy of this individual when it was alive. Here too, the comparative anatomy of living relatives is key in the reconstruction of the soft tissue of an extinct animal from bony clues. Among living apes and humans, only individuals with large temporalis muscles (the muscles you can feel moving at your temple when you chew) have such a midline (sagittal) crest. The crest forms when temporalis muscles on opposite sides grow so large in an individual that they meet at the top or back of the skull, and begin to stimulate bone growth there. Living examples with this anatomy include adult male gorillas and orangutans, and sometimes female gorillas and male chimpanzees. From study of these living forms we can understand the implications of a sagittal crest for the musculature of an extinct form. Among hominins, large males of several species of australopith have sagittal crests, and they are especially well developed in robust australopiths like the one we'll meet in chapter four. It is clear that the temporalis muscles were large in these forms.

The bony markings on the *Sahelanthropus* skull indicate fairly large temporalis muscles. Faint ridges, called temporal lines, run across the top of the skull on either side of a narrow strip of forehead, showing where these muscles were attached in life. These lines meet toward the rear of the skull to form the small sagittal crest. Coupled with the presence of a large, compound bony crest, situated in life between the rear portion of these muscles and the muscles of the neck, this feature indicates temporalis muscles that were especially well developed in the posterior

(back) portions, and I sculpted them accordingly. Markings for the other set of chewing muscles (the masseter muscles) are not as well preserved on the skull. I modeled these with contours like those of a healthy ape of *Sahelanthropus*'s estimated body size.

The emphasized development of the posterior fibers of the temporalis muscle offers another clue about how *Sahelanthropus*'s face was constructed in life. Among living forms, fibers of this muscle cross between their points of origin on the skull and their attachment to the mandible. This means that the posterior fibers attached to the skull become the most anterior fibers where they connect to the lower jaw, and they will exert their greatest power at the front of the jaws. Strongly emphasized posterior fibers of the temporalis muscles are related to the way the mouth is used. Living apes use the mouth in food procurement and preparation, as well as a sort of third hand, sometimes preferring it to using their hands when manipulating tools. An orangutan, for example, may sometimes hold a stick in its mouth while using it to extract the edible part of a fruit. In all species of living nonhuman great ape, the suite of anatomical features used in such behaviors includes large incisor teeth, along with a ring of well-developed, dextrous muscles that surround the mouth.

In contrast, manipulatory and food-preparing functions in humans have been largely transferred to the hands. The muscles surrounding the mouth are greatly reduced. This difference results in the largest quantitative contrast between the facial muscles of humans and other living apes.

Sahelanthropus's very large incisors and the more-developed posterior fibers of temporalis suggest that it used its mouth heavily in these roles. Consequently, I reconstructed the muscles ringing its mouth in a way that was still unreduced and apelike, which will strongly affect the overall look of the finished face.

In my effort to determine the width of the *Sahelanthropus* individual's mouth, its canine teeth offered a clue. In apes, the corners of the mouth are, on average, set further back along the tooth row than in humans. While the corners of the mouth in humans are commonly at or near the posterior border of the upper canine teeth, the corners of the mouth in African apes are positioned at the third or fourth upper premolars (in dentist's terms, the first and second bicuspids). When I made a survey of a small sample of African apes (a sample of nine individuals, representing all three species), I was surprised to find that the ranges for the male sample and the females did not overlap. The males had a range of corner positions farther back on the tooth row than that of the females.[7]

The canine teeth in female apes are smaller than those in males, and human canine teeth are smaller still. Based on these differences, my hypothesis is that mouth corner position in apes and humans is related to the size of the canine teeth. Longer canines may require the corners of the mouth to be positioned farther back so that the lips will "clear" them when in certain positions. As this theory is tested on more individuals, the male and female ranges will likely expand and possibly overlap, but, as a working hypothesis, I would guess that the means will still be

significantly different. The canine preserved in the *Sahelanthropus* skull is within the size range of those of female apes, and so I positioned the mouth's corners accordingly.

In the skull of *Sahelanthropus,* the preserved portions of the nasal bones and nasal opening are flat, showing no indications of a projecting nose. The first bony indicators of a projecting nose do not appear in the fossil record until at least four million years after the time of *Sahelanthropus.* The form of the nasal cartilages I built for the head was dictated by the flat nasal area, and they are very much like those of a living great ape.

I was aided in my reconstruction of the nose by two large and different collections on separate continents. The Smithsonian Institution's Terry Collection of human skeletons is so vast that drawers of bones fill floor-to-ceiling cabinets that line long hallways and the walls of several rooms of the closed-to-the-public top floor of the Natural History Building. The collection also contains a number of death masks taken from cadavers that were later skeletonized for the collection, allowing comparisons of skulls and faces from the same individuals. A similar collection of chimpanzee death masks and skulls exists at the University of Zurich in Switzerland. Both collections enabled me to test a lot of long-standing methods of forensic facial reconstruction, some of which came up sour. The breadth of the nasal cavity, long used in many methods to estimate the breadth of the external nose, turns out to be an especially poor predictor. Other dimensions of the skull's nasal area perform better, and the best of these have ratios to the breadth of the fleshy nose that are similar (though not identical) in

chimpanzees and humans. Use of either chimpanzee or human ratios predicts a broad nose for *Sahelanthropus.*

Shifting to the neck, I attached a column of cervical (neck) vertebrae to the skull's base. The vertebrae have not been found and so are admittedly fabricated out of thin air, but it is interesting to note that if the Swiss team is correct in its reconstruction of the skull's base, any cervical column attached (including a modern human's or a chimp's) will be close to vertical in its orientation. Neither a human nor a chimpanzee cervical column can be placed in a chimpanzee-like angled position under this skull without creating atlas/skull relationships not found in nature (the atlas is the first, or top, cervical vertebra).

In their *Nature* article announcing *Sahelanthropus,* Brunet and his team reported that the crests on the back of the skull for anchoring superficial neck muscles are as marked as those of the genus *Gorilla,* implying that these muscles were powerfully developed. These were sculpted accordingly in the reconstruction, although smaller than a gorilla's to match *Sahelanthropus's* estimated smaller body size.

Most of the major features of the reconstruction had now begun to take shape. I applied several thinner sheets of muscle and connective tissue, and then began work on the skin. I did not include a humanlike layer of subcutaneous fat, which is absent in African apes. In humans, it is thought to be related to the body's nutritional buffering system for the growth of very large brains, a kind of insurance against famine or nutritional stress. *Sahelanthropus* lived long before any significant brain size increase in the human

line, and I limited the facial fat in this reconstruction to small areas that can be found in both humans and African apes. Soft tissue over the brow ridges was added, enhancing their appearance of large size.

Identity Crisis

After nearly two months I had almost finished the clay reconstruction of *Sahelanthropus.* The evidence had been mostly unambiguous thus far, and things were going pretty smoothly for the reconstruction, but I was in for a rude shock. It was time to attach the ears. Unlike the nose, the ears represent a feature about which, beyond indicating their position on the head, the skull is not very informative. Fortunately, variation in the size and shape of the ears in adult African apes and humans is fairly conservative. For example, the heights of the ears in eight African apes I measured (from all three species, with a body size ranging from a subadult female bonobo to two adult male gorillas) all fit comfortably within the human range. I had data that showed this, but I decided to test the idea further on a random sample of humans by measuring the ears of whoever happened to be in the local coffee shop one morning. I overslept on the appointed day, however, and, rushing down to the coffee shop with my calipers, found only three customers, two men and a woman, just leaving. Fortunately, they were willing to stay another minute and lend me their ears (this was for science, after all). The

(facing) This sequence shows stages in the anatomical reconstruction of the head of *Sahelanthropus tchadensis.*

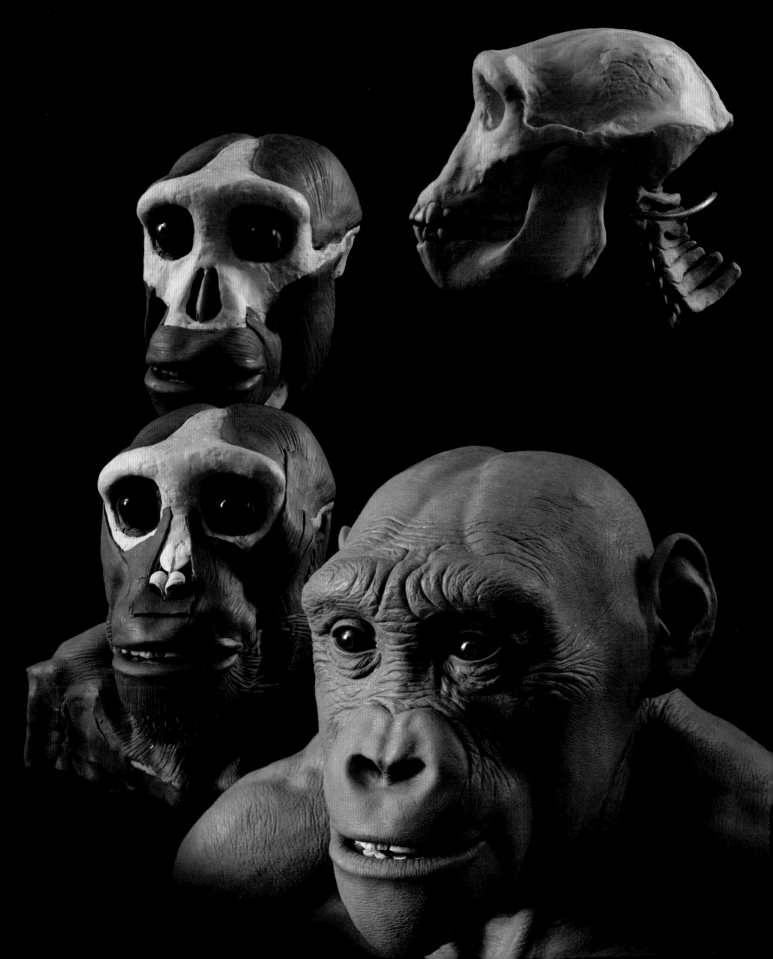

ears of just these three individuals ranged from 6.0 to 7.7 centimeters for ear height, and this range encompassed all eight of the African apes I had measured earlier.[8]

Depending on the size of the head, ears can seem large or small. For example, gorilla ears look small because they are attached to very large heads; chimpanzee ears have only slightly greater heights than those of gorillas, but they seem much larger because they are attached to smaller heads and have relatively greater breadth. Average human ears look, to human eyes, about average. I've been able to find no bony variable that correlates well with the size of the ear, so I've always tried to be cheerful about it, and have viewed this situation as an opportunity for doing a self-portrait: most of my hominin reconstructions are graced with casts of my own ears.

Interestingly, a disjuncture results when casts of modern ears are fitted onto the skulls of earlier hominins. Because the hole for the ear (auditory meatus) and the jaw joint are farther apart in the skulls of apes and australopithecines, a copy of a modern human's ear that is positioned correctly relative to the meatus (hole) will have its front edge hanging out in space, terminating before the front of the earlobe can make contact with the more forwardly placed back of the jaw. The earlobe must be extended forward in order to reach the back of the swelling representing the masseter muscle and the parotid gland (which is situated below and in front of the ear) that overlies it. As a result of this relationship, apes' earlobes are broader than humans', and reasonable reconstructions of earlier hominins must follow suit. Sahelanthropus also displays this greater distance between jaw joint and ear opening, and its (my)

earlobes were extended forward to meet the jaw, giving the earlobe a more apelike look.

But uncertainty about ear size and shape wasn't the problem. I was startled when I positioned replicas of my ears on the developing Sahelanthropus head, because the gestalt of the head suddenly became very chimpanzee-like. This bothered me because we have learned from the earliest known fossils that might be hominins that we should probably discard the long-held assumption that our ancestors will be ever more chimpanzee-like as we trace the human lineage ever further back in time toward our last common ancestor with chimpanzees.

Had I gotten some of the anatomy wrong? Perhaps I hadn't made the brow ridge thick enough. I cut into the soft tissue of the finished brow in order to remeasure both the bony brow ridge and the soft tissue over it. The former matched the published thickness measurements exactly. The soft tissue here cannot be reconstructed with absolute certainty, but soft tissue in this area has very similar thicknesses in normal-build humans and chimpanzees (excluding obese or emaciated individuals), and is even similar in the way it varies from site to site. As these thickness values vary with body size (they are larger in gorillas) there would be no justification in using gorilla values for a smaller primate of Sahelanthropus's estimated body size. My measurements of the soft tissue values confirmed that I had sculpted the soft tissue over the brow ridge so that it was consistent with human and chimpanzee values. Applying gorilla values that are corrected (scaled down) for body size gives the same results.

At this point, I left the studio and went into

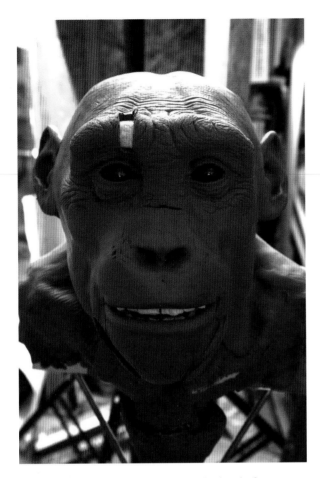

Late in the process of reconstructing the head of *Sahelanthropus*, I cut into the soft tissue of the brow to check my work.

mate recognition when she looks at me (or so she says). Replicas of my ears look large on this smallish *Sahelanthropus* head, which, of course, lacks my cerebral development. By using smaller ears, I could get away from a chimplike appearance, and the head, without anything to indicate scale, would then appear more gorilla-like in the size of the ears relative to the head. But there was no scientific justification for using ears that were much smaller in absolute size than average chimp, gorilla, and human ears, and I felt I would be cheating if I took this route, so I had to let the ears stay.

A second factor contributing to a chimplike appearance was the large size (breadth) of the upper central incisors, especially relative to the overall size of the head. The central incisor used in the *Sahelanthropus* skull restoration that was the basis of my reconstruction is one described in the initial *Nature* article and included in some versions of the Swiss team's virtual restoration. It is large, with a breadth that is greater than an average chimpanzee's. I had to consider the possibility that it came from a larger individual, but the tooth that was once in place in the *Sahelanthropus* skull could not have been very much smaller because the distance between the skull's upper canine teeth would have required incisors of about this size to fill the space. A remeasurement of its breadth confirmed that it matched the measurement published in the initial *Nature* article. Sticking with the evidence meant that I was stuck with the original incisors.

my house to make a cup of coffee. Having coffee with a developing hominin is something I often do; it's a good way to put the process on pause and unhurriedly think things over. I wanted to analyze my gestalt impression of chimp-ness in the head. By the time the cup was drained I had identified four factors that contributed to this impression. The most obvious one was the apparently large size of the ears relative to the head. I don't have particularly large or chimpanzee-like ears. My wife, Patti, thinks they look fine on me, and she even experiences species-specific

Another factor was that the size of the eyes relative to the face was chimpanzee-like. A gorilla's eyes are smaller in relation to its face in comparison to a chimpanzee. You can test this by

printing same-size pictures of the faces of adult chimpanzees and gorillas. Although the gorillas may have slightly larger eyeball diameters in a straight numerical comparison, they will have smaller eyes relative to the size of their faces. This follows a common mammalian pattern: large mammals tend to have eyes that are relatively smaller than those of their more diminutive cousins. In lions versus housecats, or baboons versus macaques, the eyes have not scaled up as quickly as body size. Eyeball diameter in the case of *Sahelanthropus* was predicted from the transverse breadth of the eye socket, and this ratio is so similar in chimps, gorillas, and humans that choosing an eyeball that departs from this relationship couldn't be justified. So I was stuck here too with anatomy that couldn't be tampered with for the sake of avoiding the subjective gestalt impression of chimp-itude.

The fourth factor I identified was mirth. Ever since I had sculpted the tissue around the eyes, the face of the reconstruction had carried the impression that its owner was rather amused by something, as if there was something funny here that I had failed to apprehend. This expression was not intentionally built into the sculpture, but sometimes small changes can produce unintended subtleties. The sculptor has to stay aware of this kind of thing, and to be ready to keep a happy accident if it influences the subjective impression of a sculpture in a positive way and conforms with the scientific guesswork, or to change a not-so-happy accident if it doesn't. I had felt good about the expression up until this point. But an expression that looks like subtle amusement to human eyes is fairly common in

chimpanzees and not so common in gorillas, so it biased the gestalt in a chimplike direction. My final decision had nothing to do with science, but I deepened the furrows in the brow a little in order to distance the sculpture from a mirthful, chimplike gestalt.

The result of all of this hand-wringing? After reviewing the work, I didn't know how to make the sculpture less chimpanzee-like without shamelessly stacking the deck or breaking some anatomical rules. For me the final clay head had a general African ape feel, with some features that leaned in a chimp direction and some that looked a little more gorilla-like.

Bringing Clay to Life

When I had finished adding the clay skin, it was time for the sculpture to go "under the rubber." I chose silicone for making a mold of the clay head because of its longevity and its microscopic fidelity to detail. Over this a mother mold was fabricated, using the kind of fiberglass a doctor would use to make a cast for a broken arm. This lends the mold rigidity. I then stripped the silicone mold and mother mold from the head and made a cast in a different type of silicone that can be tinted any color. Some thought went into how this material should be colored.

For all we know, *Sahelanthropus* may have had a blue nose and a flaming orange mane. Skin and hair color patterns within living primates can be pretty outrageous in some species (as with the red, white, and blue of an adult male mandrill's face or the decorative hair patterns of various species of guenon). But without any indications of such, a conservative guess would be skin and

hair color patterns that are within the more restricted range of humans and the three living species of African ape. Factors governing skin color in humans are not a big mystery, although historically people have obsessed over it. There is an optimum amount of the sun's ultraviolet radiation that humans take in through the skin. Too little and the skin is unable to synthesize vitamin D. Too much and there is a higher risk of skin cancer and other health problems. In the tropics, where the sun's rays are more direct, the exposure to ultraviolet light is too high, and some of it must be blocked and absorbed by dark pigments in the skin. In higher latitudes the sun's rays are less direct, so the amount of pigment is reduced in order to allow an optimum amount to be taken in by the skin. The hominin reconstructions for the Smithsonian's new hall follow this pattern, with darker skins for tropical hominins and lighter skins for higher latitude hominins.

Adults of all three species of African ape have very dark facial skin. There are variations in this pattern: the juveniles of common chimpanzees are lighter-skinned than their darker parents, and bonobos of all ages often have lighter coloration around the mouth and eyes, in an otherwise very dark face. Gorilla faces are generally very dark throughout life. We cannot know about such subtleties in the extinct hominins, but whether a human model or an African ape model is followed for an adult of the tropical species *Sahelanthropus*, mostly dark facial skin would be indicated.

I had given the later tropical hominins skin which had dark colors within the human range. *Sahelanthropus* lived so far back in time that I thought it would be more appropriate if I made it more like the dark skins of African apes: still very dark, but with some blacks and grays that are de-saturated in color, lacking the strong reds and browns that commonly color human skin. I gave the majority of the face of *Sahelanthropus* a desaturated black common to all three living African ape species, with some subtly lighter coloration around the mouth. These colors had to be mixed into the silicone and painted into the mold in layers. If color is applied externally, it will have a painted look that does not emulate skin.

There are many variations in hair patterns, but all three species of African ape share an abundance of dark hair on the face and head. For *Sahelanthropus,* I mixed in some lighter variations around the mouth, as seen in some chimpanzees. The hair chosen to implant into the *Sahelanthropus* head was not human hair. Human hair has cut ends, and these don't produce a gestalt impression of fur the way the tapered ends of an ape's hair do. Our peculiar form of ever-grow locks is not found elsewhere among primates, and it is easy to see how it could be maladaptive unless it could be tied or cut. It is my guess that it did not show up in humans until later in our evolution, perhaps not until it could be cut, tied, or burned.

For the *Sahelanthropus* head I chose black bear fur, which can be made to resemble that of an African ape. In all of the areas where one can look into the scalp, the hair must be implanted one by one into the silicone head with an altered needle. This is a difficult skill to learn, so assistants that can master it are rare. However, I've found two assistants who turned out to be good at it, and both helped with the Smithsonian project.

Artist Bryan Root, who, like me, lives in the little village of Trumansburg in upstate New York, helped with the hair for *Sahelanthropus*. When plans that my wife, Patti, had made for an April family vacation to Belize fell through in 2011, the only way to resurrect them was to reschedule the trip sooner, for February, a month before the March deadline for the reconstruction. It was a difficult decision, but I ultimately decided to go. Bryan's help made it possible, but I felt a little guilty about it, playing in the waves with my kids while Bryan punched in hair number 367,213 . . . 367,214 . . . 367,215 . . . with the February winds of the New York tundra howling outside. I returned from the vacation, finished the hair punching, and headed to the airport with the completed *Sahelanthropus* head in my carry-on luggage for the flight to Washington. I was expecting some interesting conversation at airport security, as I've previously had about other unusual baggage, but this time I was disappointed.

Many of the features reported for *Sahelanthropus* in the literature are visible in the finished head. You can see the long, narrow braincase. Encroaching on this small braincase are large temporalis muscles which are particularly well developed toward the rear, where the two opposite side counterparts meet and are anchored by the small sagittal crest. Between the bodies of these muscles at the front of the skull a flat frontal area is visible, with a nearly horizontal forehead.

The head's tall upper face is coupled with an upper jaw that is shorter vertically and projects forward less than in chimpanzees and some australopiths. The lower jaw is also vertically short in comparison with australopiths. The flat nasal area of the skull is manifested in a nose that is flat and apelike. The head looks chimpanzee-like in overall size, in the size of its cheeks and front teeth and, of course, in the relative size of the ears. It looks more gorilla-like in its widely spaced eyes, topped with a large and continuous brow ridge, and also in the relatively well-developed neck musculature.

Clearly visible are the ends of the canine teeth, worn a little flat at the tips, and the nearly vertical neck supporting the head, features shared with all later hominins. A great many features we identify with the human face and head—the large brain, the reduced jaws and teeth, and the projecting nose and chin—are all still very far in the future.

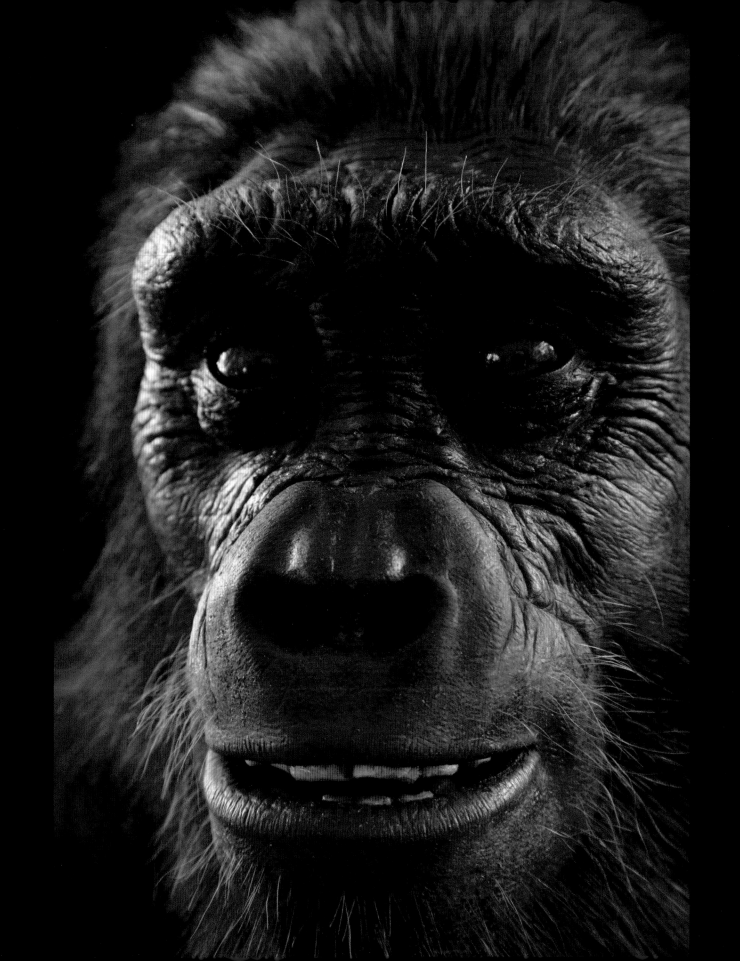

We have just begun our pilgrimage through human history with the oldest suspected hominin, Sahelanthropus tchadensis. Here we meet the Smithsonian team coming back through time the other way. For them, this is the end of the journey, as Sahelanthropus was the last hominin to be included in their new hall.

They tell us of an outlandish descendant of Sahelanthropus, living more than six million years in the future. It consists of a number of very large brains, linked by a kind of sound-mediated telepathy, so that a thought that occurs to one can instantly be transmitted to many. Singly these brains are more than three times the size of Sahelanthropus's brain, and can perform impressively. But together they can level mountains, change the planetary climates, propel complex artifacts out of the solar system. Each individual brain is supported by an individual system of organs, but functionally there is no such thing as an individual brain; these brains can function only as a group. They are dependent on their linkage to other brains to such an extent that they cannot develop normally without it. The team describes a potent system of technology supported by this new type of global colonial organism, and tells of a transformation wrought by it on the surface of the earth.

All of this sounds like a wildly improbable science fiction scenario. We've seen nothing in this small-brained early hominin to indicate that it might be on such a path. At most, it looks like an ape with small canine teeth and the unusual habit of balancing on its hind limbs to move across the landscape, which other apes do occasionally.

We wonder whether anything about these slightly unusual characteristics could enable or predispose an animal to take an evolutionary path that involves a specialization of the brain like that described by the other time travelers. It does not strike us as likely; it is almost unimaginable, but we will keep an open mind as we move forward in time.

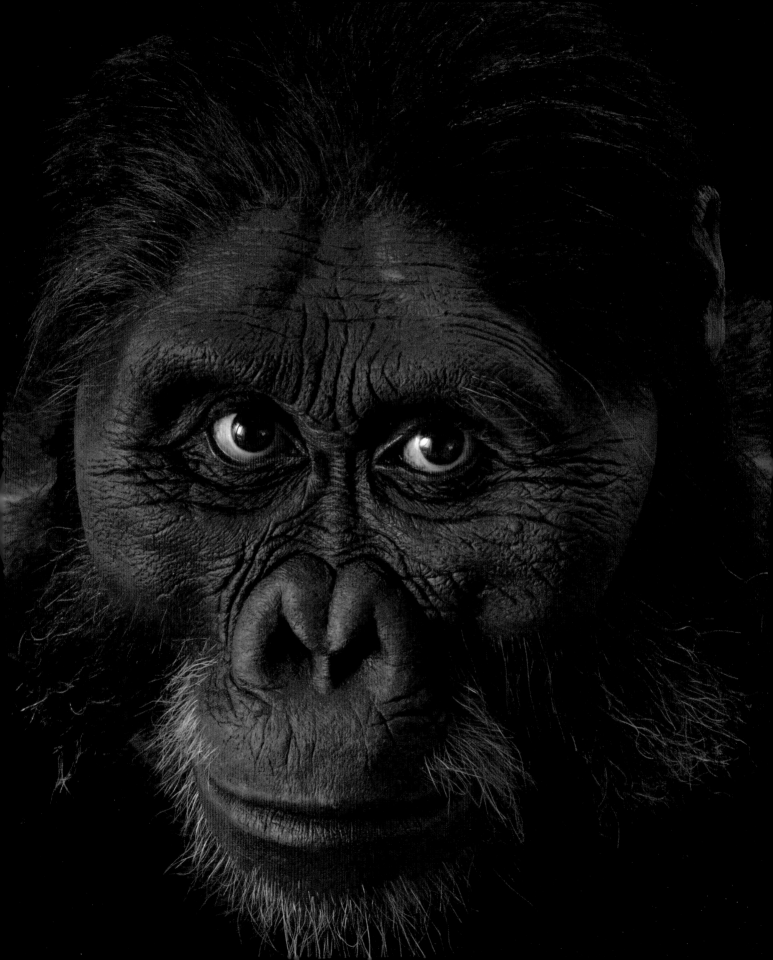

WALKERS AND CLIMBERS

Australopithecus afarensis (3.6 to 2.9 million years ago)

One morning I awoke to the sounds of primate calls from the trees behind the house where I was staying. I got up and took a cup of coffee out into the yard. I sat on a bench and watched the primates for a while. Then I went inside and made them some pancakes.

The primates were my children, Blythe, Loren, and Meave, aged eleven, ten, and eight. They spend less than 1 percent of their time in the trees, and they are firmly committed to bipedal walking when on the ground. In their skeletons, they carry signs of their arboreal ancestry. The mobile shoulders and opposable thumbs their ancestors developed for a life in the trees are still in evidence, although they have now been co-opted for other purposes in these tool-using ground dwellers. Their shoulder blades' position on the back of their rib cages and their wider-than-deep chests are those of an arboreal great ape, yet they practice arboreal locomotion for only a tiny fraction of their time.

Would a scientist of the far future, examining their bones, interpret them as those of a climber? If so, that individual would be overstepping the evidence. If, however, the scientist looked for patterns in the bones that form only during the life of an individual who is an active climber, it would be apparent that these are absent in their skeletons.

Early Discoveries

A man stands in a barren, eroded landscape under a wide-angle Ethiopian sky. In his hands he holds two fossilized bones that fit together to make a knee joint. He dares not believe what he is thinking. The two bones meet at an angle the way a human knee is angled, which allows us to bring the knee, lower leg, and foot into a position directly below the body's weight. Could these bones be those of a creature that walked upright on two legs? He knows that the sediments that yielded the bones are about three million years old. If they are from a biped, that would make the creature whose bones he

was holding the oldest known biped, and probably the oldest known member of the human family.

The knee joint that Donald Johanson discovered on that day in 1973 was not accompanied by any other parts of the skeleton except for some additional pieces of the thighbones. It was, however, a very fortunate group of bones to find. An angled knee is one of the clearest signals of bipedal walking a skeleton can offer. The bones of a chimpanzee's knee, by contrast, come together along a straight line. Since the animal cannot bring the knee under the body's weight without angling the whole leg and putting the foot in a bad position for two-legged walking, it lurches instead from side to side, positioning the body's weight over first one leg and then the other. After conferring with colleagues, Don was able to confirm what he had suspected. Although he didn't yet know exactly what kind of creature he had found, he knew it walked on two feet. It was one of us—a hominin.

On the day that the knee joint was found at Hadar, there were other, more spectacular fossil hominins weathering out of the sediments not far away. The next two field seasons would prove to be even luckier. A year after the knee joint was found, Johanson and his team discovered the partial skeleton of a diminutive australopith female that has come to be known as Lucy, named for the hallucinatory Beatles' song "Lucy in the Sky with Diamonds." On that celebratory night of the find, the camp's speakers blared into the African night lyrics describing rocking horse people eating marshmallow pies.

In the world of paleoanthropology, this find was an exciting event. The earliest hominins had

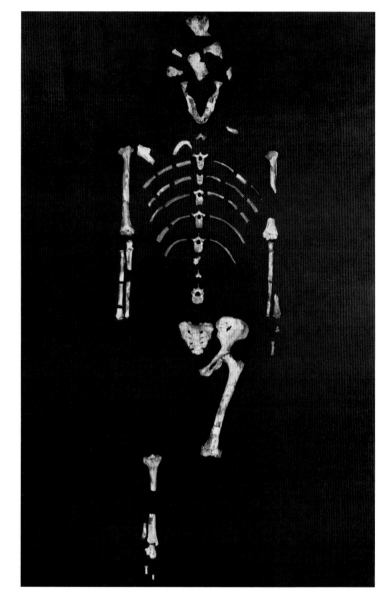

The Lucy skeleton. (Photo courtesy Institute of Human Origins, Arizona State University)

been, until then, known mostly from isolated bones and teeth. Here was a collection of associated bones from a single individual, which for the first time allowed a glimpse of the outline of an australopith's form, if the dots could be

properly connected. Never before could scientists accurately calculate the proportions and size of the body for an *Australopithecus:* arm/leg ratios, relative body breadth, proportions of the trunk, stature, and body weight. Analyzed properly, this skeleton could serve as a kind of Rosetta Stone for the interpretation of more fragmentary remains.

The team's luck continued during its third field season. A year after Lucy's discovery, the team found a site now referred to as A.L. 333, which was the scene of a dark occurrence at Hadar that scientists are still trying to understand. A group of individuals, numbering perhaps seventeen, may have been killed there in a single, catastrophic event. A flood was proposed early on, but some scientists are now considering predation by large carnivores. It is ghastly to imagine. Even if we close our mental eye, the sounds alone, the echoes of which we might hear when we touch these bones, are horrifying. Ancient tragedy aside, this event has been a boon to researchers: the assemblage includes children and adults, and males and females, and it allows an unprecedented look at variation in size and shape within a population of early hominins.

Together with fossils from the Tanzanian site of Laetoli, found by Mary Leakey and her son Philip, Lucy and her compatriots were given the name *Australopithecus afarensis* by a team that now included Tim White, a paleoanthropologist that had worked with the Leakeys. Mary, whose name was originally on the research paper announcing *A. afarensis,* thought that the Laetoli specimens she had found and the larger specimens recovered by Johanson's team at Hadar had *Homo* affinities and disagreed with their

inclusion in *A. afarensis* (she consequently asked that her name be removed from the paper). The naming met with arguments from others that the collection represented more than one species (or, from other quarters, that it was not different enough to merit the designation of a new species), but today there is a fair consensus that it samples a single species which is distinct from other hominins.

Here again the influence of Milford Wolpoff and the "lumpers" can be felt. Tim White is one of Milford's former students, and like him has a history of viewing the human fossil record as representing a simpler tree with fewer species, as opposed to the multibranched family trees favored by the "splitters." Early speculations by Johanson and his team about the Hadar hominins favored division of the collection into two or even three species. Largely due to the influence of Tim, who joined the effort a little later, the research team came to the view that the assemblage represented a single variable species.

In the years since these early discoveries, important fossils attributed to *A. afarensis* have continued to be recovered. These have included two fairly complete skulls, the spectacular partial skeleton of an infant which became known as the Dikika child, and a partial skeleton thought to belong to an adult male. Does such an extensive collection mean more clarity and less controversy? Read on (and weep).

Questions for Lucy

What was Lucy? Her world and her experience of it—are they completely lost and irretrievable? What can these fragments of bone tell us

about her story and that of her species? We have so many questions for her. How human was Lucy? How did she move? Did she walk like we do? Did she spend time in the trees? If she had children, what was birth and motherhood like for a hominin living 3.2 million years ago? What did she eat, and how did she obtain her food? Did she make or use tools? What was her social life like? How did she see her troop mates? Did she have ideas about what the others were thinking? Empathy? Can we reconstruct the being that once had this skeleton living within it? A surprising number of these questions can actually be answered to some degree by the bones of Lucy and her species mates, especially when the context of the fossils is taken into account.

You were so tiny that your discoverers at first thought you might be a monkey. Were you a child when you died?

Despite her small size, Lucy was not a child. The fused end caps of her long bones and the erupted third molars (wisdom teeth) in her lower jaw testify that she was an adult. The third molars have only minimal wear so they cannot have been erupted for long, indicating that Lucy died as a young adult.

How did you move in your day-to-day foraging? Did you cross a stretch of ground on four legs or two?

In addition to an angled knee, Lucy and her species mates show a number of clear adaptations for bipedal locomotion, up and down the skeleton. These can be seen as further improvements to the adaptive package of a biped over those adaptations seen in *Ardipithecus*.

Lucy's pelvis is short and broad. If you compare it to that of an ape, you can see that the pelvic blades have been "turned" so that the surfaces which face posteriorly in apes face somewhat to the side in Lucy. Muscle attachment sites which are on the back of the pelvis in apes have been moved more to the side in Lucy's pelvis. These muscles (the lesser gluteal muscles) are in a position to hold the trunk stable over the supporting leg as the opposite side's foot leaves the ground to swing forward. In the position and function of these muscles Lucy is like us. If her pelvis had been found with no other associated bones, it would still be clear that this was a creature that walked bipedally.

The foot of *A. afarensis* features a largely immobilized (some argue not entirely immobilized) big toe, which, in line with the other toes, can function as a stiff paddle for pushing off of the ground during the phase of walking called "toe-off." A 2011 study of an *A. afarensis* metatarsal (long bone of the foot) finds strong evidence for an arched foot, although this too is debated.

When you walked, would your movement have looked familiarly human to us, or would your gait have a strange feel, unlike the walk of anyone living in our time?

Would Lucy's short legs and relatively longer feet have resulted in a walk unlike ours? Some scientists have concluded that Lucy's gait was like ours. Others feel that the cumulative effect of all of the little differences between Lucy and ourselves in bone shape, body proportions, and the position of muscle attachments would add up to a gait for Lucy that was different from a modern

human's. A bent-hip, bent-knee gait has been suggested for Lucy by some, but others have rejected this as maladaptive because it would have been so inefficient energetically. Lucy's relatively long feet and the long lateral toes of a partial foot skeleton from the A.L. 333 site suggest to some that the toe-off phase of walking in *A. afarensis* would have been different from that of modern humans.

––––––––––––

Did you dream in the trees? Did trees represent sleep and safety to you? Did you sometimes have nightmares of falling? Were these worse than your dreams about being attacked by a predator on the ground? Had your feet lost all grasping function? What happened when you ran a fingernail gently across the sole of your infant's foot?

While there is a broad consensus that Lucy walked bipedally when on the ground, there is intense debate about the implications of more apelike features of her skeleton that are functionally related to climbing. Can these traits be taken as evidence that Lucy's kind spent time in the trees, perhaps sleeping, escaping predators, and foraging there? Or are these traits merely evolutionary baggage left over from an arboreal ancestry, in a creature firmly committed to life on the ground?

Lucy had shorter legs and longer arms (especially forearms)[1] than living humans have. Chimpanzees use their even shorter legs in a style of climbing in which they "walk up" a vertical trunk while their long arms allow the hands to be used like hooks on the back side of the trunk. Interestingly, in human cultures where tree climbing is important, people often climb in the same way, with the legs flexed so that they are effectively shortened, and the arms artificially lengthened

with the use of hooks or a strap that goes around a vertical trunk. Lucy's proportions would have been useful in climbing.

Lucy's shoulder joints are tilted upward more than those of modern humans. This apelike tilt would facilitate activities with her arms in a raised position. It has been argued that the long lateral toes of the A.L. 333-115 partial foot skeleton would enable more grasping ability than that of a human foot. In addition, some have argued that the more curved joint at the base of the big toe implies the retention of some grasping ability, but this is hotly debated. *A. afarensis* hand bones show evidence of a large carpal tunnel (the bony tunnel in the wrist for the passage of flexor tendons from the forearm into the hand and fingers), and metacarpal (bones of the palm) heads with a shape optimized for flexion. These characteristics would be useful in climbing, but might reflect other activities such as the use of tools.

Comparisons of the *A. afarensis* skeleton with those of apes suggests that features related to bipedal walking have been strongly selected for in Lucy's lineage, sometimes at the expense of features useful for arboreal climbing. The grasping ability of the foot has been largely sacrificed, for example, resulting in a stiffer foot that is a more efficient lever for pushing off the ground. Such features suggest that selection for efficient bipedal walking may have played a greater role in shaping Lucy's species than arboreal activities did.

A demonstration of the retention of features useful in climbing, but not optimal for bipedal efficiency, would offer a counterweight to such arguments, implying that selection for efficient

bipedal walking was to some degree balanced by selection for traits used in climbing. The retention of shorter legs in *A. afarensis,* which are less energy-efficient in bipedal walking than our longer ones, but arguably more useful in climbing, may represent such a trait. The retention of long forearms seems also to have been stable for a very long time.

One promising approach to the climbing question is to look for skeletal features related to climbing that are not set in bone by strict genetic control, but that are instead heavily influenced by patterns of activity during an individual's life. Such features respond to patterns of stress imposed on bones when an individual climbs, as opposed to features under tight genetic control which have been inherited from a climbing ancestor and might be present in the descendant's skeleton whether it climbs or not. One such feature that has attracted attention is the marked curvature of the finger bones in Lucy's kind. We know that apes that climb develop stronger curvatures than those that are prevented from doing so by pathology or captive conditions. Other candidates for features that might reflect climbing activity in the lives of *A. afarensis* individuals include the pronounced ridges for flexor tendons and tendon sheaths on finger bones from Lucy and her species mates, as well as evidence of powerful upper body muscles at their strongly marked attachment sites (especially pronounced in large individuals).[2]

Studies of the metacarpal bones of *A. afarensis* indicate that their bony walls are very strongly constructed, and this kind of intense bone deposition is widely thought to reflect activity patterns. Is it possible that this characteristic is a reflection of climbing behavior, or is it equally possible that it reflects some other behavior, such as heavy use of hammerstones for nut-cracking or some other use of tools? K. Coffing of the University of California, Los Angeles, and C. Boesch of the Max Planck Institute for Evolutionary Anthropology have suggested that locomotion affects the strength patterns in the bony walls of metacarpal bones more than tool use. They base this argument on finding no significant differences between metacarpals from chimpanzees that used hammerstones and those of chimps that did not. The two scientists also note that humans who have had a life of heavy manual labor do not develop metacarpal walls as strong as those of apes or australopithecines. They conclude that the strongly built metacarpal bones of *A. afarensis* are most likely a reflection of locomotor behaviors, and that this evidence fits a locomotor model for *A. afarensis* that includes climbing.

The bony walls of the femoral neck (that portion of the thighbone that runs between the spherical head at the upper end and the long shaft that forms most of the bone) also reflect activity patterns in living primates, and here Lucy and her kind show a humanlike pattern of being thicker at the bottom. This kind of bone deposition reflects patterns of stress which occur during bipedal walking. Tree climbing, as it is practiced by chimpanzees, stresses the femoral neck from a variety of angles, and the thighbone of a climber responds by laying down a nearly even layer of bone in the walls of the femoral neck. If Lucy's kind was spending a significant amount of time climbing, why don't the walls of their femoral

necks show a more even distribution of bone, as in living apes which climb? Some scientists have suggested that we cannot expect a climbing australopith to have a pattern identical to a chimpanzee's because the reduced grasping ability in the lower limb precludes a style of arboreal activity identical to a chimp's, and australopiths may have been climbing in ways that did not involve the variety of loading angles (vectors of mechanical force) which occur in chimpanzee arboreal activity. Some have also pointed out that there are other primates with a humanlike distribution of bone in the femoral neck, despite their obvious arboreal locomotion.

Pathologies sometimes give hints about how an individual's skeleton was used, how a life was lived. A 1983 study of pathological bone growth in Lucy's vertebrae concluded that she suffered from a condition resembling Scheuermann's kyphosis (a condition resulting in uneven growth of the vertebrae) in living humans, and the authors, which included Donald Johanson, concluded that her life may have included climbing or acrobatic activity.

This debate was already more than two decades old when the discovery of what has been called a "precious little bundle" of bones of an *A. afarensis* child was announced in 2006. The publication of the find, from the site of Dikika in Ethiopia, was made by an international team led by Zeresenay (*Zeray*) Alemseged. It was noted that the finger bones already (at the age of three) displayed strong curvatures, and this was taken as evidence that this individual climbed. The nearly complete skeleton showed two other features that can be seen as functionally related to climbing. First, the shoulder blade has a shape that is intermediate between the shoulder blades of juvenile humans and juvenile gorillas, with a large hollow for a muscle that raises the arm, and an upwardly tilted shoulder joint. Second, within the child's skull are semicircular canals, which once housed the vestibular organs of balance. Their proportions in living animals are related to styles of locomotion, and those of the Dikika child are apelike. Taken together, these features, in the words of Alemseged and his coauthors, "raise new questions about the importance of arboreal behavior in . . . *A. afarensis*." Other experts have used more direct language, seeing the particulars of the find as good evidence that *A. afarensis* engaged in climbing.

This discovery would seem to be a clincher, but newer evidence and interpretations have appeared supporting the opposite side of the debate, and so the discussion continues. Those who question the arguments for active climbing in this species ask, If climbing played an important part in the lives of these hominins, why do nearly all the "arrows" of natural selection seem to be pointing the other way? Why are features useful for terrestrial bipedalism almost always favored, often at the expense of features important to climbing? Those who support active climbing in the australopiths ask, Why did shorter legs persist for almost two million years in the australopiths if longer legs are more energy-efficient? Why did long forearms persist? The longevity of these proportions seems to imply that they were maintained by some form of stabilizing selection. Doesn't the fact that they would be useful in a style of climbing practiced by chimpanzees and

humans strongly imply that this was the reason these body proportions were maintained, even at the expense of more efficient bipedality? Some scholars think that stabilizing selection for a body that was capable of bipedalism on the ground and also of climbing trees for sleeping, foraging, and escape from predators was responsible for maintaining the australopith body form for such a very long period. Such a body form may have provided a variety of options for dealing with environmental variation.

You must have feared terribly the large predators in your world, the lions, leopards, hyenas, and saber-toothed cats. We know that something terrible happened to a group of your relatives who lived in your area a little after your time, and some signs point to predator attack. To us, you seem such a small vulnerable primate. How did you avoid these carnivores?

Australopiths were smallish primates which lived among some very large predators. Some have argued, purely on ecological grounds, that Lucy's kind must have sought the shelter of trees to escape predators, especially at night, citing evidence that all living primates anywhere near her size require trees or cliffs for sleeping, even among the most terrestrial species. The A.L. 333 locality may represent a catastrophic death assemblage, or it may represent serial ambush killing of hominins over time. In either case it is clear that large predators would have been a major concern, and for some it is difficult to imagine how these hominins could have safely slept on the ground.

What environment felt like home to you? We know that the climate and habitats in your area fluctuated widely. How were you able to succeed in such a large variety of habitats?

Pollen preserved within sediments from Hadar indicate that the environment strobed between grassland and woodland, wet and dry. Amazingly, remains of *A. afarensis* are found throughout the sequence, persisting through wide environmental fluctuations, with no marked preference for any single habitat. It has been argued that these early hominins exploited resources that were varied in space and time. The work of Rick Potts and his colleagues suggests that the evolution of a versatile locomotor repertoire and a flexible diet were responses to the wide diversity of adaptive settings produced by climate change. Rick calls this type of selection "variability selection" and hypothesizes that it was a strong agent of the evolutionary changes which led to *A. afarensis*. This means that these ancestors were adapting to varying conditions by developing anatomy and behavior which buffered them against change, favoring the quality of adaptability over adaptation to any specific environment. Their locomotor capabilities and their dietary adaptations served in a variety of conditions, aided by their intelligence and behavioral flexibility, allowing them to exploit increasingly patchy and seasonal resources. The persistence of Lucy's kind through broad environmental changes foreshadows the superadaptability of her descendant, three million years later, who can be a tropical species one day and an arctic species the next.

Did you have babies, perhaps several? Was the birth process difficult for you as it is for us? Were your babies helpless like ours, demanding a great deal of care, perhaps involving the help of others? Or were they more self-sufficient, perhaps able to cling to you like the babies of nonhuman primates living in our time, and forage for themselves at an early age?

The difficulties of human birth result from the tight squeeze involved in passing a comparatively large-brained fetus through a pelvis that must remain narrow for efficient bipedalism. Birth in comparatively smaller-brained, quadrupedal species such as living apes involves neither of these factors. In australopithecines such as Lucy, adult and reconstructed infant brain sizes are similar to those of chimpanzees, so one of the constraints humans face is relaxed. The side-to-side breadth of Lucy's pelvic opening would allow passage of a chimpanzee-sized fetus without great difficulty. Interestingly, the limiting factor evident in Lucy's pelvis appears to be the birth canal's narrowness from front to back, and some researchers argue that it would have required a unique fetal orientation.

The unusual degree of helplessness of human newborns in comparison to other primate babies is related to their brain growth trajectories: at birth, human babies have a larger share of the growth of their brains still in their future. The pattern shown by two skulls from juvenile *A. afarensis* individuals near the age of three, from the Ethiopian sites of Dikika and Hadar, overlaps with both human and African ape patterns, but in some comparisons is closer to the human one. Estimated cranial capacities for both skulls

represent smaller percentages of average adult cranial capacity for the species than is typical of chimpanzees at this age. If further work confirms that *A. afarensis* juveniles are more like humans in reaching a lower percentage of the target adult brain size at an early age, it would suggest that infants of this species were more helpless than those of living African apes at comparable ages.

Did males in your troop fight over you? Did you and other females travel with only a single adult male as today's gorillas do, or were there many males in your group? Did you come into estrous and mate with many males, as chimpanzees do, or were you bonded to a single male, perhaps in a long-lasting relationship, who fathered and helped feed your growing children?

How can Lucy's mute, stony bones possibly yield answers to these questions? By themselves they cannot, but, in the context of the collection of remains from her kind, they give some intriguing hints. Estimated body size can provide a clue. Certain skeletal dimensions, such as the diameter of the femur's head, are highly correlated with body weight in living humans, so this measurement can be used to estimate body weight for extinct hominins. Although there are some dissenters, many have argued that the results of such predictions for Lucy's kind indicate a range of body sizes larger than the range in modern humans, and more like the ranges seen in living gorillas and orangutans. In both of these species, there is a greater difference between the average body size of males and females (sexual dimorphism) than that in humans or chimpanzees. Strong sexual dimorphism in body size among

living species is accompanied by heightened competition among males for access to females. This can take the form of a "harem" mating system, like that seen in gorillas, where one male monopolizes several females and is occasionally challenged by other males.

So we might guess that Lucy's kind lived in social groups similar to those of present day gorillas. If only life could be so simple. Confounding our quest for a clear picture is another arrow pointing in the opposite direction. In comparison with those of male apes, the canine teeth of *A. afarensis* males are very reduced in size, and as a result the species has a low level of canine tooth size dimorphism. A reduction in the size of male canines like that seen in *A. afarensis* would suggest diminished levels of natural selection for their effective use in threat displays and as weapons. Canine reduction in males suggests to some a decrease in male to male competition in *A. afarensis,* as well as in *Ardipithecus* and in hominins in general, and this has been used as a basis for theories about monogamous social organization in these species.

Alternatively, if reduction in the size of the canines in a species with large body size dimorphism suggests reduction of their use in threat displays and as weapons, maybe this reflects the use of some other mode of threat and battle, perhaps involving the hands or hand-held weaponry, in a species with high levels of male competition.

Since a large number of bones has not resolved this controversy, it is possible that only the discovery of a troop of living *A. afarensis* individuals would settle the matter. But we can continue to hope for new analytical tools that will shed light on this issue.

How did you see your world? Did you construct your world internally with a modeling consciousness? Were you able to visualize the fruit that would later appear on a currently barren tree? When you saw your reflection in the lake, did you understand it as a representation of yourself? Could you model, to some degree, the motives and emotions of your troop mates? Did your group have behavioral traditions, a familiarity in the ways you greeted and groomed each other?

Evidence for cognitive capacities in *A. afarensis* is meager. Lucy's cranium is shattered in bits, and the connections between them are lost. Their internal topography consists of gentle hills and valleys, and one piece has a pattern of grooves that looks like an aerial view of a river and its tributaries. Blood vessels that supplied the meningeal tissues surrounding Lucy's brain once lay in these grooves. The gentle valleys held the folds of Lucy's brain, but her cranium is too fragmentary to allow their identification.

A partial cranium of a second small (and probably female) individual from Hadar preserves a more complete representation of some of the brain's convolutions and fissures. These have been tentatively identified by Columbia University's Ralph Holloway, who cautiously interprets their pattern as indicative of a humanlike reorganization of the brain in comparison to the brains of apes, with an expansion of the area of the cerebral cortex known as the parietal association cortex, which integrates input from primary sensory areas of the brain. This too has been the subject of debate. Preserved crania of *A. afarensis* indicate that brain size in Lucy's kind was small, but Dean Falk of the School for Advanced Research in Santa Fe and Florida State University argues

for a small but significant increase over brain size in earlier hominins and apes. Recent studies have confirmed that both absolute brain size and brain size made relative to body size are related to cognitive capacities among living primates. Many consider the capacities of living chimpanzees as a kind of bare-minimum estimate for those of *Australopithecus*. Evidence of small size increases or humanlike reorganization hints at capabilities beyond this level.

The chimpanzee model for bare-minimum *Australopithecus* cognitive capacities would include the capacity for behavioral traditions which have been classified as culture. Although chimpanzee culture is different from human culture in a number of important ways, bodies of learned behavior passed to other individuals include the making and use of tools such as termite probes, hammerstones, and sharpened spearlike sticks (as weapons for hunting small animals).

Selection for social intelligence is widely thought to have been important in the evolution of cognition. The chimpanzee referent model for minimum cognition in australopiths includes a conceptual "theory of mind" for modeling states of mind in one's fellows. Some apes show the capacity to empathize and make Machiavellian use of this ability in manipulating their peers. In experiments with mirrors, chimpanzees, bonobos, orangutans, and gorillas seem to show the ability to understand their images as representations of themselves. Awareness of self is important in projecting one's internal states onto one's peers.

Although apes have been taught to use languagelike symbolic communication in captivity, there is no evidence of such behaviors in the wild,

and the chimpanzee-referent model for minimum capacities in australopiths does not usually include language. All of the anatomical changes which have been argued to be related to the origins of language occur much later in the fossil record.

Hominin adaptation to habitat patchy-ness and temporal change has been argued to include advances in intelligence. One hypothesis for the evolution of intelligence and culture in the ancestors of humans and chimpanzees includes selection for sophisticated modeling of reality states other than the here and now (for example, fruit on trees currently out of season), allowing more efficient use of resources which were scattered and seasonally ephemeral. This may have contributed to the versatility with which Lucy's kind adapted to varied environments.

Did you make or use tools to obtain your food? When you came upon a termite mound, did you scan the ground for something that could be modified into a termite probe? Could you think a step ahead, making a tool and visualizing its future use?

There is a fair consensus that clear evidence of stone tool making does not appear in the record until 300,000 years after the last of Lucy's kind lived.[3] Bone tools also first appear after her time. However, all living great apes use some type of tools in the wild,[4] and many feel that it is reasonable to guess that her kind possessed at least a level of toolmaking and tool-using ability similar to that seen in living chimpanzees.

There is intriguing anatomical evidence that bears on this question. Lucy's skeleton preserves only two of her hand bones, but her species mates at Hadar left behind a good number of them,

and some of these have been assembled into a composite hand skeleton, possibly representing several individuals. If its proportions are confirmed by hand skeletons from single individuals, the thumb of *A. afarensis* is long relative to the fingers in comparison with a chimpanzee's or those of *Ardipithecus ramidus,* allowing the terminal thumb pad to make contact with the terminal pads of other fingers, as in human "precision grips" important in tool-making and use.[5] Studies of the joints between carpals (bones of the wrist) and metacarpals (bones of the palm) in *A. afarensis* hands suggest changes, such as a greater ability to rotate the index finger, that would enhance manipulative abilities. Arizona State University's Mary Marzke cites these and other grip-related features as evidence that *A. afarensis* was capable of some of the grips we modern humans use when we use or make tools. She concludes that some of these features would confer an ability to use tools with more force and greater control of the fingers than chimpanzees are capable of. The bones of the thumb also suggest that it was more muscular than in great apes, although the bones are not as comparatively robust as in living humans. The tip of the terminal bone in the *A. afarensis* thumb is broader than in chimpanzees, and is within the range for living humans. This feature is widely seen as correlated with a broad, fleshy thumb tip that would allow greater control and firmness in precision grips such as those used in toolmaking.

Why were features that conferred better grip and manipulatory capabilities (in comparison to those of living apes) selected for? To

some researchers the evolution of manipulatory capabilities which are beyond those seen in apes suggests evolution within a more developed tool-using milieu. A study of the bones of the arm in *A. afarensis* has found that, unlike the more

A composite hand skeleton of *A. afarensis,* assembled from casts of bones from the A.L. 333 site.

extension-optimized arms of living apes, they were optimized for habitual loading in a right angle, flexed position, and this too has been seen as evolution in which selection is enhancing tool-using capabilities.

Chimpanzees and, apparently, some later australopiths have used tools (modified twigs and modified bone, respectively) in obtaining termites from termite mounds.[6] If their common ancestor did so as well, this type of practice may have been widespread among the hominins, and Lucy's kind may have practiced similar behaviors.

What were your foraging days like? As your troop moved through a grassy area or open woodland, what foods were you hoping to find?

Lucy's mandible contains six whole teeth and fragments of others. A large dental sample has been recovered from her species mates. Their shape, size, wear patterns, and enamel thickness have been studied for clues about their diets. In comparison with the teeth of apes, Lucy and her kind have large, flat molar teeth with thick enamel. Muscle attachment sites on skulls of her kind indicate powerful chewing muscles that could generate a large bite force. These features and the unusually thick body of the lower jaw in *A. afarensis* (in comparison to those of apes) suggest unusual mechanical demands, by either extended repetition or high peak loading during the crushing of hard seeds and nuts. However, the microwear on *A. afarensis* molars, which gives indications of an *individual's* recent diet, does not match those of hard-object feeders living today, being more similar instead to the molar microwear of consumers of leaves and

soft plant foods such as fruits, buds, and flowers. In attempting to understand this seemingly mixed signal, some researchers have proposed that tooth size, shape, and enamel thickness, as well as the anatomy of the muscles and bones involved in chewing, may reflect adaptation to a fallback food resource consumed when other resources are unavailable, while molar wear patterns may reflect foods more commonly consumed by the individual in the period just before its death.

The dental toolkit of *A. afarensis* seems to have served the species well in adapting to a variety of habitats, including more open ones, and in coping with variation in the availability of food resources. One food that the teeth of *A. afarensis* and other australopithecines were apparently not well designed for processing is meat. The teeth of *A. afarensis* lack the shearing topography which even chimpanzees have in moderation, useful in processing of tough fruit, leaves, and meat.

Lucy's relatively broad pelvis and lower rib cage show some similarities to those of great apes, including room for a relatively large gut. The comparatively abbreviated intestines seen in modern humans may have evolved when meat became a significant part of the diet and gut fermentation became less important, or it may have reduced to compensate metabolically for the first major expansion of the brain, according to the predictions of the "expensive tissue hypothesis" (see chapter 4). Either way, the reduction of the gut would probably have postdated Lucy.

So what was Lucy? She was a capable biped,

with well-developed adaptations to upright walking, beyond those interpreted for the skeleton of *Ardipithecus ramidus,* which predated Lucy by 1.2 million years. She probably also spent time in trees, although how much is uncertain.

Lucy was an australopith. The origin of the genus *Australopithecus,* with the arrival of Lucy's lesser known ancestor *A. anamensis* some 4.2 million years ago, seems to have involved a dietary shift to harder or more abrasive vegetable foods (at least as a fallback resource) that involved larger mechanical loading of the chewing teeth. It also may have involved some or all of the improvements in bipedal adaptation we see later in the bones of Lucy and her kind, over those evident in the bones of *Ardipithecus ramidus.* Lucy's versatile locomotor repertoire and heavy chewing equipment seem to have outfitted her to roll with changes in her habitat, both in time and over space.

For several decades, Lucy's kind has been seen by many as the lone hominin of her time, a "stem" hominin leading to most or all later hominin species. Recent work has challenged this view, especially the 2012 announcement of a 3.4-million-year-old partial foot skeleton from Ethiopia that does not match the morphology of *A. afarensis,* but is contemporary with it. Occasionally there has been the suggestion, based on one anatomical region or another, that she has derived anatomy that is shared with the robust australopiths but not with other later hominins, and that her kind is ancestral to them alone. More fossils will undoubtedly help resolve questions about Lucy's relationship to other hominin species.

Perhaps more that anything else, we wish to look upon your face. This is a final wish in our desire to know you. It will not give us any specific information about you that we can articulate in words, but communicates you to us on other channels. Without this final step, you are still an abstraction, a set of probabilities: we know something of your anatomy and behavior, but you are a shadow.

A Face from Afar

Lucy made her public debut without her head. How can we coax a face from her shattered bits? Although her preserved skull fragments are not complete enough to allow reconstruction of her skull, there are other, more complete fragments of female crania that can be combined with Lucy's fragments in a composite skull reconstruction. The accuracy of such a composite can be assessed as more complete female crania are discovered and published (one such skull, A.L. 882—the reverse of Lucy's specimen number—is now under study, and researchers have begun to publish their findings). In order to walk the reader through the details of an *A. afarensis* head reconstruction based on a more complete skull from a single individual, I'll switch to the one based on a male skull, A.L. 444-2, the most complete skull for which research has been published for the species. The fleshing out of the composite female skull proceeded similarly, but with more maybes.

A. afarensis went headless for twenty years until the 1994 announcement of the discovery of the first fairly complete skull by Tel Aviv University's Yoel Rak. At that time, *National Geographic* approached me about whether I would be

interested in doing a reconstruction of the head of the A.L. 444-2 individual. The compensation was not especially good for the amount of time it would take, and my wife, Patti, was pregnant with our first child, but the opportunity to apply my methods to this first-known skull of *A. afarensis* left no room for indecision. Of course I would be interested. This reconstruction was duplicated later, with a few anatomical updates, for the Smithsonian's exhibit.

Meeting A.L. 444-2 was something of a shock. It is a beautiful, massively built skull. In some dimensions it is the largest known *Australopithecus* skull. It includes an upper jaw and about half of the lower jaw, as well as the right cheekbone, and most of the braincase with portions of the bony arches of the cheek (zygomatic arches) attached to the sides. A.L. 444-2 is judged to be a male on the basis of its large size, its large canine teeth, and the strongly marked attachment sites for its chewing and neck muscles. It is thought to belong to an older individual because of its extreme dental wear and the fusion of its cranial sutures.

The first step in the process of reconstructing his head was a reasonable assembly of the skull's various pieces, largely done by Yoel Rak and Bill Kimbel of the Institute of Human Origins. Yoel, working with the digital team of Christoph Zollikofer and Marcia Ponce de León of the University of Zurich, took the next step by digitally correcting distortions which had occurred during fossilization, and replacing missing parts with mirror images of existing parts. They also added a fragment of frontal bone from another large male to an area of the forehead that is missing

in the A.L. 444-2 skull. I then added a bony area just to the side of the nose (the frontal process of the maxilla, or upper jaw) from yet another specimen[7] so that A.L. 444-2's nasal bones could be articulated to it. When it was completed and up on its stand, the large, mute skull begged a thousand questions, the most urgent being: what face will result from this massive and unique anatomy?

The eyeballs created for the A.L. 444-2 skull feature de-pigmented sclera (as do the eyes created for the Lucy reconstruction). This is a debatable feature for *A. afarensis*,[8] but I guessed that the inclusion of more open habitats, which has been suggested based on pollen and faunal evidence from some of the sedimentary horizons at Hadar and Laetoli, as well as possible cognitive/social changes may have shifted the balance of selective pressures by this time in human history toward lighter sclera.

The sites where the chewing muscles, masseter and temporalis, were attached to the skull are very strongly marked, indicating well-developed muscles. The clearly marked temporal lines, where the temporalis muscles once attached, show that they extended well up the sides of the cranium, leaving a flat triangle of bare bone between them on the frontal bone (the brow ridges make the third side). Moving back along the top of the skull, this triangle becomes a narrow strip of bare bone between the temporal lines on the top of the skull. These lines meet toward the rear of the cranium to become a low, doubled sagittal crest. The crest, and the individual temporal lines that diverge again below it, are the most strongly marked portions of the temporalis attachment site. As with the *Sahelanthropus* skull, this shows

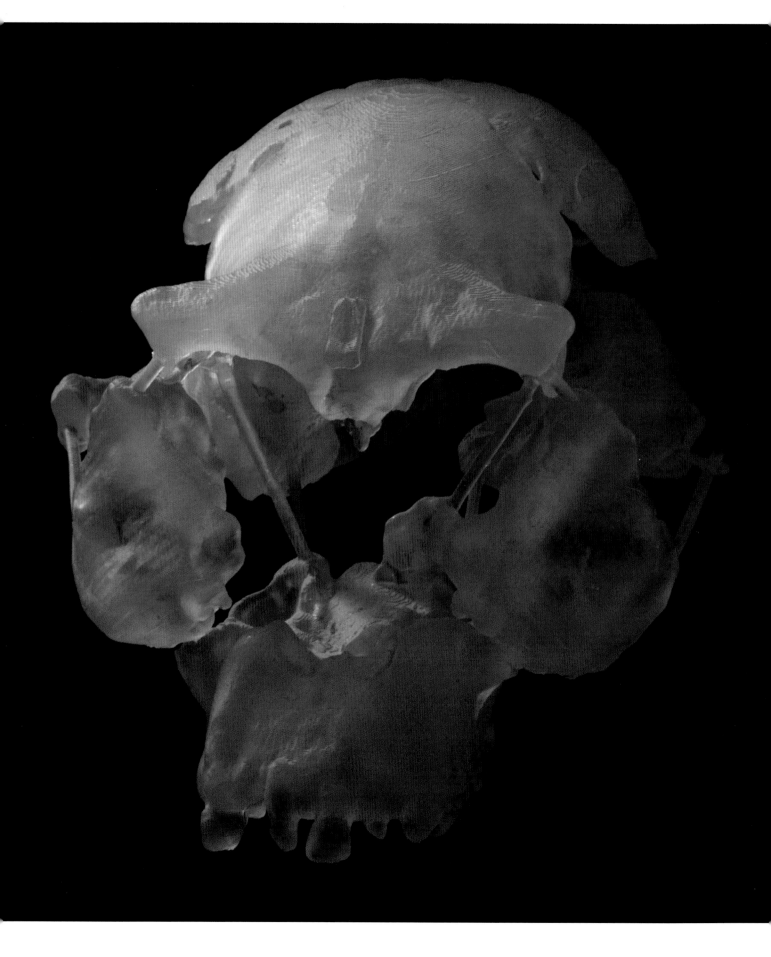

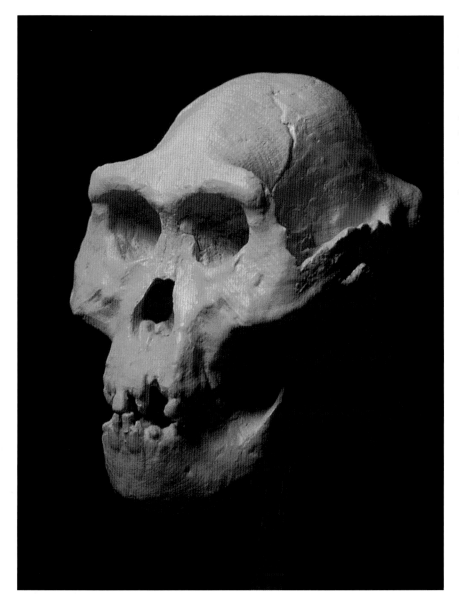

(*facing*) This digitally created skull of a large male *A. afarensis* was generated from scans of the A.L. 444-2 skull. Some portions have been mirror-imaged to fill in gaps on the opposite side. A small portion of the frontal bone of A.L. 438-1b has been incorporated into the virtual skull.

The fully restored A.L. 444-2 skull.

a posterior emphasis in the development of the temporalis muscles, which concentrated their force at the front of the jaws. The emphasis on the development of posterior fibers of temporalis shown by this and most other *A. afarensis* specimens is considered apelike and primitive for hominins. This contrasts with the emphasis on more anterior fibers indicated in most later australopiths.[9]

A close look at the markings for attachment of the temporalis muscles on the A.L. 444-2 skull reveals that they are not completely symmetrical. The temporal lines that diverge at the back of the skull below the sagittal crest have slightly

different courses. On the right side of the A.L. 444-2 cranium, the temporal line swings downward and out to the side, to meet the ridge anchoring the neck muscles below in a compound crest. On the left, the temporal lines do not quite meet the ridge anchoring the neck muscles, so there is no formation of a compound crest. Here, for a moment, we stop. The slight side-to-side difference in the pattern of crests in the A.L. 444-2 skull interrupts our study of the skull and, for a moment, we are in touch with the quirky, living world. A slight difference in the way the muscles attach on the left and right sides, and suddenly we sense him as an individual. We run fingers along the surface of his skull and here we can feel the strain of muscles. A window of color opens and we see them contracting, the bone of the jaw tightening. It is only a moment, and then we are once again looking at cold stone that long ago replaced the once-living bone.

Sometimes a fossil offers glimpses into the individual life of a long-dead hominin. Wear on the teeth is like an individual signature, a sort of trace fossil of foods processed, offering hints about an individual's diet and methods of food procurement. In specimens of the two earliest species of *Australopithecus* (*A. anamensis* and *A. afarensis,* which are considered by many to belong to a single evolving lineage), wear on the anterior teeth suggests heavy use of the mouth and front teeth in the procurement and preparation of food. Sometimes a specific kind of tooth wear resembles that in living forms with known food processing behaviors. For example, some of the irregular wear on the front teeth of *A. afarensis* specimens resembles wear on the teeth of gorillas

that are known to place a leaf in the mouth and pull its stem through nearly closed front teeth, stripping the leafy matter from the stem. A number of researchers have seen evidence for the clamping and stripping of hard or gritty vegetable material in the front teeth of *A. afarensis.*

Complementing this evidence are other clues. The emphasis on the development of the posterior part of the temporalis muscles (that portion of the muscle which brings the front teeth together) in most specimens of *A. afarensis* and the large size of the front teeth point to heavy loading of the front teeth, probably during feeding behaviors. Strong neck muscles that stabilize the head or pull it back during such activities are also part of this picture, and evidence for their development can be seen on the rear and underside of the A.L. 444-2 skull.

This evidence has strong implications for the way a face is built. As discussed in the last chapter, the muscles that ring the mouth are much more developed in apes than in humans, and this seems to be related to their greater role in food procurement and preparation among the apes; in humans, these functions have been largely taken over by the hands. The evidence for a posterior emphasis in the development of the temporalis muscles and powerfully developed neck musculature in *A. afarensis* combines with tooth wear evidence to suggest that the front of the mouth was still important in food procurement and processing in this species. The hard tissue elements of this anatomical complex imply the presence of its soft tissue elements as well, and *A. afarensis* is likely to have had a robust, apelike circum-oral musculature in this area of the face.

The nasal bones are partially preserved in the A.L. 444-2 skull and in two other crania of *A. afarensis*. Their lower portions are flat and show no indications of a projecting nose. The nasal opening as a whole is a single flat plane, and the attachment site for the base of the midline nasal septum's cartilage on the maxilla is at or just inside of the nasal opening, in a position similar to that found in many chimpanzees. Any reasonable reconstruction of nasal cartilages results in a flat, apelike nose. The openings for the ears indicate an ear position very far back on the skull.

More than most areas of the face, the soft tissue that covers the frontal bone and the front portion of the temporalis muscle approaches an evenly graded sheet in humans and in apes

Irregular wear on the front teeth of this *A. afarensis* specimen (cast) is similar to that found on the teeth of living apes that use the front teeth for stripping leaves or other plant foods.

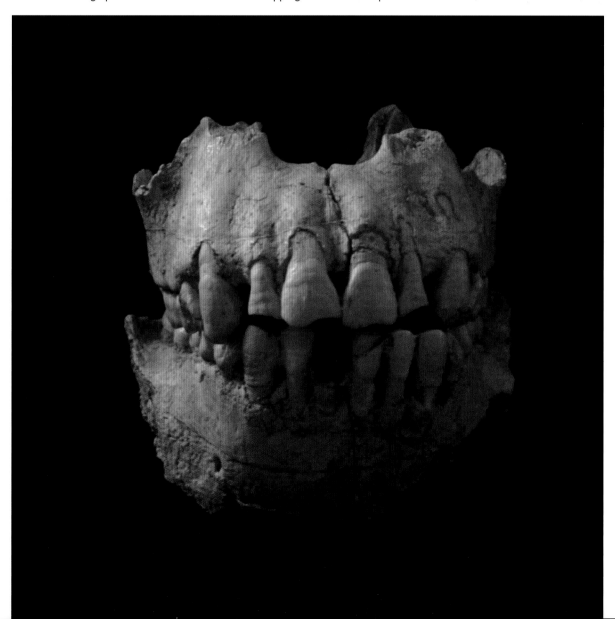

without large sagittal crests. Consequently, much of the frontal bone's morphology shows in the fleshed-out faces of these forms. In the case of the soft tissue I reconstructed for A.L. 444-2, the brow ridges are gently arched above the eyes and thicken laterally to each side, with squared-off corners at their lateral-most extents. These facial forms reflect the bony anatomy beneath, but it is somewhat softened by the overlying thin layers of soft tissue, as is the morphology of this area in the faces of living great apes. Behind the brow ridges, the frontal bone is flat, without the concave sulcus (furrow) seen in apes or the concave triangle seen in robust australopithecines.

The Smithsonian redo of the A.L. 444-2 reconstruction required a few updates on the original done for *National Geographic* in 1995, because I now had much more data on the faces of great apes and humans. For the Smithsonian reconstruction, I adjusted the corners of the mouth a bit, in accordance with my working hypothesis about the relationship between canine tooth size and mouth-corner position (see chapter 1).

At the end of the process, we have an apelike face that conveys an impression of massiveness— something like a great ape with an enhanced masticatory (chewing) system. The jaws and cheekbones are large and heavily constructed, and the chewing muscles are very well developed. Many of the distinctive features of the restored A.L. 444-2 skull are reflected in the final form of the fleshed-out head. The lateral flare of the cheekbones results in a very wide face. It is also a very tall face, with a large, deep lower jaw that makes up a greater portion of the height of the face than it does in living great apes or humans.

The area below the mouth is nearly vertical, reflecting the orientation of the front of the mandible. The nose is flat and apelike. The jaws project forward, with a convex area between the nose and mouth. The division of the cranium's lower face in lateral view into two discrete segments[10] is visible in the fleshed-out profile as well.

The cheeks are set back from the front of the mouth and nose, and their lateral flare carries the masseter muscles to a lateral position. The shapes of these large muscles are visible below the prominent zygomatic arches. As in living African apes, the curved contours of these muscles are only minimally softened by facial fat. The small distance between the eyes reflects the narrow interorbital region of the skull, and this imparts a unique look in combination with the wide face.

The braincase is small. The upper edges of the temporalis muscles are visible as slight bulges (as in living chimpanzees), but the muscles extend further up the side of the head, so that their upper edges are closer together than is usual in chimps, leaving only a narrow recessed flat strip between them on the upper part of the head. Toward the back of the head these bulges meet.

The head was now ready to be molded and cast in lifelike silicone. I implanted hair and installed the eyes. What do we have at the end of this four-month process? There is information here to be sure, as many of the distinctive features of the underlying skull of A.L. 444-2 are reflected in its facial form. But it also must be a face that we can relate to as a living being. If this final phase of bringing the head to life is not successful in achieving a living presence behind the eyes, the purpose of doing a reconstruction is

defeated. For the facial expression of the reconstruction, I was shooting for a kind of startling awareness—a feeling of sentience at least as powerful as that visible in the eyes of any of the living great apes. If this kind of effort is successful, you may have something truly magical at the intersection point of science and art: a conduit to a living presence from another time, enabling you to imagine in a detailed way what it would be like to see one of these creatures alive. If the work is done well, the illusion can transport a viewer from museum floor to forest floor.

Five stages in the reconstruction of the head of the A.L. 444-2 individual (*A. afarensis*) are shown here, from skull to skin.

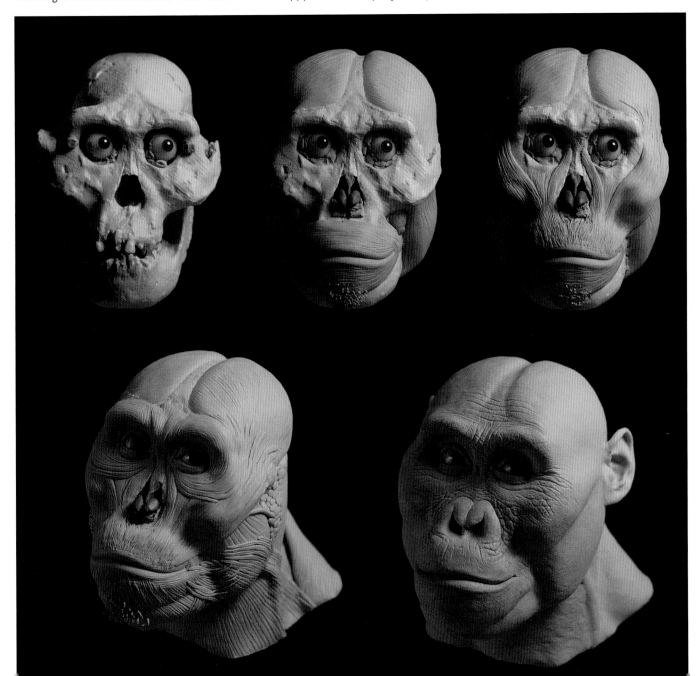

We are close enough to see the individual beads of his sweat. The sheen of his skin pulses at his jaw and his temple as he chews, and we can see muscle moving under his scalp nearly at the top of his head. He is a majestic creature. There is a slight frown on his robust features. We can see him breathing, and we become aware of a slight zoo-y smell. He brushes away a fly. We are struck with a strong first impression: Ape. He is absolutely an ape. We wait for something to contradict this impression, and we see nothing. Then he opens his mouth and pulls a berry-laden branch through his front teeth, jerking his head back as he pulls. Gorillas do this, but there is something different here, something decidedly un-apelike about it. It was only for a moment, but we've seen it: His teeth look human. He lacks the big canine teeth of a male ape.

Calls ring out, an unnerving sound that is only marginally like a human voice. He turns his head, looks back over his shoulder in the direction of his unseen compatriots who have been foraging nearby. They are gathering to move out from this open woodland setting. Those in the trees begin climbing down; mothers gather their young. The adult male we've been observing tucks a few remaining berries into his cheek and, for the first time, turns to look directly at us. Not having to search, he looks at us in a way that tells us he's known of our presence from the beginning. He continues his gaze for just a moment longer than a mere curious glance. He stands up, still keeping a wary eye on us. Then, in a very familiar motion, he turns to stride away and is gone.

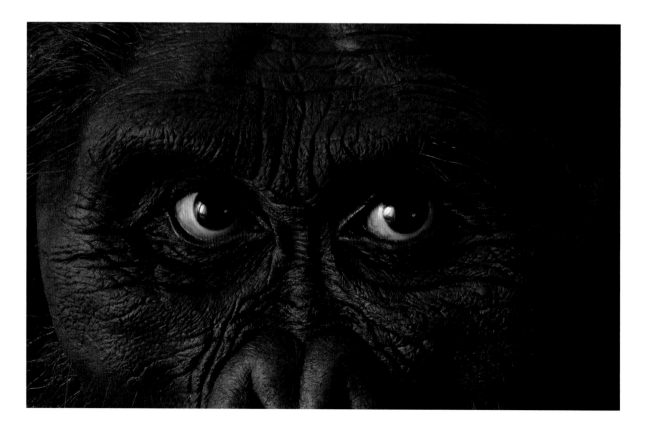

When the Smithsonian reconstruction of A.L. 444-2 was put on display, there was a miscommunication that resulted in it being mounted in a position in which the eyes are looking upward. The result is unfortunate, because this sculpture offers one of the strongest feelings of connection when seen eye to eye. But it does have the unintended effect of begging the arborealism question: Is he looking at a compatriot in the trees? We wanted the visitor to keep this kind of question foremost in mind; it represents one of the key questions scientists are trying to answer about this species.

Building Lucy

I have an interesting job. Some days it might involve paying a woman to climb up and down a pole naked while I take notes and photographs. But that's a terrible way to begin this section. Let me explain. When I first learned of Lucy's discovery, I wanted to build her. It is a wonderful endeavor to seek answers to questions about how she lived, but seeing her as she may have appeared in life can make a connection for us that nothing else can foster. My first chance to build Lucy's body came in 1996, when the Denver Museum of Nature and Science (then Natural History) asked me to produce a life-sized, three-dimensional reconstruction, as lifelike as current methods would allow. If her skeleton was properly articulated, and I used the muscle attachment sites visible on her bones to build her body muscle by muscle, what kind of creature would emerge?

It was obvious from the beginning that the most important issue to represent in the Lucy sculpture was locomotion, including upright walking as well as the climbing issue. Commonalities in the way that chimpanzees and humans climb informed my guess about how Lucy, with body proportions intermediate between the two, may have climbed.

Was there a way to represent both climbing and upright walking in the same pose? It would be tricky, but perhaps I could depict a moment of transition, where it is obvious that Lucy is climbing down from a tree, and equally obvious that she is dropping into an upright position (as opposed to dropping to all fours). Indicating a climber who is transitioning to an upright posture on the ground would involve capturing just the right transitional pose, a posture unique to humans and their ancestors. To narrow my search for appropriate poses, I decided to photograph a human climber, preferably a female adult and preferably without clothing, so that I could see how the various muscle groups were being used.

Thus did a team at the Denver Museum of Nature and Science film a naked woman as she climbed up and down a pole under my direction. She was a trooper, and a very strong woman. She climbed up and down the pole until her stamina ran out. The exercise yielded good references for the kind of transitional pose I was looking for. One of the poses was particularly good and it was chosen for the Lucy figure: it is dawn, and she is just climbing down from a tree, her right hand still wrapped around a branch, and her right foot pushing off against the trunk. Her left leg is extended toward the ground, so that her left foot is just making contact with it. This moment of

touchdown also works on symbolic levels, representing humanity's descent from the trees. The question for museum visitors (and for anthropologists) is this: how common was this behavior, and how important was it in shaping her species?

Wanted: Petite Female Biped

After I had selected a pose, my first task was to articulate Lucy's skeleton over a metal armature. I began with her trunk. I didn't yet know what I was getting into.

A delving into the literature showed that experts disagree about thorax (rib cage) shape for australopiths and about the relative influences of respiration and locomotion on its form. Some believe their rib cages were funnel-shaped like those of apes, and others think they were more barrel-shaped like those of humans. I had to make a decision about Lucy's, and I thought it best to inform my judgment by building a thorax with her preserved rib fragments. A good number of rib fragments were recovered with the Lucy fossil, and when I incorporated these into a thorax, the result was a shape that is not identical to either the thoraxes of living humans or those of living apes. The reconstructed upper thorax is somewhere between the two in shape, and the lower thorax is broad like an ape's in order to accommodate a couple of long, only modestly curved, lower rib fragments.[11] This broad lower rib cage aligns nicely with the broad blades of the upper pelvis, as reconstructed from its original damaged condition by Kent State University's Owen Lovejoy.

The length of the trunk is an important dimension for body-proportion studies, and groundbreaking primatologist Adolph Schultz used this measure as a standard of reference in calculating relative lengths of limb bones and segments. It also represents the largest single component of stature, so it's important to use the best information available in its estimation. Six fairly complete trunk vertebrae were recovered with Lucy's skeleton. The question was: how to use these in predicting the length of the trunk?

Once again, I turned to the Smithsonian's Terry Collection of human skeletons. Some of the cadavers that were skeletized for the collection were measured beforehand, and from these measurements trunk length, as used by Adolph Schultz,[12] can be calculated. The heights of the entire series of trunk vertebrae can then be measured for the same individuals, and their sums correlated mathematically with the length of the trunk. The relationship between fleshy trunk length and the summed heights of the trunk vertebrae can be expressed as a ratio or a regression equation, and these can be used to predict trunk length for fossil individuals. This can be done even when the vertebral data are incomplete, as with Lucy, although with somewhat less accuracy than what could be obtained using an entire series.

But there was a problem. All of the modern human skeletons I measured are much larger than Lucy's. Because of the potential for allometric differences (size-related shape differences), I could not assume that the relationship between two measurements (trunk length and summed vertebral heights, for example) in the human

sample would hold for a tiny being well outside of their size range. I would need to confirm the relationship in a biped closer to her size.

I searched for skeletal collections of small-statured humans for which the length of the fleshy trunk was known, but found none. Adrienne Zihlman had recorded trunk length for bonobos close to Lucy's size, but the vertebral columns of apes have a different configuration within the trunk than those of humans, which results in a different relationship between summed vertebral heights and trunk length. I needed a tiny biped.

Fortunately there is a diminutive female biped, a relative of Lucy's, that I could turn to. Her name is Sts 14, and she is the partial skeleton of a female *Australopithecus africanus* about the size of Lucy, from the South African site of Sterkfontein. She preserves a somewhat distorted pelvis and fifteen consecutive vertebrae from the trunk, which can be articulated to the top of the fourth thoracic vertebra. The standard measurement of trunk length is from the top of the pubic bone to the top of the upper breastbone (manubrium), which is level with the upper surface of the third thoracic vertebral body in human females. I could physically *build* the spine of Sts 14, and I would need only to estimate the height of the third thoracic vertebra and correct for some distortion in the pelvis to get an approximation of the length of her trunk.

I visited this tiny female in her museum vault in Pretoria, South Africa, three times during the 1990s. I articulated three versions of her trunk skeleton: an improbably tall version with too-large cartilaginous disks between the vertebrae and a too-straight spine; an improbably short version with almost no space for intervertebral disks and a pathological-looking exaggeration of the spinal curves; and a "probable" version with a more reasonable articulation of the vertebrae. Sort of a three-bears approach.

It was then possible to attach Sts 14's corrected pelvis and measure her trunk length. I could then calculate the ratio between her measured trunk length and the summed heights of the same vertebrae as those preserved in Lucy's skeleton. This ratio could be used with Lucy's vertebral heights to predict the length of her trunk. The outcome was very satisfying: the resulting ratios were similar for the "probable" articulation of Sts 14's trunk and for the average modern human. This means that when these ratios are used to predict the length of Lucy's trunk, the prediction based on Sts 14 is similar to the prediction based on the human sample.[13] The improbably tall and improbably short articulations of Sts 14's bones resulted in ratios that provided brackets for the estimated trunk length for Lucy.

This may sound like a lot of work for predicting a single dimension of the body. It was. But trunk length is an important dimension for estimating a fossil hominin's proportions as accurately as available information will allow for a reconstruction. The ultimate result of the work on Lucy's torso was a trunk that is not identical to that of either living humans or apes. It features humanlike spinal curvatures, but its trunk is broader for its length than that in any human.[14]

My next task was to articulate the bones of

The spine and pelvis of this small specimen of A. africanus (Sts 14) was complete enough to allow its articulation, informing the process of reconstructing Lucy's trunk from her pelvis and six vertebrae.

tricky trying to articulate them into a pose that would imply both climbing and upright posture, capturing the moment of transition between the two as Lucy touched down.

Lucy in the Flesh

Lucy's hands, feet, and head were reconstructed separately before attachment to the skeleton. In order to create hands for Lucy, I first measured the bones of a composite *A. afarensis* hand skeleton composed of bones from the A.L. 333 site. These were then mathematically scaled down to the size indicated by Lucy's proximal (nearest the body's center) finger bone. My intention was to cast the hands of a living person and alter them to fit the size and proportions of the scaled-down composite *A. afarensis* hand. I had considered using a child's hands, but children's hands have somewhat different proportions (stubbier fingers, etc.), and Lucy's needed to look adult. In the end, I cast the hands of my wife, Patti (it's good that I got that clause into our marriage contract), in a shrinkable material, and reduced them to Lucy's size. I then arrested the shrinkage for most of the hand, further shrinking the width of the thumb and the breadth of the fingertips, until I had a hand with the composite's proportions, including a slightly attenuated thumb and narrow fingertip pads. The resulting hands look basically human, if a little unusual.

the arms and legs. Owen Lovejoy and his students had created restored versions of Lucy's limb bones, healing damage and filling in missing areas with anatomy from other *A. afarensis* specimens. I began the work with casts of these. It was

(facing) Lucy's foot skeleton was reconstructed by casting other *A. afarensis* foot bones in a shrinkable material and reducing them to Lucy's size. Her hands were created by casting a pair of modern hands, then shrinking them to Lucy's size and differentially reducing various areas to match her proportions.

The human hand, in many poses, evokes something strong in us that words are not adequate to describe. Later on, when I was working out poses for the Smithsonian figures, I found it easiest to let the hands lead. I worked the hands into a pose that moved me, then let something flow from the hands into the rest of the figure. I couldn't define the something at the time, and I still cannot, but it felt right, and it worked. For some of the figures, I cast the hands of living people; for others I sculpted them, reconstructing

from the bones up. For still others, I cast the hands of a living person and shrunk the parts of the resulting casts differentially to change their shape. But in all cases, the hands were taken apart and rearticulated, moved into positions that I thought were powerful aesthetically, before solidifying the rest of the body's pose. For Lucy, one hand is gripping a branch. In the other I wanted to imply a heightened wariness, so the hand is tensed, in an "aware" position that is echoed in the rest of her body's posture.

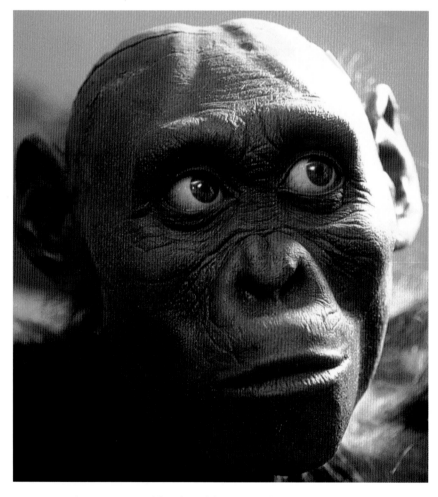

The reconstructed head used for Lucy, and based on a composite adult female skull of *A. afarensis.*

To create a foot skeleton for Lucy, I essentially executed a 3-D version of a graphic reconstruction done earlier by paleoanthropologist Tim White and the University of Tokyo's Gen Suwa, scaled to Lucy's size using her preserved foot bones. This involved casting a number of foot bones known for *A. afarensis,* including the partial foot skeleton, in a shrinkable material, and shrinking them to Lucy's size. I then built tendons and musculature and, eventually, skin. The resulting foot was weird-looking by modern human standards. Even with the big toe adducted into line with the others, the long lateral toes give a hint of the handlike look of the feet of nonhuman primates.

The head reconstructed for the Lucy figure was based on the composite female skull restoration and proceeded similarly to the reconstruction of the A.L. 444-2 head. The composite female skull has a shape similar to

the big male's in many ways, but there were some subtle differences as well: the lower jaw is more V-shaped, the back of the skull more rounded, and the cranial crests not as well-developed as in A.L. 444-2. The area below her mouth is nearly vertical like the big male's, but in this area Lucy's V-shaped lower jaw comes to a rounded point in the front, in comparison to the broader region in the big male. Her chewing muscles are relatively less developed than his. Preserved bits of her skull indicate that the temporalis muscle extended higher up on the skull than in female chimpanzees or humans, but did not extend far enough up and back on her cranium to meet its opposite side counterpart like those of A.L. 444-2. The markings for neck musculature on Lucy's occipital bone (the bone of the skull at the rear and base of the braincase) are fainter and less excavated than in the big male's, and I gave her more delicate neck muscles. The crest that forms when temporalis and neck muscle ridges meet, visible in most *afarensis* specimens preserving this area, is absent in Lucy. Her muscles did not develop enough to reach a point of contact, so the crest never formed and there is a strip of bare bone between their attachment sites on Lucy's skull. The final reconstruction of Lucy's head and face looks much like a daintier version of the A.L. 444-2 reconstruction.

Lucy's skeleton displays many clues about the position and

development of her musculature in life. These can be "read" using the anatomy of modern apes and humans as guides for their interpretation. Following the muscle markings on Lucy's bones, I gave her arms that are well muscled—not bulky like a bodybuilder's arms, but more like those of a very athletic dancer. When fleshed out, her arms have a somewhat human look, but with proportionally longer forearms and some apelike nuances in the arrangement of muscles.[15] The

The restored skeleton of Lucy, with head, hands, and feet reconstructed.

look of her legs is also somewhat human, but her leg muscles are packed onto leg bones that are relatively shorter than ours, and with a stronger (hyperhuman!) angle at the knee.[16]

There are other subtle differences in the arrangement of musculature suggested by Lucy's bones from that in a living human. The University of Zurich's Peter Schmid and Martin Hausler have proposed that the attachment site of the major back muscle, latissimus dorsi, along the crest of the upper pelvis is broader than in modern humans. This muscle, heavily used in climbing, has a broad pelvic attachment in the great apes as well. The unique shape of Lucy's thorax results in a more V-shaped lower border of pectoralis major than that in most living humans.[17]

Lucy's hip musculature is essentially human-looking, but, following the laterally flared form of the pelvis, is not as "wrapped" around the lower trunk as it is in living humans. Because her

Two stages in the muscular reconstruction of Lucy.

pelvis is flatter from front to back, with blades splayed out to the sides instead of wrapping the viscera, she has an apelike pot belly that is undercut below by (inguinal) ligaments.

Carol Ward has pointed out a number of subtleties in muscular attachment sites for the lower limb musculature which are apelike in *A. afarensis*. These nuances were taken into consideration when sculpting Lucy's hips and legs, but most are so subtle that they would be noticed only by an anatomist with an obsession with legs.

As Lucy's body took shape under my fingers, it became evident that it would not be like that of any creature alive today. There are both apelike and familiarly humanlike aspects of her anatomy, but her body is not identical to either. The implication of the anatomical work is that, when reconstructing Lucy, she must be met on her own terms. I could not build a diminutive human form over this unique skeleton, nor could I build that of an ape. The process reveals a body unique to her kind.

Lucy was cast in silicon, colored so that she would have dark skin like tropical humans. The amount of body hair in australopiths is unknown. We assume that the common ancestor of chimps and humans, like all of the non-human apes, had a full coat. We can guess that this coat was lost by the time of *Homo erectus,* as its skeleton's proportions show that it was adapting to heat stress like modern humans do, and part of our adaptation involves an enhanced sweat gland cooling system which would not function well with a full coat of body hair. For Lucy, I chose a model that was at the sparsest end of the range for living chimpanzees. Once again, because its taper, color, and straightness make black bear hair a good stand-in for chimp or gorilla fur, this is what I used for Lucy. About a million individual hairs were punched into Lucy's silicone skin over a period of three months (in each of her incarnations, for the Denver museum and later for the Smithsonian).

Strong. Capable. And a bit wary. This is how the figure of Lucy looked to my eyes when she was completed. She is climbing down from a tree and is just dropping into an upright pose. But she doesn't do this casually. The ground is a dangerous place.

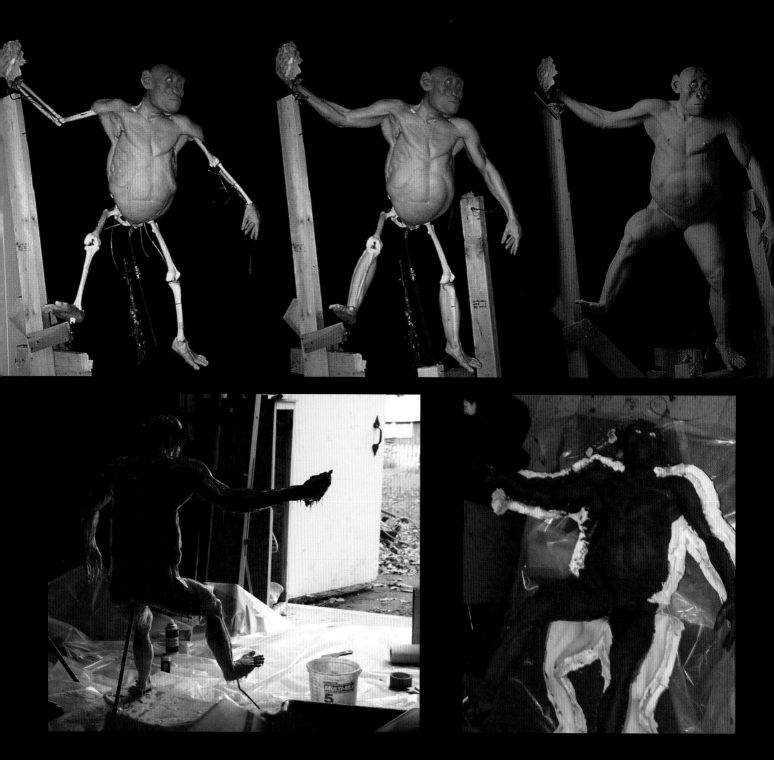

Three stages in the further muscular reconstruction of Lucy, and two phases of molding and casting. At lower left, the Lucy sculpture is wearing the first coat of the silicone mold. At lower right the silicone cast of Lucy is shown while still in one section of the mold.

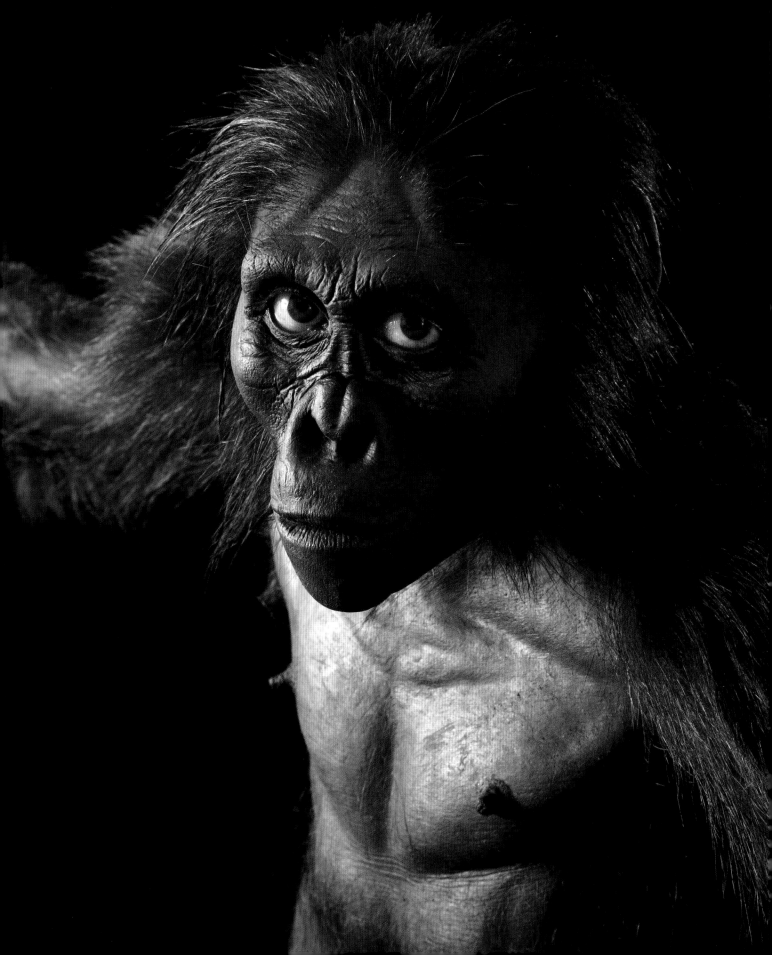

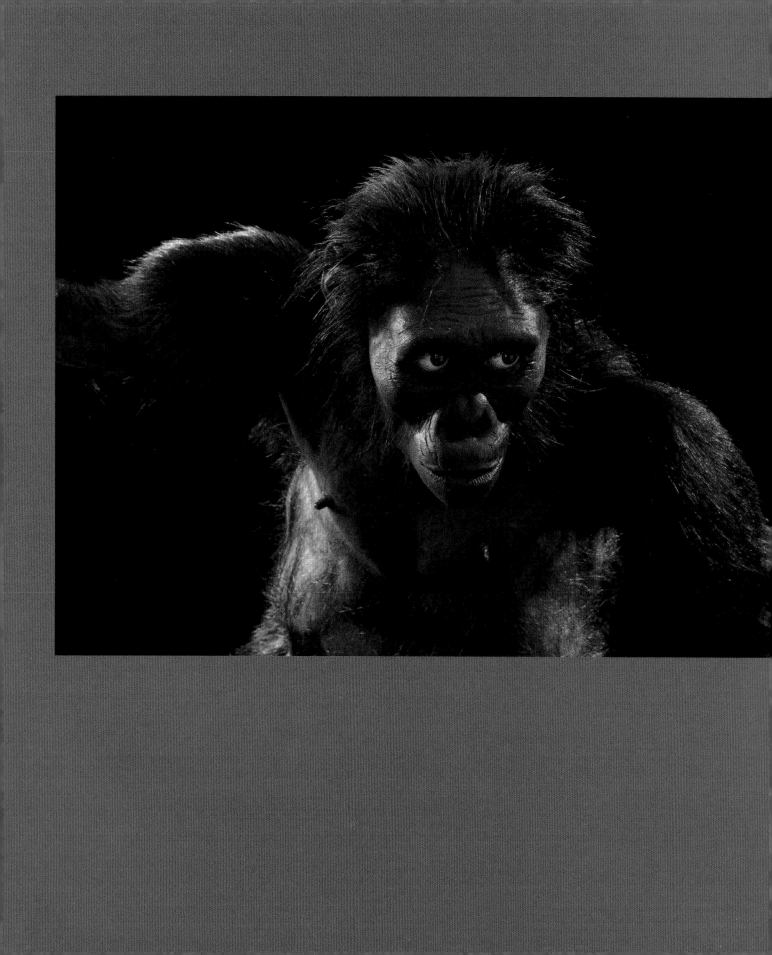

Rebirth

When I first began creating hominin reconstructions in 1984, I did not try to use existing methods of approximating a lifelike look. I was determined to make them more lifelike than any I had seen, and began testing new methods. I got advice from many experts, including some of the best special effects make-up and prosthetics people in the movie industry (Dick Smith, then working on old-age makeup for David Bowie for the film *The Hunger,* was especially helpful). I was soon at a fork in the road. I could develop methods for making lifelike reconstructions out of either silicone or urethane plastic. I chose urethane, and this turned out to be the wrong path. Not only did this later prove disastrous to my health, but the "plasticizers" used in making urethanes soft (which is necessary if hair is to be punched into it) can eventually liquefy the material. Although there are still in existence several intact urethane heads I made during that time, those figures that were exposed to heat and light eventually melted.

With the Denver museum's Lucy, this began with what looked like a single tear and ended with her complete disintegration. Fifteen months of work were down the drain. This is another way in which the long delay in the Smithsonian human origins hall's progress turned out to be fortuitous. I now work in silicone. I shudder when I imagine what might have happened if I had made all of the Smithsonian sculptures out of urethane—a room full of melting heads perhaps, recalling scenes from the Vincent Price grade Z movie *House of Wax.*

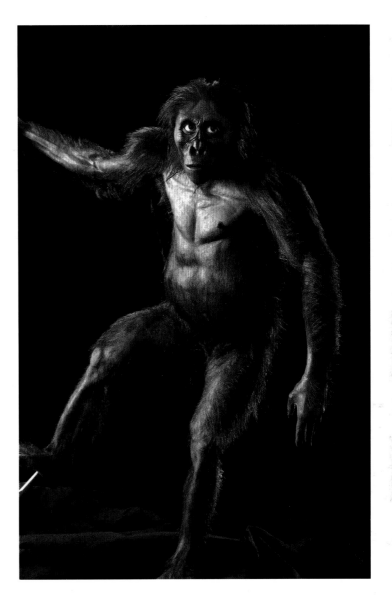

When Rick Potts and I discussed the best pose for the Smithsonian's Lucy figure years later, we decided that the most important issue to be addressed was still locomotion, even without anything like a final answer to the locomotion debate. Specifically, we wanted a pose that would imply upright posture when on the ground, but also address the question of her arboreality. Both of us liked the symbolic moment of touchdown depicted in the Denver figure. We settled on a pose very much like that of the Denver museum's Lucy. That this creature may have spent variable amounts of time in the trees and on the ground, and that it is difficult even for experts to gauge the relative importance of climbing and walking in this species, struck Rick and me as very appropriate to the variable, quirky, sometimes messy biological world. I had always loved the pose and was very happy that it would be resurrected in this way. I sent for the Denver Lucy's eyeballs, the only part of the original sculpture to survive. They would once again hold the reflections of museum visitors who are Lucy's descendants of 230,000 generations.

We consider again the bizarre descendant that the Smithsonian team described at the end of the last chapter. It seemed unlikely that this lineage of apes, much like other apes except for its unusual teeth and its novel way of moving around on its hind legs, was headed for such a fantastic future. We have now come half the distance from those earliest hominins to the strange descendant they described, and still we see no signs that this lineage is moving in such a direction. The brain is only marginally larger than in Sahelanthropus and shows some subtle shape differences. Otherwise we see only dietary adaptations, as well as improvements in bipedal anatomy and the hand's gripping capabilities. We wonder: Is there anything in these changes that might incidentally pave the way for the evolution of the colony of linked brains our friends described?

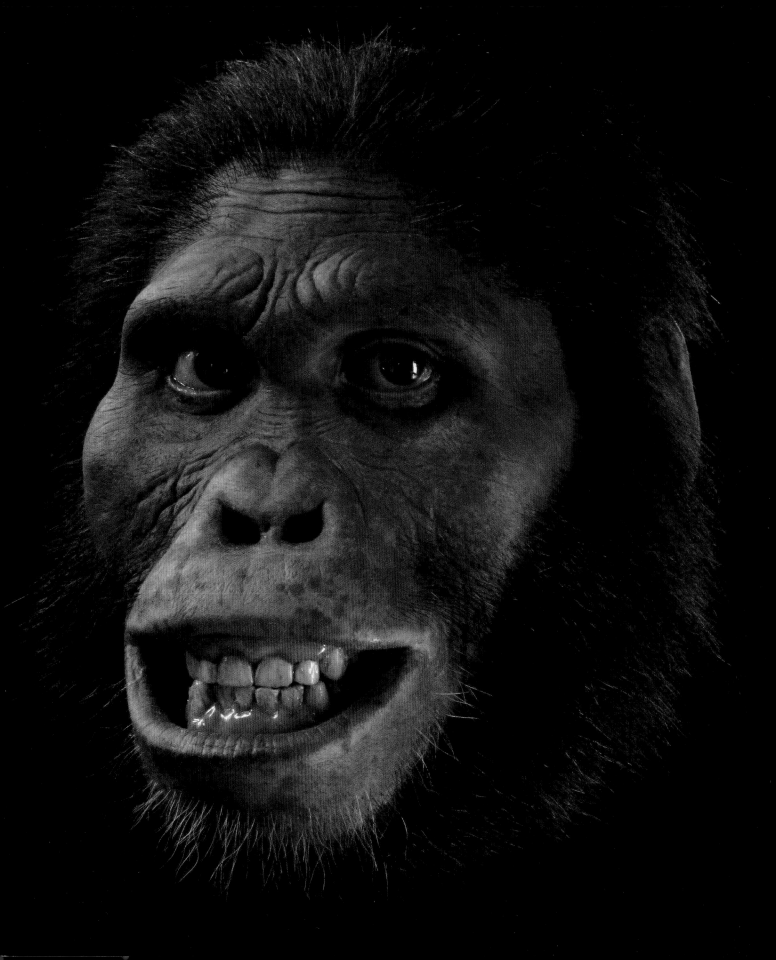

Chapter 3

THE IMPOSSIBLE DISCOVERY

Australopithecus africanus (3.3 to 2.1 million years ago)

In 1924, anatomist Raymond Dart of the University of the Witwatersrand in Johannesburg, South Africa, found what could not have existed. He discovered a skull with a brain capacity the size of an ape's, but with humanlike qualities of the teeth and lower jaw. Most of the anthropological establishment responded that this combination was nonsense; we knew that the enlargement of the brain occurred early, at a stage when the jaws and teeth were still apelike. We knew this because this combination existed in the Piltdown skull, found twelve years earlier.

Fifty-four years after Dr. Dart's discovery I tracked him down in Philadelphia, where he had been recently spending several months out of each year. When I was young, Raymond Dart had something like legendary status for me, and I had always wanted to meet him. This first meeting was for the purpose of taking photographs in preparation for a portrait I was painting of him. Even at age eighty-five, he had the sparkle of a much younger man. He told me the story of his discovery.

It began on an October day with what looked like a brain made of stone. This was a natural cast of the interior of a cranium, formed when sediment inside of the skull hardened to rock. The skull had been subsequently broken away. Dart received it in a crate of rocks and fossils, which was delivered to his house moments before a friend's wedding was set to begin there (he was the best man). An earlier discovery of a fossil baboon skull by quarry workers at the Taung Limeworks in South Africa had prompted Dart to request that any additional material be sent to him for examination. Now he stood, preparations for the wedding momentarily forgotten, holding the small stone brain. As he tells it, humanlike details of the brain's anatomy immediately caught his eye. But it was so small!

Dart painted a comic picture of himself as he excitedly, and only half-dressed, began to rummage through the rest of the crate as the groom-to-be tugged on his arm and threatened to find another best man. The guests had arrived, and the wedding was about to start. He found a rock that the front of the stone brain cast fit into, and he could see fossil bone in the rock. He realized that, whatever creature this was, the front of its skull was face down in the rock.

After the day of the wedding, he worked intensively for ten weeks to expose the skull, using anything useful at hand, including his wife's knitting needles. Just before Christmas 1924 he finally succeeded in freeing the skull from the rock. The face that emerged was that of a child. It had the full complement of deciduous teeth, with the first permanent molars just emerging. It was a very apelike face, with a flat nose, receding chin, and a comparatively large distance between nose and mouth.

Dart's conclusions about the skull are astonishing in retrospect, in that they presaged the criteria for recognizing very ancient hominins still in use today. Other than brain morphology, he employed essentially the same two features used seventy-seven years later to argue that *Sahelanthropus* was a human ancestor: the small size of the canine teeth and a forward position of the foramen magnum, suggesting carriage of the head on a more vertical neck. He named a new genus and species for the skull: *Australopithecus africanus* (southern ape of Africa) and proposed in an article published in *Nature* that it was a human ancestor.

The reaction of the scientific community was disappointing. Many dismissed the skull as that of a fossil ape (does this sound familiar?). A major reason was that the Piltdown skull, discovered in an English gravel pit along with stone tools

Raymond Dart at age eighty-five, with a cast of the Taung child's skull.

and the bones of extinct mammals, showed in some ways the opposite combination of the Taung skull's anatomy: a very large human-looking braincase in association with an apelike lower jaw and teeth, in comparison to Taung's small brain and humanlike teeth. Dart's new skull could not sensibly be assimilated into a tree of human ancestry which included "Piltdown Man." Given a choice between the two, the leading British anthropologists of the day preferred the Piltdown evidence. It fit well with one of Darwin's ideas, that the enlarged brain has a very ancient history. And it was English.

The Taung skull's very apelike anatomy had much to do with the scientific community's reaction. The world had never before seen a human ancestor with such an apelike face and so small a brain. For many of the experts, these features dominated, and any humanlike features, if indeed they were there at all, may have evolved independently, in parallel with those of the human lineage.

Dart was deflated by this reaction, but he lived to see most of his claims for the skull vindicated. The Piltdown skull was shown in 1953 to be a hoax. It consisted of a modern human braincase coupled with an orangutan's jaw with filed teeth, which were stained to look ancient and placed in a convincing paleontological and archeological context by someone who knew what he was doing. The identity of that someone has remained a mystery, although there are many theories. The list of suspects includes Sir Arthur Conan Doyle and visionary French Jesuit priest and paleontologist Pierre Teilhard de Chardin. The strongest current evidence points the finger at Charles Dawson, the amateur archeologist and fossil collector for the British Museum who co-discovered the find, and at Martin A. C. Hinton, a curator of zoology at the British Museum who was known for his practical jokes.

The perpetrator probably did not foresee the way his prank would rip through anthropological history like a shotgun blast, expanding as it went. Certainly he could not have predicted that the combination he chose, while in agreement with Darwin's idea that brain enlargement came early in human evolution, was the opposite of the way it actually happened. Perhaps horror at the magnitude of the damage he caused kept the prankster from revealing himself. Whoever it was, he carried his secret to the grave.

Even before the Piltdown forgery was proved to be a hoax, more specimens of *Australopithecus africanus* had been discovered, mainly the result of the efforts of Scottish paleontologist Robert Broom at the South African site of Sterkfontein. These included adult crania and mandibles, pelvic and limb bones, and ribs and vertebrae. Anthropologists had begun to give the species serious consideration as a human ancestor, and some had begun to suspect that the Piltdown find was a fake. "All my landmarks have gone," said Sir Arthur Keith at eighty-one, who had much earlier pronounced the Taung skull that of a juvenile ape related to the chimpanzee. "You have found what I never thought could be found." In a letter to *Nature* he conceded: "Professor Dart was right and I was wrong." A landmark paper published in 1950 by Sir Wilfred Le Gros Clark of Oxford University convinced many that *Australopithecus africanus* and another South African

species (*Paranthropus robustus*) were more closely related to humans than to living apes. For most, the removal of Piltdown Man from the human tree in 1953 removed a last obstacle to acceptance of these australopiths as human ancestors.

The acceptance of *Australopithecus* as the most primitive of known human ancestors supported one of Charles Darwin's ideas about human evolution and refuted another. Anatomical similarities between humans and African apes led Darwin to suggest that the origin of humanity occurred in Africa. Later (but before the discovery of *Australopithecus*) fossil finds in Asia and Europe had seemed to point to other regions. If *Australopithecus* was accepted as an ancestor, it was the most primitive and presumably oldest ancestor then known, hinting that the early history of humans occurred in Africa.

Darwin had envisioned a gradual, simultaneous emergence of several human characteristics, two of which were bipedal locomotion and brain enlargement. Skulls of australopiths showed that brain size was small in these early bipeds, indicating that the evolution of bipedalism preceded brain enlargement. This was an early clue that different human qualities emerged at different times, in mosaic fashion.

In retrospect, the story of Dart and the Taung skull is an incredible one. Dart had been a demonstrator in anatomy at University College, London, where he trained under Grafton Elliot Smith, an expert in brain morphology and one of the world's few who studied hominin endocranial casts. Although the stone brain of Taung is tiny, Dart thought he saw in its shape the glimmerings of something human. The endocast of the Taung child had found its way into the hands of one of only a few people in the world capable of making such a judgment. He did so with a very humble comparative base. Although not all of Dart's proposed humanlike brain features have stood the test of time, current experts in the field of paleoneurology, with vastly more comparative information, have been able to confirm some of the human features he saw in the Taung endocast, more than eighty years later.

What Was *A. africanus*?

It can be almost overwhelming to have the remains of an ancient human ancestor spread out on a table before you. Your rational side says: Let's dive in and start measuring, but something makes you hesitate. Here is something of incalculable value. It was once alive; it felt joy, grief, and anger. It knew the sound of running water, the dreamlike motion of a running giraffe, the smell of flowers in bloom. Perhaps it briefly wondered about the stars. What remains of it holds clues about your own deep past, at an almost unimaginable number of generations before your time. It can inspire a sense of wonder and reverence that is sometimes difficult to communicate with others about; it is beyond words. Except that there *are* others who feel it too; you sometimes see it in their eyes, and not always in someone known for having a lyrical outlook.

This is the kind of reverie I was having in June of 1990, as I had my first look at a partial skeleton known as Stw 431, newly discovered at Sterkfontein and not yet announced in the scientific literature. Before starting the measurements, I wrote in my notebook:

Sterkfontein, the next generation: so exciting; almost overwhelmed. Before I begin, a few words about the new specimens. . . . This individual who lies in bits before me; what was he? A string of vertebrae. A pelvis—looks like not much wider than tiny Sts 14. . . . But we will see. My calipers are articulated, warmed up and humming; ready to go. We will see what the numbers say. Over the years, the identity slowly revealed . . .

This was during the years when the Smithsonian project had stalled and each year brought us no closer to getting it moving again. But in good faith that the hall would one day be realized, Rick Potts and I maintained an ongoing trickle of work on it. I was in the process of creating body blueprints for adult males and females of a number of ancient hominin species, to be used as templates for art in the hall. I had gone to South Africa especially to study fossils with implications for postcranial anatomy. The number one mystery I needed to solve concerned *Australopithecus africanus*. Several fossils had made it clear that the smaller, presumably female members of the species were about the size of Lucy. But how big were the males at the other end of the body size range? Was sexual dimorphism in body size in this species of *Australopithecus* like that of *A. afarensis*?

Based on a very few fossils, I had thought it might be close. There is an associated set of remains from a single larger individual from Sterkfontein that includes a fragmentary mandible, the upper half of an upper arm bone (humerus), and a partial shoulder blade (scapula). My length

estimates for the humerus were longish. Primatologist Adolph Schultz had shown years ago that the humerus is the most conservative of the limb bones, in that its relationship with the length of the trunk is the most constant across species. Any reasonable prediction of trunk length from this humerus resulted in a large-bodied individual, whether ape or human numbers were used to make the prediction. But there was a problem. If there were large-bodied *A. africanus* males at Sterkfontein, where were their heads? The use of any of the published skulls of *A. africanus* with such a body resulted in a pin-headed figure, with a head that was smaller relative to trunk length than in any of the humans or apes I had measured. I began to doubt my prediction of large-bodied *A. africanus* males.

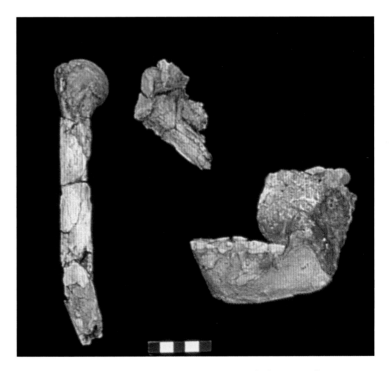

An associated humerus, scapula, and mandible of a large *A. africanus* individual known as Sts 7.

The trip to South Africa in 1990 was my second visit there. Unbeknownst to me, a magnificent large skull had been discovered since my first visit in 1987. Not only that, but there was also a newly discovered partial skeleton that confirmed the existence of large-bodied individuals of *A. africanus*. This was the Stw 431 skeleton, which preserved parts of a pelvis, clavicle (collar bone), scapula, humerus, radius, ulna (the radius and ulna are the two forearm bones), and nine vertebrae from the trunk. The lower half of the humerus preserved with the new skeleton has mid-shaft dimensions near the break that are similar to those of the previously known large humerus. And the partial pelvis and nine vertebrae from the trunk in this skeleton indicate a trunk length close to that which I predicted from the earlier-known humerus.

This was very satisfying. Incorporation of the new skull into the growing body blueprint for adult male *A. africanus* resulted in head to body size ratios in line with those of living apes

This composite large *A. africanus* skeleton includes newer discoveries, such as the Stw 505 skull and the Stw 431 partial skeleton.

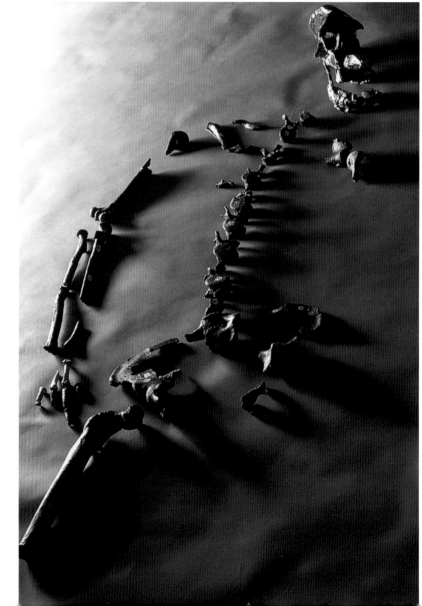

and humans, and with what we can estimate for
A. afarensis. The work of Henry McHenry at the
University of California at Davis has indicated
that *A. africanus* is like *A. afarensis* in that it is
characterized by greater sexual dimorphism in
body size than that in modern humans.[1]

The relationship of *A. africanus* to other
hominin species is not definitively resolved, but
many consider it a candidate for the ancestor of
Paranthropus robustus and/or the genus *Homo*.[2]
Support for this latter relationship has come from
the recent discovery at the new site of Malapa
in South Africa of two spectacular partial skele-
tons that are similar to *A. africanus,* but that also
uniquely share some features with the genus
Homo. These seem to show that something very
like the Malapa individuals descended from
A. africanus and is closely related to the ancestry
of *Homo,* even if the Malapa fossils themselves
occur too late in time to be ancestral to all of the
fossil hominins now widely considered to belong
to *Homo.*

Some scholars have proposed an ancestor/
descendant relationship for *Australopithecus
afarensis* and *A. africanus.* When *A. afarensis* was
initially named, some argued that there were only
minimal differences between it and the already
known *A. africanus.* Some even argued that there
was not enough difference to warrant a species
distinction. With further study and additional
finds, the differences between *A. africanus* and its
possible ancestor *A. afarensis* became clearer.

If *A. africanus* might be a descendant of
A. afarensis, what has changed? A number of
features seen in *A. africanus* fossils differ from
those of *A. afarensis* in one of two ways. Some

seem to involve greater specialization for heavy
mechanical loading of the teeth and jaws than in
A. afarensis, perhaps representing further adapta-
tion to fallback food resources of hard or abrasive
foods. Other features are more *Homo*-like.

A. africanus has larger chewing teeth with
thicker enamel than those in *A. afarensis.* The
body of the lower jaw is relatively thicker, with
fuller contours. Cresting patterns indicate that
the emphasis on the posterior fibers of tempo-
ralis seen in most *A. afarensis* individuals has
shifted in *A. africanus* to more anterior fibers
that concentrate force on the chewing teeth of
the cheek. The cheek bones have shifted forward,
bringing the chewing muscles they anchor (the
masseter muscles) closer to the action. In the face
of *A. africanus,* strong pillars have emerged on ei-
ther side of the nose in an A-frame arrangement
which frames the nasal opening. This may relate
to resisting high chewing forces which are now
transmitting greater stress to the face, as masse-
ter muscle action has moved more anteriorly in
A. africanus.

Microscopic analysis of tooth wear sug-
gests that leaves and soft plant foods such as
fruit, flowers, and buds were still important in
A. africanus's diet. Chemical studies of the teeth
indicate a varied, opportunistic diet that included
grassland resources, which might mean grasses,
the mammals which ate them, or termites.

Australopithecus africanus appears to be more
Homo-like than *A. afarensis* in some features of
the teeth, skull, and hands.[3] The teeth are more
human-looking, with smaller, spatulate canine
teeth and fully bicuspid, more oval-shaped
premolars. The upper dental arcade is often

parabolic in shape, with tooth rows that diverge in back (unlike the more U-shaped arcade of *A. afarensis,* which may converge at the back ends), and usually lacks a diastema (a gap between the upper canine and the upper lateral incisor, which functions as a spacer for the lower canine tooth in apes and is still fairly common in *A. afarensis*).

When large male crania were discovered for both species (*A. africanus* in 1989 and *A. afarensis* in 1992), it became especially clear that claims for cranial similarities between the two had been overstated. A number of features of the face and cranial vault are more *Homo*-like in *A. africanus*. These include a more globular braincase, cheekbones with less flare to the side, and a palate that is, on average, deeper in *A. africanus*. The brow ridges of the large male *africanus* skull known as Stw 505 display strong swellings near the midline that can be seen in some early *Homo* skulls, and even in some male humans living today. These are absent in known skulls of *A. afarensis*.

Studies of endocranial casts of *Australopithecus africanus* have resulted in a decades-long debate about whether certain patterns of folds and fissures indicate a cerebral cortex that was reorganized in a human direction, but there is agreement that details of brain shape are more human-like than in living apes. It is especially interesting that Dean Falk sees an area which corresponds to Brodmann's area 10 in humans and chimpanzees as elongated in endocasts of *Australopithecus africanus*. In humans this area of the frontal lobes is twice as large as in chimpanzees, with greater interconnectivity between neurons, and it is involved in higher cognitive functions. Measurements of the internal spaces within the crania of *A. africanus* have indicated that there is little or no difference in brain size in comparison with its potential ancestor *A. afarensis* (this is true whether absolute sizes are compared, or they are mathematically made relative to body size).

Intriguingly, the hands of *A. africanus* seem to show additional features that might be related to toolmaking and use. There is debate on the physical traits that indicate the capacity for humanlike "precision grips" like those used in making stone tools, and on which anatomies characterize various species, but when the dust clears, three features of the *A. africanus* hand appear to show improvements in the capacity for humanlike precision grips over those seen in *A. afarensis*. The head of the first metacarpal (the nearest long bone of the thumb) in *A. africanus* is relatively broader, which would provide a firmer hold in precision grips. The terminal bone

Hand remains attributed to *A. africanus.*

(distal phalanx) of the thumb has a broader tuft at its end, indicating a broad, fleshy pad at the thumb's tip, and this is commonly seen as a sign of improved capabilities for precision grips.[4] An additional detail of this terminal bone's anatomy rotates it into opposition to the fingers when it is flexed.

Body proportions in *A. africanus* may be intermediate between those of living apes and humans, as they are in Lucy's kind, but as yet we have no *A. africanus* individual as complete as Lucy's 40 percent to confirm this. However, upper limb joints in *A. africanus* remains appear to be even larger (in comparison to the lumbosacral joint) than in *A. afarensis*. Fragmentary radii and ulnae attributed to *A. africanus* suggest that the forearms were long, as they were in *A. afarensis*, and this is echoed by the long forearm elements in an adult female skeleton discovered in Malapa, South Africa, representing *A. africanus*'s proposed descendant *A. sediba* (see Interlude). Some scholars take these proportions as evidence that climbing was still an important part of the locomotor repertoire of *A. africanus*.

More accurate determinations of body proportions must await the discovery and publication of more complete skeletons. A spectacularly complete *Australopithecus* skeleton is currently being brought out of the rock at Sterkfontein by Ron Clarke of the University of the Witwatersrand, and it may help resolve these issues for *A. africanus*. That is, if it is attributable to this species; it is from a rock formation different than the one that has yielded most of the other hominin specimens, and so it may represent a different hominin species.

One additional intriguing piece of evidence relates to locomotor behaviors practiced by *A. africanus*. The proportions of the semicircular canals within the ear are like those of living apes and *A. afarensis*.

Recently, evidence has been presented that challenges an ancestor/descendant relationship for *A. afarensis* and *A. africanus*. At the annual meeting of the American Association of Physical Anthropologists in April of 2012, two surprising presentations argued for features of the foot that appear more primitive in *A. africanus* and its presumed descendant *A. sediba* than in *A. afarensis*. This would imply evolutionary reversals in any proposed lineage with *afarensis* as ancestor and *africanus* and *sediba* as descendants. Perhaps more likely is that *A. africanus* and *A. sediba* are of a different lineage, rather than descendants of *A. afarensis*. The evidence presented also suggests that although members of both *A. afarensis* and *A. africanus*/*A. sediba* were bipedal, their style of walking would have been different.

What we seem to see in *Australopithecus africanus,* then, is a creature much like *A. afarensis* in many ways, but with some features which show further adaptation to hard object feeding, and some that are subtly more like those of *Homo*. Perhaps one of the most important messages to emerge from studies of the bones of *A. africanus* is one of stability. Like *A. afarensis*, *A. africanus* is a small-bodied, small-brained hominin with long arms. These two species of australopith are also similar in their flaring hip bones (wide in relation to trunk length) and in many of their adaptations for efficient bipedal walking, combined with the retention of some features related to climbing.

The persistence of these characteristics shows that a Lucy-like body plan endured in *Australopithecus* for over a million and a half years.

❋ ❋ ❋

Initially, the Smithsonian team wanted a bronze figure of an *A. africanus* mother and child. The mother was to be pregnant, suggesting an early appearance of the capacity of human females to conceive while still nursing a child, thus allowing closer birth spacing than in apes. There was to be a social learning component to the sculpture, indicating the communication of some aspect of culture from mother to child. In the end, it was felt that both of these were too speculative for such an early hominin, and that we might better communicate the social learning aspect with a later hominin for which evidence for such behaviors was more solid. I was relieved not to have to create a hominin for which our understanding of body proportions seemed to be in a state of flux (see, however, the rug pulled from under my feet regarding hominin proportions in chapter 4).

This move left only a head reconstruction representing *A. africanus* in the new hall. What important features of this species might we highlight? If the facial expression is one that exposes the front teeth, the smaller, more humanlike canine teeth would be clearly visible, as would the absence of a gap between them and the incisors. Some of the differences in the A. *africanus* skull from that of *A. afarensis* relating to further specialization as a hard object feeder will show in a head reconstruction. Would the subtly more *Homo*-like details of the face and head result in something that looks more human

than *A. afarensis?* Before digging in and doing the reconstruction, it was too close to call.

The Long Road and Winding Road: The Reconstruction of Sts 5

The reconstruction of the head of *Australopithecus africanus,* based on the specimen known as Sts 5, was begun in 1986 and reached its final form in 2008, making it by far the longest hominin reconstruction I've ever worked on (possibly the longest in human history). During this time, as new information came to light, the face changed.

When I began the work on *A. africanus,* I had dissected a number of humans, but only five great apes: two orangutans, two chimpanzees, and a bonobo. By the time I finished the sculpture in 2008, I had much more extensive dissection experience. The dissections were performed mostly through the generosity of Adrienne Zihlman at the University of California in Santa Cruz. She is best known for her work on great ape anatomy and body composition, and their implications for human evolution. No study of primate anatomy or body proportions is complete without citing her work. I made inquiries, and she kindly invited me to work with her team.

Through the years, Adrienne and I have had some pretty schizophrenic phone calls. She might begin a call by telling me sadly about the death of a chimp or gorilla at a zoo. We would stay for a moment in this emotional zone, before letting ourselves give vent to our excitement about the opportunity this gave us to study the animal. By the end of the call, we would be breathlessly discussing the logistics of dissecting it.

It was a high-octane work environment in Adrienne's lab, typically with several people each dissecting different areas of a single animal, each trying to wring as much information as possible from the animal in a short time. I concentrated especially on the anatomy of the face. Exhausting hours, but an exhilaratingly steep learning curve and an exciting atmosphere of discovery dominated in her lab. I took hundreds of measurements during a typical facial dissection. I also made notes and drawings and took photographs of each step in a dissection. Each stage of the dissection was molded and cast in dental plaster before taking a face down to the next layer. This extensive documentation would theoretically allow me to rebuild each animal's face in accurate detail. But of course that's not what it was for. It was to allow me to answer current and future questions about how the animal's face was built, and to serve in the search for patterns in all of this data that are common to apes and humans.

My great ape and human dissections continued through the years, in Adrienne's lab and in labs around the world. The new information

The Sts 5 skull.

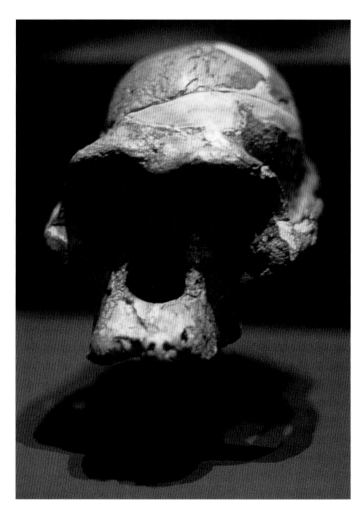

gathered had profound implications for the reconstruction methodology. As I learned more about how faces are constructed, it became obvious that, in creating the initial version of the *A. africanus* sculpture, I had made a number of unwarranted assumptions about the face. In all cases these amounted to the supposition that, since *A. africanus* is more closely related to humans than it is to any ape, human anatomy would make a better model for it than great ape anatomy. As I learned more about facial anatomy, these assumptions, one by one, fell away.

One of the areas most affected was the nose. The anatomy of human and ape noses is similar underneath the skin. The curled form of the largest cartilages of the external nose (the greater nasal or alar cartilages) is similar, and it is easy to see the form of the human nose as a reengineered ape's nose. The nasal area of an ape's skull is flat, or nearly so, with the nasal bones and the nasal aperture lying in parallel (or identical) planes. To create a human nose from an ape's, the entire structure, including bone and cartilage, must be pulled forward so that it overhangs the lower face. This creates a marked angle between the nasal bones and the nasal aperture. The bulbous tip of the human nose is formed by a partial walling in of the now-extended openings framed by the greater nasal cartilages on both sides. Since this change involved alterations of bony anatomy, it can be detected in the fossil record.

My earliest version of the nose for Sts 5 followed the efforts of other paleoartists working in the early 1980s in having an incipient bulbous tip. The more I learned about the anatomy of the nose in apes and humans, it became obvious that

to build a nose that projected slightly, enough to allow room for the partial walling in that would create a small, bulbous tip, I had to cheat. I had to violate soft tissue/bone relationships observed in the dissections. While it is *possible* that the nasal area was built like this in australopiths, it would require bone/cartilage relationships not seen among living apes and humans. It began to seem to me like special pleading to reconstruct the nose this way simply because it was a hominin, possibly ancestral to later hominins with projecting noses. Comparative studies indicate a number of bony features which reflect a projecting nose in humans and which are absent in great apes. I thought these were also absent in casts of australopith crania. But casts of fossil skulls often obscure portions of the nasal anatomy. I needed to look at the real thing.

In summer 1987 I traveled to Africa to study fossil hominins from east and South Africa. I paid special attention to the nasal areas, where preserved. I found that in every specimen of *Australopithecus* and *Paranthropus* preserving this area, the plane of the distal nasal bones was close to parallel with (sometimes identical with) the plane of the nasal aperture, as in apes. All of them lack any indication of a projecting nose. Building any reasonable nasal cartilages onto these skulls would not result in a nose that projected enough to have room for both a nostril *and* a bulbous tip.

During the following year, new research on nasal projection in fossil hominins, published by Bob Franciscus and Erik Trinkaus, then both at the University of New Mexico, likewise concluded that the bony signs of a projecting nose were

absent in australopiths. As new information continued to come to light, I rebuilt the nose of my *A. africanus* sculpture several times. As I learned more, it became flatter and more like the nose of an African ape.

Another change had to do with the use of soft tissue thickness values from modern humans for reconstruction of such an ancient hominin. Humans have a blanket of subcutaneous fat, which is thought to have evolved partly as a buffer against nutritional stress in an animal which grows and maintains a very large brain. Chimpanzees, bonobos, and gorillas have little facial fat, so the soft tissue is thicker in many areas of the face in humans than in African apes. Since australopith brain sizes were apelike, it is probably not appropriate to use human soft tissue thickness values in reconstructing these areas, so these had to be thrown out.

The *A. africanus* reconstruction initially had a humanlike placement of the corners of the mouth, resulting in a narrow mouth. The canine teeth of *A. africanus* are larger than in modern humans and, based on my hypothesis that placement of the mouth's corners is related to upper canine size, the mouth had to be widened. The width of the nose, based initially on the notoriously unreliable nasal aperture breadth, had to be redone using better predictors, and use of either the chimpanzee or the human values for these ratios indicated a wider nose for Sts 5. All of these changes had the effect of making the sculpture look more apelike. Over twenty-two years the face de-evolved.

Rick Potts and I thought it might be a good idea to open the mouth and show some teeth for this reconstruction, as those on either side of it in time have closed mouths. Since the Sts 5 specimen preserves no teeth, I cast those of another individual with a comparably sized tooth row, known as Sts 52, in order to make paleodentures for transplant into Sts 5's mouth. These were subtly stained as a nod to tooth wear studies indicating that fruit was an important part of the diet for this species (I was thinking of figs).

Paleo-dentures made for the Sts 5 skull using the teeth of Sts 52.

With these changes made, the version of *A. africanus* that was finished in 2008 had come a long way from the one I began in 1986. Stripped of humanlike characteristics such as an incipiently humanlike nose and a narrow mouth, the final form had lost ground in terms of its resemblance to humans. When I compare its final gestalt to that of the reconstructed A.L. 444-2

male *A. afarensis* head, however, my own impression is of a subtly more humanlike head for Sts 5, reflective of some of the more humanlike details of the *A. africanus* skull.

We don't know what facial expressions were practiced by early hominins. The face that now peers from within a Plexiglas case above the label *Australopithecus africanus* in the new Smithsonian hall has an expression that is in the area of overlap between those typical of chimpanzees and those practiced by humans, so it is a fairly safe bet for early hominins. This expression is analogous to a chimpanzee's "fear grin." The human equivalent is the nervous smile. This is a smile with a lot of tension in it, and I've sculpted it so that it changes subtly with different lighting. When the head is lit from the side, the furrowed brow is emphasized. The stress in the smile is at a maximum, and you can tell that the individual is uncomfortable. When it is lit from directly above or from the front, the furrows vanish; the tension seems to melt away and the smile looks warmer. As the *A. africanus* head's case is lit by several spotlights, the movement of museum visitors outside of the case can cause subtle changes in the lighting angle that appear to change the expression. This is one additional way of making the sculpture come to life. I wish that I could have had the pleasure of showing it to Raymond Dart. He was still living when I began the reconstruction, but he died in November 1988 at age ninety-five, twenty years before I finished it.

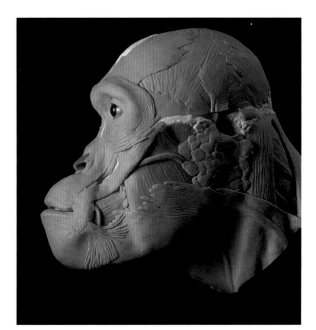

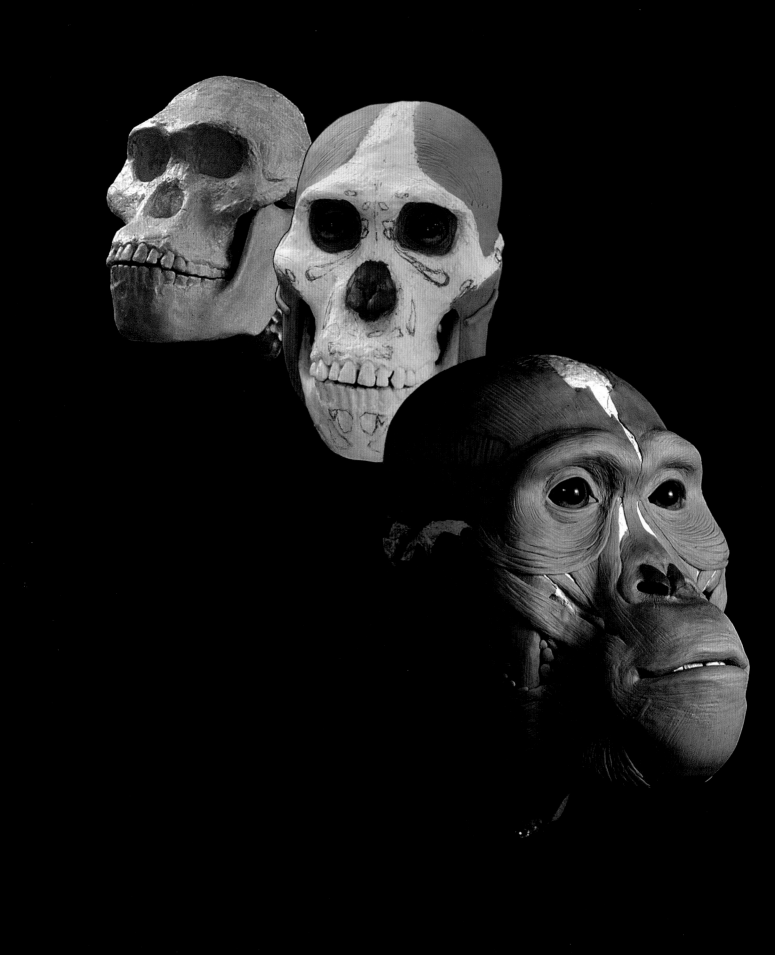

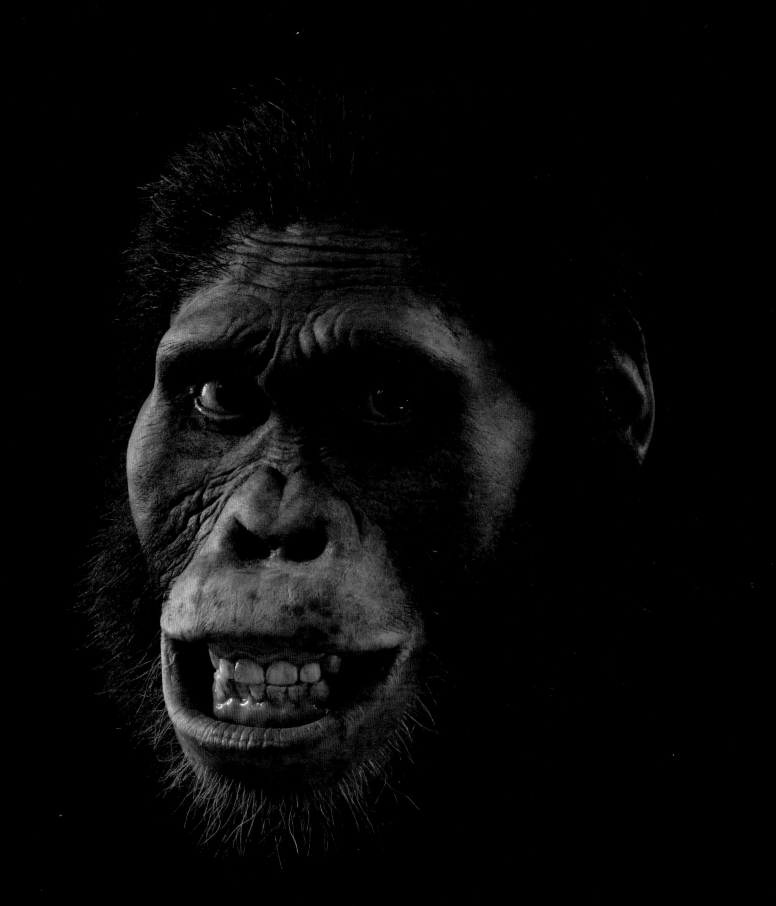

The anatomical reconstruction of Sts 5.

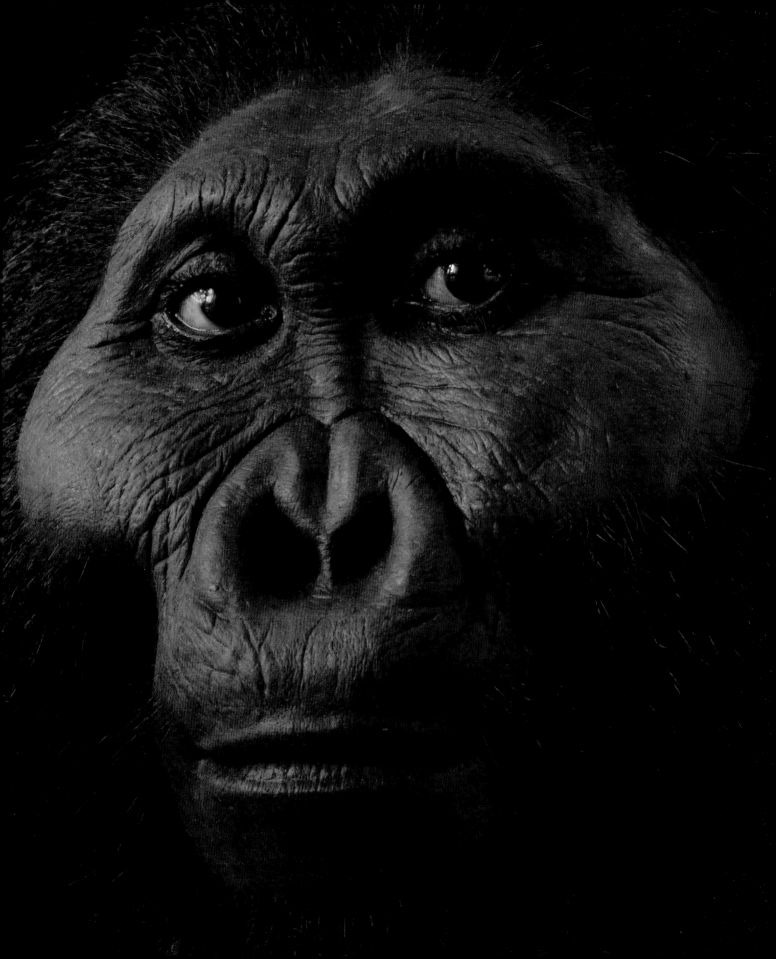

Chapter 4

THE PARADOXICAL SPECIALIST

Paranthropus boisei (2.3 to 1.0 million years ago)

At this point in the narrative we meet a strange relative. Our first three meetings have been with beings that are candidates for the direct ancestry of humans. This one is more of an evolutionary cousin, on a branch of the human tree that probably did not lead to us but instead vanished from the earth, with no descendants.

The modern world got its first glimpse of this relative in 1959, when Mary Leakey discovered a scrap of skull and two large teeth, which were mineralized to a beautiful gray-black, sticking out of sediments at Olduvai Gorge in Tanzania. She and her husband, Louis, had been searching the site off and on for more than twenty years. They had found primitive stone tools, but the makers of the tools had proven elusive. Now, finally, they had found the skull of their toolmaker, or so they thought. Its anatomy was unexpected.

The molars are huge, four times the size of a modern human's. The braincase is small and there is almost no forehead. The skull has a massive upper jaw and a large, slightly concave face with robust, flying buttress cheekbones that flare out to the side and are placed in a forward position relative to the tooth rows. This position carries the masseter muscles forward so that force is more optimally distributed among the premolars (bicuspids) and molars. Muscle attachment areas show that the chewing muscles were very large. The temporalis muscles had extended all the way up the side of the head and met at the top, where they were anchored by a large sagittal crest, as in an adult male gorilla (but with more emphasis on anterior muscle fibers, which exert their greatest force at the cheek teeth). One might ask: What was all of this extreme anatomy for? The find acquired the nickname "Nutcracker man."

Louis Leakey had expected that the toolmaker, when finally found, would look more human. One of his mentors, Sir Arthur Keith, had been one of the original doubters of Dart's *Australopithecus* as an ancestral human. In 1959 Louis was one of the few experts who still had doubts about this. He had inherited from Keith a conviction that the enlarged brain had great antiquity, and that a yet-to-be-found

large-brained ancestor gave rise to humanity, whereas all the australopiths were on a side branch. He had suspected that, when found, the unseen toolmaker at Olduvai would prove to have a large brain. The new skull did not fit these expectations.

Toolmaking, however, went a long way toward proving the find's humanity for Louis. Although the skull displayed anatomy very similar to that of *Paranthropus robustus,* known from South Africa, he played this down. He saw a number of features in which the skull instead resembled a human's. Louis named a new genus and species for the fossil—*Zinjanthropus boisei*—and announced to the world that they had found the toolmaker of Olduvai. Nearby volcanic tuffs provided the first solid date for an ancient African fossil hominin, and showed that the fossil was older than anyone expected: 1.75 million years old.

Just months after Louis had introduced *Zinjanthropus* as Olduvai's stone toolmaker, another type of hominin turned up at Olduvai. This was

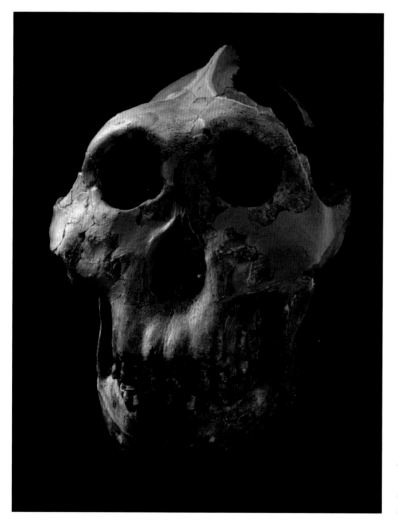

A cast of the *"Zinjanthropus"* skull (OH 5), now attributed to *Paranthropus boisei,* shown with a mandible from another individual.

a very different one, with smaller jaws and teeth and a larger brain, giving it a more human look. *Zinjanthropus boisei* was promptly stripped of its toolmaking status, which was conferred instead on the new find that was eventually named *Homo habilis*. In view of *Homo habilis*'s greater similarities to humans, *boisei* was put on another branch: an evolutionary cousin of ours that became extinct.

Since that time, other *boisei* skulls have been found, both male (like the first skull) and female. Mandibles, some of them huge, have been found, with teeth that match the upper teeth seen in these skulls, and they have been attributed to *boisei*. Because of its similarities with those South African finds attributed to *Paranthropus robustus*, *boisei* is now commonly included in the same genus and called *Paranthropus boisei*.

How Many Branches?

Each species of hominin plays its own unique part in our understanding of the human story. *Paranthropus boisei* offers a glimpse of an alternative way of being human, different from our own. It gives us clear evidence of at least a second branch in the human tree, with adaptations that are different from those that feature in our own lineage. Are there other branches? Here again, the question comes up: Is the human evolutionary tree a simple one, or a more bushy, multibranched tree? The answers to these questions revolve around the interpretation of variation. Does the physical variation we see in the hominin fossil record indicate a large number of species? Or is it more appropriate to group the fossils into a few highly variable species?

At one time there was a serious proposal that the entire human fossil record represents a single evolving lineage. C. Loring Brace and Milford Wolpoff, both anthropologists at the University of Michigan, proposed that the differences between fossils attributed to *Australopithecus africanus* and those attributed to *Paranthropus robustus* parallel the differences between female and male gorillas. These scholars suggested that the hominins in question belonged to the same species, and that their differences—such as the presence or absence of a sagittal crest—are due to sexual dimorphism (differences in shape or size according to sex). According to their theory, called the "single species hypothesis," it was not possible to have two hominin species in the same place at the same time because of a principle called "the law of competitive exclusion." This held that, in such a situation, one species would compete the other out of existence because they both occupy the same ecological niche, that of using culture in adapting to their environments. This hypothesis met its end because of a stunning find by a team led by Louis Leakey's son Richard.

The year 1975 was an exciting one for me. I was to enter graduate school in anthropology and study under a new arrival to the University of Kansas faculty, Dave Frayer, himself fresh from grad school under Brace and Wolpoff. Dave turned out to be a great teacher, one of those who can change a life. This was also the year that the single species hypothesis was dealt its fatal blow; studying under a Wolpoff student, I felt I had a ringside seat. In that year, at the Kenyan site of Koobi Fora, a nearly complete skull that is similar to Asian skulls of *Homo erectus* was found. It was

from the same stratigraphic level that had yielded another fairly complete skull that is very similar to the *Zinjanthropus* skull. Their differences in brain size, facial architecture, and cresting pattern go way beyond those found within any living species.

After some initial questioning about the stratigraphy, the single species proponents relented. But they did not disappear. Former advocates of the single species hypothesis adopted a simple Y-shaped tree, with one line leading to *Homo* and the other, occupied by the robust australopiths, marked for extinction.

We first met the proponents of this school of thought in chapter 1 as the "lumpers," led by Milford Wolpoff and others, which variously consider *Sahelanthropus* either likely to represent the same genus as *Ardipithecus* and *Orrorin* or to not be a hominin at all. Both of these suggestions have the effect of trimming the human family tree. Other experts, the "splitters," have seen the plethora of new hominin specimens discovered in the past two decades as evidence of a bushy tree with a diversity of species. The lumpers see them as fitting into a human tree with just two or three branches. For them, the *Kenyanthropus* skull is too damaged to warrant the naming of a new genus or species, Neandertals and fossils grouped by others under the name *Homo heidelbergensis* belong to *Homo sapiens*, fossils that inspired the creation of the new species *Australopithecus sediba* are most likely late *A. africanus*, and *Homo floresiensis* is actually a pathological modern human. We will touch on each of these arguments as we review each species. For now it's important to know that fossils grouped under *P. boisei*

represent the strongest case for a separate lineage that coexisted with but did not lead to *Homo*.[1]

The Specialist?

The structural details of the crania and jaws of *P. boisei* have been widely seen as anatomical specializations built to support very large chewing muscles, and to resist the stresses they generate. The large, thickly enameled chewing teeth add to this image of a "chewing machine," a specialist in hard or abrasive vegetable foods such as nuts, seeds, roots, or tubers. These features could be related to very large forces occasionally experienced during activities such as cracking nuts or seeds, or they could be adaptations to repetitive chewing. But once again, as with other australopith species, study of the microwear patterns on the teeth of *P. boisei* has offered a puzzle: they do not match patterns on the teeth of present-day animals known to eat hard and abrasive foods. Instead, they often indicate that softer plant foods were consumed in the weeks before death.

As with the wear patterns of *Australopithecus afarensis* and *africanus*, scientists have theorized that the heavy chewing equipment of *P. boisei* was adapted to fallback foods it consumed when preferred softer foods were unavailable. The specialized chewing anatomy that characterizes australopiths and finds its most extreme form in *P. boisei* may have enabled them to eat a wider range of foods than an animal equipped to eat only softer foods. So, as in our own lineage, this lineage was adapting to environmental variation and uncertainty by expanding its range of options, but it was doing so in a very different way. The paradox of this kind of scenario is that

specialized anatomy becomes the means to a more varied diet.

Even with the greater dietary versatility these studies suggest, there was obviously strong natural selection for building specialized anatomies to resist heavy loading of the chewing teeth and skull. As Rick Potts points out, the heavy equipment must be maintained and mobilized whenever a *P. boisei* individual eats even the daintiest morsel: the tiniest termite or the most overripe fig. This is a hominin that has committed its resources to maintain and operate specialized anatomy.

In our planning for the bronze figures, the Smithsonian team's discussion of *Paranthropus boisei* centered on its anatomical specialization. By presenting it in a pair with *Homo erectus,* we could contrast their very different evolutionary paths. For *P. boisei,* we wanted to imply a narrow focus on food, specifically on hard or abrasive vegetable food, perhaps roots or tubers. But

simple eating or chewing is not especially dramatic, and we were looking for poses that would dynamically involve the entire body. Some scholars think that *boisei* was probably climbing, and climbing poses were considered, perhaps with a root hanging from the corner of the figure's mouth. Such a pose would combine two issues, but it seemed to weaken the picture we wanted to convey. I drew a number of on-the-ground, root-pulling poses, interested especially in the tension they variably evoked. I tried more upright standing poses, but it looked wrong to have the figure pulling this high up on the plant, which in any case looked too much like a vine. The team pointed this out at one meeting, and I scribbled a tiny figure in the margin of my notes, which was bent low at the hips, with one leg nearly straight forward and one leg bent at the knee, with the shin pointing backward. I loved the scissoring legs and the tension of this pose, and it is the one eventually adopted for the final figure.

An early drawing and a matchstick model, made in the process of working out the pose for the *P. boisei* bronze.

An early idea, to strengthen the approach of doing *P. boisei* and *H. erectus* as a pair, was to have *boisei* making eye contact with the *H. erectus* figure. In some later drawings, the head was thrown back, which was a great pose for expressing the strain of pulling. Ultimately, these poses were scrapped for a head-down pose that better expressed a narrow focus. This individual is oblivious to everything else, including the passing *Homo erectus* figure. We thought his narrowness of focus nicely paralleled his narrow adaptive path of committing resources to the development of specialized anatomy. There is a poignancy about this. As Rick points out, specialists in the human family have not fared well. There is nothing like him alive today.

Disembodied

As with the other hominin bronzes, I would build *P. boisei* from the bones up, so building a reasonable skeleton was the first step. We chose a male figure because the features are more robust in males, providing a greater expression of the characteristics that distinguish it from other hominins. The skull I selected for my *P. boisei* skeleton was the very skull Mary Leakey had discovered nearly fifty years earlier, known as OH (for Olduvai hominid) 5. It is still one of the most complete known for the species. A number of postcranial (below the head) bones have been attributed to *P. boisei* since that time, but there is uncertainty about many of them. They have almost never been found with diagnostic elements: skulls, jaws, or teeth that would allow confident attribution to species. Since between one and three other hominin species (all proposed to

belong to the genus *Homo*) coexisted with *P. boisei* in east Africa, there has been debate over the attribution of postcranial bones. At first glance it might seem straightforward: if there is a range of morphologies known for a particular bone, the ones most similar to their human counterpart might be more likely to belong to the genus *Homo*. Those most different from their human counterpart might likely belong to a hominin on another branch of the tree: *Paranthropus boisei*. Alternatively, taking a cue from *P. boisei*'s massive jaws and skull architecture, the most massive postcranial bones might be attributed to *P. boisei*.

Problems have emerged with both of these approaches. Work by Henry McHenry of the University of California at Davis showed that body sizes predicted by postcranial bones attributed to *P. boisei* are, on average, not especially large, and that smaller, presumed females can be downright dainty. So larger or more robust postcranial bones cannot be assumed to belong to *P. boisei*.

The 1986 discovery of a skeleton attributed to *Homo habilis* at Olduvai further confused the situation, as it showed that craniodental similarities between *Homo habilis* and modern humans don't necessarily imply postcranial similarities. For example, the skeleton's diminutive partial femur and long humerus were at first interpreted to imply that *Homo habilis* had more apelike body proportions than Lucy. This cast doubt on using the degree of dissimilarity to modern anatomy as a reliable way to assign trunk and limb bones to *P. boisei*.

I followed the debates on *P. boisei* postcranial bones, and in 2007, just as I was to begin my Smithsonian assignment to build a full figure

of *P. boisei,* Bernard Wood and Paul Constantino of George Washington University published a review of almost fifty years of research on the species, and effectively stripped it of all of its proposed postcranial bones. One by one, they reviewed the finds, knocking them down like bowling pins. These authors stressed the lack of proposed *P. boisei* postcranial material associated with craniodental material (skulls or teeth) that would yield a firm diagnosis. Since we now know that early *Homo* postcranial bones can be very different from their human counterparts, many of the bones formerly attributed to *P. boisei* might just as likely represent early *Homo.*

I considered positioning my *P. boisei* figure behind a bush. Rick and I talked over alternatives. Could *P. robustus,* a possible relative of *P. boisei*'s from South Africa, be of some help? Quite a number of postcranial bones are known from deposits that have so far yielded only *P. robustus* craniodental material. These might have been of some help, but so far there is no consensus about how these inform the attribution of remains to *P. boisei.* Worse, some consider the similarities between the two species to be the result of parallel evolution and not of a close phylogenetic relationship. I was, for the moment, stumped.

P. boisei Body Blueprint

I had heard that Brian Richmond, also of George Washington University, was studying a newly discovered partial arm and hand skeleton discovered in Kenya, which he thought was likely to belong to *P. boisei.* But he had not yet published his work on the find, and scientific journals often impose strict rules of secrecy about discoveries before publication. Scientists are likely to share information only with those they trust to keep it confidential. I didn't know Brian very well and had no right to assume that he would share information with me.

Brian turned out to be extremely kind. He trusted me with very helpful information about the arm. I was allowed to represent the new find *visually,* but I couldn't talk about it to anyone. I am now free to share the details of what he shared with me, as he has since reported publicly on the find. The arm was discovered at the Kenyan site of Illeret on the east side of Lake Turkana. It is dated to 1.50–1.55 million years ago and it includes portions of the humerus, radius, and ulna, and some of the bones of the hand. It shows apelike proportions within the arm (meaning a relatively long forearm) and a thumb that is humanlike in relative length compared with the fingers but attenuated like those of apes (and *A. afarensis*). In these characteristics and a number of others, it is unlike the contemporaneous *Homo erectus* skeleton found in sediments at the Kenyan site of Nariokotome (see chapter 5). The time range of the find samples a time when, if the fossil record known to date is an accurate guide, other species of early *Homo* were either extinct or rare. Brian thinks it is most likely attributable to *P. boisei.* At last, I felt I had a leg to stand on (or an arm) in my quest for material on which to base my *P. boisei* body. The humerus is very much like a more complete specimen found decades ago in the same area, so this could be added to the pile of likely *P. boisei* postcranial bones. The arms I built for *P. boisei* were based on the proportions and muscle markings of the new find.

Brian's fossil arm yields an interesting combination of evidence from the arm and hand. Robust bones together with strong muscle markings hint at a powerfully muscled arm with long, meaty forearms. But the thumb is delicately built. Humans and their ancestors going back at least to *Homo erectus* have very robust thumbs, and most researchers connect this with the making and use of stone tools. If this represents a causal relationship, it implies that *P. boisei* was not subject to the kind of natural selection for robust thumbs that might be expected in a context which included the making and use of stone tools. Brian suspects that the powerful musculature of *P. boisei*'s arm was developed for some other purpose, and one possibility is climbing. Bone tools have been recovered from the South African sites of Swartkrans and Drimolen, and *P. boisei*'s possible sister species (close relation) *Paranthropus robustus* is highly implicated as their maker, but stone tools found in the same stratigraphic layers as remains of *P. boisei* cannot be attributed to this species with any confidence, because *Homo* is also found in these layers.

A small, scrappy skeleton analyzed in 1988 by Hannah Grausz and Alan Walker, then both at Johns Hopkins University, is one of the few proposed *P. boisei* fossils that are associated with a fragmentary mandible, and the resemblance of this mandible to a more complete one with undisputed *boisei* teeth makes this skeleton, in my view, another likely specimen of *P. boisei*. The proportions among the bones these researchers were able to measure resemble those of Lucy. Although we can't be certain about how these measurements translate into limb bone lengths, this

is suggestive that *P. boisei* might have had body proportions similar to *Australopithecus afarensis*.

Following this hypothesis, I drew a body blueprint that is like Lucy in its humerus-to-femur ratio, and like Brian's new arm in its proportions within the arm and hand. The details of the shape of the femur followed a composite femur reconstruction Alan had created in 1973 from fossils he thought likely to belong to *P. boisei*.

The pelvis was a major problem. There simply are no pelvic remains that can be confidently assigned to *P. boisei*. I would have to guess about important dimensions like pelvic breadth, but upon what could I base such a guess? If I assumed that the lower end of the femur Alan used in his composite femur reconstruction actually represents *P. boisei*, this could provide a clue. This femur deviates from the vertical at a marked angle when the knobs of its lower end are placed on a flat surface, as they are placed on the upper plateau of the tibia (largest bone of the lower leg) during bipedal walking. Using Alan's reconstruction and its mirror image for the opposite side, the femur heads are farther apart than they would be with a lesser knee angle, and this suggests a wider pelvis.

If, alternatively, I based my *P. boisei* pelvis on the assumption that it would have resembled that of *P. robustus,* I would get the same results: several pelvic fossils assigned to *robustus* indicate a broad pelvis.

A broad pelvis might be expected for *P. boisei* on theoretical grounds as well. The diet reconstructed for the species includes a lot of cellulose-heavy vegetable material. Generally, this diet would require a larger gastrointestinal tract or

gut as a sort of fermentation vat, as found in living great apes. A larger gut also fits with the predictions of the "Expensive Tissue Hypothesis," put forward in 1995 by Leslie Aiello and Peter Wheeler. This theory postulates that gut size reduced in our lineage as the brain enlarged, in order to balance metabolic demands (see Interlude between chapter 4 and chapter 5 for details). Since *P. Boisei* had a comparatively small brain, it would not be expected to show such an abbreviated digestive system as living humans have. A wide pelvis is one of the ways that a capacious gut might show up in the skeleton. I included both a broad pelvis and, later, a large gut in my figure of *P. boisei*.

Building *boisei*

The three-dimensional skeleton was physically built in clay over a metal armature, measured hundreds of times during construction to make sure it remained consistent with the proportions I had worked out. When complete, the bones were stabilized with a coat of acrylic polymer.

Attaching a cast of the OH 5 skull to the otherwise finished skeleton resulted in an eerie transition. Suddenly the figure had will! Intention! Focus! It was now looking at what it was doing. Even though it was only a skeleton, there was, for the first time, something to it that strongly

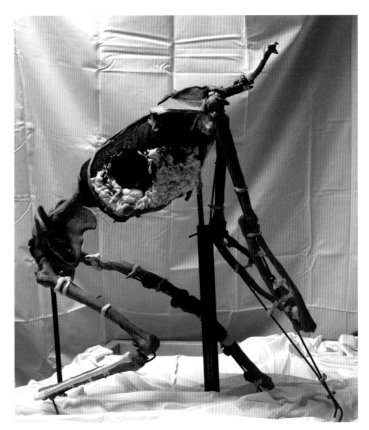

The composite male *P. boisei* skeleton in progress.

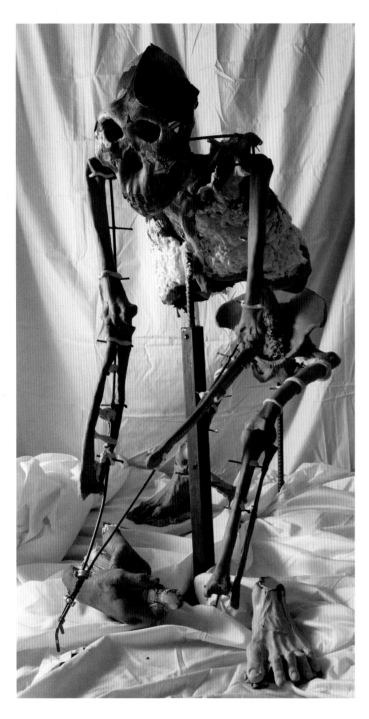

(facing) This drawing shows the restored OH 5 skull with chewing muscles reconstructed.

suggested a being. However faintly, someone was there.

Study of OH 5's muscle attachment sites in light of the anatomy of living forms makes it quite clear that this is a form with enormous chewing muscles. I knew what sizable temporalis and masseter muscles looked like, having dissected adult male gorillas and orangutans. OH 5's skull is not identical to either, and a *P. boisei* male is much smaller in estimated body size than both of the male apes, but my slides, casts, and notes on dissections of them guided my hands in sculpting details of these muscles appropriate to the OH 5 skull.

The OH 5 skull's nasal bones are nonprojecting, and any reasonable modeling of greater nasal cartilages will result in a flat, apelike nose, unless unusual bone/cartilage relationships not found among living forms are posited. There is an additional clue in a groove on the floor of the nasal cavity. This is where the base of the nasal septum's cartilage once attached. Like that typical of an adult gorilla, it sits well inside of the nasal opening. When the fleshy nose is completed, this will impart a gorilla-like look to the nose, with the fleshed-out septum sitting deep relative to other nasal structures, as in most adult gorillas. As in other australopiths and living apes, the position of the holes for the ears is posterior, indicating that the ears were positioned very far back on the head.

Much of the specialized anatomy of OH 5's skull is visible in the finished head reconstruction. The massive jaws, flaring cheekbones, and the very large chewing muscles indicated by the

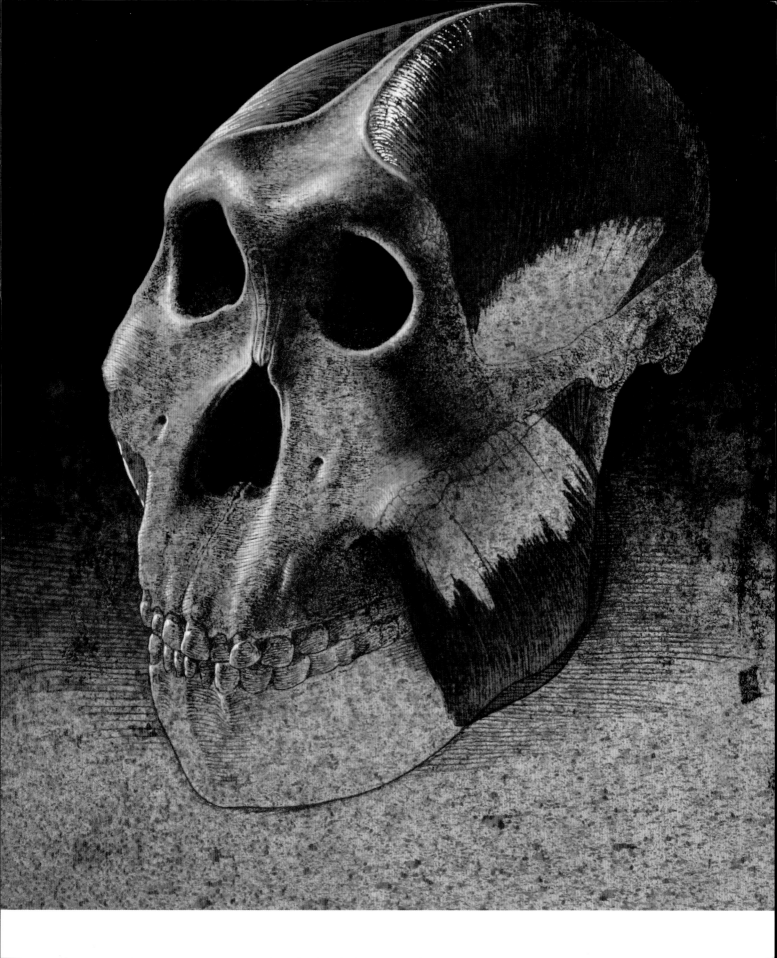

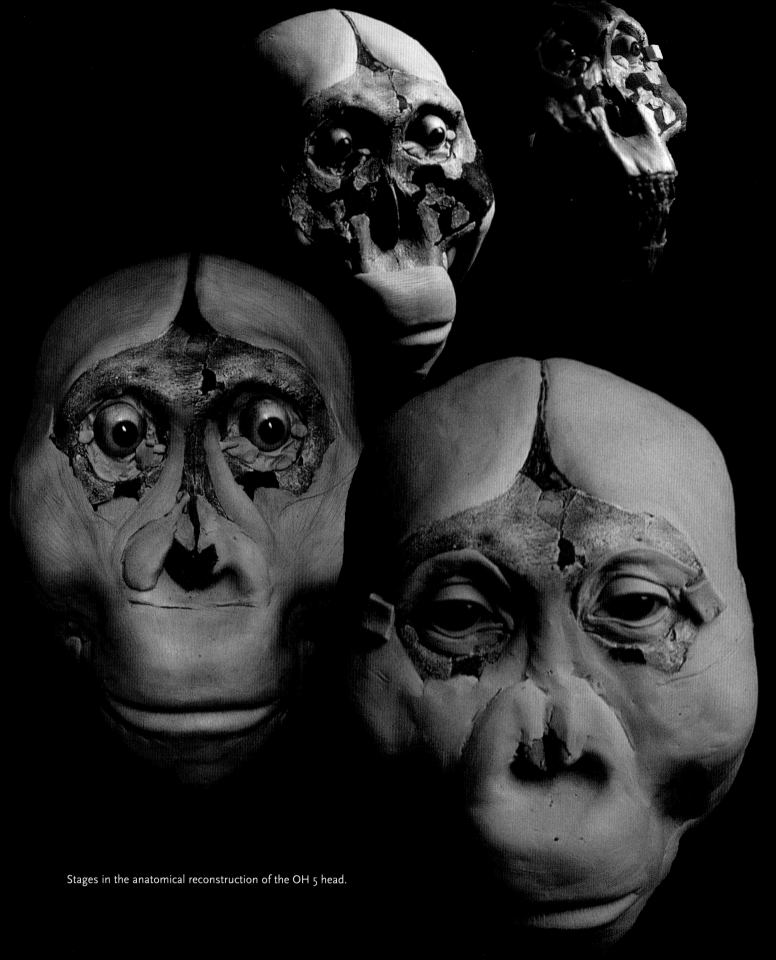

Stages in the anatomical reconstruction of the OH 5 head.

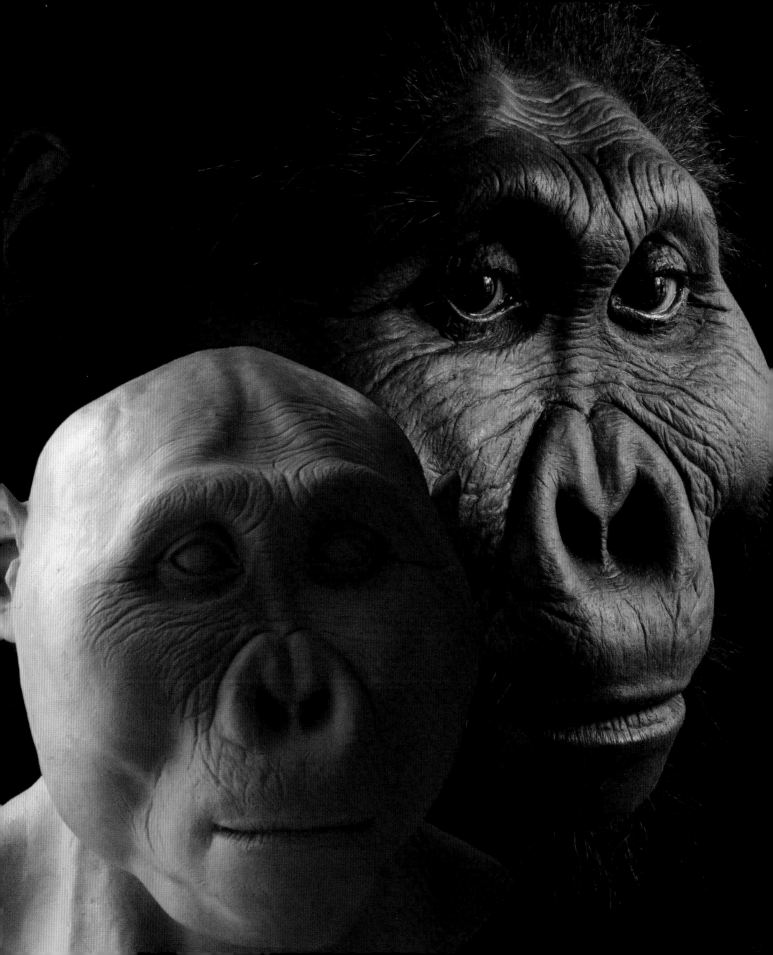

bony anatomy have an unmistakable influence on the shape of the head and face. Would OH 5's mother recognize the final silicone sculpture? Have the art and science of hominin reconstruction advanced that far? Maybe. I'm reasonably confident about many areas of the face and head. But there is a wild card: epigams. These are features with the primary function of visual communication. Many primate species have them in one form or another, including humans. They are often sculpted in hair or fat. Sometimes they involve color. Rarely are they associated with any bony form that would allow their prediction. In the case of a male *P. boisei,* I could justifiably have chosen to put a large fat pad directly on top of the large muscle-anchoring sagittal crest that runs, Mohawk-like, across the top of the skull. This choice would make sense because, as has been made clear by Adrienne's and my dissections, a fat pad commonly sits directly atop the large sagittal crest in both species of living great ape in which adult males possess one. The fat and skin over the crest can reach a combined thickness of over seven centimeters in adult male gorillas, and this can give the head a kind of "conehead" look. It may relate to sexual selection, as it has the effect of visually exaggerating a male feature in these species. I would have been perfectly justified in speculating that *P. boisei* might also have sported such a look. It was tempting, but my approach to reconstruction is a conservative one, that of trying to stay as close to the evidence as possible. So the Smithsonian's *P. boisei* figure lacks this feature. It's possible that his mother would have been disappointed.

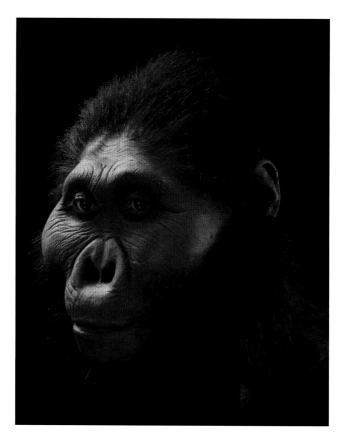

Alternative version of the male *P. boisei* reconstruction with a "conehead" look, resulting from a hypothetical sagittal fat pad placed as in male gorillas and orangutans, atop the sagittal crest.

Muscle attachment sites on bones used to create the skeleton guided the placement and size of muscles added to the figure. Obviously, the sculpture I've created should not be taken as the last word on the body form of *P. boisei.* It is better thought of as a best guess, a hypothesis to be tested in light of new discoveries and interpretations.

Three stages in the muscular
reconstruction of *P. boisei*.

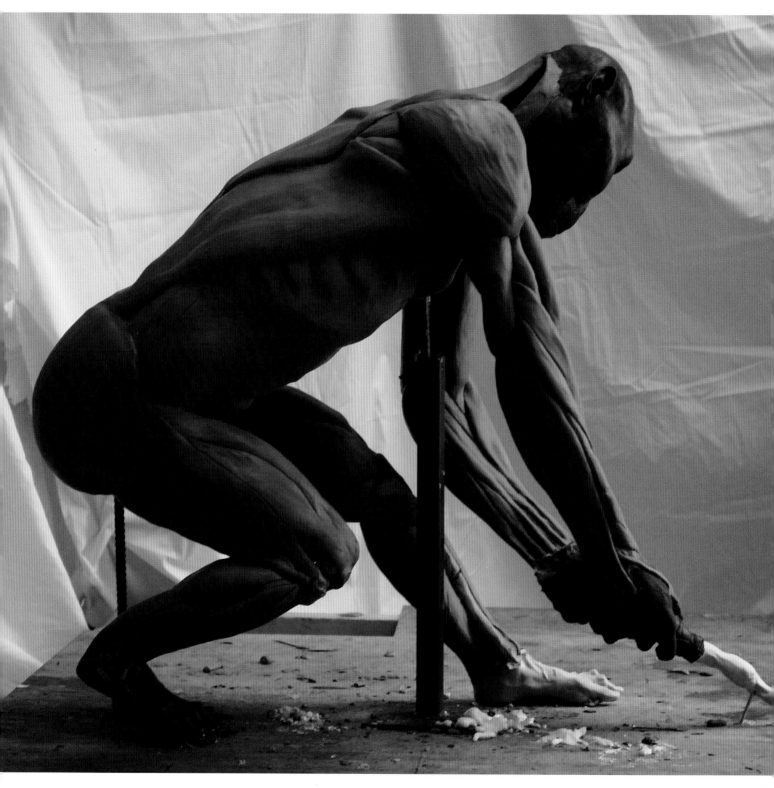

Reconstruction of the hypothetical musculature of *P. boisei* in clay, lateral view.

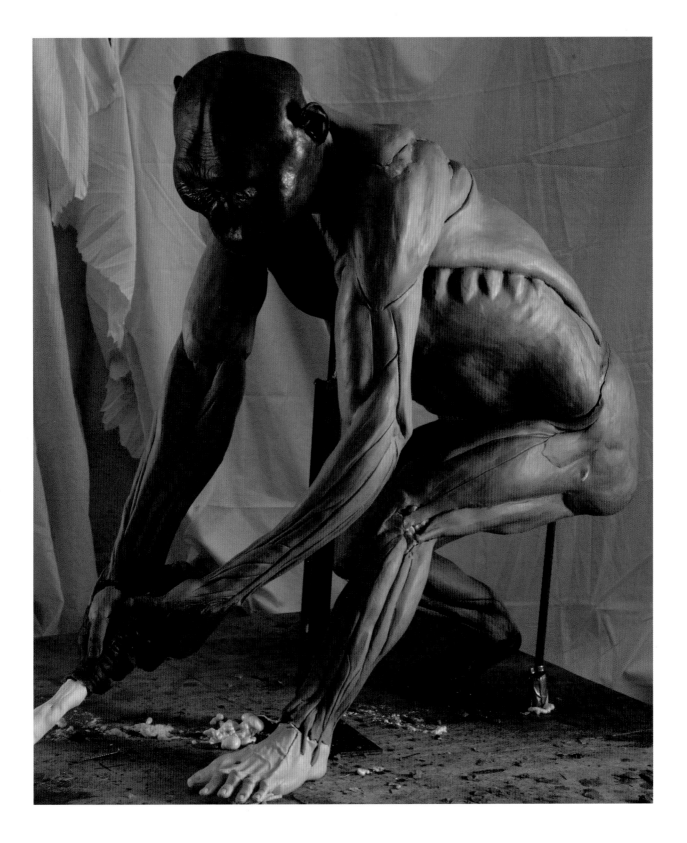

Representing hair in a bronze sculpture is a challenge. For *P. boisei* I had a whole body's worth to depict (I assumed the same sparsely haired chimp model I had used with Lucy). I did many experiments: made casts of wigs and my daughter Blythe's hair, carved "negative" hair into clay with a needle and cast it. The most convincing "fur" was created by making latex texture pads of bear fur, and pressing them into clay.

❋ ❋ ❋

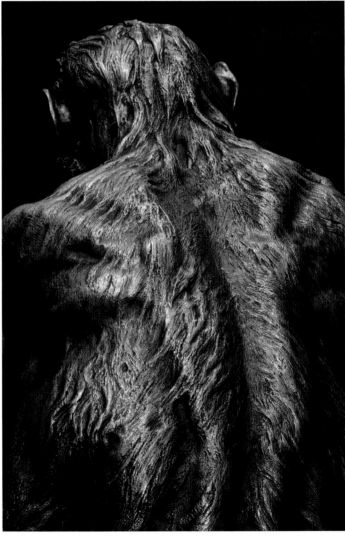

Rear view of the *P. boisei* bronze showing body hair.

What kind of plant should the *boisei* figure be pulling from the ground? I felt that it should have a root that is identifiable as such. And it would be most convenient if its root is known to be a food source for both humans and chimpanzees. Researching the use of roots and tubers as food sources by humans and chimps, I found an African plant that met these criteria and has a mellifluous name to boot: *Tacca leontopetaloides*. It has a turniplike root that is known to be consumed by both chimps and humans.

By the point at which I was ready to integrate this plant into the sculpture, I had spent so much time on anatomy that the clock was running short. The quickest, simplest way to represent this plant would be to cast a member of this species or one that looked very similar. It turned out to be difficult to import an actual *T. leontopetaloides,* so I went to a nursery that sells a wide variety of plant species to look for a doppelganger, or at least a starting point: a plant that could be modified to look like *T. l.* I ended up with plants of six different species, each with parts resembling those of *T. leontopetaloides*. These I put together in Frankenstein fashion, altering their shapes where necessary, and then I made a silicone mold of the resulting chimera. From this mold I made three individual plants, one that could be in the process of being pulled from the ground, and two already uprooted plants that were to be neatly put aside—to give the impression that the individual is gathering them but not for immediate consumption. This is a typical human behavior. He may intend to share these with others. If Kent State's Owen Lovejoy and his colleagues are correct, he may intend to use them to provision his favorite female and her young.

Tacca leontopetaloides plants created to accompany the *P. boisei* bronze figure.

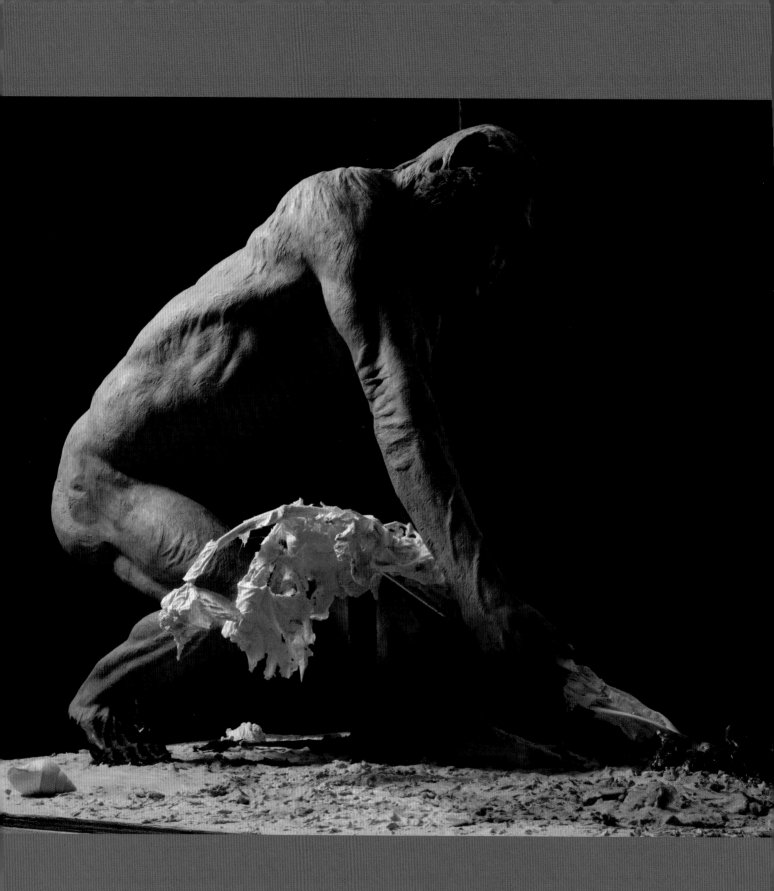

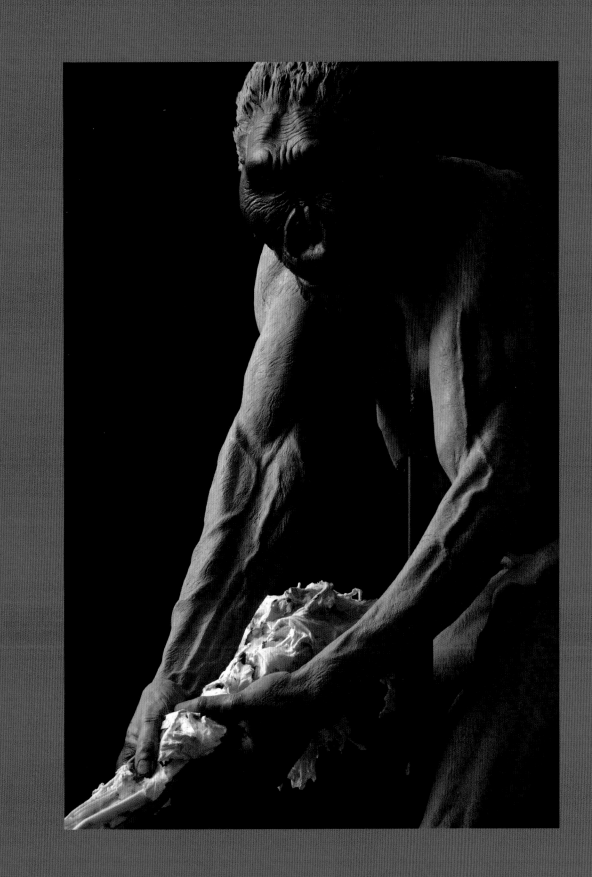

When the sculpted clay figure of *P. boisei* was complete, a mold-making team from the New Arts Foundry in Baltimore arrived to mold the figure, along with the other bronze figures-to-be. They first made a mold of flexible urethane (upper left), and then a plaster mother mold (lower right) was created over the urethane mold to give it rigidity.

(*facing*) A wax casting of the *P. boisei* sculpture was made by pouring hot wax into the urethane and plaster mold once it was removed from the clay figure. From this, a ceramic mold is made. The wax is then melted out of the ceramic mold, and liquid bronze is poured in.

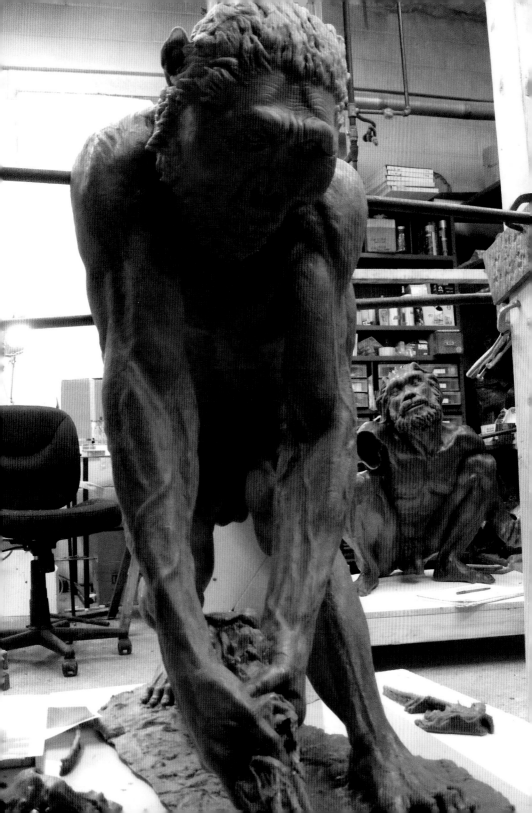

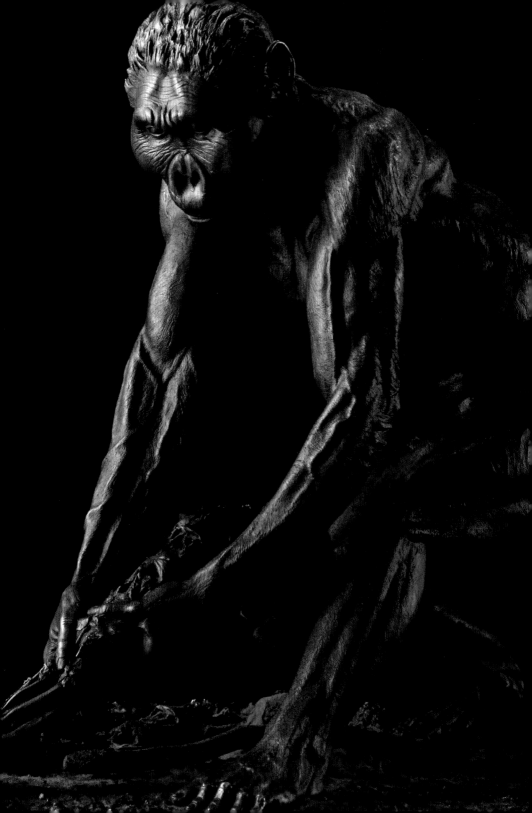

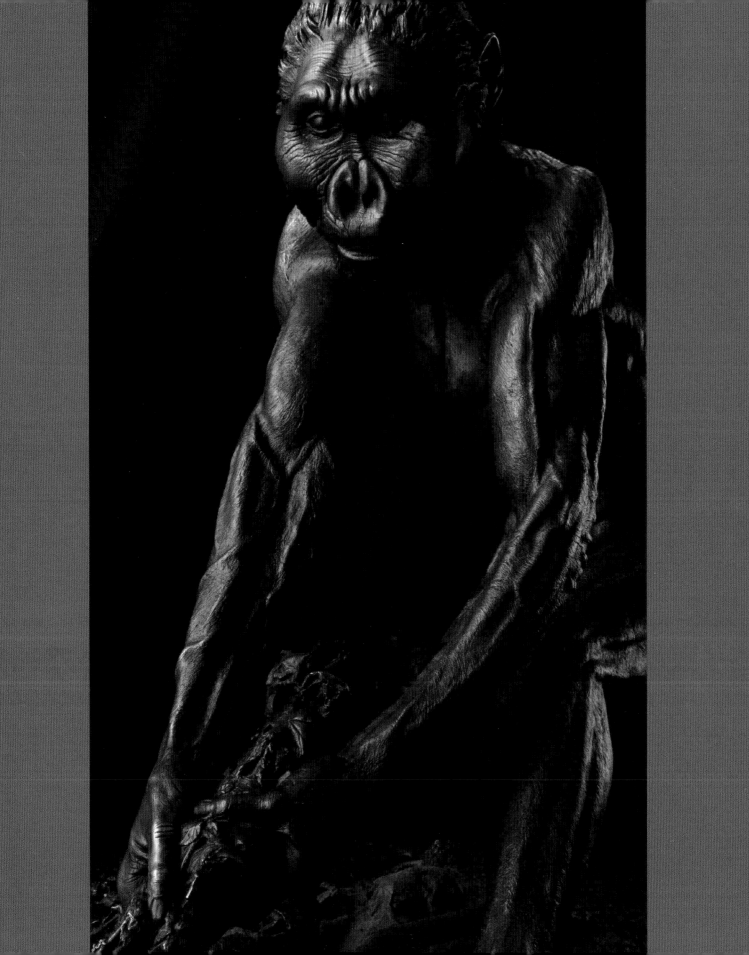

As with all of the Smithsonian bronzes, the *P. boisei* figure has a secret. Something that is unmistakably present in the sculpture, but subtle and not easy to find. The reward for anyone able to find it is a bit more knowledge of this individual's story.

There is something that happens between sculptor and sculpture that might be called animistic magic. This has to happen if the sculpture will work as an evocation of something alive. If this is the intended effect on the visitor, it must also happen for the sculptor. There must be a transition in his mind from the nonliving to the living, a process of imbuing nonliving materials with life. So there are, with each sculpture that succeeds in doing this, moments when you feel this transition happening under your hands as they move (*blood flows, clay warms into flesh*). Rationally, you are aware that this is a projection of your hope and your will onto clay and plaster, but still you feel that something else, some quality of the living, is present.

I've spoken of the moment of attaching the *P. boisei* skull to its headless skeleton and the immediate upgrade to a new level of being that seemed to occur, a being with will and intention. This transition also occurred with the other bronze figures. But unlike the others, when the *boisei* figure was finished, there was a barrier of some kind, a feeling of not knowing him. His face was inscrutable, and I had the feeling of being totally unable to reach into his mind. Is this because of my awareness that he is not a direct ancestor, but is instead on a different branch of the tree? Maybe with those who are closer to my direct ancestry, I unconsciously project a bit more of myself into them. I have the feeling that some small part of myself, perhaps in a more primitive form, exists in a direct ancestor.

Still, *P. boisei* is a hominin. Compared with other primates he is a close relative. Shouldn't I be able to relate to him as such? Maybe the problem is the figure's intense focus, body and soul, on food. His narrow concentration doesn't let me in. There is no room for consideration of an anomaly like myself, no chance of a mental bridge.

It is no better with the silicone head reconstruction of *P. boisei*. The facial expression I was aiming for with this herbivore with specialized anatomy was one of bovine contentment (apologies to all vegetarians, including my two daughters, whose names I cannot use in the same sentence with the word "bovine"). In a wide variety of mammal groups, herbivorous mammals are usually less intelligent than their carnivorous relatives. I wanted to imply that *P. boisei*'s whole existence was tied to vegetable foods, as implied by much of his anatomy, in contrast to the path of our lineage, with its enlarging brains, carnivory, and developing technology. But this expression may have put the reconstructed *boisei* individual at a further remove. I may have to settle for seeing him as the strange uncle I never could quite relate to.

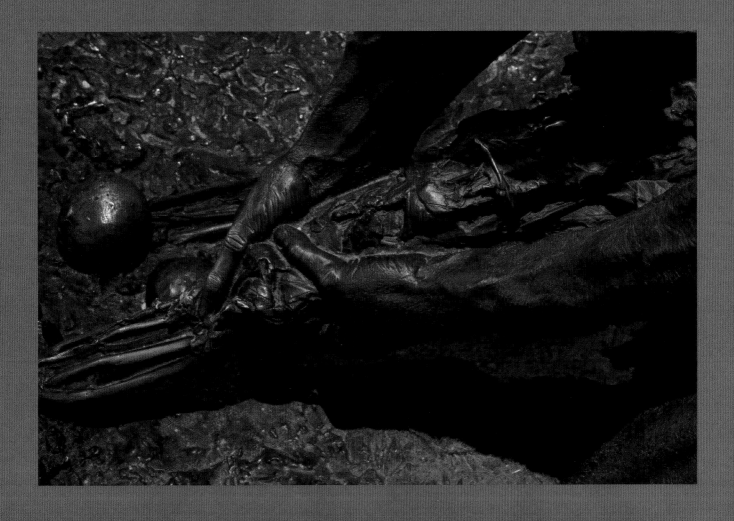

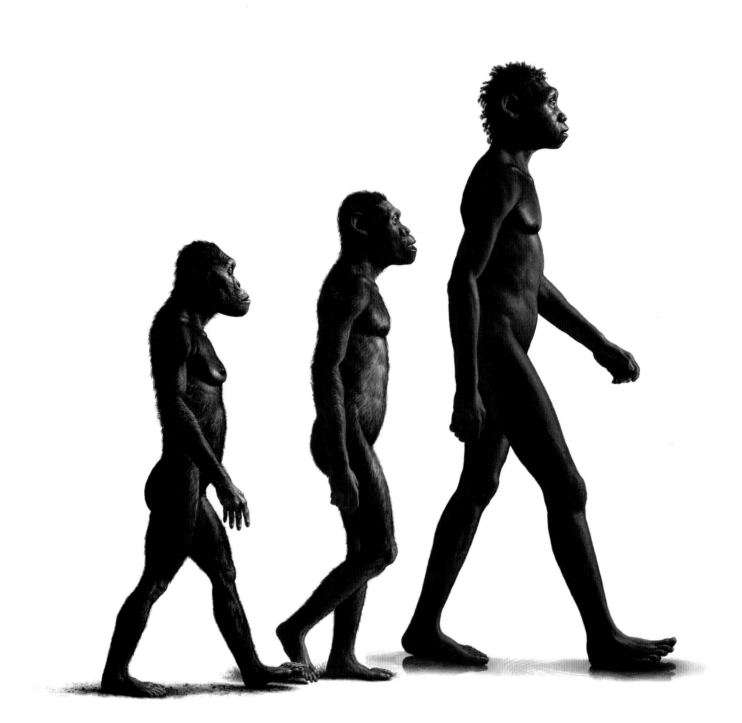

Reconstructions of Lucy (*Australopithecus afarensis*), MH 1 (*Australopithecus sediba*), and the Nariokotome boy (*Homo erectus*). (Courtesy of National Geographic Television; reconstructions and painting by John Gurche)

TRANSITIONAL HOMININS AND THE ORIGIN OF *HOMO*

For nearly the first two-thirds of human history (six to two and a half million years ago), hominins were small-bodied, small-brained bipedal apes with long arms and short legs, and unusual teeth. *Australopithecus* occupied the latter part of this period, roughly the middle third of human history. Except for minor adjustments, the body plan of *Australopithecus* and the suite of adaptations it represents seem to have remained stable from its beginning just over four million years ago, for a period of over one and a half million years. As discussed in the preceding chapters, this may have been the result of stabilizing selection for a body form capable of both bipedal walking and climbing. Then, between 2.5 and 1.8 million years ago, a major overhaul occurred. There is a general consensus that a genus should reflect adaptive plan or grade, and many scholars support a genus level distinction to reflect this major adaptive shift. The transition from the genus *Australopithecus* to *Homo* reflects a change from the ancestors we've met so far to a more humanlike adaptive package. This package is seen in remains of *Homo erectus,* with some features appearing in more primitive versions of *Homo* (specimens attributed to *H. habilis* and *H. rudolfensis*).

I will break the pattern of this book for early *Homo,* in order to cover hominins not represented by sculpture in the new Smithsonian hall.[1] Rather than subject the reader to the evolutionary vertigo that might result if we vault from the australopiths directly into *Homo erectus,* we'll take a brief breather from the sculptures and discuss this important transition, and the fossils that might shed light on how it occurred.

Outer Limits and Inner Changes

If you are old enough, you may remember the mid-sixties science fiction TV program *The Outer Limits,* which began with an ominous voice intoning: "There is nothing wrong with your television set. Do not attempt to adjust the picture. We are controlling transmission. We control the horizontal. We control the vertical . . . You are about to experience the awe and mystery which reaches from the inner

mind to . . . *The Outer Limits.*" In one episode, actor David McCallum enters a machine that can move an individual backward or forward along the evolutionary trajectory of his species. I'd like to borrow that machine for just a moment, so that we can watch the transition from an australopith like Lucy into an early *Homo* individual (I've chosen early African *H. erectus* here, as the transformation is more or less complete at this point, and the evidence is sketchier for earlier species).

Lucy is in the machine. She has walked in of her own free will, with only a little prodding by those of us wearing lab coats. Her movement as she walks is surprisingly familiar given her appearance, which looks to us like an ape with upright posture.

Cautiously, we move the lever forward just a tiny bit (this is a 1960s model; today's would have a keyboard). At first we notice nothing, then she begins to change. We realize she is growing. Body size enlarges in this transition, more so in females than in males, so that body size dimorphism is reduced in *Homo erectus* in comparison to the australopiths, and more like that in living humans. Her legs are disproportionately lengthening, outpacing the elongation of her trunk, so her body proportions are changing.

Her body breadth does not increase much with these changes as her body telescopes upward. Her comparatively narrow pelvic breadth keeps her femur heads close together for efficient walking and running. It also keeps her surface-area-to-volume ratio high, counteracting the effect of volume outpacing surface area that simple enlargement would produce. Higher surface area is important because her body fights heat stress not only by radiating heat, but also with evaporative cooling at her skin's surface. She sweats. She has lost her coat of body hair, which facilitates the function of her enhanced sweat-gland cooling system.

Her body seems to be "humanizing" as it grows. Her forearms do not lengthen as fast as the rest of her body, so they will be relatively shorter. Her slightly hunched shoulders (thought to characterize at least some australopiths),[2] drop into a more human position and simultaneously move a bit forward. She is losing some of her climbing adaptations. The muscles of her arms and shoulders are becoming more delicate, especially some of the shoulder muscles that raise the arms.

We've rigged the machine with a high-resolution CT (computerized tomography) scanner, in order to keep track of internal changes. We watch a close-up of her semicircular canals changing shape. These canals house the vestibular organ of balance, which helps stabilize the head during locomotion, and their different shapes in apes and humans are related to their different styles of locomotion and posture. On the screen we see the anterior and posterior loops lose their diminutive chimpanzee-like shape and enlarge into more human proportions, which are suited to bipedal walking and running, with little or no climbing.

Her hands are changing. Her thumbs become thicker, with robust joints the sculptor Rodin would appreciate. Her fingers straighten, and the pads at their ends broaden slightly.[3] Changes in the bones of her hand facilitate greater capacities for both precision and power grips. We now

have something unique among primates: the feet and hands have become completely segregated as to function.[4] In apes and other primates, both the hands and the feet function in locomotion and manipulation. In humans, the feet are specialized for locomotor function only. The hands, liberated from locomotor duties, are now free to specialize as dexterous organs of manipulation.

Returning our focus to the head, we get a shock. It has ballooned, as the brain has doubled in size. Her flaring cheekbones and large, protruding jaws have reduced in relative size. The CT scanner's screens show us that her chewing muscles have shrunk and her cheek teeth have become smaller.

Her trunk is now looking more human. Subtle changes have humanized her lower rib cage. She has lost her apelike pot belly as her gut reduced in size and her pelvic blades lost some of their lateral flare. They now "wrap" the viscera more, bringing her lower abdominal (inguinal) ligaments (which in Lucy undercut and so emphasized the gut) into a more forward position and giving her a deeper lower trunk (from front to back). Her relatively reduced digestive tract fits into the comparatively smaller volume framed by her relatively narrowed pelvis.

At the end of this exercise, the being that steps from the machine looks human to our eyes, at least from the neck down. This is a female early African *Homo erectus*. Her head is somewhat human-looking, but with some interesting differences, such as a brain only two-thirds the size of ours, and a shelflike brow ridge above her eyes. There are some subtle differences from modern humans in the details of her pelvis and

thigh bones, relating to changes that were made later in the human lineage to accommodate the passage of larger-brained babies. She is obviously an adult, but if we could count her dental perikymata (bands in the teeth that can be counted like growth rings to give an estimate of the age of the tooth) we would see that she is only fifteen years old. Studies of the *Homo erectus* skeleton known as the Nariokotome boy and other specimens have revealed that members of this species matured on a faster developmental clock, closer to those of apes than humans. Nevertheless, she has a very human-looking body.

"We now return control of your television set to you, until next week at this same time, when the Control voice will take you to . . . *The Outer Limits.*"

A New Niche on Earth

The ecological niches of the early australopiths were arguably similar to those of other living and fossil apes, some of which walk bipedally (gibbons),[5] make and use tools (the living great apes, although they seem to be unable to make *stone* tools), or have hard object feeding specializations (fossil apes such as *Gigantopithecus*). The ecological shift at the origin of *Homo* resulted in something new on earth: an enormously large-brained, social, carnivorous, culture-dependent, diurnally active, multihabitat, endurance-walking and -running biped. How did this new niche arise?

The work of Rick Potts and his colleagues explores the possibility that this new ecological role arose in response to climate change, and that these adaptations allowed hominins to better

adjust to variable conditions over time and varied habitats across space. The time between 2.8 and 2.4 million years ago was a period of marked global climate change, characterized by wide swings of wet and dry conditions and cooler and warmer temperatures, and by an expansion of grasslands related to increased aridity. At least three new hominin species appeared during this period.[6]

One lineage of social, probably tool-using, mostly herbivorous hominins adapted by expanding their range of foraging skills to include new tool-making and tool-using behaviors, allowing human ancestors to broaden their ecological niche into a hunting/scavenging/gathering niche. These behaviors enabled access to richer, high-quality foods, especially meat and marrow, and probably higher-quality vegetable foods as well.

Our vision of the deep past has blind spots. If a tool was composed of a perishable material, it is invisible to us with present methods. For example, if chimpanzees had become extinct long ago, we probably would never know about the tools they make from twigs and sticks. We've seen hints in the fossil record that the hands of australopiths seem to be improving through time in terms of their precision grip capabilities, and we can guess that this implies tool manufacture and use, but the tools used in that time are unknown. Then, as we move forward through the record, these "invisible" behaviors blossom into a form we can see, in the form of stone tools. The oldest yet found are 2.6 million years old, from east Africa.[7]

Appearing at about the same time and place in the record are assemblages of animal bones that indicate some of the ways the earliest stone tools were used. These are the first known butchery sites, smoking-gun evidence for stone tool–enabled meat-eating, complete with bones bearing stone tool cut marks, and some that have been smashed for marrow extraction. One antelope jawbone has stone tool cut marks on its inner surface, showing where the tongue had been cut out. Marks on another antelope bone offer a vision of a few seconds of history that transpired two and a half million years ago: *A hand swings a hammerstone into contact with the bone, but it bounces to the side, only scratching it and sending a small flake of bone flying. The swing is repeated at exactly the same angle, breaking the bone, which is then raised to the hominin's mouth* . . . The researchers reporting on this early evidence point to the absence of stone tools from some of these sites as suggestive that the hominins took the tools with them when they left, highlighting the foresight involved in curating the tools for future use.

Whose hands did this work? The answer is not known, although circumstantial evidence suggests the only craniodentally identifiable hominin species found nearby and in a similar time horizon: *Australopithecus garhi*. *A. garhi* retains a small brain like other australopiths, and larger brains appear only later in the fossil record, so the implication is that the invention of stone tools did not require an enlargement of the brain beyond australopith levels.

"Thus Spake Zarathustra" and the Momentous Dietary Shift

The hominins that made the first stone tools did not hear "Thus Spake Zarathustra" from the

2001, A Space Odyssey soundtrack as they struck a rock with another rock to fashion an implement. This action may have seemed to them only a minor extension of behaviors already in place, such as toolmaking with perishable materials. The scenario depicted in *2001* involves the first use of tools (in that case, weapons) to gain access to a rich new food resource: animal protein and fat, and the tool-using man-apes are shown feasting on meat. Weapons as the first tools are now out of favor, as are the "killer ape" and "man the hunter" hypotheses. But the first use of *stone* tools to access this new resource is well supported by the evidence, and, in retrospect, we can see that this was a major turning point in human history, worthy of the monumental tone poem from the soundtrack of *2001*. Although the consequences would not occur immediately, this stone tool–enabled dietary shift would prove to be a game changer which paved the way for developments that were nothing short of spectacular.

The two species of early *Australopithecus* we met in chapters 2 and 3 were already the largest-brained animals on land, relative to body size (nearly equaled by apes of today and possibly by those alive in their time). Brains are the most calorically expensive of the body's organs, and it is thought that a still larger brain would not have been possible, unless hominins were able to accomplish a dramatic shift in their diets. It is argued that the mostly vegetarian diets of living apes and those attributed to australopiths place a nutritional upper limit on the size the brain can reach. To go further would require a special trick.

To reach their adult brain size, modern human individuals begin by employing a steep rate of brain growth before birth, much like many other mammals. Unlike other mammals, humans continue this steep fetal rate of brain growth up to a year after birth. The steep juvenile rate of brain growth necessary to reach very large adult brain size is possible only if the mother nursing the infant is able to provide a dependable high-calorie source of fat, protein, and nutrients to the developing child, such as would be impossible with the lower-quality diet reconstructed for australopiths. A rich, untapped source of such nutrients was literally walking all around them: meat. The acquisition of animal tissue such as muscle, fat, and marrow is thought to have removed this dietary constraint on brain enlargement, and to have been crucial to further increases in brain size over the already-large-for-a-mammal brains of australopiths. One main obstacle was that this rich food was packaged in a tough membrane of skin. Having no sharp teeth or claws, early hominids lacked an opener.

The invention of stone tools overcame this obstacle. It may have been accompanied by the use of other tools made from perishable materials (e.g., wood) and by tool-enabled gathering. Some experts have suggested the possibility of digging sticks and skin containers. A further broadening of hominin foraging niches may have resulted from tool-enabled food processing (smashing or pulping) that transformed formerly inedible foods into a consumable form.

Current evidence suggests that the assembly of the *Homo* niche did not happen all at once, but occurred in a mosaic fashion. Stone tools and butchery sites appear in the hominin

record at about 2.6–2.5 million years ago. Skulls with larger brain cavities begin to show up at about 1.9 million years ago with early members of the genus *Homo,* although they may go back to 2.4 million years ago, the time of the oldest known *Homo* teeth and jaws. Either way, consumption of animal tissue was in place before the significant increases in brain size seen in early *Homo.*

Assembling the Niche

The niche-broadening dietary shift to include meat-eating would have imposed new demands, especially whenever it was that hunting entered the picture. As Alan Walker and Pat Shipman have pointed out in their influential article "The Costs of Becoming a Predator," the transition to a carnivorous diet involves major changes in the way an animal lives. They examined a wide range of mammals and came up with predictions about what changes in lifestyle and anatomy might be expected in a mammal making this shift. They then tested these against the hominin record. One major change seen in other mammal lineages that have made this transition is a drop in population density, because a given tract of land can support fewer carnivores than herbivores. This reduction is often accomplished by an expansion of territory or foraging range. A lifestyle that includes hunting might also be expected to include increases in running ability (speed or endurance or both), advances in social behavior, the development of sharp teeth (or, in this case, their technological equivalents) for slicing meat, and decreased gut size. Intriguingly, the fossil record for undisputed *Homo* (*Homo erectus*) contains

hints of all of these (some may have appeared earlier).

But were they hunting? We don't know what proportions of meat were obtained by scavenging and by hunting during these early times. Chimpanzees are known to hunt occasionally, sometimes with startlingly humanlike behaviors such as using a sharpened stick as a weapon. Some scholars argue that a dependable source of nutrients is necessary for a developing child to grow a brain the size of an adult *Homo erectus*'s brain. To some, this means that scavenging of carcasses is likely to have been augmented by at least a moderate amount of hunting. *Homo erectus* does seem to fit the expectations for an animal making a transition to a lifestyle that includes hunting. There are indications in the archeological record that, at least some of the time, *Homo erectus* had early access to carcasses. All of this evidence is suggestive but indirect; as of yet we have no direct evidence of hunting during these times.

Homo (*H. erectus* and, perhaps, to a lesser degree earlier *Homo*) is an animal built to cover ground. A number of anatomical features of *Homo* have been interpreted as adaptations to long-distance walking and endurance running. These include elongated legs, large hind limb joint surfaces, an enlarged heel bone, shortened toes, and features relating to counterrotation of the upper body, especially during running. These last include shortening of the forearm and a narrow (from side to side) pelvis and lower rib cage, with a tall, narrow waist between them. A decoupling of the head and shoulders, with shoulders held in a lower position and a decrease in musculature connecting them with the head,

facilitates counterrotation of the shoulders and arms while the head is held in a steady position during running.

The elongated legs of *Homo* allow an energy-efficient form of walking gait: striding, which is very useful for extended bouts of traveling. Studies of muscle activity during human striding have revealed that many of the leg muscles fire only during a portion of the gait cycle, remaining at rest much of the time. Once given an initial "kick" into action, a leg segment is carried forward by inertia in the leg's double (with each leg's upper and lower segment) pendulum.

An intriguing co-occurrence seems to support the connection between elongated legs and meat-eating. The first evidence for elongated legs and meat-eating among hominins goes back to the same time and place, before the time of *Homo erectus.* Two-and-a-half-million-year-old layers of the Bouri Formation in Ethiopia have yielded the oldest known butchery sites, as well as a skeleton with the first elongated legs in the hominin record.

Homo, the long-distance rover, is also outfitted with a moisture conservation feature: a nose that projects from the face, which has been seen as an innovation that helps free this wide-ranging hominin from the necessity of staying near bodies of water, making it capable, if necessary, of moving over large tracts of hot, dry landscape. The nostrils of an ape (and those we can reconstruct for australopiths) are basically tunneled straight into the face. The moisture in the 100 percent humidified air exhaled by the lungs is lost into the external environment. With a projecting nose, the humid air exhaled passes over mucous membranes that are slightly cooler than the body's core temperature. Some of the moisture condenses on them and is available to humidify the next incoming breath. Although loss of moisture is not critical in wetter environments, it is a problem in drier habitats. The projecting nose of *Homo* helped adapt it for travel through a variety of environments. More than with earlier forms, this is seen as a multihabitat hominin. The long-distance travel-related features of this hominin are consistent with expectations for a range-expanding carnivore. The rapid spread of the species *Homo erectus* out of Africa and across Asia probably was made possible by these characteristics.

The size of the digestive tract is smaller in carnivores than in herbivores, especially those herbivores that include in their diets significant amounts of low-quality vegetable foods (such as leaves), which must be digested in a large fermentation vat such as a gorilla's digestive tract. Leslie Aiello and Peter Wheeler's "expensive tissue hypothesis" posits that in the human lineage gut size decreased as brain size increased, in order to balance metabolic demands. The metabolic costs of growing and maintaining a large brain are very high. Tripling the size of the body's most calorically expensive organ, as occurred in human evolution, is no small feat. One would expect an increase in human basal metabolic rate over that seen in the great apes. But humans do not show such an increase, so the thought is that another system must have reduced in compensation as the brain enlarged, and comparative anatomy suggests that this was the gastrointestinal tract. This reduction may be part of what is reflected in

the relative narrowing of the pelvis and lower rib cage seen in *Homo erectus* as compared with those of australopiths.

The teeth are another portion of the digestive anatomy that might change as a mostly herbivorous animal becomes a carnivore. Teeth used in grinding vegetation may reduce. Teeth used in biting, cutting, or shearing meat may enlarge or become sharper. In *Homo erectus,* molars and premolars are reduced in size in comparison with those of *Australopithecus.* Any cutting functions of the teeth are greatly augmented by the invention of "external teeth," in the form of stone tools that are used to cut and shear meat.

Entering into a hunting/scavenging/ gathering niche would have put hominins in competition with other carnivores. Humans reduce competition and confrontation with large predators, which are mainly crepuscular (active during early morning and twilight), with heat-shedding adaptations that allow them to be active in the hottest part of the day. Such adaptations are also useful to humans in running down prey (persistence hunting), which are more likely than humans to collapse from heat exhaustion. These are the heat stress adaptations we saw in the *Outer Limits* transition, including the human enhanced sweat-gland cooling system, and body shape adaptations that maximize the amount of surface area over which a given body volume can shed heat. This latter includes long, linear builds, with relatively narrow hips and elongated distal limb segments (forearms and shins). These proportions are apparent in the *Homo erectus* skeleton known as the Nariokotome boy.

A Dizzying Acceleration

If you were an alien biologist with a long life span, and visited Earth every three million years, you would have noticed and perhaps kept track of brain evolution in some lineages of mammals. On your last visit, three million years ago, you would have seen that the brain had become quite large in some species, which also showed evidence of some cognitive and social advances. Several species of dolphins would be at the top of the list, but you would also have noticed the progress of a group of land-dwelling forms, the apes. Included in this last category would be some two-legged forms, but aside from their somewhat unusual style of locomotion, they would not have stood out from the other apes, which had similar brain sizes.[8]

Then, as the time of your next visit approaches, you are surprised to receive the first radio transmissions from earth. Before you successfully decrypt the signals, you wonder: could it be one of the dolphins? Upon translating the signals into pictures and sounds, you realize to your astonishment that it is one of the apes, from the bipedal lineage. It now seems to have tripled the size of its brain, passing the dolphins in relative brain size, and it now has a worldwide technology-based culture. It appears that other apes still have brain sizes and behaviors comparable to those you saw among the apes on your last visit. You surmise that something incredible happened to accelerate the evolution of the brain in the lineage of the bipeds.

This is something like the perspective offered by new genetic evidence regarding the evolution

of the brain. Since the split of the chimpanzee lineage from the human lineage, something has happened on the human side to greatly accelerate change in some of the genes relating to the development of the brain. Now that the complete sequencing of the human and chimpanzee genomes has made detailed genetic comparisons possible, researchers have identified stretches of DNA that have evolved much faster on the human side than on the chimpanzee side, and geneticists call these areas "human accelerated regions." In one example, scientists found eighteen human/chimp differences in a stretch of DNA related to brain development. In the same stretch, there were only two differences between chimpanzees and chickens. This means that, in the three hundred million years since the branch of reptiles that later gave rise to the mammals split from the branch that later produced birds (including chickens), only two alterations occurred in the sequence on the mammal branch before the chimpanzee/human split. After the human and chimp lineages split some seven million years ago, at least sixteen more changes in this DNA region occurred on the human side. Change in this sequence of DNA had accelerated to an evolutionary rate that is about 330 times faster than the average rate before the split of the human and chimpanzee lineages. What kind of natural selection favored such an acceleration?

Studies of living primates indicate that larger brain size is linked to increased cognitive capacities, and behavioral complexity and plasticity (this correlation is true of both absolute brain size and brain size relative to body size). Larger brains are correlated with increased folding of the cerebral cortex. They also show increased specialization of areas of the cortex and more extensive interconnectedness between regions, which may enable more complex cortical processing by sponsoring more problem-specific cognition and greater interconnection of cognitive "structures." These structural and cognitive aspects characterize great apes and especially humans in comparison with other primates. All of this may translate into capacities for a more flexible, adaptable repertoire of behavioral responses to changing or unpredictable conditions among larger-brained primates.

Increased brain size in the genus *Homo* may be partly linked to selection for increased sociality. In their research on the costs of becoming a predator, Alan and Pat found that highly successful predators living today are either very fast or very social. Early hominins were already very social before the dietary shift, and there is evidence of further increases in sociality in *Homo* (especially *Homo erectus*). These take the form of tantalizing hints more than smoking gun evidence, and some involve the care of incapacitated individuals (details of two examples are included in chapter 5).

Larger brains in living primates are associated with better abilities for complex social problem–solving. Some models of primate brain evolution predict that competition with increasingly savvy species mates can select for the enhanced cognitive abilities of ever-larger brains. The playing of "social chess" within primate groups is thought to have selected for a degree of "Machiavellian intelligence," which allows manipulation of one's fellows. This kind of

social intelligence relies on the ability to develop a "theory of mind" about the motivations and likely actions of others. It is based partly on self-awareness: the introspective ability to monitor one's own thoughts as a basis of extrapolating those of others, and may be based on foundations that are very old among primates. A group of neurons in the frontal lobes of monkeys, which are active when they grasp or manipulate an object, also fire when they see another individual perform the same actions. Some of these "mirror neurons" are thought to have been co-opted for higher cognitive functions in apes and humans, including imitative social learning, the development of "theory of mind," and even aspects of language production. Capacities for social cognition in primates are taken to extremes in the human lineage.

Not all aspects of social intelligence are so starkly self-oriented, at least not as overtly so. Quite a bit of human social intelligence relates to cooperation, reciprocal sharing, peacemaking, and the forming of friendships and alliances. Reduced sexual dimorphism in *H. erectus* in comparison to that of australopiths might signal competition-reducing social changes such as the origination of monogamous pair-bonding, if it was not already in place. A reduction in competition for access to females might facilitate greater cooperation among males.

The demands of maintaining group cohesion over larger territories might also select for advances in social intelligence. The early development of communication systems that were the precursors of language may have been among the enhancements of social behaviors in early *Homo*.

Additional selective pressures for advanced cognition in the *Homo* niche may relate to the unpredictability of resources. Seasonality and the lessened predictability of resources that comes with greater climatic variation may have provided challenges that selected for increased cognitive capacities. Among primates, fruit eaters are known to have larger brains than leaf eaters. This is thought to be related to demands associated with dependence on more unpredictable food sources with patchier distributions in space and time. Reliance on animal resources further raises levels of unpredictability. Another aspect of the dietary shift that might have selected for greater intelligence would be the addition of hunting or confrontational scavenging to foraging behaviors.

Homo erectus appears to have been excellent at colonizing new areas, this ability to do so enhanced by adaptations to varied environments. New areas offer the challenge of new resources to learn about, and new problems to solve. Larger territories also require greater spatial mapping skills.

So we can identify a number of factors that theoretically would be expected to select for advances in cognition and larger brain size in hominins that have entered a hunting/scavenging/gathering niche. How do these expectations stack up against the fossil and archeological records?

Studies have shown that great apes cannot learn to make stone tools as sophisticated as the earliest stone tools made by hominins, even with training. Unless the chimpanzee lineage has *lost* cognitive ground, it would follow that this inability would also apply to the last common ancestor

of chimps and humans, and to the first hominins that immediately followed them. Changes in the brain must have occurred between the first hominins and the first makers of stone tools. It is interesting that increases in brain size were minimal during this period, so any changes were likely to have been organizational. Larger brain volumes appear later (about 1.9 million years ago) in skulls attributed to *Homo habilis* and *Homo rudolfensis.*[9]

Enlargements of the brain in the human lineage may have involved runaway positive feedback loops that drove increases in cognitive capacities, with increasingly demanding foraging strategies both necessitating and enabling increases in brain size in a sort of dietary/cognitive arms race: a dietary shift to high-quality foods requires higher-cognition foraging that selects for brain enlargement, which requires a still-higher-quality diet . . . The dietary shift seems to have both removed a constraint on large brain size and, later, selected for the higher cognitive functioning it confers.

Is there evidence for cognitive advances in the archeological record? The first well-documented use of fire occurred during the time of *Homo erectus.* At first this development may not have included the actual making of fire, but this resource may have been "gathered" from grass fires started by lightning strikes or volcanic events, and controlled. Hand axes and cleavers (collectively referred to as the Acheulean tradition) also appear in the archeological record during *H. erectus*'s time. The manufacture of hand axes requires more complex techniques than those of earlier tools, and they have been called the first

objects upon which a specific shape was imposed. Psychologist Frederick L. Coolidge and archeologist Thomas Wynn of the University of Colorado, Colorado Springs, see the Acheulean archeological evidence as supporting advances that include developments in spatial and, perhaps, social cognition. They have argued that these are the first tools to be consistently curated (as opposed to being left on the landscape after use), and could thus serve as a symbol of potential future use between times of their employment. They suggest that gesturing with tools may have been among the communicative signals of this time. Coolidge and Wynn hypothesize that these cognitive advances may have been facilitated by physiological changes in sleep patterns tied to the transition to sleeping on the ground.

Wood residues found on some Acheulean tools suggest the possibility of an invisible arm of Acheulean technology: woodworking. This may be an example of a very human behavior—that of using tools to make tools. Or it may just mean they were chopping firewood.

Why did such dramatic accelerations in brain evolution and cultural development occur in the human lineage and not in others? This question has not been satisfactorily answered, although there are a number of theories. Some of them have to do with the unprecedented freeing of the hands from locomotor duties that occurred in our lineage, and its effect on the evolution of culture and the brain. Our hands are the interface between our wills and our world. Liberated from compromises having to do with locomotion, the hands were free to go much further in their development as dextrous organs of manipulation,

and there may have been feedback loops between this process, brain evolution, and the development of culture.

More intelligent, highly social, technology-bearing hominin groups may have been better able to cope with environmental variability than earlier groups. This prefigures a later descendant species which takes these abilities to extremes.

Cast of Characters

What species were involved in the steps of this transition? There are a number of candidate human ancestors between the time ranges of *Australopithecus afarensis* and *africanus* and that of *Homo erectus*. These fossils have been grouped differently by different scholars, and in many cases their claims to *Homo*-like features are the subject of debate. Most of these fossils have been kicked back and forth between *Australopithecus* and *Homo,* perhaps underscoring their transitional status. All of them have been claimed to share at least some features with undisputed *Homo* (*H. erectus* and later forms).

The following is not meant to be a comprehensive review, but rather an introduction to the cast of characters that may fit into this gap, with a brief mention of their claims to humanity. Since the grouping of fossils into species varies with each researcher and I don't want to mire the reader in the treacherous swamp of nomenclature, I'll tread lightly regarding names. I will follow the classification scheme of those who favor dividing the early *Homo* fossils into two species. The convention I will use here is to refer to a cranium known as KNM-ER 1813 and all of the skulls that are similar to it as one species. This

includes the Olduvai Gorge specimens, one of which is the type specimen of *Homo habilis* (each fossil species has a type specimen for others to be compared with in assessing whether they belong to the species; the species name is firmly attached to the type specimen), so I will use that name for this group. This is *Homo habilis* in the strict sense as it includes a more restricted group of fossils than in classification schemes that lump all of the early *Homo* fossils under this name.

The second group of early *Homo* fossils we'll examine includes a skull known as KNM-ER 1470 and a few other specimens that resemble it. This group is often referred to as *Homo rudolfensis,* and I will use that name.[10] The third group of fossils we'll examine represents a newcomer, the recently discovered *Australopithecus sediba,* an australopith which shares intriguing features with members of the genus *Homo.*

Homo habilis (in the Strict Sense)

This group includes several skulls found by the Leakeys' team at Olduvai Gorge in Tanzania and at the site of Koobi Fora in Kenya. Most of these are small skulls, more delicately built than those of australopiths, with much smaller jaws and muscle markings that indicate smaller chewing muscles. Their brains are significantly larger and their cheek teeth are reduced in comparison to those of australopiths.

The first find, a juvenile partial cranium, mandible, and hand remains that became collectively known as OH 7, was discovered at Olduvai Gorge in 1960 by Jonathan Leakey only months after *Paranthropus* (then *Zinjanthropus*) *boisei* was announced by his father, Louis, as the ancient

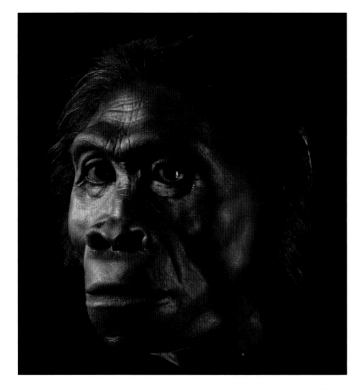

A reconstruction of *Homo habilis*, based on the KNM-ER 1813 skull and the OH 13 mandible.

maker of the stone tools at Olduvai. OH 7's larger brain, smaller teeth and jaws, and thin skull fit much better with Louis Leakey's idea of a human ancestor than did *Paranthropus boisei,* which was relieved of its status as a toolmaker and relegated to a side branch of the human tree.

More remains were found at Olduvai by the Leakey team, and *Homo habilis* was introduced to the world in 1964 as a sort of superancestor by Louis Leakey, along with University of London's John Napier and University of the Witwatersrand's Philip Tobias (Raymond Dart's student and successor as head of the Department of Anatomy). It initially was based on four fragmentary skulls, the type specimen's set of hand bones, a set of foot bones, and a few other fragments. It

seemed to have everything: an enlarged brain, a dexterous hand with toolmaking capabilities, and a foot capable of humanlike bipedal striding.

Some of the remains were found in association with stone tools. The authors added toolmaking behaviors to the morphological features used to diagnose the species and revised the definition of *Homo* so that the fossils could be included. Previous definitions had suggested seven hundred to eight hundred cubic centimeters as a lower limit for brain size in the genus *Homo.* Leakey's team revised this to six hundred cubic centimeters (about the volume of a grapefruit with a diameter of just over four inches), which accommodated the new fossils. Raymond Dart suggested the name, which means "able or handy man."

The announcement met with a raft of criticism from colleagues. Some claimed that insufficient "morphological space" existed between *Australopithecus africanus* and *Homo erectus* to insert another ancestor into the lineup, an idea that seems almost laughable now that these species are better known. The discoverers had flouted naming conventions, especially by including behavioral inferences (toolmaking ability) in their diagnosis. Some researchers accepted the species *habilis* but wondered if it should be included in *Australopithecus* instead of *Homo.*

The Leakeys found more material, and gradually *Homo habilis* gained acceptance as a valid species. A beautifully preserved cranium, KNM-ER 1813, was found at the Kenyan site of Koobi Fora in 1973 by star fossil-finder Kamoya Kimeu. Many eventually accepted *Homo habilis* as a direct human ancestor, sitting in our lineage between

Australopithecus and *Homo erectus,* based mostly on features of the skull, jaws, and teeth. In 1986, those scientists who had become comfortable with this idea got a rude shock with the discovery of a small partial skeleton that came to be known as OH 62. Don Johanson and Tim White had returned with a team to Olduvai Gorge, the Leakeys' former stomping ground and home for many years. Within a few days, they discovered a partial hominin skeleton not far from a dirt road that had taken hundreds of tourists and excavators into the site. The palate and teeth associated with the skeleton made it clear that it was not a robust australopithecine, and the limb bones were too small to belong to *Homo erectus.* Unless it was something new, the only other reasonable candidate was *Homo habilis,* and the palate's resemblance to a *Homo habilis* palate from Olduvai and one from South Africa that some attributed to this species made this seem likely.

The KNM-ER 1813 skull (cast).

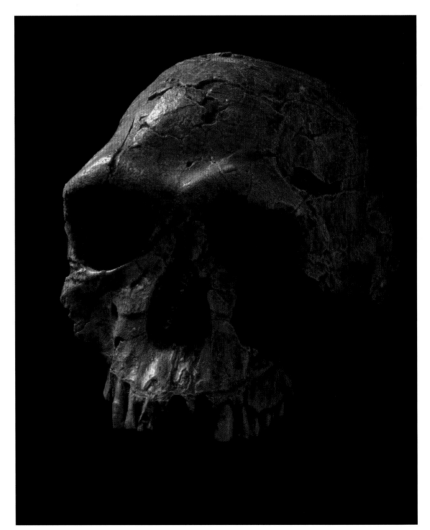

The shock was that, as the scraps of this tiny individual were slowly found and assembled, the body that began to take shape had startlingly primitive proportions. The morphology of the skulls and teeth previously known for the species had seemed intermediate between that of *Australopithecus* and that of *Homo erectus,* and this led to the expectation that its postcranial skeleton would be intermediate as well. But OH 62's humerus (which is longer than Lucy's) and its tiny upper half of a femur suggested body proportions at least as apelike as Lucy's and maybe more so, according to her discoverers. The publication of this find upset a number of applecarts. If the fossil represents a descendant of *A. afarensis,* it suggested the possibility of an evolutionary reversal in body proportions. If it gave rise to *Homo erectus,* the body size and shape implied for *Homo habilis* by the 1.8-million-year-old OH 62 had to change rapidly, in perhaps as little as 200,000 years. This seemed to some a very brief period for such marked change: from a Lucy-sized hominin with primitive body proportions to a tall female *Homo erectus* with modern proportions.[11] The article announcing OH 62 suggested that "views of human evolution positing incremental body size increase through time may be rooted in gradualistic preconceptions rather than fact."

When OH 62 was discovered, it reexhumed the troublesome question of whether *Homo habilis* may have been placed on the wrong side of the divide between *Australopithecus* and *Homo* adaptive plans (a question which in truth had never really gone away). But *Homo habilis* was a shape-shifter still in motion. Years later I sat in a crowded room at an annual anthropologists'

meeting, listening to a talk by Henry McHenry of the University of California–Davis in which he compared the OH 62 femur with a long, very thin femur from Olduvai (OH 34), concluding that the tiny shaft diameters of the OH 62 femur did not necessarily mean that the bone was short. He and his colleague Martin Haeusler had done a study which found the evidence for primitive proportions (a large humerus-to-femur ratio) in OH 62 lacking, and suggested that it was more likely that *Homo habilis* had elongated legs, which would push the arm length/leg length ratio in a human direction.

Alan Walker, a paleoanthropologist then at Johns Hopkins University and a former student of John Napier's who had witnessed the birth of *Homo habilis* at close range, was sitting next to me during the presentation, and he did not agree. "That Olduvai femur is very abraded," he whispered. "You can't get much information from it." He and Richard Leakey had reexamined a partial *H. habilis* skeleton from Koobi Fora after the OH 62 skeleton was discovered, and they found that the fragmentary bones and muscle attachments of the upper limb and shoulder were large and robust in comparison to those of the lower limb. The Koobi Fora skeleton preserves two finger bones, and these are curved and marked by strong flexor muscle attachments. This combination suggested considerable climbing ability to Alan and Richard.

We may have to settle for a stalemate on the issues of arm/leg proportions and arboreality in *H. habilis* until more complete fossils are found. The legs of OH 62, and consequently of *habilis,* have accordioned up and down, from short to

long to indeterminate. This is a frustrating situation, not only for those of us who might wish to reconstruct a body blueprint for *habilis,* but also for those who would understand its adaptations and relationship to other hominins. It is clear to most that we must await further material before we can accurately gauge whether arm-to-leg proportions were more humanlike or apelike in *Homo habilis,* but support for a relatively longer-than-human forearm in OH 62 has appeared in several studies, based on the fairly complete humerus and ulna.

The reduction of the jaws, cheek teeth, and chewing muscles in *H. habilis* may relate to improvements in technology-based food processing, and/or to a dietary shift to softer or less-abrasive foods as a fallback resource. Evidence from tooth wear studies suggests a varied diet, and association with butchery sites indicates that meat was an important component. The nasal bones of some specimens indicate slightly projecting noses in comparison to those of australopiths. Hand remains indicate widened finger and thumb pads in comparison to early *Australopithecus,* and a broad basal thumb joint that would convey improved precision grip ability in this stone-tool-associated hominin. However, the bones of the wrist in *H. habilis* closely resemble those of australopiths in many ways.

Where does *Homo habilis* fall in terms of the *Australopithecus/Homo* adaptive transition? *H. habilis* seems to fit the *Homo* adaptive grade in some ways, but not in others. Although humerus/femur length proportions are indeterminate for *H. habilis,* the retention of primitive conditions

such as large, powerfully muscled upper limbs, relatively long forearms, and curved finger bones with powerful flexor sheath attachments suggests arboreal ability to some researchers. Female body size is small, similar to Lucy's. A newly discovered small partial pelvis, with an associated upper femur that has a shaft like that of OH 62, displays a hip joint that is larger than Lucy's, as in undisputed *Homo,* but the pelvis lacks the heavy buttressing we see in *Homo erectus* and later *Homo.* *H. habilis* may lack many of the endurance walking and running features seen in later *Homo.*

On average, brain size has increased (both absolutely and relative to body size) in *H. habilis* over that recorded for *Australopithecus.* Evidence of humanlike reorganization includes asymmetries in areas related to motor control of speech and/or motor sequencing in general.

New discoveries at the Georgian site of Dmanisi appear to provide a snapshot of the *H. habilis/H. erectus* transition in progress. Several partial skeletons are now known from the site, and they seem to sample a population that combines primitive characteristics, such as *H. habilis*–like aspects of the cranium, an upward tilt to the shoulder joint, primitive proportions within the foot, and an average cranial capacity between the means for *Homo habilis* and *Homo erectus,* with characteristics of later *Homo erectus.* These smallish skeletons exhibit a humanlike ankle and a degree of leg elongation. In the absence of the larger body size estimated for later *H. erectus,* and in a nontropical setting, this evidence makes it unlikely that leg elongation

was primarily the result of selection related to increases in body size or adaptation to heat stress. There is strong evidence for carnivory among these hominins; they lived in a climate where cold winters would have made many plant foods seasonally unavailable, and stone tools associated with cut-marked bones have been recovered from the site. Taken together, the Dmanisi data suggests that leg elongation and a humanlike ankle joint are related to the increased locomotor demands of a wider ranging, carnivorous lifestyle.

Homo rudolfensis

In June of 1973, a large domed skull peered from the pages of *National Geographic,* accompanied by the headline "Discovery in Kenya of the Earliest Suggestion of the Genus *Homo*—Nearly Three Million Years Old—Compels a Rethinking of Mankind's Pedigree." The major significance of this fossil was instantly recognizable: the brain appeared jaw-droppingly large for a skull of this antiquity.

This adventure began the previous August when Bernard Ngeneo, cook's assistant and aspiring fossil hunter at Richard Leakey's camp at the site of Koobi Fora in northwestern Kenya, squatted over some bone fragments that had already been passed over twice by a team of crack fossil finders known as "The Hominid Gang," which thought it was a shattered antelope skull. With less experience, Ngeneo missed whatever it was that made the group consider the skull to be that of an antelope and instead dreamed that it might be a hominin. He turned out to be right. That was his last day in the kitchen.

It was an exciting find, but it proved challenging in a number of ways. The skull, which was given the name KNM-ER 1470, was found in about 150 pieces, and fitting it all back together was a monumental task. Meave Leakey did much of the reconstruction, with the help of her mother-in-law Mary Leakey and anatomists Bernard Wood and Alan Walker. When she was a child, Meave had engaged in a rainy-day activity of assembling jigsaw puzzles that had been dumped on a table face down (hiding the image), a pastime that preadapted her for the difficult task of assembling a shattered skull like that of KNM-ER 1470. When the assembly was nearly complete, it was obvious that the brain was large—too large for an australopith and similar to the lower end of the range then known for *Homo erectus.* The fit of the facial assembly to that of the braincase was uncertain. For the *National Geographic* photograph, the face and

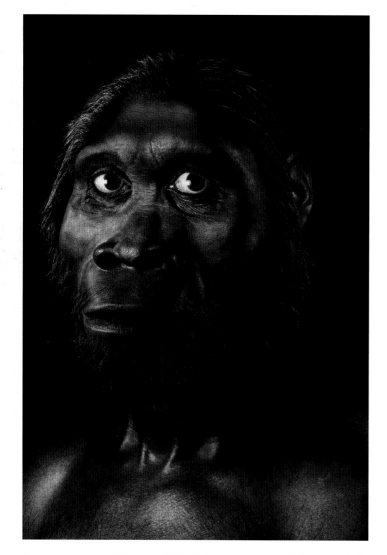

A reconstruction of *Homo rudolfensis*, based on the KNM-ER 1470 skull.

cranial vault were fit together in a way that made the forehead seem high, which emphasized its large brain. The deposits that yielded the skull were initially reported to be 2.9 million years old.

Richard Leakey did not call the new skull *Homo habilis,* preferring to leave it an unnamed species of *Homo.* In a single stroke, however, this fossil confirmed the existence of an ancient pre-erectus form of *Homo,* as proposed by his father, Louis, and the namers of *Homo habilis.* In fact, the skull was thought to be so old that it fit well with another of Louis's ideas, inherited from his mentor, Sir Arthur Keith, one of the original doubters of Dart's proposed genus *Australopithecus* as a human ancestor. According to this idea, large-brained *Homo* extended far back into time, and *Australopithecus* (not then known to be from deposits this old) was not ancestral to later humans and should be considered a side branch in the human tree. The find had the effect of reconciling the somewhat estranged father and son.[12] Louis saw the specimen five days before his death in October 1972.

The article announcing the discovery of the skull also reported the finding of several leg bones, two of them complete thighbones. All of the specimens were found within an area of about two or three square kilometers, in strata below a volcanic tuff named the KBS Tuff, after a site discovered by geologist and paleontologist Kay Behrensmeyer. Volcanic tuffs contain radioactive isotopes that decay at a known rate, and the ratio of original material to the resulting product allows them to be dated. Many of the fossil beds in east Africa feature widespread volcanic

tuffs, from ashfalls which erupted from nearby volcanoes intermittently so that they conveniently bracket fossiliferous layers and can yield minimum and maximum ages for a fossil found between them. The KBS Tuff was dated from outcrops in nearby areas (its outcrop at the discovery site was considered to have been chemically altered) to 2.6 million years ago. The KNM-ER

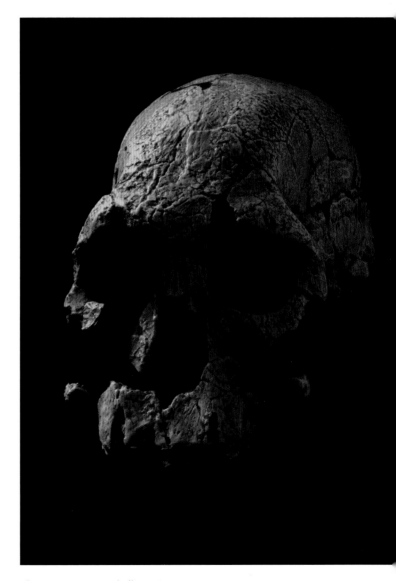

The KNM-ER 1470 skull (cast).

1470 skull was judged to have been situated a good bit below this, and another 300,000 years was added to this figure.

The discovery of such a large-brained fossil at such a great age was a stunning development. But it wasn't long before trouble began. Animal fossils were also recovered from layers near the KBS Tuff, and it soon became evident to paleontologists that there was a problem: something was wrong with the pigs.

The fossil pigs found in sedimentary horizons near the KBS Tuff did not match 2.6-million-year-old pigs from other sites, but instead belonged to species known from more recent horizons. This discrepancy was debated for a time, as scientists tried to make sense of it. One proposal suggested that perhaps evolution had occurred at different rates in different places; if accepted, this proposition would invalidate the very foundations of the field of biostratigraphy, which proposes that species found at two different sites can be assumed to be about the same age and can be used to date the strata in which they occur relative to other layers. The dating team of Fitch and Miller assured Richard Leakey and his colleagues that the 2.6-million-year-old date for the KBS Tuff was solid. But as time passed, it became obvious that the troublesome pigs would not go away. At one point, pig-proof helmets were suggested.

Ultimately, the 2.9-million-year-old dating did not stand. It became clear that the dated samples had been contaminated by older volcanic rocks. Further work established a date of 1.8 to 1.9 million years ago, similar in age to *Homo habilis*.

What was KNM-ER 1470? Even the principal scientists working on the skull had trouble agreeing on this question while they wrote their initial anatomical description of it. Features of the braincase, especially its large cranial capacity (775 cubic centimeters), suggested alignment with the genus *Homo*. The facial skeleton, with its wide, flat-fronted upper jaw and its forward-placed cheekbones, was unlike that of any other hominin, but it seemed closer to known *Australopithecus* than to *Homo*. Richard Leakey, Michael Day of St. Thomas's Medical School, and Bernard Wood of Middlesex Hospital Medical School favored inclusion in the genus *Homo,* but to Alan Walker it looked like a large-brained *Australopithecus.* During one particularly heated discussion Alan came close to walking away from the project, but eventually the coauthors decided that they need not be in complete agreement about the issue for the project to move forward. The team's publication on KNM-ER 1470 sticks to descriptions of its anatomy, with little comment on phylogenetic or taxonomic interpretations.

The leg bones found nearby are long, and were reported in the announcement as being very humanlike. A partial pelvis found later in a similar time horizon nearby is a heavily buttressed bone with a large hip socket, matching the morphology of *Homo,* especially *H. erectus.* The physical association of these postcranial bones with KNM-ER 1470 is not close enough to establish certainty that they represent the same species. But their discovery in the same area and time horizons, and their humanlike attributes, tempt some to assign them provisionally to the same group as KNM-1470.

Those who see the human family tree as a simple one (the lumpers) tend to include these finds with KNM-ER 1813 and the Olduvai skulls under the name *Homo habilis,* which then becomes a physically variable species, with KNM-ER 1813 and most of the Olduvai skulls as females, and the larger skull KNM-ER 1470 as a male. Some suggest that shape differences between skulls representing the two groups may be related to difference in size. It has even been proposed that the long thigh bones found near the KNM-ER 1470 skull make reasonable male counterparts to those of OH 62 as a female, with size differences on the order of male/female differences in *A. afarensis* femurs.

A number of experts have trouble with this scheme. The differences in the facial architecture of ER 1470 and ER 1813 are extreme, and do not compare well to male/female differences seen in living primates. Some are the reverse of what would be expected. The jaws of male apes, for example, tend to be more forward-jutting than in females, the reverse of the situation if KNM-ER 1470 is a male to KNM-ER 1813's female. Adding to this, the morphologies of the brow and forehead don't match. In August of 2012, a team led by Meave Leakey announced the discovery of a maxilla and a nearly complete mandible that match the morphology of KNM-ER 1470. The maxilla is small but shares features with that of KNM-ER 1470, making it less likely that shape differences between skulls of the KNM-ER 1470 group and the KNM-ER 1813 group are due to size variation within a single species. Based on this and other KNM-ER 1470–like features of the new specimens, the team argued that the new evidence supports the hypothesis that the KNM-ER 1470 group and the KNM-ER 1813 group represent two different species.

In the wake of a 1999 discovery by the team working with Meave Leakey and her daughter Louise, the possibility of yet a third genus has been proposed for the KNM-1470 skull. In 1999, J. Erus discovered a fossil skull in 3.5-million-year-old sediments at a site at Lomekwi, Kenya, west of Lake Turkana. Although the fossil was distorted by sedimentary matrix that had expanded between its many fragments, its morphology obviously indicates a very flat face and forwardly placed cheekbones. Some of its features are like those of KNM-ER 1470 but it lacks that skull's large brain. It displays a combination of features which do not fit easily into *Australopithecus, Paranthropus,* or *Homo,* according to the Leakey team, which included Fred Spoor of University College, London. This suggested a radical possibility to the team. Most family trees championed at the time featured a single stem (Lucy's species: *Australopithecus afarensis*) at three million years ago and earlier, with two or more branches after three million. The new find suggested the possibility of a second hominin lineage in existence at 3.5 million years ago, and cranial similarities suggested that it might be ancestral to KNM-ER 1470. The team proposed a new genus and species for the find; *Kenyanthropus platyops* (flat-faced man of Kenya), and suggested that KNM-ER 1470 might also belong to the new genus. This proposal added a new branch to the human tree, extending back at least 3.5 million years. Together with proposed lineages that had sprouted to accommodate other

new finds, this made the human tree look very bushy, with up to four lineages coexisting at some points, according to some of the splitters. To some of the lumpers, the situation had gotten out of hand.

In 2003 paleoanthropologist Tim White gave a talk at the annual meeting of the Paleoanthropology Society, criticizing the establishing of the new genus and species *Kenyanthropus platyops* on the basis of such a distorted skull. He flashed slides of quotes by other paleoanthropologists, many of whom were in attendance, about the bushiness of the human tree due to recent finds, and offered his rebuttal. He argued in particular that the new skull was so distorted that it was impossible to classify confidently, and that erection of a new genus and species was unwarranted. The alternative to having two lineages at 3.5 million years ago is that the *Kenyanthropus* skull represents *Australopithecus afarensis,* the only other hominin species known from that time. Some researchers consider this a stretch, but new fossils are needed to decide the issue.

KNM-ER 1470 may or may not have descended from something that looked like *Kenyanthropus.* Many workers provisionally accept KNM-ER 1470's attribution to *Homo rudolfensis,* but if more evidence is found supporting *Kenyanthropus* and KNM-ER 1470's descent from it, it may become *Kenyanthropus rudolfensis.* Such a scheme would require large brain size to evolve independently in at least two lineages, as the ancestors of both lineages at a point 3.5 million years ago would have had small brains.

Where do KNM-ER 1470 and similar fossils fall in regard to our adaptive grade divide between *Australopithecus* and *Homo?* It is certainly large-brained in comparison with *Australopithecus.* If the limb bones and pelvis from the same area and time horizon represent the same species, it is a capable biped with a degree of leg elongation and a very *Homo erectus*–like pelvis, implying that some of the features suggested to be related to endurance walking and running are in place in this species.

Australopithecus sediba

The story of *Australopithecus sediba* begins in South Africa in August of 2008 with the words "Dad, I found a fossil." They were spoken by then nine-year-old Mathew Berger as he handed a large chunk of rock to his father, paleoanthropologist Lee Berger of the University of the Witwatersrand's Institute for Human Evolution. The two were prospecting for new fossil hominin sites, not far from Johannesburg. Lee, who had written his Ph.D. dissertation (under Philip Tobias) on the evolution of the shoulder girdle, immediately recognized a hominin clavicle embedded in the rock. Turning the rock over, he was stunned to see that it contained a hominin mandible. Mathew Berger had just discovered the first pieces of a skeleton at what would turn out to be one of the world's best early hominin sites, known as Malapa.

I heard nothing about the find until I attended the annual meeting of the American Association of Physical Anthropologists the following spring. There were rumors flying that

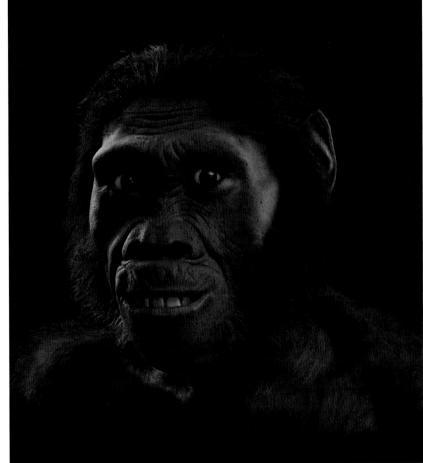

A reconstruction of *Australopithecus sediba*, based on the MH 1 skull. (Courtesy of National Geographic Television; reconstruction and photograph by John Gurche)

The MH 1 (right) and MH 2 (left) skeletons of *Australopithecus sediba* from Malapa. (Courtesy of Lee Berger)

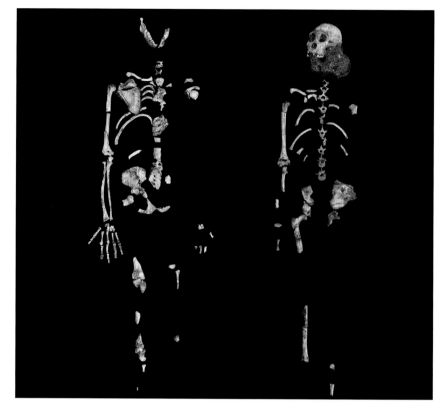

Lee Berger had found fossils that might represent early *Homo,* and his colleague Darryl de Ruiter of Texas A & M University had brought a few photos of the finds. These featured a few postcranial bones and a surprisingly human looking mandible (the second to be discovered, that of an adult female).

One year later, the find was announced in *Science.* The usual fare for the best South African sites is a collection of isolated bones and teeth, and a great once in a great while something more, such as a set of associated remains representing a single individual. Malapa produced two partial skeletons, one with a beautifully preserved skull, right off the bat. These were identified as a juvenile male and an adult female. Bones of other individuals were found, promising more to come. They were all found in blocks from an earlier dynamiting operation by lime miners before the site was abandoned in favor of more promising sources. At the time of the published announcement Lee and his team had not yet begun to excavate.

The article in *Science,* which appeared less than a month after the opening of the Smithsonian hall, described the two partial skeletons, dated to 1.98 million years old. In many ways they resemble the anatomy of *A. africanus.* But they also share features with members of the genus *Homo* that are not found in any australopith. This mix can be seen in the cranium, mandibles, teeth, hand, foot, and pelvis. The team debated

whether to put the new finds in the genus *Australopithecus* or into *Homo* before ultimately deciding that the overall body plan of the fossils supported placement in *Australopithecus*. They proposed the species name *Australopithecus sediba* (sediba means fountain or wellspring in the Sesotho language) and argued that it makes a good candidate for the ancestor of *Homo*.

Reaction to the announcement has been interesting. Many scholars have accepted the finds as a new species, but there has been debate about whether the species should be put in *Australopithecus* or *Homo*. Some have considered them to be late representatives of *A. africanus*, without denying that they uniquely share some features with *Homo*.

Shortly after the announcement, Lee and his team members flew to St. Louis to lecture on the finds at the annual meeting of the Paleoanthropology Society, and then they went to Albuquerque, New Mexico, to the annual meeting of the American Association of Physical Anthropologists for an informal presentation of casts of the finds to colleagues. Chris Sloan and Jamie Shreeve, the two most paleo-savvy individuals then at *National Geographic,* traveled to Albuquerque to discuss plans for a story. Lee wanted me to create the first reconstructions of the finds, and encouraged me to attend both meetings. Over dinner in a southwestern style restaurant in Albuquerque, we hammered out a plan for a *National Geographic* article on the finds. I was excited and honored to be given the job of figuring out what *sediba* looked like.

The skull of MH 1, *Australopithecus sediba.*

That August *National Geographic* sent me to Johannesburg to study the fossils. The team had found quite a few more bones from the two individuals since their debut. The adult female now had a manubrium (the uppermost segment of the breastbone, which had never been found for an adult *Australopithecus*), a complete clavicle, a scapula, all three complete bones of the arm, and most of the hand skeleton, all from the right side of the body. The pelvis was now complete enough to allow its reconstruction, and this had been done by the University of Zurich's Peter Schmid. Lee, who has been determined to set a new precedent of openness by sharing the fossils under his care, threw the doors to the fossil vault wide open, and I spent two weeks measuring, photographing, and taking notes on the fossils, sometimes until late into the evening, long after everyone else had gone home. In my notebooks, the outline of a body began to take shape.

When I began the reconstructions of the head (in sculpted form) and body (in painted form) of the juvenile male (known as MH 1), I wondered what kind of being would emerge. I was aware of the adaptive divide between *Australopithecus* and undisputed *Homo*. These finds seemed to offer an unprecedented opportunity to see the details of how this transition occurred by capturing a species that appeared to be in the middle of the change, represented by two relatively complete skeletons.

The results of the team's study offer the following picture: at first glance *A. sediba* looks much like *Australopithecus africanus*. It retains an *A. africanus*–like head, with a small brain and tall face with jutting jaws. The body is small, with a primitive funnel-shaped upper rib cage like an ape's. The shoulders are held in a high, apelike position. A closer look at the head reveals that the nose projects slightly from the face, unlike that of any other australopith. In this feature *A. sediba* resembles early *Homo*.

What about other *Homo*-like adaptations? Although retaining some typical *Australopithecus* features, the pelvis differs from those of other members of this genus in a number of ways, in which it more closely resembles *Homo*. It lacks the lateral flare (of the pelvic blades) typical of other *Australopithecus* pelves. Its lateral portion, instead of jutting out to the side, curves around to face more anteriorly, providing more of a "cup" for the viscera.[13]

The cheek teeth are at the small end of the known range for *A. africanus* or, for the adult female, just below it. Their form retains primitive elements that resemble those of *A. africanus*. Mandible shape varies, with the adult female's being more *Homo*-like in shape.

The hand of *A. sediba* features a thumb that is longer in relation to the fingers than that known in any other australopith; wide thumb tip and fingertips; an *erectus*-like beak on the head of the thumb's basal bone; and other changes likely to enhance precision grip capabilities useful in tool-making. Some other features would act to resist forces such as those generated by the making of stone tools. These characteristics are combined with more primitive features of the hand bones, and some of these relate to a still-powerful flexor apparatus in the forelimb (although reduced in comparison to those of *A. afarensis* and the *H. habilis* OH 7 hand). The team suggests that

A. sediba's powerful flexor muscles were used in climbing. The foot skeleton is not yet fully known, but remains recovered so far indicate that it combines a humanlike ankle with a very primitive heel bone, which perhaps is indicative of a way of walking bipedally that is different from those of other hominins. Even the earlier *A. afarensis* has a more modern-looking heel bone than *A. sediba's.*

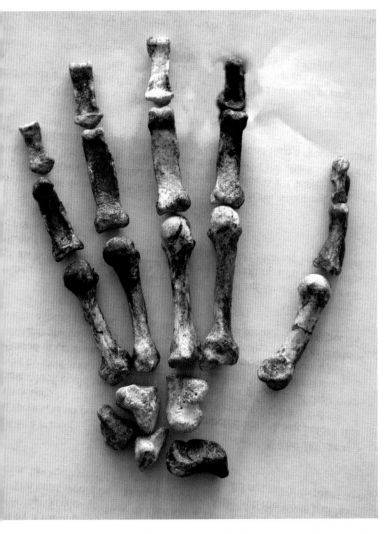

The right hand skeleton of MH 2, *Australopithecus sediba.*

The interior of the MH 1 cranium shows that the brain is small, similar in size to that of *A. africanus.* Convolutional details are especially clear on the virtual endocranial cast produced from scans of the skull. These show apelike patterns like those of *A. africanus,* but the team has identified some humanlike asymmetries, and reports some details of the frontal lobes that suggest a humanlike reorganization.

None of the leg bones are complete enough at present to allow accurate assessment of their length, so we can't be certain about the humerus/femur length ratio. The femoral head and neck size and various angles can, however, be measured on preserved fragments of the femurs. Four years before Lucy was found, Owen Lovejoy and Kingsbury G. Heiple of Kent State University used such measurements and the geometric constraints of bipedalism to estimate a femur length for a Lucy-sized *A. africanus* partial skeleton. The length of Lucy's femur turned out to be very close to their prediction.

The results from using their method on the adult female (known as MH 2) femur fragments, with a neck and upper shaft borrowed from MH 1, produce a range of estimates, depending on different assumptions about how the MH 1 fragment should be scaled to fit with the MH 2 fragments. The entire range of predicted femur lengths results in longer legs relative to the humerus for MH 2 than in Lucy. We'll know for sure only when more complete leg bones are found, but this preliminary estimation predicts somewhat elongated legs for *A. sediba,* which is most interesting in combination with its slightly projecting nose, as both are seen in more extreme

form in *Homo erectus,* presumably adaptations to extended ranging over varied (including dry) habitats.

Other proportions appear more primitive. A long forearm is retained, but not as long as the relative size (compared to the humerus) estimated for Lucy's kind, other australopiths, or *Ardipithecus ramidus.* Based on the mix of *Australopithecus*-like traits and *Homo*-like traits found in many areas of the body, the team makes a case for *A. sediba* being ancestral to *Homo.*

But MH 1 and MH 2 were born too late. At 1.98 million years old, they cannot have been ancestral to all of the fossils that are widely considered to belong to *Homo.* Kicking *habilis* and *rudolfensis* out of the genus *Homo* does not help. Whatever names we give these two groups, there remain fossils among them that appear to predate known specimens of *A. sediba.* Both groups share features of undisputed *Homo* (*erectus*) that *A. sediba* lacks.

Yet *A. sediba* does share features with undisputed *Homo* (*erectus*) that are not seen in any other species of *Australopithecus.* This could be explained in one of two ways. Either the *Homo*-like features of *A. sediba,* which include characteristics of the cranium, mandible, teeth, pelvis, foot, and hand, evolved independently in *Homo* and *A. sediba,* or these features were inherited from a common ancestor which had them. Given the number of features and their distribution throughout different areas of the body, the latter possibility seems more likely.

The team proposing that *A. sediba* is a likely candidate for the *Australopithecus* ancestor of *Homo* has dealt with the time problem partly by suggesting a critical reexamination of the dating

of the few specimens of early *Homo* with dates older than two million years old; perhaps they may be dated incorrectly, or they may not actually represent *Homo* or are too fragmentary to tell. This hasn't been received well in the scientific community, especially by those who discovered and published the specimens in question. A solution that is perhaps more tenable is the team's suggestion that the Malapa individuals are not likely to represent the first or last of their species. The team has suggested that perhaps earlier populations of the species gave rise to *Homo.*[14] In this scenario, the common ancestor of *Homo* and the Malapa hominins would be similar enough to the Malapa hominins to be attributed to the same species, and *A. sediba* could still be ancestral to *Homo.*

We don't know whether this scenario reflects what occurred. An alternative scenario, that this common ancestor of *Homo* and the Malapa hominins was not *A. sediba,* must be considered a possibility. It would be expected, however, to be much like *A. sediba*—certainly in its *Homo*-like features, and probably in much of the rest of its anatomy, which in *A. sediba* resembles closely its probable ancestor *A. africanus.* Earlier fossils are needed to resolve the issue.

Putting It All Together

Although there is some overlap, the three figures of *Homo habilis, Homo rudolfensis,* and *Australopithecus sediba* appear roughly in the temporal gap between *Australopithecus* (*afarensis* and *africanus*) and *Homo erectus.* We see them at various degrees of clarity, from shadowy to more clear. Our views of them are in a state of flux; with new finds and interpretations they

shift shape and emerge in a different form. Such is the current state of our knowledge, with its unknowns and problems to be worked out.

All three appear to retain some primitive features seen in earlier australopiths, and to share others with undisputed *Homo* (*H. erectus* and later), so they don't fit easily into either the *Australopithecus* adaptive grade or that of *Homo* as outlined here. They do offer hints about how this adaptive shift occurred, and show that it happened in a mosaic fashion (unlike our *Outer Limits* transition).

So, from the archeological and fossil record currently available—and this picture will likely change with new finds and new dating—the transition may have happened like this: Perhaps in response to increased environmental variation between 2.8 and 2.4 million years ago, some hominins expanded their foraging behaviors, allowing a wider range of potential food resources. The making of stone tools was part of this expansion, and it enabled hominins to enter a hunting/scavenging/gathering niche which included consumption of higher quality foods, including meat. This development introduced new selection pressures associated with carnivory. These included selection for elongated legs, projecting noses, and a number of other features related to long-distance endurance running and walking, advances in social behavior, and abbreviated digestive tracts. The earliest stone tools, the first solid evidence of meat eating (butchery sites), and the first record of a degree of leg elongation appear almost simultaneously 2.6–2.5 million years ago.

It is possible that all three of the hominin species considered in this chapter (all of which appear between 2.4 and 1.9 million years ago) have elongated legs, but there is a long list of ifs attached to this proposition: *if* the leg bones from the area 131 locality at the site of Koobi Fora belong to *H. rudolfensis, if* Lovejoy and Heiple's geometry-of-bipedalism method accurately predicts femur length for *A. sediba,* and *if* OH 34 is a good model for predicting the length of the OH 62 femur. All three species also have hints of a nose that projects from the face more than in any non-*sediba* species of *Australopithecus* (but not as much as that of any specimen of *Homo erectus,* except for perhaps the D2700 skull found at Dmanisi, Georgia).

The dietary shift to meat eating removed a nutritional constraint that had imposed an upper limit on brain size, opening the door that made subsequent increases in brain size possible. Later, feedback loops between environmental variation, brain size, social behavior, carnivory, the manipulatory evolution of a hand freed from locomotor duties, and an increasing dependence on technology fueled selection for enhanced cognitive abilities and enlargement of the brain. Significant increases in brain size appear at about 1.9 million years ago in skulls attributed to *Homo habilis* and *Homo rudolfensis.*

The full package of "traveler" features is seen first in the 1.55-million-year-old *Homo erectus* skeleton known as the Nariokotome boy, although it may go back to the origin of this species at about 1.8 million years ago. Among these are features that adapted *H. erectus* to a wide variety of environments, allowing it to move through patchily distributed habitats. As a result this species is thought to have become adept at quickly colonizing new environments, and at dealing

with unpredictable climatic variation. *Homo erectus* quickly spread beyond Africa into Asia and to the border of Europe. Further brain size increases and reorganization of the cerebral cortex allowed cultural innovations that enhanced these abilities in the ancestors of earth's most adaptable mammal.

Your own hunger is not yet desperate, but your children have started to whimper. No success in finding meat the last . . . several days? . . . many days? You've searched the grasslands near the cliffs, where you remember finding the baby antelopes last year at about this time, but there were none. Yesterday your group dug for tubers with digging sticks, but even these were few. All three of your children have been whining, but you are especially concerned about the youngest, who has become very lethargic and seems to have lost interest in living.

You wonder where the group will travel today. You have a dim memory of some fig trees where the group fed for several days last year, but it might be too early for ripe figs now. Lacking a better plan, you favor going there anyway, but is your status within the group high enough to convince them to go?

Wondering about this, you approach your troop mates. Some of them are focused on something far away and you follow their gaze. Just near the horizon there is movement in the sky. Squinting your eyes, you can make out four specks circling in the air. You instantly know what this means. Something has died over there. But the birds are so far away. Can your runners get there in time to salvage any of the carcass?

Not everyone in the group will go. But you want to be one of the runners, so you can make sure to secure food for your offspring. You think your superiors will probably allow it, as you have a good reputation for sharing. You look at your gathering troop mates and sound off boldly, tapping your shoulder. Four others separate from the crowd and prepare to begin the run. It is understood among the larger group that the runners will carry whatever they can salvage to a nearby butchery site that most of them remember how to find, which has stone tools on the landscape and material for making more if necessary. This site is in the same general direction as the circling birds. The rest of the troop will meet the runners there for the dividing of meat. You go to your mother, still alive and active, and embrace her. It is understood that she will shepherd your children on the walk there. She is still strong enough to carry your youngest if he cannot make the trek. You know there may be dangers ahead, maybe predators at the site of the carcass or at the butchery site, but you put these out of your mind. With a heart full of hope, you begin to run.

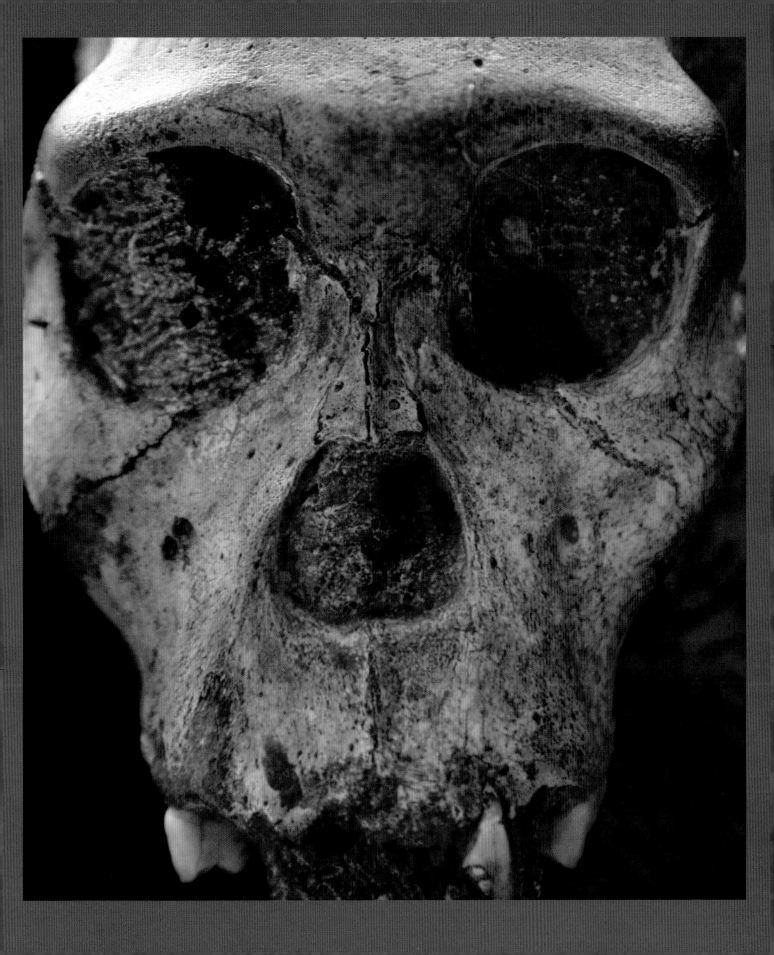

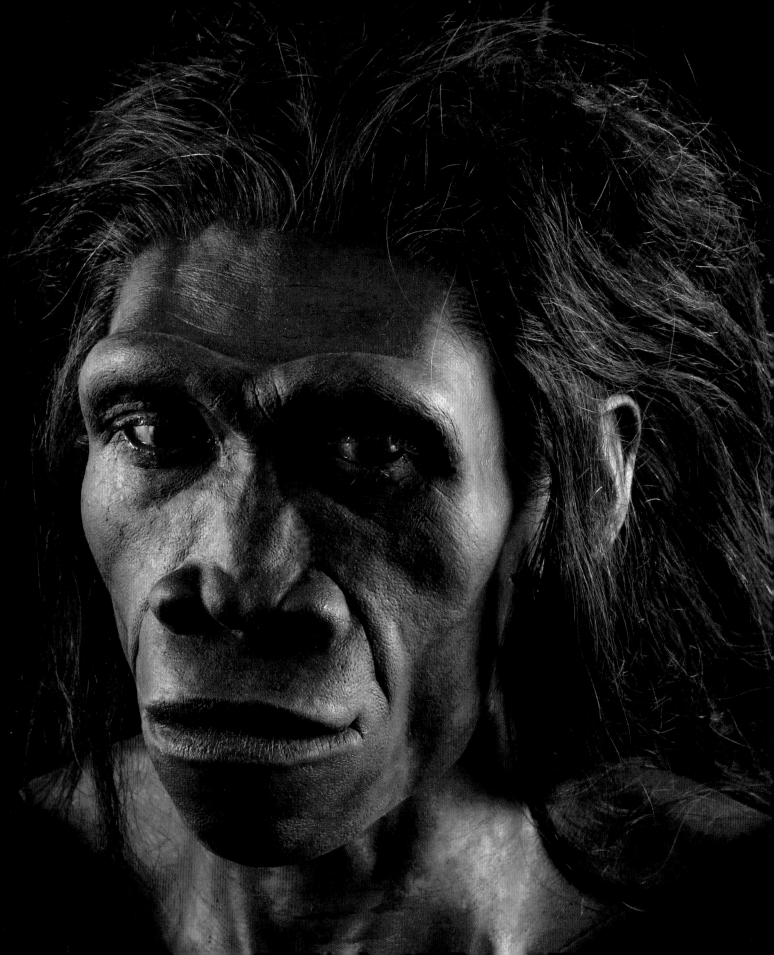

THE TRAVELER

Homo erectus (1.8 to 0.1 million years ago)

A Dead Boy Speaks Volumes

Returning to the next hominin species to be represented by a bronze sculpture and silicone head reconstruction in the new Smithsonian hall, we turn our focus to *Homo erectus*. The recovery of a nearly complete skeleton of an early African *Homo erectus* by a team led by Alan Walker and the Leakeys in the mid-1980s capped nearly a century of more fragmentary finds of *Homo erectus*. This was the beautifully preserved skeleton of a young male found in 1.55-million-year-old sediments at the Kenyan site of Nariokotome. The Nariokotome boy, as he came to be known, was roughly equivalent in age to an eleven to thirteen year old in human terms, although there is strong evidence that his species was on a faster developmental clock and that his actual age was between seven and nine years old. In the 1993 monograph describing the find, Alan Walker describes the circumstances of the boy's death, burial, and fossilization:

> The youth was living just before he died in the rich floodplain grasslands on the western side of the Omo River. The river's seasonal flood had left several large swamps that would take most of the year to dry out fully. The grasslands were home to many species of herbivore together with their attendant predators and scavengers. The youth died in or very near one of these swamps. We do not know the cause of death, but it may possibly have been septicemia following gum infection after the shedding of a milk tooth. The state of preservation of the bones indicates that he was not killed by a predator in all probability.
>
> At death, the body either fell in the swamp or was later washed into it by a minor flood. For some time it floated face down in one spot while decomposing. Some of both upper and lower front teeth with simple, straight roots slipped from their sockets here. They were later washed into and around a hippo footprint. The body drifted, decomposing, a few meters to the southwest through

the reeds. Bits and pieces of the rest of the body were washed back and forth, mostly in an east-west direction, and perhaps at the swamp's edge. These remains were kicked by passing large herbivores, sucked on by catfish, and chewed on by turtles. In time, only single bones or a few pairs of bones tied together by ligaments were left. Nearly all of these ultimately came to rest on one relatively small patch in a shallow part of the swamp, but one or two bones were washed further away. The bones became embedded in the swamp mud and remained there for over a million and a half years until they began to erode out of the sediments at the side of a small tributary of the Nariokotome.

This unusually complete find allowed a much more far-reaching analysis than is usually possible for hominid fossils. Alan assembled a team of young, unossified minds who were able to address a wide range of questions about human evolution, including climatic adaptation, brain evolution, language evolution, the origin of the human birth process, the evolution of body size and body size dimorphism, the origins of human carnivory, and the origin and taxonomy of *Homo erectus*. The picture of early African *Homo erectus* painted by this analysis was of a hominin species that was startlingly different from australopiths like those we met in earlier sections of this book. The *Homo* bauplan had arrived.

The Nariokotome boy's skeleton shows the adaptive package of a fully terrestrial biped built to travel. It shows a number of features associated with long-distance walking and running,

including large hind limb joint surfaces and features related to the counterrotation of the upper body during running while the now decoupled head remains stable. These last include shoulders that are held in a low (nonhunched) position, a reduction of musculature linking the head to the shoulder girdles, and a comparatively narrow pelvis and rib cage with a tall waist between them. The legs of the Nariokotome skeleton are fully elongated (to a modern level) and capable of an energy-efficient striding gait. As reconstructed by Alan and Johns Hopkins's Chris Ruff, the narrow pelvis has hip joints that are comparatively close together, also advantageous for efficient bipedal locomotion. They estimated a tall stature for the skeleton, both as a juvenile and as projected for adulthood. Both estimates have now been questioned, but other femurs attributed to early African *Homo erectus* adults indicate tall individuals, and stature estimates from footprints confirm this picture. The *Homo erectus* face sports a definitively projecting nose.

Gone are many of the climbing-related features seen in the australopiths (whether leftover baggage from a climbing heritage or features actually used by them in climbing). The proportions of the scapula are humanlike, with a relatively small area of attachment for arm-raising muscles. The finger bones have lost most of their curve. The semicircular canals in *Homo erectus* skulls show a form like that of later fully terrestrial bipeds such as modern humans, and unlike the apelike canals of australopiths. The forearm in this skeleton is shorter relative to the upper arm than in australopiths. This may relate to both a relaxation of selection for long arms in

a creature that no longer climbs, and to selection for shorter forearms which are better suited for the counterrotation of the upper body during running and are also advantageous in accurate throwing.

The narrow body form indicated by the team's pelvic reconstruction and the comparatively long distal limb segments (shins and forearms) of the Nariokotome boy match the long, lean body forms of people living at the same tropical latitude today, suggesting that *Homo erectus* was adapted to climate like our species. His tropical body shape is adapted to heat stress, maximizing the body's surface area for radiating heat and evaporative cooling by sweating. Specimens of *Homo erectus* from the colder temperature Georgian site of Dmanisi are not as tall and show relatively shorter distal leg segments. These individuals would be expected to have less tropical body proportions than the Nariokotome boy according to the theory of ecogeographic adaptation, which predicts that body shape will vary with climate, resulting in bodies with less surface area per unit of volume in colder climates. (Imagine the body attempting to more closely approximate a sphere in colder conditions.) The Nariokotome boy had the body size and proportions of a boy living in the tropics today, and would look human to our eyes, at least from the neck down.

Narrowed hips may also reflect a reduced gut, expected for a more carnivorous animal, and especially for one who has an enlarged brain without an increased basal metabolism: something's got to give. Also expected with a dietary shift to include more meat is a reduction in the chewing teeth and the bony jaws that support

Replica of the Nariokotome *Homo erectus* skeleton. (Photo courtesy of Alan Walker)

them, both evident in the Nariokotome skull and other skulls of *Homo erectus*. Markings for the chewing muscles indicate clearly that these too are reduced in comparison to those of australopiths. Incisor teeth are large, and of course this species is associated with external slicing teeth in the form of stone tools.

The brain capacity of the Nariokotome boy's skull (and of other *Homo erectus* skulls) is outrageously large by mammal standards, conspicuously larger than those of apes, australopiths, *Homo habilis,* and *Homo rudolfensis.* A diet rich in protein, calories, and fats would have been essential for the growth rate necessary to reach the brain size of an adult *Homo erectus.* There is solid evidence of stone tool–enabled meat eating

for this species. What seem to be the basal bones of the boy's thumb[1] are robust, and this feature is probably related to resisting forces generated by manipulatory activities such as making stone tools.

Homo erectus appears to be the first species for which the demands of efficient bipedalism and those of increasing brain size collide head-on. Efficient bipedal walking and running require that the hip joints be close together. But reaching a large adult brain size requires birthing larger-brained babies, and this means a larger birth canal in the pelvis. Pelvic anatomy in living humans represents a compromise, which is why human birth is so much more difficult and potentially traumatic than it is for any of the other living great apes, which face neither of these demands. Humans partially deal with this problem by giving birth to babies earlier in their development. This is why human infants are altricial, or comparatively helpless. It is as if human babies are born a year early in order to be able to fit through the narrow human birth canal while their heads are still small enough. Once outside, the steep fetal rate of brain growth, which in other mammals lessens at birth, must continue for the first year of life in humans in order to reach the enormous brain size of an adult.

Was this adaptation in place for *Homo erectus?* Alan and Chris's pelvis reconstruction for the Nariokotome boy allowed them to extrapolate an adult female *Homo erectus* birth canal. This opening was narrow, and they calculated the maximum neonate head and brain size that would fit through it. Taking this estimated neonate brain size as a percentage of adult *Homo erectus*

brain size, the two scholars determined that the percentage was more human- than apelike, suggesting developmentally immature newborns for *Homo erectus*.[2] With such a restricted birth canal, birth for *Homo erectus* would be difficult as it is in living humans. This difficulty may have required assisted births, as it usually does among modern humans.

In a 2002 article Leslie Aiello and Cathy Key of the University College, London, described the considerable demands of being a female *Homo erectus*. Adult females of this species are estimated to have been more than 50 percent heavier than australopith females, so they had larger bodies to maintain. If they also had comparatively helpless babies to care for, as well as the possibility of a humanlike adaptation by closer birth spacing with overlap in their offspring's nursing periods, they would have required a significantly higher daily energy budget than that of earlier hominin females, especially during the gestation and nursing of young. The authors argued that these requirements were most likely met with social assistance in obtaining food and reducing energy demands.

The birthing of babies with a larger percentage of brain growth still in their future has implications for cognition and culture in *Homo erectus*. Chimpanzees at birth have reached 40–50 percent of their adult brain size, while humans are born with only 25 percent of their adult brain size. This means that for humans, a larger percentage of brain growth will occur in a learning environment. We know that learning actually sculpts neural circuitry during development, determining which neurons will proliferate and

which will be pruned. This implies the opportunity for a greater role for learning in humans, and if the estimates of neonatal brain size in *Homo erectus* are correct, it would imply the same for this species.

What to Depict in the *Homo erectus* Sculptures?

The anatomical adaptations seen in *Homo erectus* seem to have evolved at a time when drier, more open environments became more prevalent and the climate more unpredictable in east Africa. Faunal evidence indicates that the appearance of *Homo erectus* in the Omo-Turkana basin of east Africa, for example, is timed with an increase in grassland habitats and in aridity and environmental instability. Archeological sites from this time include more species of open plains animals, supporting evidence that *Homo erectus* was not limited in its travels to lands near bodies of water. Evidence of increased environmental instability in the time of *Homo erectus* in Africa fits well with Rick Potts's idea of environmental variability as a driver of human evolution.

Rick and his team have worked at the Kenyan site of Olorgesailie since 1985. This is one of the world's most prolific sites for hand axes. You find them everywhere. The older ones from the site, beginning at about 1.2 million years old, were made by *Homo erectus;* picking one up, you pause in the dry heat and feel a connection tunneling back through the years (. . . *The last hand that held this was not entirely human* . . .). Even back in the lab, with solid research goals firmly in mind, the poetry of the ancestral connection sometimes asserts itself. One February night after midnight

Rick wrote me a long e-mail from Nairobi, where he was spending a month arranging logistics for next summer's field season, and working on research then in progress. He was bemoaning having to spend so much time on logistics at the expense of research time. He wrote,

The best part was that every day working with these stones, there was some point of overwhelming connection. I could see (and can demonstrate) the way those early homs selected certain stone shapes from an outcrop 30 meters away. The power, the utter strength of their acts of pounding and crushing food, and flaking rock, is astonishing and palpable with every observation of their artifacts, every time I lift one to carry it from one table to another in the lab. They had a consistency to their movements and choices and final products that shouts "Human," but without the fluidity of "modern." We know this already about these handaxe makers. . . . The concrete and fully sensed experience of handling those rocks makes [the hand axe makers] both better known to me and more mysterious than ever. . . . I want to dive into this stuff, into this empirical world . . . for weeks on end. The drilling planned for September, the new field vehicle I will drive in July, the shillings I will count to pay for the summer projects . . . those are the oddities of *Homo sapiens.*

I want more *Homo erectus.*

When I first visited Olorgesailie in 1987, I asked Rick to give me a day in the life of *Homo erectus.* It was my first exposure to some parts

A hand axe from Olorgesailie. (Photo by Chip Clark; courtesy of the Human Origins Program, Smithsonian Institution)

related to moving over long distances and adaptation to varied environments? I kept returning to images of *Homo erectus* as a large-brained, carnivorous traveler.

The larger brain of *Homo erectus* would be obvious in the figure, and putting it in a striding posture seemed not only doable, but aesthetically a good choice. Was there also a good way to represent the switch to a diet including more meat? We thought one of the most intriguing ways might be to show the figure carrying a carcass. I began drawing figures carrying all sorts of dead animals.

It didn't take long before the team realized that the figure should be female. For one thing, in art about the past there were just too many depictions of ancient guys bringing home the bacon, and we all recognized this practice as a superimposition of our own cultural history on the past. This was not our culture; it wasn't even our species.

Also, the best adult specimens upon which to base a figure of an adult early African *Homo erectus* were female, including a pelvis and associated femur from Olduvai in Tanzania, as well as two adult partial skeletons and a fairly complete skull from Kenya. The evidence that the skull, known as KNM-ER 3733, is probably from a female comes from comparison with the range of skulls known for *Homo erectus*.[3] This skull is toward the delicate end of the spectrum. The brow ridges and other cranial I beams (thickened areas that strengthen the skull at certain

of the web of interconnected evidence that bears on the adaptations of this species. Twenty years later the two of us were part of a larger team discussing ways to portray this web in bronze for the Smithsonian's new hall. Our main focus was, How best to show what was important about this species?

This subject occupied much of our discussion when Rick and I were together, and many of our thoughts when apart. I filled sketchbooks with images of *Homo erectus*. I saw long, lean figures striding out across open landscape, and this theme is repeated in many of the several dozen drawings I made. How could we best represent the adaptive warp and woof linking brain enlargement and dietary changes with features

(*facing*) Early sketches made in the process of determining the pose for the *Homo erectus* bronze figure.

locations) are more gracile than many, even if only African skulls are considered for comparison. The partial skeletons have been judged to be female on similar grounds if skull fragments were preserved, and on evidence from pelvic remains. There were no adult male counterparts this complete. But we were all fine with that. It was, in fact, very exciting to picture a strong, lean *Homo erectus* female striding with her dangerous burden.

There was quite a bit of discussion between the scientists on the team and me about what animal the *H. erectus* female should be carrying. This turned out to be a months-long multicontinent discussion. One obvious possibility was a carcass of an antelope, which was common

The KNM-ER 3733 skull, attributed to *Homo erectus* (cast).

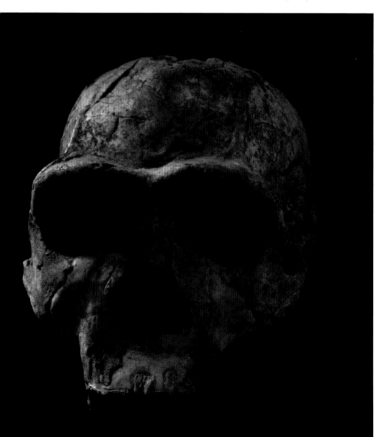

in archeological sites from that time and light enough to carry. But I wanted a pig. A big pig. From the moment I learned that there were giant warthogs living at that place and time I was enthralled with the vision of all those bony excrescences in bronze. I saw the head facing backward, protruding off of the female's rump; a balance of two organisms facing in opposite directions, connected intimately, perhaps almost seeming to merge in the center of the sculpture. I liked the intimacy of the two shapes, symbolic perhaps, of how intertwined the very existence of such a creature as *Homo erectus* was with animal food. Without it there could be no *erectus*. The question was, did this choice fit the archeological evidence?

The discussion was interrupted temporarily when Rick and other members of the team left for their annual summer fieldwork in Kenya. When I took my eleven-year-old son, Loren, to Kenya that summer (2008), we visited Rick and his team at Olorgesailie. We spent hot days scanning the badlands hillsides under a blazing sun for stone tools, and had dinners outdoors at the canvas-shielded mess table by lantern light. A veritable brain trust of expertise was there, and they were generous with their knowledge. One night at the dinner table I asked if I could hijack the conversation and initiate a discussion on the issue of what the *Homo erectus* figure should be carrying. Present at dinner were the Smithsonian's Briana Pobiner and Jenny Clark, George Washington University's Alison Brooks, University of Connecticut grad student David Leslie, John Yellen (program director for archaeology at the National Science Foundation and founder and president of the Paleoanthropology Society), and Rick. Rick wanted an antelope, perhaps an

impala, arguing that antelopes are among the most commonly represented animals in archeological sites of that time, and that the impala is an esthetically beautiful animal by almost anyone's lights. Briana Pobiner suggested *Antidorcas recki,* a paleo-springbok which is common in *H. erectus*'s time range at Olduvai. Someone suggested that perhaps the figure should be carrying a dead ostrich or a snake. John Yellen took the prize for most original thinker that evening. He was full of outside-the-box suggestions and advocated strongly for the dimensions that would be added if the female was carrying not just dinner, but an infant as well. I thought to myself: "This would be some kind of paleo-superwoman. *She does it all.*" Intriguing as that idea was, I was not sure I could add the challenge of figuring out what a *Homo erectus* baby would look like to the pile of work ahead. A few young children are known for *Homo erectus,* but none preserves a face. I would largely be making it up.

I heard nothing that night that I felt was as aesthetically juicy as a giant warthog. Some of these animals were big enough to cause doubts about their being carried whole, even by a strong *erectus* female. To be plausible, it would have to be only part of the animal. In this case the head was the most important part sculpturally. But would something as heavy as a giant warthog's head be worth carrying? This question sent us off into a discussion, there at the Olorgesailie mess table, about the nutritional value of various parts of the head. John and Alison Brooks both thought that a head-carrying scenario was plausible. Alison enumerated the resources within a head: tongue, brain, chewing muscles, and perhaps marrow within the jawbone. John pointed out that the

head is commonly used by modern hunter-gatherers. The most important question was, How frequently did head elements of pigs show up in the archeological sites of these times? Some of the dinner guests thought they did occur, but no one was sure how common they were.

When I returned from Africa, I dived into the scientific literature to try to answer this question. I found some of the most complete data in a book called *Early Hominid Activities at Olduvai,* which Rick had written twenty years earlier. I went through the tables listing archeological data, site by site, on animals and the frequency of parts represented. I was almost trembling with tentative hope as I logged the suid (pig) head elements represented at each site: one maxilla and four mandibles at one site; three braincases, three maxillae, and four mandibles at another . . . The numbers of suid skull elements were not huge, but they were consistently present at most of the sites. There were also other suid bones from the front half of the animal. I learned from the Smithsonian's Kay Behrensmeyer, an old friend, that a giant warthog named *Metridiochoerus* was the most abundant suid at archeological sites of this time.

I began to envision my *H. erectus* female carrying the front half of an adult *Metridiochoerus.* The animal is facing backward, its rib cage cupping her back, and she is holding it by tendons from the back musculature like straps over her shoulder. The organic shapes of pig and hominin blend into each other in places as if one organism. It was a very powerful design. Excitedly, I took the new information back to the team.

In the end this pig did not fly. The issue was not so much scientific as it was one of

EMBRACE

head bowed?
EMPTY EMBRACE
(kids can wriggle into
Sara Earth Mother)
closed eyes compressed up
by

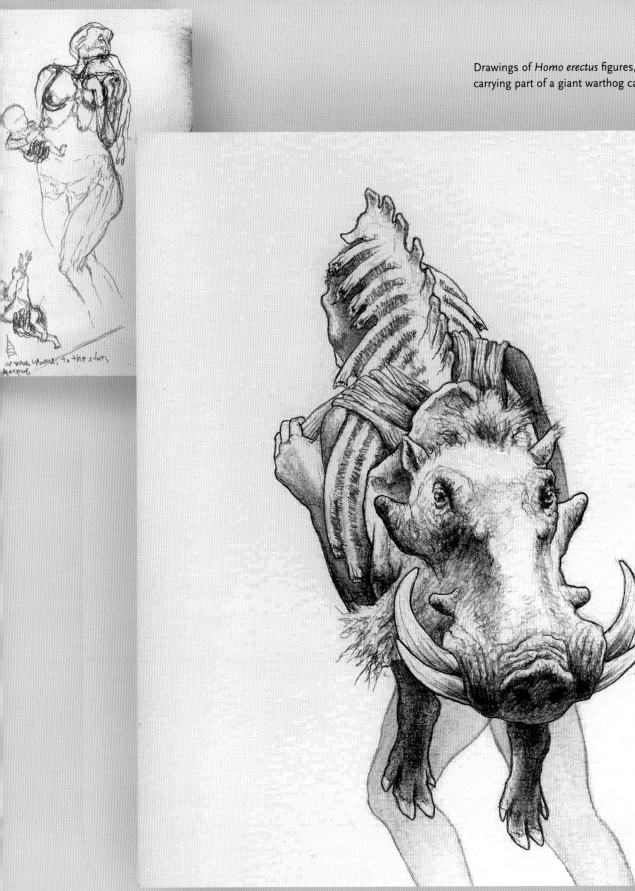

Drawings of *Homo erectus* figures, most of them carrying part of a giant warthog carcass.

accessibility. Rick's vision for the hall was one of connection. The bronze figures were not behind glass or up on a pedestal, but were right down on the hall's floor, where people could get close, touch them, and look into their metallic eyes. The giant warthog was too grotesque, and more so for being half a warthog, so it might be off-putting to visitors. Because this bronze was to be situated near the main entrance, it was important that it not be too disturbing. "As much as we love your sense of drama, significance and metaphor," wrote Rick in an e-mail to me, "we should probably kill the pig."

I understood this and accepted it, but not without some sadness. I formalized my letting go with a parting good-bye and final statement of my feelings on the subject in a letter to the team in mid-September 2008:

Dear friends, Thank you for your input on the *Homo erectus* pose. I think I understand your concerns, and I am willing to let the pig go and move on to another design for the *Homo erectus* figure. But I wanted first to get some thoughts about it on paper: One of the things I had to ask myself in thinking about the pose is: Why do I think this pose is so good? If I think about visitors making a connection with human history as one of the highest goals of the hall, why do I think this pose is ok?

For me, making a connection with human history through the sculptures does not necessarily mean in every case a happy mode of identification, but may include a range of emotional tones, and the cumulative effect may end up feeling more "real" to the visitor. This might include a happy sense of identification (for the Neandertal figures, for example), a sad or anxious empathy (*H. floresiensis*), and a mildly horrified fascination with something mysterious (the pose in question).

I think that both Rick and I use something like this last to help people celebrate or connect with the mysterious parts of human life at Halloween. In the case of the *H. erectus* pose, the emotional tone might be something like a reaction, almost in horror, of: That's a part of being human too? People may have a similar reaction to the Body Worlds exhibit (That's a part of me too?). It's true that people that enter the hall with an inclination to doubt human evolution might react by turning away from this individual sculpture, and maybe we don't want to risk that.

When I am reading or seeing a depiction of "the other" in a book or movie; a different culture or a different time, it does not feel real to me unless portions of it feel strange. This is one of the main reasons that [Jean Auel's] "Clan of the Cave Bear" doesn't work for me, while Bjorn Kurten's "Dance of the Tiger" does. This is a different kind of human we are talking about: portions will feel familiar, and some things should feel very different.

Does this sculpture carry negative emotional tones? It's true that what's expressed in the pose includes some things that might be viewed as mildly negative, but representing this side is what gives it "teeth." Frederick Hart's "Creation" at the National Cathedral is

one of my favorite sculptures. It has a powerful composition that includes a whirling arrangement of rock and water, with human figures emerging. What I find most compelling about it is that the just-created humans don't look entirely happy about it. Existence has its horrors too, and a totally happy just-created humanity would not feel real to me. Why is William Golding's "The Inheritors" so much more compelling than Jean Auel's Ice Age saga? Why do people identify with "The Scream"?

I feel that "Creation" successfully balances hints of the negatives and positives of existence, and this would be my hope for the Smithsonian sculptures. In my view the happier emotional tones of the Neandertal and the *heidelbergensis* figures are balanced by the, if not negative, then somewhat darker tone of the *erectus* female with *Metridiochoerus*. Becoming human involved the somewhat desperate step of consuming other animals. We are meat. The acquisition of meat is so integral to the process by which we became human, that we are metaphorically fused with it. This is one of the things I am trying to get across with this pose: from a distance the figure is a chimera; a Pilobolus-like [Pilobolus is a dance group that excels at representing organic forms; the name comes from a genus of fungus] fusion of the human's form with the pig's; you are drawn to it (ok; with fascinated horror), to see what this monstrosity could be, and only when you are up close do the forms resolve as clearly delineated human and pig forms. One problem that would have to be

solved is that the composition doesn't draw the visitor right past important introductory info. Seeing the figure in frontal view might take care of this: It is the only angle from which the chimera is not apparent, and looks instead like a human carrying something.

It could be argued that the negative side of life is covered in the *floresiensis* sculpture, in which you get a strong sense of her vulnerability and potential imminent demise. This does cover the darker side in terms of her situation: the *erectus* pose would hint at the darker side of being, the internal as opposed to the *floresiensis* figure's external-world dark side.

So that's it. I will assume this pose is dead unless I hear otherwise, and will be working to come up with another. Thank you all for your thinking about the sculptures.— John G.

A week later, I was stunned to find a quote by Rodin that neatly expressed in a sentence some of my thoughts on the subject: "As it is solely the power of character which makes for beauty in art, it often happens that the uglier a being is in nature, the more beautiful it becomes in art." With a sigh I put the pig aside and began researching antelopes.

Rick and the team thought it might be good to show the *Homo erectus* and the *Paranthropus boisei* figures as a pair (they occur in the same time horizons at east African sites) and to contrast the very different directions of their evolutionary paths. Both of their evolutionary trajectories are intimately involved with dietary

issues, but their different diets took them down very different roads. We began to think of the two in terms Alan Walker had suggested years earlier: the thinking machine and the chewing machine, the large-brained social carnivore and the specialized herbivore. To contrast with the *Paranthropus boisei* figure's narrow focus on pulling his dinner from the ground, we could present something that suggests a more evolved brain and sociality; we could imply awareness. The *P. boisei* figure is symbolically oblivious to the "other" that is passing nearby. The *Homo erectus* figure's activity is focused on food as well, but she also has her eye on her contemporary. Her focus must be broad; she must, in addition, watch the landscape, as she is doing something very dangerous.

In creating such a sculpture, I am engaging in a form of scientifically informed fiction. I am selecting a moment from deep time which we think actually occurred, and am filling in all of the unknowns with educated guesses. There is an implied story here revolving around several questions. How did she obtain the carcass? Was it through hunting or scavenging? If it was the latter, did she simply find it, or was the story more complicated, perhaps involving confrontational scavenging (the stealing of another predator's kill)? Where is she taking it? Is she alone, or are others with her?

Drawings of *Homo erectus* carrying antelope carcasses.

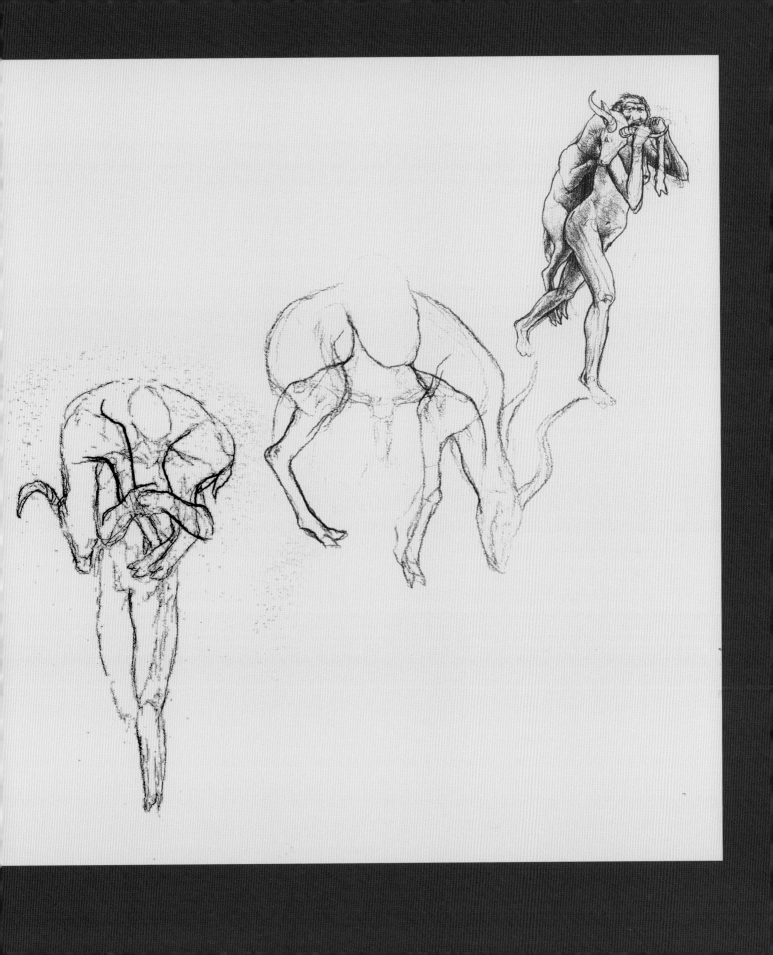

The team gave a lot of thought to this backstory behind the sculpture. Team member Briana Pobiner is known as a sort of taphonomic detective. She studies animal remains from archeological sites in order to understand narratives of carcass acquisition and consumption—the details of taphonomy, or what happens between death and discovery of fossil remains. Each site presents a unique story, which can be partially reconstructed with careful scrutiny of the evidence. This kind of study can answer important questions such as: Who got to the carcass first, hominins or other carnivores? Does the site represent a place to which hominins habitually brought animals for butchery? In trying to interpret these clues, she also studies carcass acquisition and dismantlement by modern carnivores, and she was a great source of much-needed input and often grisly photographs as food for thought.

A number of details had to be consistent with what we thought the story should be. The most solid of the knowns is that butchery sites usually have cut-marked bones from more than one individual animal, often from more that one species, as well as stone tools. This means that when a carcass was obtained, it was often carried to a remembered location where there were stone tools for butchery.

At one point we wanted to include stone tool use in the picture, along with the other themes. The *H. erectus* female was to be carrying a hand axe in one of the hands that was also gripping the antelope. But it became obvious that this wasn't quite right. If she already had a stone tool, why was she carrying a carcass to a stone tool site?

Then there is the issue of how she obtained the carcass. Did acquiring the carnivorous habit initially involve our ancestors becoming predators? Some have argued that hunting is probably necessary to provide a dependable source of fat, protein, and calories for an animal which is growing such an outrageously large brain. But we have no direct evidence of hunting, in the form of weapons or weapon-notched animal bones, this early in the record. Scavenging, including the theft of kills from other carnivores, is an alternative. If this was the more common practice, certainly there would have been pressure to increase the dependability of animal resources for an animal with the steep rates of brain growth projected for *Homo erectus*. The development of hunting skills would aid such an increase.

There is evidence suggesting that early hominins sometimes had early access to a carcass, implying either hunting or a form of scavenging in which hominins get to a carcass before other carnivores have consumed much of it. For example, butchered remains of bovids (antelopes and their kin) at east African sites have occasionally included a small bone (the hyoid) from the throat, at least two with stone tool cut marks on them. The hyoid bone floats in the soft tissue just in front of the larynx and is attached to the base of the tongue. With the viscera, these are usually among the first tissues consumed by carnivores. Cut marks on this bone imply that the hominins who made them had early access to the carcass, before other carnivores could consume the soft tissue of the throat. Since a carcass does not remain undisturbed for long on the east African landscape, this seems to imply hunting or another form of very early access. There are other

clues suggesting early carcass access, such as the likely consumption of a carnivore liver by another *Homo erectus* individual. This may imply hunting, but it's impossible to be certain. So I would have been going too far out on a limb to show the *H. erectus* female with a sharpened stick or spear.

What are the other possibilities for early access? It was probably uncommon for a carcass to be found pristine on the landscape before other animals got to it. What about an aggressive form of scavenging, such as stealing a predator's kill? This might have happened, if an *erectus* group was aggressive and noisy enough to frighten off a group of lions or hyenas. Groups of modern humans such as the Maasai are known to do this (with spears). We decided to think more about this possibility. In the end, a number of details were made consistent with early access to this antelope carcass, leaving open the question of whether it was hunted by *H. erectus* or not. It is still largely intact, although its missing viscera indicate that this portion has already been consumed, presumably by whatever hunted it, whether human or otherwise.

I had a conversation with Rick Potts about whether the antelope should have its skin intact or not. He pointed out that skin is heavy and suggested that if it was possible to remove it before carrying, it would have been desirable. The removal of the viscera means that the carcass's skin had already been breached. Whatever had hunted it had already opened the body and consumed some of the viscera, so there wasn't a problem with entry in this case. Would an adult female *Homo erectus* have been strong enough to rip off the skin without stone tools? Considering

the evidence from the thickened bony walls in the upper arm bones of *Homo erectus,* and the strength of muscle markings, I thought it likely. I was not-so-secretly delighted at this decision. An antelope without its skin offers, in my opinion, much more interesting possibilities sculpturally than one with its skin intact. Details of muscles, tendons, the trachea, tongue and teeth, and the eyeballs might all be visible. I flashed back to something Loren and I had seen a hyena carrying in the summer of 2008: a skinless, grisly trophy that was once a wildebeest's head. I mused happily: "As it is solely the power of character which makes for beauty in art, it often happens that the uglier a being is in nature . . ."

Building the Traveler

As with the other hominids, I created the *Homo erectus* female from the bones up. I focused on a particular individual, a woman who lived just less than a million years ago, at a verdant site that is now the barren and eroded Olduvai Gorge. She is known today as OH 28. All that we know of her is her fragmentary pelvis and femur, but these are fortunate finds, as they are informative bits.

The pelvis gives the most reliable indication of sex in human skeletons, so its recovery is valued in forensic contexts. OH 28 comes out as an unambiguous female. That she is adult is indicated by the fusion of the individual elements of her pelvic bone. The size of the hip socket is correlated with body weight in living humans, so hers can be used to estimate her body mass. Likewise, the estimated length of her femur can be used to estimate OH 28's stature. These clues

suggest a moderately tall (5 feet 4 inches), lean adult female. This is a much larger body than is indicated for female australopiths. By comparing OH 28 and other east African specimens, Chris Ruff and Alan Walker were able to estimate the body size range for early African *Homo erectus,* which suggested that sexual dimorphism (sex-related differences) in body size had reduced from levels seen in australopiths, and was similar to modern levels. This reduction of sexual dimorphism may be related to social changes, possibly a reduction in competition among males within a more cooperative society. The increases in sociality expected as a mostly herbivorous mammal shifts to more meat-eating may be reflected here.

Once her body size statistics are estimated, we can look at body proportions. Since the Nariokotome boy's proportions would not have changed much as he grew into an adult, and since adult males and females in modern populations have similar long bone proportions, the boy's limb proportions can be used to estimate those of OH 28. These parameters helped bring my evolving body image for the *H. erectus* female into focus.

Alan and Chris's reconstruction of the pelvis of the Nariokotome boy from the parts preserved was narrow, like those of people living at that latitude today. Because absolute values of the maximum breadth of the pelvis are not significantly different in adult males and females today, an age-progressed Nariokotome boy pelvis allows an estimation of this variable in adult females of the species, so I could use that for my developing OH 28 body plan.

All of these measurements and estimates allowed a basic blueprint to be drawn up for OH 28's skeleton. Casts of all of the most relevant fossils were on hand to provide details for the clay skeleton. Overall, the skeleton developing under my fingers had a very human outline, but some of the details were subtly different from those of modern humans. Stony Brook University's Susan Larson and her colleagues had recently published an interpretation of a pair of unusual features that appear in *Homo erectus* (and also in *Homo floresiensis*): a lack of the twist in the orientation of the head of the humerus which characterizes modern humans, and relatively short clavicles. Noting that this humeral head orientation would, with a normal human shoulder blade orientation, cause the elbow joint and the forearm and hand to face a more palms-out position, they suggested that *Homo erectus* instead had a forward-placed shoulder joint, with the shoulder blade more toward the side of the rib cage than on its posterior surface as it is in living humans. The palms-out position, which she and her colleagues see as disadvantageous for a toolmaker, is then avoided. Is this interpretation correct? Only time and future work will tell, but in the case of the *Homo erectus* and *Homo floresiensis* figures I was able to hedge my bets: both of them are in poses that would bring the shoulder joint forward anyway, even in a modern human.

One day, as I was working on building the pelvis, I came up with some questions for the experts. My expert of choice was Chris Ruff, who had worked on the original Nariokotome boy's pelvic reconstruction, and who also studies body mass estimation and climatic adaptation in

hominins. At the end of the day I called him to ask my questions.

"Um . . . Have you seen today's issue of *Science*?" he asked. I had not, but it turned out that in it was an article announcing the first recovery of a nearly complete pelvis from an adult female *Homo erectus*. And everything we thought we knew, it seemed, was wrong.

The article, by Case Western Reserve's Scott Simpson and his colleagues, described the discovery of a hominin pelvis from the locality of Gona in Ethiopia, dated to between 0.9 and 1.4 million years old. The hip socket indicated a very small body size. The pelvis was relatively wide, contrasting with Walker and Ruff's reconstruction of the Nariokotome boy's pelvis. And the authors included a femur length estimate which was based on the size of the hip joint, and which indicated a short stature for this individual.

A short, wide *Homo erectus* female? Was this possible? These new statistics had far-reaching implications for a broad range of issues, including body size, body shape, climatic adaptation, locomotion, sexual dimorphism, obstetrics, and the altriciality of newborns. More immediately for me, this research had rather drastic implications for the figure I was creating. I tried to ready myself emotionally for what might be ahead: taking a hacksaw to the skeleton I was building. But first I would try to get a better understanding of the issues, and how the new evidence fit with existing evidence, by speaking with experts and carefully rereading the article.

At this point, a little history might be in order. In the early 1990s, when I first began drafting body blueprints for early African *Homo*

erectus, inferring body size and shape for members of the species seemed pretty straightforward. I had begun the effort just after the initial analysis of the Nariokotome boy's skeleton, which seemed to clearly indicate a large body with a tall and narrow form. Other, more fragmentary, African specimens seemed to confirm this picture. But in the following decade, things began to get weird. Between 2002 and 2004 three small skulls were announced, from sites in Georgia and east Africa, raising questions about the existing picture of a large-bodied adult female *Homo erectus*.

These skulls were all from the time range of *Homo erectus*. One was found at Olorgesailie, in sediments from a time when *H. erectus* is the only known hominid species in Africa. All three shared features with *Homo erectus,* but all were significantly smaller than the known range of *Homo erectus* skulls, and their cranial I beams were variably less developed. Some scientists argued that these were not *Homo erectus*. Others believed that they were attributable to *H. erectus* and suggested that the small size and delicate development were because they belonged to teenaged females (one of the skulls has teeth confirming adolescent status). Still others argued that the skulls' small size indicated a larger body size range for *Homo erectus* than earlier thought, suggesting the possibility that sexual dimorphism in this species was not so human after all.

A year before I started building the figure, the first research was published on postcranial bones (bones behind or below the head) discovered at the site of Dmanisi, some of which were associated with previously published skulls,

offering a glimpse of the bodies of these individuals. Many scholars had agreed that the skulls from the site should be attributed to *Homo erectus,* but most recognized that they seemed to show some features that were primitive for that species. The preservation of the Dmanisi fossils is exquisite, and the postcranial bones included several complete or nearly complete long bones. These indicated that the Dmanisi individuals were not tall. It was suggested that either they were primitive (that is, like earlier hominins) in this respect, or their differences in stature from taller-bodied African *H. erectus* individuals represent adaptation to different climates. Or both.

Now the Gona pelvis was proposed to indicate even smaller *Homo erectus* individuals. But did it? Chris Ruff pointed out that the Gona hip joint indicated a very small body weight, far outside of the range for previously known specimens of *Homo.* We've never before called anything with a body size this small *Homo erectus.* And if it is included in this species, some very weird things result. *Homo erectus* then becomes the most sexually dimorphic hominin in body size. And the body size range for females becomes larger than the female range for any living primate. The Gona pelvis was found with no associated dental or cranial remains that might provide a more definite species designation. Are there possibilities other than *Homo erectus? Paranthropus boisei* is known to have lived at this time, and the designation of *Homo habilis* has been suggested for one specimen from as late as 1.44 million years ago, near the older end of the range of possibilities for the Gona pelvis. Chris thought that the species

designation for the Gona pelvis was not yet a closed issue.

In this confusing environment, I had to make a decision. Was I to make a figure that represented an "average" *Homo erectus* female, averaging individuals from multiple continents? It seemed to me that this would mean little biologically. I chose to focus instead on east Africa. I thought it was reasonable to ask at this point: what do we know? We knew that there were tiny females of a not-yet-resolved species-attribution alive at some time between 0.9 and 1.4 million years ago in east Africa, as represented by the Gona pelvis. We have two small skulls from east Africa, but they are similar in size to D2700, the small skull from Dmanisi in Georgia, which we now know is associated with postcranial bones indicating a body size larger than the Gona individual. And whatever the Gona pelvis turns out to be, we have evidence of taller, larger-bodied *Homo erectus* females in east Africa at just under a million years ago and older: when comparisons of OH 28 are made with other fossils attributed to early African *Homo erectus,* she seems not to be an outlier. My sculpture represents one of these individuals.

But what about pelvic breadth for these tall, large-bodied females? To address the issue of pelvic breadth in *Homo erectus,* I had to return to the bones. I stopped work on the figure and spent three days working with casts of all of the preserved pieces of the Nariokotome boy's pelvis. The Simpson publication was not the only one to suggest that the Nariokotome boy's pelvis could have been reconstructed a little wider, and Chris admitted this might be true to a degree. I worked

on the reconstruction for three days. I began the work thinking that I could reconstruct the sacrum a little wider than Chris and Alan had, but was unable to make it much wider without creating some unlikely relationships within it. However, it is possible to get a wider pelvis by opening the blades, butterfly-like, so I had to consider my three-day study inconclusive.

Chris helped shed light on the problem of pelvic breadth in OH 28 in a clever way, by reversing equations he had worked out for predicting body weight from stature and pelvic breadth. He used her body weight (as predicted by the size of her hip socket) in conjunction with her stature (as predicted by her estimated femur length) to predict her pelvic breadth, and arrived at an estimate that is wider than if using a feminized adult version of the Nariokotome boy's reconstructed pelvis, and only four millimeters less than that of the Gona pelvis. Work on this and other pelvic remains now seems to show that body breadth in Early and Middle Pleistocene hominins was indeed somewhat wider than that of people living in similar climates today, but that ecogeographic adaptation (changing body shape to adapt to climate) in these early times followed a pattern similar to today's. Those living in colder climates had wider bodies than hominins living in tropical climates. Considering this information, I added eleven millimeters to the breadth of my female *Homo erectus*'s pelvis so that it would be between the pelvic breadth predicted by Chris's calculations and that of a feminized adult version of the Nariokotome boy's pelvic reconstruction. This agonizing series of mathematical contortions is illustrative of a situation paleoanthropologists are often forced to live with: less complete fossils mean more ink, paper, and estimation.

Since that time, both Chris and Scott have worked on this problem. At the 2010 meeting of the American Association of Physical Anthropologists, each of them gave presentations on the pelvis previously worked on by the other. Chris talked about the implications of the Gona pelvis, focusing partially on the taxonomic uncertainty surrounding the find. Scott and his colleague Linda Spurlock presented new reconstructions of the Nariokotome pelvis. There was still quite a bit of distance between their positions at the end of the conference, especially about inclusion of something as small-bodied as the Gona individual in *Homo erectus*. I suggested to science writer Ann Gibbons that we lock the two of them in a room with the relevant fossils until they sort it out. At least there is the consensus that pelvic breadth in *Homo erectus* may have been wider than previously supposed.

After widening the pelvis, I continued reconstructing the female *Homo erectus* skeleton. When the skeleton was near completion, I topped it off with a cast of the KNM-ER 3733 skull, the most complete skull known for early African *Homo erectus*, together with one of the most complete *Homo erectus* mandibles known from Africa. And once again, whereas moments ago I had been by myself in the night-darkened museum space where I was working, I was no longer alone. Unmistakably she was there. Not quite the feeling of a whole person, but neither was she entirely just a framework, a *thing*.

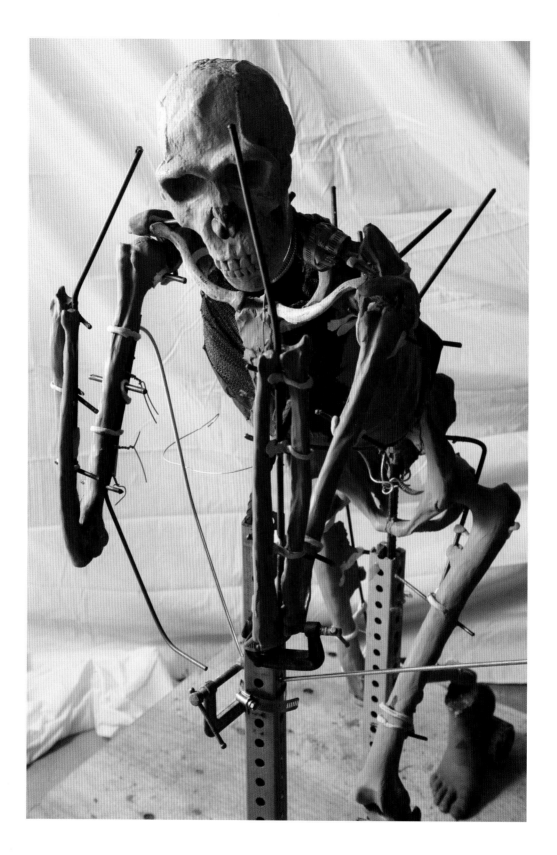

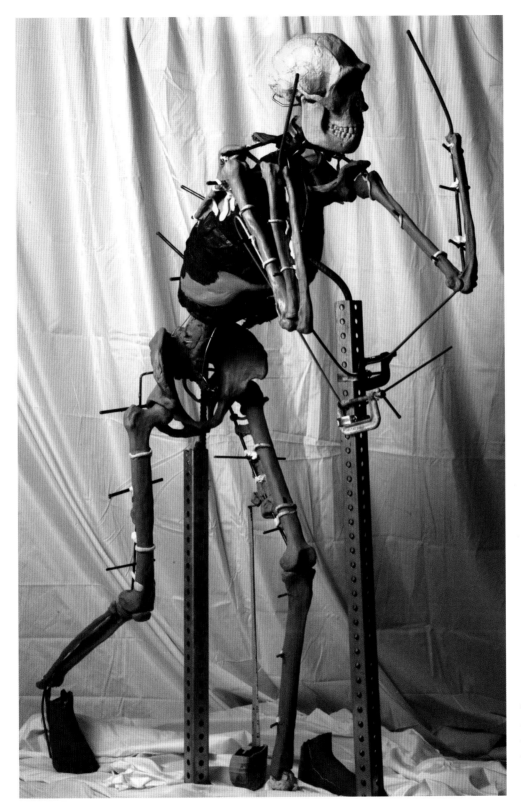

Two views of the composite female *Homo erectus* skeleton, which served as the basis for the bronze figure. The skull is shown with nasal cartilages reconstructed.

When the skeleton was completed, muscles were then individually added. The position and prominence of muscle attachment sites, visible on the fossil bones as crests and pits, guided their placement and development. Both the muscle markings on the bones and the thickness of the bony walls of the long bones (which respond to mechanical loading with increased bone growth) indicate that OH 28 and some of the other fossils attributed to *Homo erectus* had great strength in comparison to modern people. This does not mean they were built like power lifters. This powerful musculature was spread into a long-limbed body form. As I worked on the sculpture, I had lots of time to think of ways to give the impression of great strength in this individual. Carrying a heavier object would have done this, but I did not want to dig up the "what species should she be carrying" argument again. I discovered a subtle way: her right hand's grip on the antelope's forelimbs is so powerfully tight that one of them, wrenched into a better carrying position, is dislocated at the elbow.

The *Homo erectus* skeleton, with partial muscular reconstruction. Visible are the biceps and brachialis muscles, as well as some of the shoulder muscles and one head of triceps. Modern fitness trainer Patti Booth Taylor models.

The *Homo erectus* skeleton with partially reconstructed musculature.

It was time for the skull to receive a face. The nasal area of the ER 3733 skull bears unambiguous indicators of a projecting nose, such as the pronounced angle between the midline of the lower nasal bones and the plane of the nasal aperture (the bony nasal area of ER 3733 also fits the bony criteria for a projecting nose outlined by Franciscus and Trinkaus in 1988).

The prominent brow ridges of adult early African *Homo erectus* skulls are projecting and separated from the forehead by a marked valley. The expression of these features is somewhat variable, and in ER 3733 it takes the form of a shelflike projection of the brow ridges over the eye sockets. Since the soft tissue over this area in humans and noncrested apes approximates a thin and fairly even sheet of soft tissue, this anatomy will show in the fully fleshed-out face. There would be no anatomical precedent, for example, for reconstructing this area to look more human by partially filling in the valley behind and above the brow ridges with thicker soft tissue. The shelf and furrow will be quite visible in the fleshed-out head.

The resulting visage looks perhaps on the border of a face we would consider human. The brain has expanded and the face has reduced just enough to give it a familiar look. The head's borderline human status is underlined by the fact that subtle differences, such as length and style of hair, change the impression of humanness for the sculpture.

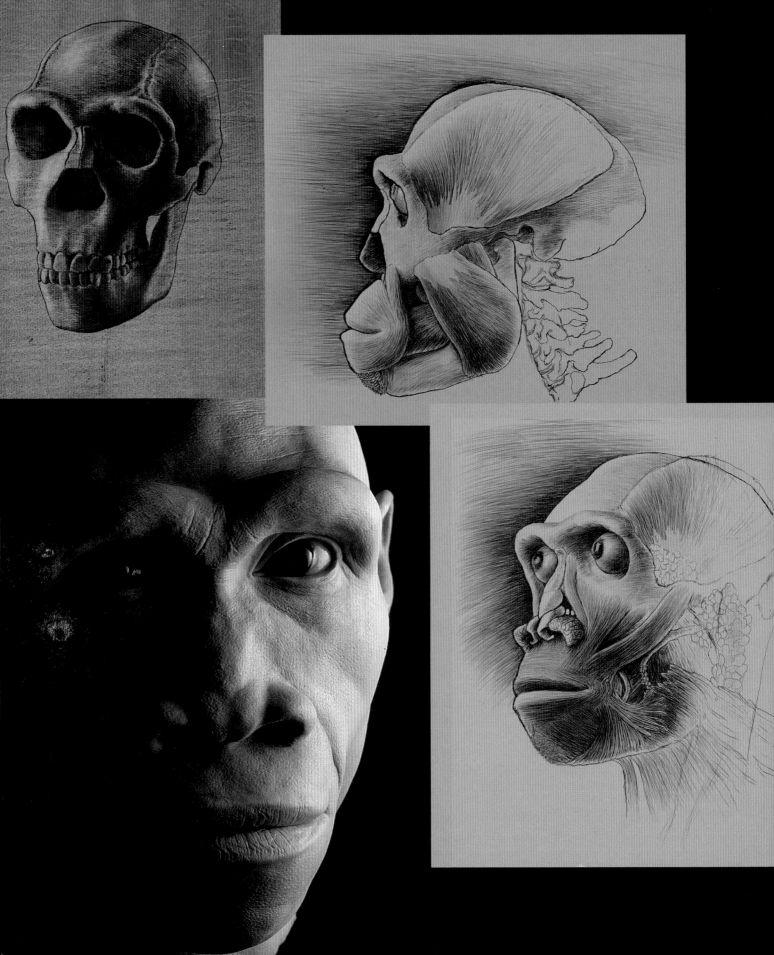

Drawings depicting stages of the head reconstruction based on the KNM-ER 3733 *Homo erectus* skull, along with photographs of the finished head in clay (left) and cast in silicone (right). (Left photo by Chip Clark; courtesy of the Human Origins Program, Smithsonian Institution. Right photo, drawings, and reconstruction work by John Gurche)

The skull is replaced by a cast of the head reconstruction in the developing figure of *Homo erectus*.
(facing) Posterior view of the full muscular reconstruction in clay of *Homo erectus*.

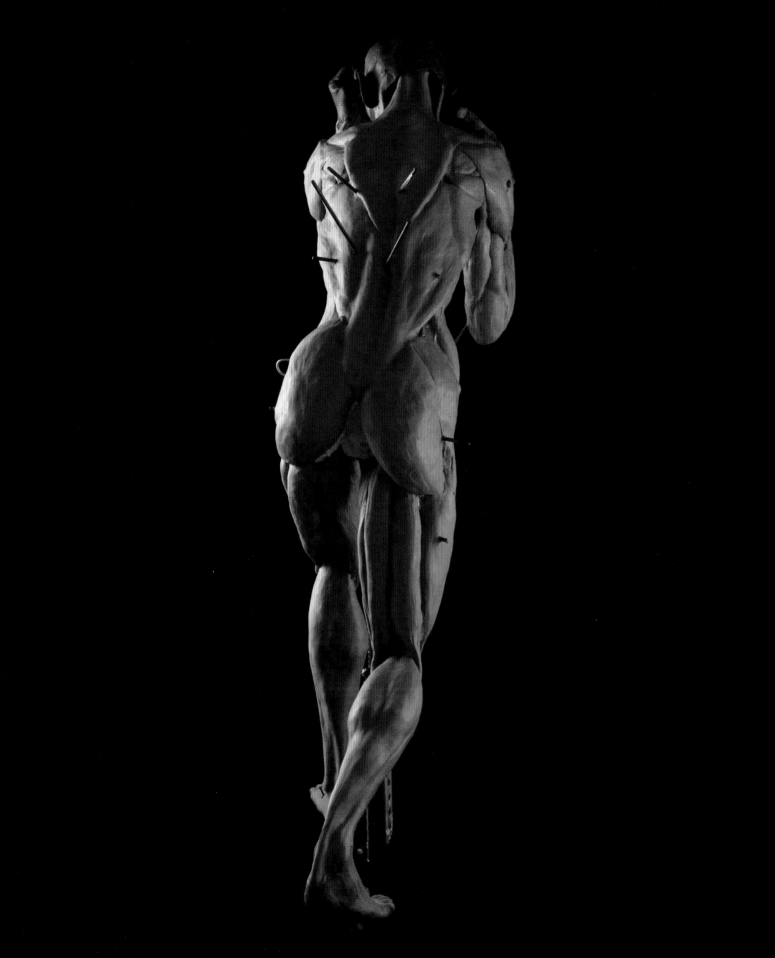

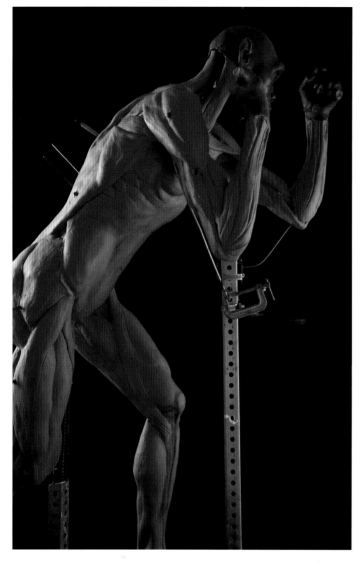

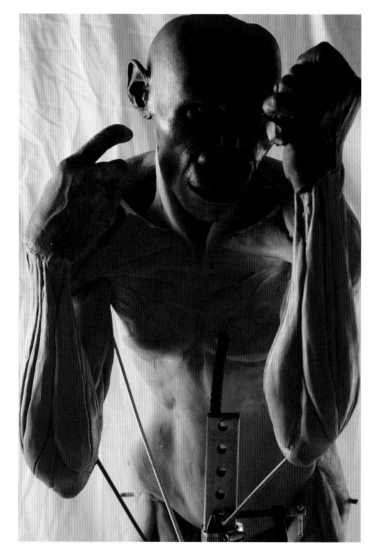

Lateral and frontal views of the full muscular
reconstruction in clay of *Homo erectus*.

Many of the details that gave the bodies of the Lucy and the *P. boisei* figures a not-quite-human look appear more human in this figure. Gone are the wide, flaring pelvic bones and the resulting potbelly. Gone are the short legs and long forearms that characterize australopiths. Her body was very human-looking.

How much body hair should I give the figure? Humans are unlike other primates in that they lack an extensive coat of body hair. Since our enhanced sweat gland cooling system works best without thick body hair, and with a tropical body shape, one approach to the body hair problem might be to ask when hominins began to adapt to climate with body shape as living humans do. At present, early African *Homo erectus* represents our first indication of this adaptation, so among the Smithsonian figures this is the earliest with naked skin.

Character and Humanity

Where does Rodin's *character* come into all of this? It has to be there at every step. If I had waited until a late phase of the sculpture's creation to start asking this question, I'd have been in trouble. Instead of a sculpture, I'd have an anatomy lesson. From the beginning the pose has to be built to *convey,* or you're lost. You have to switch lenses constantly from the scientific to the aesthetic, and back again. The sculpture has to work in both realms to be worth anything.

Walking poses have always moved me. Something in the way we move says eloquently: "Human," and this pose was no different. Rodin's *Walking Man* strips this kind of pose down to its essentials—no head, no arms, but still the pose

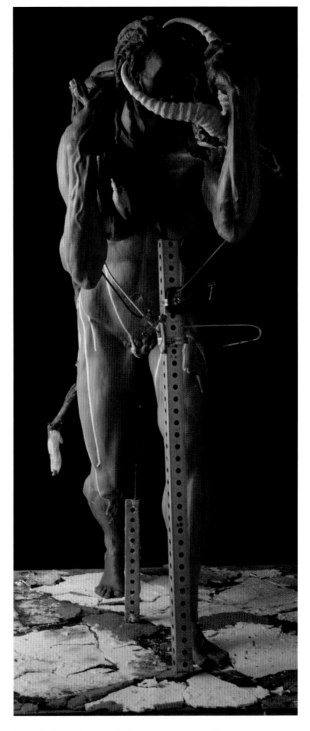

The final clay figure of *Homo erectus*, carrying the antelope carcass.

moves us with its implied motion, which is a specifically human movement. Of course, the human form in many poses has great power to move us, and much of the aesthetic juice that flows from the *Homo erectus* figure will come from this, our first sight in the hall of a form that looks fully human. In body that is.

Surely one of the esthetic ingredients for this sculpture should be to include a feeling of what it would be like to stand face to face with a member of this species. As mentioned earlier, chimpanzees can give an astonishing feeling of sentience—of mind-behind-the-eyes—if you can get up close to one. I've guessed that a chimpanzee-like level of this impression is appropriate for australopiths, but here is a hominin with a brain that is two-thirds the size of ours. Looking into its eyes, shouldn't it have a "feel" more like us?

Upon concluding his analysis of the Nariokotome boy's skeleton, Alan Walker thought it might be more like gazing into the blank yellow eyes of a predator you can't reason with—in Alan's words, a kind of "deadly unknowing." This was largely because he had reason to suspect that the species did not possess a form of spoken language. University of Roehampton's Ann Mac-Larnon had studied measurements of the spinal canal of the Nariokotome boy, and determined that it lacked an enlarged thoracic region characteristic of modern spinal canals, which accommodates a part of the spinal cord engaged in, among other things, the fine control of the breathing muscles, as during speech.

This image is a powerful one—that of a human-looking creature but startlingly lacking in some key human qualities. The picture may

stand, although in the case of the evidence for some type of language in *Homo erectus*, the pendulum seems now to have drifted back to a more uncertain position. Further studies of the Nariokotome boy's spine have now shown it to be pathological, so all bets are off regarding the spine's broader implications for the species. There now seems to be less reason for denying *Homo erectus* some form of language or prelanguage.

The underside of *Homo erectus* skulls are flexed to a degree that implies that an angled vocal tract, like those of modern humans, has begun to evolve. This is taken by some researchers as evidence that some kind of sophisticated vocal communication was evolving. The flexed cranial base of modern humans is associated with a lower position of the larynx, making more room for an expanded pharynx. This anatomy is unique among mammals. Newborn humans lack it, and it develops during the first year of life. Unlike other mammals and newborn humans, adult humans cannot drink and breathe at the same time. They are also at greater risk of choking. So with these disadvantages, what selected for this unusual anatomy? The human pharynx is a vowel modification chamber, and its expanded form in adult humans allows a greater range of vowels to be produced. Some have argued that certain vowel sounds which are key to the subconscious decoding of rapid-fire speech with overlapping sounds cannot be produced without such a humanlike modified pharynx. Alternatively, these changes in the upper respiratory tract may be related to increasing respiratory volume for high diurnal activity levels in arid environments.

Distinct language-related areas have been identified on endocranial casts of *Homo erectus* and earlier *Homo,* and some, such as the area of the left frontal lobe known as Broca's area, are asymmetrically enlarged in the left hemisphere as in modern people. This may reflect the neurological basis for a precursor of language, or it may relate to the sequencing of hand movements. Some language-related areas in living humans intimately connect with or even overlap with areas active during movements of the hand, so the two are not mutually exclusive. Further work on Broca's area in living humans has indicated that parts of it, which are active when the name for an object is spoken or silently voiced, overlap with areas of the brain active during actual or imagined manipulation of the object with the hands. Dean Falk is among those who have hypothesized that language function in such areas of the brain has partially co-opted areas related to grasping and manipulation of objects. From this perspective, the presence of an enlarged Broca's area in fossil endocranial casts might relate to the behavioral foundations of language, but this could mean enhancements of circuitry involved in object manipulation, or even tool use, that predated vocal language. Some researchers see their tight interconnectedness as support for the idea that the first languages were gestural.

Dean suggests that it is reasonable to speculate that some form of language evolution has taken place in a species which possesses a large brain, gross anatomical asymmetries (petalias) resembling those of modern humans, and an advanced pattern of convolutions at Broca's area

of the left hemisphere, all of which characterize the brain of the Nariokotome boy. Extensive anatomical changes in the brain and vocal tract must occur before spoken language is possible, and many researchers think they would have taken a long time to evolve, so it would not be unexpected for its early roots to go back this far.

This is not to suggest that *erectus*'s form of communication would have all of the attributes of a fully modern language. Other forms of symbolic behavior don't show up in the archeological record until much later. The evidence reviewed here offers hints concerning the existence of possible precursors of language ability in *Homo erectus,* but stops short of offering specific ideas about what those precursors might have been.

What about other evidence of a human spark? There are tantalizingly incomplete bits of evidence suggesting a human capacity for caring in the record for *Homo erectus.* Two of the best examples involve individuals that were incapacitated to such a degree that they would not have been likely to survive without extensive help from others. Seemingly these individuals were not just left to fend for themselves but were helped, fed, and protected by others.

The first case involves an individual who died 1.77 million years ago at the Georgian site of Dmanisi. This was the fourth skull to be found at that site, and I had eagerly followed the progress of its removal from the block of rock matrix in which it was encased. David Lordkipanidze, who directs the excavations, was kind enough to send me occasional photographs of the progress as the preparators worked their way down the face, exposing it little by little. When they got to

the mouth, they were surprised to find that it was not there. Because of dental disease this individual had lost all but one of his teeth. The bone of the maxilla and mandible that had once held the teeth had dwindled over a period of years, leaving a stick of a mandible and a similarly diminished maxilla.

This kind of bone resorption (wasting) is not uncommon in modern individuals who have outlived their teeth by several years. But nobody would have suspected that an individual living 1.77 million years ago could have survived for several years without the ability to chew. That he did probably implies help from others, food preparation techniques more advanced than we had guessed, or both. In an attempt to understand the significance of this find prior to preparing some artwork for a 2005 *National Geographic* article about Dmanisi, I spoke with team member Philip Rightmire of Binghamton University about the research the team would soon publish announcing the skull's discovery and significance. He told me about the implications of the find for the possibility of social help. "Maybe someone chewed his food for him," I suggested. "Yes, well, we don't get into *that*," he replied.

The other find suggesting a humanlike level of caring involves a 1.69-million-year-old case of vitamin A poisoning in a *Homo erectus* female, possibly as the result of consuming a carnivore's liver. This is a debilitating condition that causes the membrane around the bones (the periosteum), and the muscles that attach to it, to detach from the bone. As the disease progresses, it becomes impossible for the victim to walk or even stand. The clue as to the care this individual must

have received comes from an unusual type of "woven" bone that was deposited over her normal bone. When someone suffers from this condition, the tearing of the periosteum and muscles away from the bone causes blood vessels to break and bleed. The clotted blood then ossifies, and a characteristic woven-looking type of bone is deposited over the normal bone. The poisoned female had at least several weeks' worth of this kind of bone deposited over many of her bones. During this time, she would have been unable to walk or defend herself from predators. A sick or incapacitated animal usually does not last a day on the east African landscape. Her survival for a number of weeks means that someone cared for her, brought her food and water, and defended her from predators night and day.

Does the level of caring implied by the cases of the toothless male and the poisoned female indicate a level of humanity that might be apparent when standing face to face with a member of this species? Possibly it does to a degree, but we must stop short of thinking of these beings in fully human terms. Most definitely, they were not just like us. There are aspects of the archeological signal of their behavior that are very different from those left behind by modern human societies. We modern humans are restless and innovative. We cannot hold still and we change everything we touch. Change is our constant, and this can be seen when tracing the archeological record of a modern culture through time. It can also be seen in geographic patterns of cultural diversity: when a human group splits into two, both subgroups continue to change in individualized ways, and very soon there are cultural differences.

Although there is some variation, the archeological record associated with *Homo erectus* does not indicate a modern degree of cultural change. Instead, stone tool form, especially that of the hand axe, remains nearly the same for generation upon generation, through hundreds of thousands of years. And geographic variation in hand axe form is minimal across three continents. This makes a stunning contrast with modern human culture, implying a lack of innovation or a resistance to change that is mind-numbing to consider. Adding to this picture is the fact that symbolic behaviors like art, music, and body ornamentation still lie very far in *Homo erectus*'s future, banners for other species to erect. This is one reason why it seems unlikely that *erectus* had anything like fully modern language.

One of my jobs, then, is to bring some of this into the pose and expression of the *erectus* female if I can—a feeling that, although she is human in many ways, physically and behaviorally, there is still something like an absolute barrier between her and us, an alien quality such that looking into her eyes with an expectation of humanity, perhaps generated by her human-looking body, would result in a feeling that something is very wrong, that something is missing. Much later, as I looked at her finished bronze form in the hall, I was satisfied to feel this quality strongly; something in her somber metallic gaze strongly suggested a lack of the full package we think of as human. There is even a hint in her humorless gaze of Alan's "deadly unknowing."

There is resonance in what can be communicated about the plight of an individual at the moment depicted in a sculpture, something that makes the viewer empathize with her situation and feel something about what it would be like to be in her place. In this case there is her exertion to consider—the strain of carrying her heavy load. The visible veins in her arms and the tension in her muscles help with this. And her body is bent to some degree under her burden. The Smithsonian's Rick Potts and Jenny Clark had reacted to the first of my drawings of the pose by enthusing that it reminded them of women they had seen carrying heavy loads along roadsides in Kenya.

Intense as the strain is, it is not the largest part of what she's feeling. She is quite aware that she is doing something very dangerous. She is carrying a bloody, odiferous piece of meat through lion, hyena, and saber-toothed cat country. The more I thought about it, this was an act of desperation, a really insane thing to do. And yet we know it was something that was done again and again; it was a way of life.

I tried to imagine something this dangerous as part of everyday life. It reminded me of something I had seen the summer before I began building the figures. During our trip to Kenya in summer 2008, Loren and I were fortunate to have arrived at Masaai Mara at the front end of the wildebeest migration. No film footage I had ever seen had prepared me for the drama of this event. The wildebeests gathered by the tens of thousands on one side of the Mara River, knowing they must cross but hesitant to do so. We counted five very large Nile crocodiles waiting in the river or on its banks. As more animals kept pouring over the horizon, the tension built to an incredible level. The hippos in the river were noisy and restless. Though not directly affected by the drama, they seemed to feel the tension nevertheless.

Finally one of the wildebeests jumps in and the waiting is over. Hordes begin plunging into the water, some from high places on the river-bank. Their swimming is awkward and desperate, the whites of their eyes showing. Confused animals, having reached the other side but separated from their mothers or offspring, turn back and recross. The crocodiles are all in the water now. We see one wildebeest go under but the action is mercifully hidden from our eyes by the frothy brown water.

A desperate act, but one repeated each year. And in order to survive, the similarly desperate act of carrying an odiferous, bloody carcass through predator country had to be repeated many times by *Homo erectus*. The question for me was: Was there a way, along with the other themes, to get that kind of desperation into the expression and posture of the *erectus* female? I imagined her sweating under her load. A strand of her hair falls into her eyes. Blood and juices from the carcass are *streaming down body and legs. The sound of flies buzzing is maddening. It's hot, way too hot to be doing this. But far worse is what's out there, or might be. If I can just get this to the cutting place . . .* For a moment I am there in her place, a bright African landscape reflected in my sweat-squinted eyes, and a feeling of dread so strong I can feel a weight in my chest. In my vision of her, her expression is serious, absolutely without humor, her eyes full of some kind of life-or-death awareness of what might happen to her. I file this away, along with the other qualities I wanted in her gaze, hoping that I can infuse the sculpture with them when the time comes.

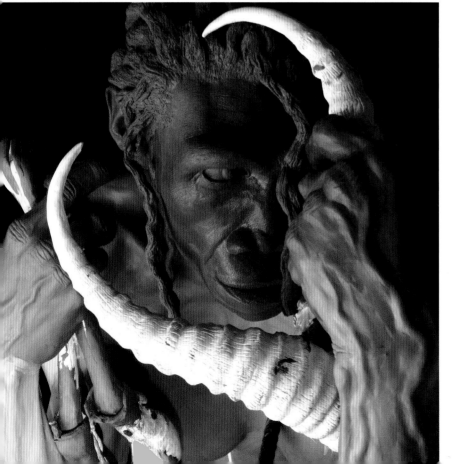

Close-up of the final clay figure of *Homo erectus*, carrying the antelope carcass.

Eleventh Hour Inspirations and a Final Surprise

The antelope chosen was the one suggested by Briana Pobiner, a prehistoric relative of the modern springbok known as *Antidorcas recki*. Paleoartist Mauricio Anton had published a pencil-drawn reconstruction of one, and I built a three-dimensional model that followed the proportions of his reconstruction. Rick and the team had expressed two concerns. First, they thought the antelope might be too big and would swamp the gestalt of the sculpture, stealing its intended emphasis on the hominin. There were suggestions that I use a female or a young animal. Because these would lack horns, I opposed these ideas, campaigning for a small adult male with beautiful spiral horns. I felt that the sculpture's plan already had lost aesthetic ground by sacrificing the warthog and that, if possible, it shouldn't be allowed to slip further. *Antidorcas recki* is slightly smaller than the modern springbok. I thought the size of the carcass was perfect: large enough for this to be a desperate, straining, hot, sweaty endeavor, but not so large that it dwarfed the *erectus* female. This time I won the argument, and some of the most powerful images of the final bronzes taken later are close-ups of the head, arms, and hands of the *H. erectus* female cradling, and entwined with, the curves of the antelope's horns.

The team's other concern was to make sure that the carcass looked dead enough. Some early drawings showed a hominin with a small antelope carcass carried in a position common among hunter/gatherers of today, on the shoulders and back of the neck, with forelimbs on one side of the hominin's neck and hind legs on the other. It looked too cuddly, like a pet. Making sure it looked dead? I thought I could handle that. It helped to be dealing with an eviscerated carcass. The decision to portray it skinned went a long way to further this impression. And the legs could be made to dangle stiffly off of the *erectus* female's back. Bodily fluids could be made to run down her body, and chunks of tissue ("Stop," you say?) could be included in the streaming liquids. At one time I considered including flies on the carcass ("it often happens that the uglier a being is in nature . . ."), but I wasn't sure that it could be done convincingly in bronze and I abandoned the idea.

I was to have one more surprise before the *Homo erectus* female was done. *Homo erectus* foot bones are rare, and we have nothing like a complete foot skeleton for this species, even in composite form. Many of the bones of the foot are still unknown for the species. Upon what basis could I establish the form of the foot? One possibility might be to assume that the foot has essentially a modern shape, as does the rest of the body below the neck. But I couldn't help wanting to base my decisions about the morphology of the foot on something more solid.

I thought of a different path, although an indirect one. The discoverers of the species represented by the tiny skeleton (known as the Hobbit) found on the Indonesian island of Flores proposed that it was a dwarfed descendant of *Homo erectus*. The nearly complete foot skeleton associated with the find has primitive proportions, with the lateral toes a good deal

longer than the big toe. If *H. floresiensis* really was a descendant of *Homo erectus,* there are two possibilities: that *erectus* had similarly primitive foot proportions or that *erectus* had more human-looking feet and *H. floresiensis* reevolved primitive proportions. I thought the former more likely, and I thought of a quick and dirty way to test it. One of the Dmanisi skeletons, thought by many to represent a primitive form of *Homo erectus,* preserves a first (big toe) metatarsal and a fourth metatarsal from the same individual. The ratio of the lengths of these two in the Flores skeleton reflects the relatively shorter big toe in this species, and I wondered whether this ratio would suggest the same for the Dmanisi individual. No lengths for the bones were given in the literature, but I measured a scaled photograph of the two bones that appeared in one research paper, and the ratio of their lengths turned out to be closer to that of the Flores skeleton than to those of the modern humans in my small reference sample.

Lacking any such remains from African specimens, I decided to follow this speculative path and reconstruct the *erectus* female's foot with a big toe that was slightly shorter than the lateral toes. Although the evidence was indirect, I was happy, even a bit smug about having found any evidence-based path forward at all. I had no sooner implemented this path than a research paper was published showing that I was wrong.

The first footprint trail for east African *Homo erectus* had been discovered, and the toe proportions were like those of modern humans. This time I really did have to backtrack on the figure, taking a chisel to the toes. The result was a modern-looking foot.[4]

Only a few weeks before finishing the sculpture, I had a late flash of inspiration about a way to further represent the theme of adaptation to climatic variation in *Homo erectus.* I had been working on the bases for all of the sculptures, and I was pondering what texture I should use for the ground beneath the *erectus* female's feet when I was struck by a solution that immediately seemed the obvious choice: mud cracks. It seemed a perfect way to reinforce the theme of climatic variability, by showing a surface texture that forms only when a sediment is wet, then dry. Moreover, by showing the *H. erectus* female passing over a localized minienvironment that is now dry, I could reinforce the theme of adaptation to arid environments suggested by the projecting nose.

As with the other hominin figures, I spent long hours with this sculpture, which provided lots of time to think as my fingers worked her surface. Some further ideas about details of her narrative found their way into the sculpture. Those who are able to find them will know a bit more of this individual's story.

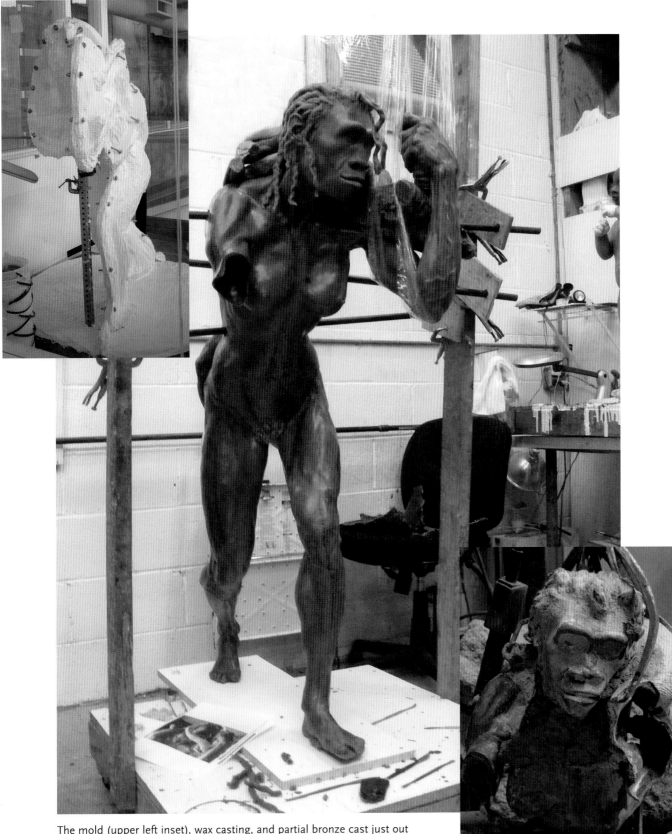

The mold (upper left inset), wax casting, and partial bronze cast just out
of the mold (lower right inset) of the *Homo erectus* figure.

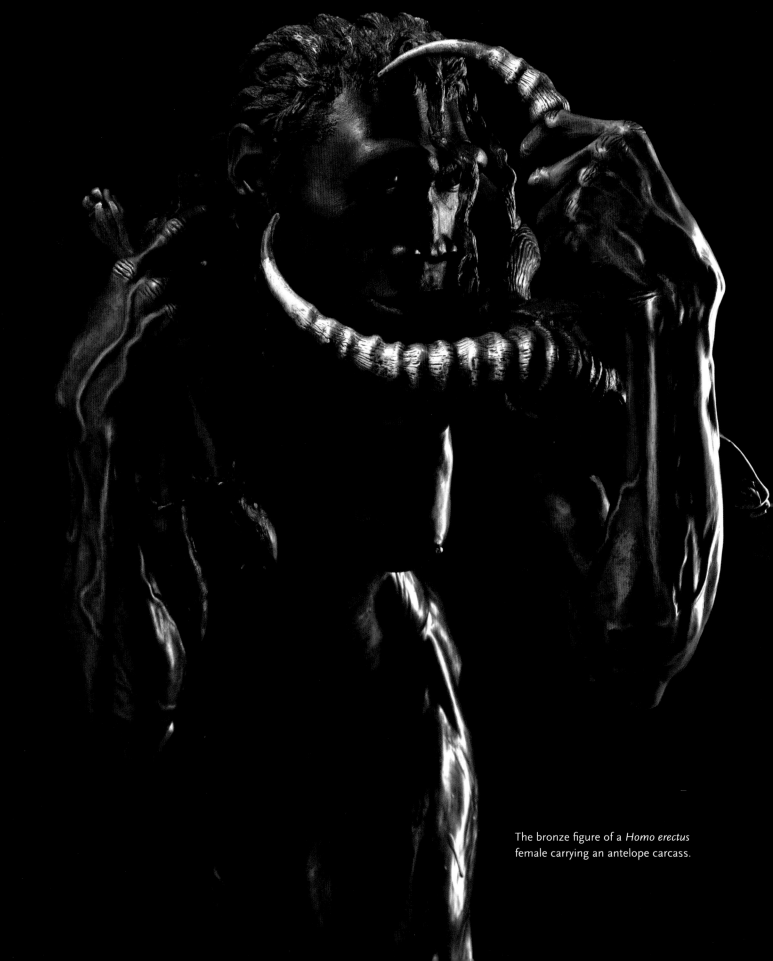

The bronze figure of a *Homo erectus* female carrying an antelope carcass.

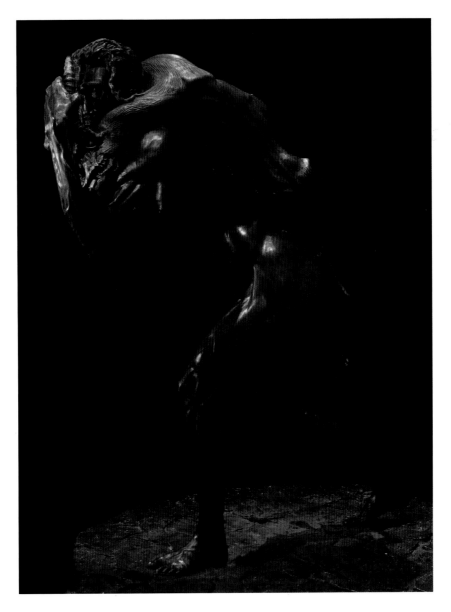

End Notes

When the noise and busy movement of the day cease at the museum, the bronze female *Homo erectus* stands silent and still. Sculptures often have the seemingly paradoxical quality of representing movement with a form that is static, a kind of single frame that implies the rest of the movie. The Smithsonian's *Homo erectus* female is a snapshot that implies travel. It is also a single frame in a series of images representing our understanding of this species. That this understanding is still in a state of flux is indicated by the fact that almost every new find brings with it surprises, indicating morphology or behavior that the current model hadn't anticipated.

Presently, *Homo erectus* represents the first time we see together in one species a number of features and behaviors we consider human. This includes an enlarged brain, a reduced face with a projecting nose, and the first body with human proportions. It is the first known hominin in the fossil record that is clearly adapted to climate like modern humans are, and it appears to be one of the first obligate tool-using carnivores in our lineage. These qualities seem to be linked in a web of interrelated adaptations in this built-to-travel social carnivore, and most of them are evident or hinted at in the sculpture. Although it is getting dangerously close to a progressive view of evolution, it is tempting to regard this as a creature with expanded capacities: increased ability to adapt to varied environments, expanded social behavior, and increased brain power in comparison to earlier forms. Is this an accurate picture? As current debate indicates, questions remain. And as we deliberate, erosion is doing its steady work under African and Asian skies, at sites known and yet to be found, uncovering answers that will bring our image of *Homo erectus* into sharper focus.

We are now at a point in time that is only 1.5 million years before the supposed time of the outlandish descendant described by the Smithsonian team we met at the six-million-year point, at the end of chapter 1. We have come three-fourths of the way through time from that point, and here, for the first time, our disbelief about that bizarre development falters, and we wonder if it might be possible after all. This is partly because we've now seen a dramatic increase in brain size—more than double that of Sahelanthropus—and partly because the record for Homo erectus bears suggestions of social connections among individuals that seem beyond those of most other mammals. The use of a rudimentary technology and the control of fire by this animal to adapt to varied environments is impressive. But the development of a world-changing culture and technology still seems a long way off, especially with only a quarter of our journey through time remaining.

Chapter 6

A SYMBOLIC ANIMAL

Homo heidelbergensis (0.7 to 0.2 million years ago)

A 600,000-year-old-skull found at the site of Bodo in Ethiopia bears cut marks made with a stone tool where someone removed the soft tissue of the face. We have no indication of why or what was in the mind of the hominin wielding the stone tool. But this behavior hints that something had changed for members of the human lineage.

About 300,000 years ago, over thirty human bodies were dropped into a deep hole in a cavern at the Spanish site of Sima de los Huesos (Pit of the Bones). Is it possible that this behavior signals an increased awareness of death? The team that found these remains interpret the find as evidence of a funerary practice, a way to venerate the dead. It is perhaps a prelude to the practice of burying the dead, common with Neandertals who would later occupy this region. One question on everyone's mind about these finds is: were these symbolic behaviors that imply belief in some kind of continuance of human life after death, perhaps in an afterlife or a spirit world?

Humans are the only animals that know they will die, that everyone dies. This knowledge is a heavy burden that brings with it a host of questions and fears. Not knowing what lies on the other side of death appears to be an unacceptable condition for most human groups, which have mythologies and rituals to deal with such unknowns and to make the knowledge of mortality bearable. These include funerary practices such as ritual treatment of the dead and can include burial, de-fleshing, or ritual cannibalism.[1] Such rituals are considered fitting ways to treat the dead, and if these are not observed, there will be consequences. Ritual treatment of the dead may represent the "proper" way to guide a soul to the spirit world, to absorb something of an individual consumed, or to make sure the dead stay dead and don't trouble the living. Among some Christian groups, the lack of a "good Christian burial" brings unease and disquieting fears of a soul not at rest. With present methods, we cannot know the meaning of the defleshed skull at Bodo or the accumulation of bodies in the Pit of the Bones, but these are the first hints in the record of special treatment of the dead.

The Bodo and Sima de los Huesos remains have been attributed to *Homo heidelbergensis*. There are

other hints of symbolic behavior from the time range of this species, between 700,000 and 200,000 years ago. Like the evidence for special treatment of the dead, these show us only part of the picture, leaving us mysteries to ponder. A series of parallel lines engraved on a straight-tusked elephant bone from layers dated to 350,000 to 400,000 years old at the German site of Bilzingsleben may indicate symbolic behavior. Pieces of red and yellow ocher (mineral pigments) have been found at many sites representing this time period in Europe and Africa. Some have flat areas where they have been rubbed on a soft surface. Were they coloring animal skins? Each other? Grindstones for processing pigments are known from at least 250,000 years ago. These finds represent the earliest known use of pigment by humans, and are thought by many to indicate early symbolic behavior. Alternative practical explanations, such as the use of colored earth in tanning hides, have been offered, but in some cases a wide range of colors appears to have been chosen, making these seem less likely.

In layers over 230,000 years old at the site of Berekhat Ram in the Golan Heights a stone was unearthed that has a natural shape like a chunky female body. That this was recognized as such by hominins of that time is indicated by closer examination: someone has incised lines into the stone which emphasize and outline parts of the body.

Nothing resembling these behaviors has shown up in the record for *Homo erectus,* the presumed ancestor of *Homo heidelbergensis.* Taken together, they give us strong hints that something was different for humanity by this time. Were these the first people to hear voices in the wind?

There are anatomical signs that developing speech capabilities might be part of the picture of this species' ability to use symbols. Hyoid bones (a U-shaped bone in the throat that supports the vocal apparatus) known for *H. heidelbergensis* suggest a humanlike vocal tract. Anatomical features of the skull's ear region suggest special sensitivities to the high frequencies humans use in producing some consonants. Diagonal scratches on teeth found at Sima de los Huesos were made by stone tools as they were used to cut something (probably food) that was clamped in the front teeth. The direction of the scratches clearly indicates handedness (95 percent were right-handed), suggesting a humanlike degree of lateralization in the brain, and this is thought by some to be linked with language.

Symbolic behavior is a vital part of human culture. Modern humans live in a world where nothing is merely itself. Even our day-to-day landscapes are imbued with music and peopled by phantoms. Superimposed on the strictly physical world is a multilayered veneer of symbolic meanings. These may include religious and aesthetic meanings and may have subconscious dimensions. They often incorporate fragments of symbolic "mirrors" that reflect an individual's identity within a human group or his/her relationship with the larger cosmos. It sometimes takes some effort and some objective distance to see the symbolic levels of an everyday activity. Symbolic layers may be so much a part of our conception of a given behavior that when it is described in a stripped-down way without its symbolic context, we do not recognize it. The late Kurt Vonnegut was especially good at this kind

of objective distance. In one passage from his novel *Breakfast of Champions* he writes: "I sat in a Plymouth Duster I had rented from Avis with my Diner's Club card. I had a paper tube in my mouth. It was stuffed with leaves. I set it on fire." It takes us a moment to realize that he's talking about smoking. We have so overlaid this behavior with symbolic meanings that when they are removed and the behavioral elements are described simply, we don't initially recognize it. We humans are symbolic beings. We have no choice but to be. Although the details are not available to us, hints in the ancient record suggest that *Homo heidelbergensis* had begun the first journeys into a symbol-haunted world.

A Landscape Busy with Ghosts

If you walk the landscape at the Kenyan site of Olorgesailie, you often cross paths with the ghosts of *Homo heidelbergensis* individuals. You find traces of their behavior: objects they made, especially stone tools. No fossil remains from this species have yet been found there, so they are like an unseen presence, and you are left to deduce what you can about their adaptations and behavior from what they left behind. Important in the mix is the record of environmental change preserved in the sediment.

In the eroded outcrops at Olorgesailie are thick sequences of white sediment, sometimes blinding in the full light of day. These are largely made up of the skeletons of geometrically shaped microorganisms called diatoms, the kinds of which vary with the environment and so can provide clues to past conditions. These tell a story of environmental variation during the time in which

Homo heidelbergensis lived here. The diatoms lived in lakes that strobed in and out of existence in this area, and the story can be followed through the thick layers of sediment, recording thousands of years of environmental change.

Rick Potts and his colleagues who work at Olorgesailie pay close attention to these records, leafing through the strata like the pages of a vast book. They have found evidence of an oscillating climate, and of evolutionary responses to it by the organisms preserved in the sediments as fossils. The shape of the teeth of fossil herbivores and plant pollen found in the sediment offer additional clues about environmental change. Elsewhere evidence from ocean floor sediments gives clues about how much water has been locked up in ice sheets at various points in earth's history, and to what degree aridity has allowed volumes of dust to blow into the sea.

Rick's theory of variability selection, which has emerged from studies at Olorgesailie and elsewhere, suggests that in response to this kind of environmental variation, adaptability was favored in hominins over specialization to any single environment. If he is right, it is in this context that human cultural capabilities emerged. With the origin of human beings, nature has responded to this kind of selection by producing an organism with the cognitive capacity for creating a new kind of extrasomatic evolution: cultural evolution. With its versatility and ability to adjust rapidly to changing or unpredictable conditions, this potent adaptation makes humanity earth's most adaptable mammal.

Sediments at Olorgesailie from the time of *H. heidelbergensis* preserve snapshots in the

development of the human animal, recording some of the first traces of symbolic behavior. When my son, Loren, and I visited the site in the summer of 2008, we found stone tools, made presumably by the hand of *H. heidelbergensis,* littering the landscape. John Yellen spent a morning giving us a tour of the exposures, and schooling us in what to look for. Loren, then eleven and already a veteran of dinosaur and mammoth digs in Colorado, was all ears, and it didn't take him long to develop an eye for finding these stone tools. He scampered up and down slopes, locating artifacts and fossils more quickly than his adult companions (I am an active adult, but I no longer scamper). Some of the tools were of a fine-grained, creamy, gray-green material. Scientific interests often have an aesthetic dimension for young people (and, I would argue, for many professionals as well), and Loren found these very beautiful. I couldn't help wondering whether the choice of stone by *H. heidelbergensis* individuals reflected something similar in the minds of these toolmakers, the first hominins we know of that are associated with behaviors that may indicate an aesthetic sense.

Loren's eye is incredible, and toward the end of the morning he discovered a new site. Following a cascade of worked stone up a hillside, he located the sedimentary layer that was their source. Tracing this layer laterally, he found more worked stone, along with fossil bone and lumps of mineral pigment embedded in the sediment. The site became officially known as "Loren's Site."

At this writing five years later, the site has yet to be excavated. What may lie under its cap of protecting stone? At the very least, some of the earliest traces of earth's first symbol-using animal, caught in the act of developing a new formidable tool with which to address environmental change: human culture.

Who Was *Homo heidelbergensis?*

For some (notably the lumpers) this hominin group is modern enough to be included in our species, and it is referred to by them as archaic *Homo sapiens.* Dramatic brain enlargement occurring between 800,000 and 600,000 years ago (near the beginning of the time range of *H. heidelbergensis*) brought brain size to a range overlapping that of modern humans, with some individuals near the modern average. This is perhaps the strongest argument for including these individuals within our species.

H. heidelbergensis skulls differ from those of modern people in having thicker walls, larger and more projecting faces, and well-developed brow ridges. For some researchers, fossils such as the Bodo skull and the Sima de los Huesos remains are too archaic and too different to be included in our species, and they group them under *Homo heidelbergensis.* For a few, even this group should be further divided into two or more species. The Smithsonian team took a middle road and considered the group to represent a single, variable species: *Homo heidelbergensis.*

According to this view, *H. heidelbergensis* was a widespread species, occupying parts of Africa, Europe, and Asia between 700,000 and 200,000 years ago. There may have been gene flow between continents, but a degree of isolation of populations in different continents is indicated by evidence that European and African populations

evolved in different directions, eventually founding the first populations of Neandertals and modern humans, respectively.

Physically, some *H. heidelbergensis* individuals are the most massive-bodied in the human fossil record. The thick, bony walls of their limb bones, strongly marked muscle attachment sites, and very broad pelvic bones suggest large, powerfully built bodies for some of them. This implication is echoed for some *H. heidelbergensis* individuals by the large size of joints which are, in living humans, highly correlated with body weight.

H. heidelbergensis has added a few more modern features to the bauplan visible in its presumed ancestor *Homo erectus*. The shoulders have modernized. Gone is the peculiar combination of low-torsion humeri and short clavicles, implying more forward facing shoulder joints in some more primitive hominins. Modifications in the pelvis allowed the birth canal to be enlarged so that a larger-brained fetus could pass through.

Was the increase in the size of the brain in this species over that of *Homo erectus* accompanied by cognitive advances? Certainly hints of the first humanlike symbolic behaviors would imply this. But at first glance, a look at stone tool typology might suggest that not much alteration has occurred between the tools of *Homo erectus* and those of early *H. heidelbergensis*. The same types of tools (hand axes and cleavers) were still being made generation after generation. The evidence for change is faint.

A closer look, according to some archeologists, reveals some significant improvements in the way stone tools are made, even if the types

of tools seem constant. One stone tool method invented during the time of *Homo heidelbergensis* is notable because it involves advance visualization of the tool. This prefabricated tool method, called the Levallois technique, involves shaping a tool while it is still attached to the stone core, then striking the result off as a finished tool. This technique gave the tools maximum edge per unit of weight. Manufacture of stone tools using soft hammers, perhaps made of wood, was introduced during the time of *H. heidelbergensis*. The use of soft hammers allows the production of thinner, sharper flakes. Tools made from long stone blades appear during this time as well.

During the time of later *Homo heidelbergensis*, a new type of archeological assemblage, called the Middle Stone Age, appears in Africa, replacing the hand axe–dominated Acheulean tradition in many places. Several new types of tools appear with the Middle Stone Age, including points which may have been hafted onto spear shafts.

Some authors have suggested advances in spatial cognition to nearly modern levels during the time of *Homo heidelbergensis*, even using the word Euclidean in describing their understanding of space. Bifaces (tools worked on both sides) generally become more beautiful during this period, at least to modern eyes. The earlier clunky hand axes are replaced by a wider variety of more carefully crafted and aesthetically beautiful tools that seem to go beyond what is necessary for butchering animals. This is another hint that something is changing in this lineage, perhaps involving a growing sense of aesthetics. Some have suggested that the conceptualization of two-dimensional symmetry used in the making

of *Homo erectus*–associated hand axes gives way to three-dimensional conceptualization in the time of *H. heidelbergensis*. This includes control of shape from a variety of viewing angles simultaneously, some of which (such as cross-sectional shape) cannot be seen from any viewpoint but must be imagined.

Advances in spatial cognition in *H. heidelbergensis* are also hinted at by sites that preserve indications of more structured patterns of land use. At the English site of Boxgrove, archeologists have been able to trace a paleolandscape for hundreds of meters. This ancient ghost landscape, superimposed over today's, offers hints of its use by early humans over a 20- to 100-year period some 400,000 years ago. On its north side, it was bounded by a cliff with fallen debris at its base that included numerous flint nodules. Here, a group of early hominins prospected for raw material. Usable nodules were carried away, some after being roughed out as hand axes. Others were discarded after a couple of flakes were removed and were found there by archeologists nearly half a million years later.

A few hundred meters away, a horse had been butchered. Near the remains of the horse were ten individual flaking stations, each recording where a stone tool was made. When each collection of flakes is fitted back together, a hand axe–shaped hollow is left in their middle. The hand axes themselves had been "curated," or carried away. At another point on the paleolandscape was a pond, and at its edge was a scatter of bones of a number of butchered animals, along with hand axes and flakes, indicating that carcasses were brought here multiple times to be butchered.

Archeologists have suggested that this pattern represents a structured approach to use of the landscape, which includes both longer-term butchery stations and other places where a single animal was butchered and the tools then carried away, suggesting that the hominins did not intend to return.

Also from Boxgrove is another clue that may reflect an advance in cognition. At one locality, a *Homo heidelbergensis* individual flaked a core in order to produce a hand axe. But (s)he appears to have been simultaneously optimizing features of the flakes themselves, and keeping an eye out for the best ones. When archeologists fit the cast-off flakes back together again, there was a hand axe–shaped hollow at its center, but also hollows for the thinnest and sharpest of the larger flakes. This individual was doing something cognitively new: engaging in an activity that involved keeping track of two goals at once. Some archeologists see this as requiring enhanced working memory, although they suggest that this "executive function" was not yet at modern levels.

Members of this species were capable hunters of big game such as horses, rhino, and large deer. Rare finds of wooden throwing spears, which are aerodynamically weighted like modern javelins, show a high degree of workmanship at around 400,000 years ago. Other wooden tools, such as an apparent wooden club and a plank-like form that was possibly used as a lever, offer rare glimpses into this mostly unseen branch of *H. heidelbergensis* technology. Such tools may have been common, but typical conditions at most archeological sites do not preserve wood.

If the evidence at localities such as Terra

Amata and Lazaret (two archeological sites in France) have been interpreted correctly, the first known shelters may have been constructed during the time of *H. heidelbergensis*. The earliest good evidence for well-made hearths also comes from this period. Living spaces seem to be organized into specialized activity areas at some sites. This is perhaps the earliest time that a hominin living site would look something like home to us. At least to those of us who go camping.

How Best to Characterize *Homo heidelbergensis* in Sculpture?

To the Smithsonian team and me, it seemed important to address new behaviors implied by the evidence for *H. heidelbergensis*. It would be easy to put the figure in a setting that included a hearth. How could we also imply that symbolic thought had entered the picture? I drew sketches of an idea that had begged me to paint or sculpt it for years. This image depicted the ritual defleshing of a head as implied by the cut marks on the Bodo skull. The head is in the lap of a hominin wielding a stone cutting tool and who has tears streaming down his face. I wanted it to be apparent that this was not an act of vengeance, and that it was not done casually. Obviously, the act had deep meaning for the hominin with the tool.

But this was a bit too grim for the mood of the hall. Rick's vision for the new hall emphasized making the subject personal and accessible. This was approached in a variety of ways, in order to provide a range of personal experiences for different learning styles. The silicone head reconstructions had to be as lifelike as possible; the visitor must see them as living, breathing beings, must expect them to blink. Bronze figures would be down on the floor so you could touch them and see them at eye level, as opposed to up on a pedestal or in a roped-off area. In both cases we wanted to make the interaction with the sculptures as intimate as possible for the museum visitor.

It was this way of visualizing the sculptures as interactive elements that set off a small detonation in my head in early February of 2008. I sent an e-mail to the team saying: "It has occurred to me that the hominins are all (we assume) social species, and that every social interaction is a dance. At first this train of thought led me only to a dead end: all but one of the sculptures is of a single individual, so where is the 'partner'? Then I realized that the partner could be the museum visitor. This could open up an exciting range of possibilities, and I look forward to some fruitful brainstorming with you about them."

Afterward, this approach seemed so obvious that I wondered why we hadn't thought of it before. I began to sketch vignettes of social interaction that could be completed by the visitor. These included sketches of a *Homo heidelbergensis* figure at a hearth, sitting on a stone with his arm positioned as if around someone, but without the someone—a vacuum waiting to be filled. Rick liked this invitation to the visitor to interact, and the positive emotional tone fit the hall better than the somewhat grisly alternatives for *H. heidelbergensis* I had sketched so far, dealing mostly with cannibalism and ritual treatment of the dead.

After much discussion the team decided that an arm hanging out in space would be a bit

too weird a pose for *H. heidelbergensis,* and the decision was made that he should be interacting with the visitor by offering food. Rick thought the human style of food-sharing was an important theme and, other than the *P. boisei* figure's harvested but not consumed plants, we had yet to address it in the series of figures so, in keeping with the interactive dimension, I had done sketches of various hominin species offering to share food with the visitor. It is a characteristically human behavior to refrain from immediate consumption of food when it is obtained, and to later share it with group mates. The social rules by which food and other resources are shared form part of the basis for social relationships. For example, the economic bond formed by the pooling of resources is part of the foundation of marriage in many cultures, including ours. In one of my sketches, an *Australopithecus africanus* offers a bushbaby (a small, lemurlike primate) it has impaled on a sharp stick. (This follows the discovery made by a team led by Iowa State University's Jill Pruetz that some chimpanzees hunt small mammals such as the bushbaby by poking sharpened sticks into hollows in trees.) There were also sketches of an *H. floresiensis* figure offering a rat. I always seemed to be coming up with visions a tad too dark for the hall.

Depicting food-sharing later in the evolutionary sequence was a better idea, as we could imply symbolic levels to the offering—that is, giving in a human way. If I could manage to pull it off, I could suggest in the pose that he is not merely sharing food as a chimpanzee might, but that in his mind he is honoring the recipient. A deferential, slightly obsequious tilt of the head, and a forward, almost eager lean into the act of giving might give the proper body language to communicate the symbolic complexity of his giving, which touches on the human social concepts of peacemaking and reciprocity. Would I be able to accomplish these subtleties? My system of lightweight, tweakable internal supports tied into solid external supports would allow a lot of fine-tuning once the flesh was on the bones. The drawback to this system was that the sculptures were too delicate to travel; the mold-makers would have to come to me. But this was in my view more than balanced by the advantage of not being locked into the pose of a more solid internal armature. Subtle changes could be made very late in the sculpture's progress. With delicate tweaking, I thought I could adjust the form to reflect the symbolic levels of the figure's giving, to add to the themes of hearth, home, and food-sharing.

(above) Two drawings of potential poses for *H. heidelbergensis.*
(right) The Kabwe skull, shown with the Mauer mandible
(both casts).

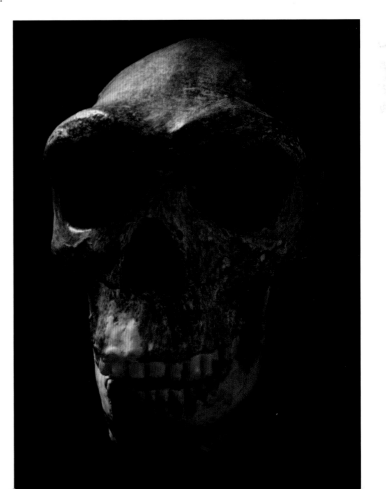

No complete skeletons have been recovered
for *Homo heidelbergensis.*[2] For the *H. heidelber-
gensis* bronze figure and head reconstruction, I
chose a set of remains from the site of Kabwe in
what is now Zambia, partly because the collection
includes both cranial and postcranial elements,
some of which may represent the same individ-
ual. Alternatively, I could have chosen to base
the bronze on a composite skeleton composed
of remains from Sima de los Huesos, but these
hominins are already starting to display some
features of Neandertals, and I did not want to
repeat myself in the series if possible. The Kabwe
remains lack a mandible, so I used the Mauer
mandible, the type specimen of *H. heidelbergensis*
found in Germany in 1907.

The Face of Mr. Heid

*And still the figure had no face by which he
might know it, even in his dreams . . . and thus
it was that there sprang up and grew apace in
[his] mind a singularly strong, almost an inordi-
nate, curiosity to behold the features of the real
Mr. Hyde.*

 —Robert Louis Stevenson, *The Strange Case
 of Dr. Jekyll and Mr. Hyde*

The study of behavioral and anatomical
clues goes a long way in satisfying our desire
to know an ancestor, even with their many
ambiguities and uncertainties. But still, the
ancestor remains something of an abstraction
until we can put a face to it. For me, the desire
to see the face of an ancestor is very strong; it
satisfies the need for connection in ways that
nothing else can. Here, science is the ally of
aesthetics. The more data-driven a reconstruc-
tion is, the closer one can come to confidence
that the face that results is close to the origi-
nal, and this fosters a powerful reaction that
can only be called an aesthetic response. Since
a reconstructed face is the cumulative result of
hundreds of anatomical decisions, it is often
true that, other than a general outline, the
final face is a surprise to me. So this process is
one of discovery.

Stages in the head reconstruction from
the Kabwe skull.

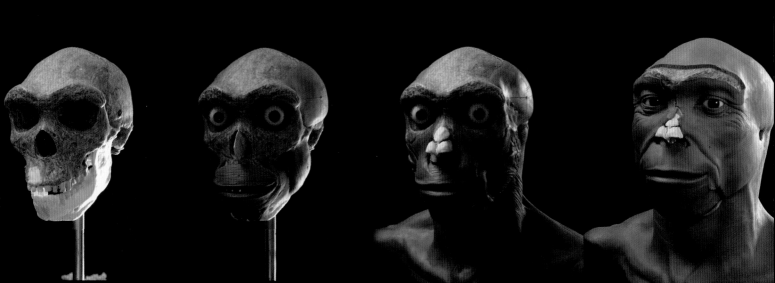

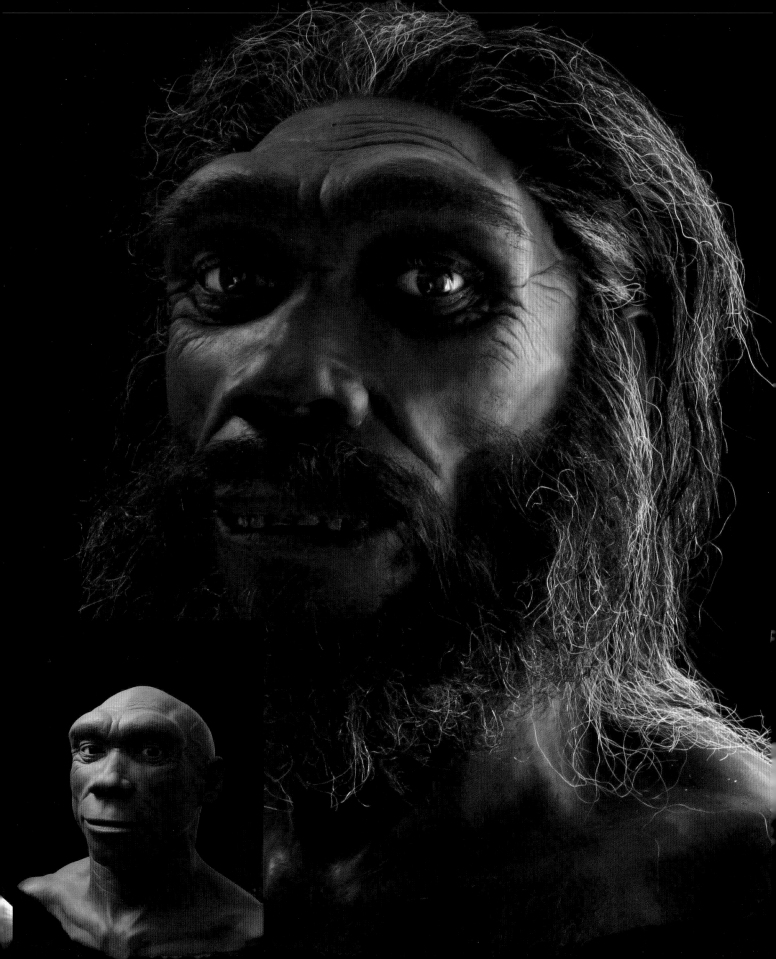

Many of the bony indicators used in my reconstruction procedures to predict soft tissue indicate, for the Kabwe skull and the Mauer mandible, features within the range of variation of living humans. Not that he could pass for modern; the brow ridges are more massive than in any living human, the forehead more sloped, the upper jaw taller, and the face more robust. But overall, when I had completed the *H. heidelbergensis* head, it looked human to my eyes. Unlike the situation with the *Homo erectus* head, this is true regardless of hairstyle. This hominin, the first in the Smithsonian series to have a brain size within the modern range and considered by the lumpers to be an archaic form of *Homo sapiens,* looks the part.

Body Building

As a basis for the bronze figure, I chose larger, presumably male trunk and limb bones from Kabwe to go with the robust male skull from the site. The tibia is the postcranial bone thought most likely to be associated with the skull, and it was used in estimating the body weight and stature for this composite individual. A gargantuan pelvis (which quickly acquired the name Elvis) discovered at the Spanish site of Sima de los Huesos is complete enough to allow measurement of the breadth of the hips, and this dimension is so extreme that few anthropologists would have accepted it if it had been proposed hypothetically before the time of its discovery. The work of Johns Hopkins University's Chris Ruff and his colleagues has shown that, although pelvic breadths in *Homo heidelbergensis* may be broader than in modern humans living in similar environments today, they seem to vary with climate as ours do, with wider bodies in colder climates. The fossils from Kabwe include a sacrum and two pelvic bones, but these are not complete enough to allow a solid measurement of pelvic breadth. Chris Ruff had published breadth estimates for the two pelvic bones, and I used the larger of these, which is also within the range of prediction by paleoanthropologist Erik Trinkaus.

The work of Chris and others has shown that variation in body shape and size within a population can be modeled as an elliptical cylinder which maintains a constant surface area to volume ratio as it varies in length (stature) by keeping breadth more or less constant. Even though the pelvic bones probably come from different individuals than the skull and tibia, the breadth of the pelvis would not be expected to be very different, according to this model.

The lack of a partial skeleton of *H. heidelbergensis* posed a challenge, as it was not possible to measure bone lengths that would enable proportional studies for a single individual. The length of the Kabwe tibia served as a starting point for my educated guesses about body proportions for tropical, African *H. heidelbergensis*. Since earlier tropical hominins in our lineage (the Narioko-tome boy) had been shown to have adapted to heat stress with limb proportions like those of today's tropical Africans, I felt that they were a good bet for tropical *H. heidelbergensis* also, as it is widely thought to be an evolutionary intermediate between *Homo erectus* and *Homo sapiens*. I used means of recent African populations to calculate the lengths of the other limb bones from the Kabwe tibia. The result was a large individual. From other sites, nearly every skeletal element is known for *H. heidelbergensis,* and these helped me complete details of the skeleton over which the body would be built.

Reconstructed composite skeleton of *H. heidelbergensis*.

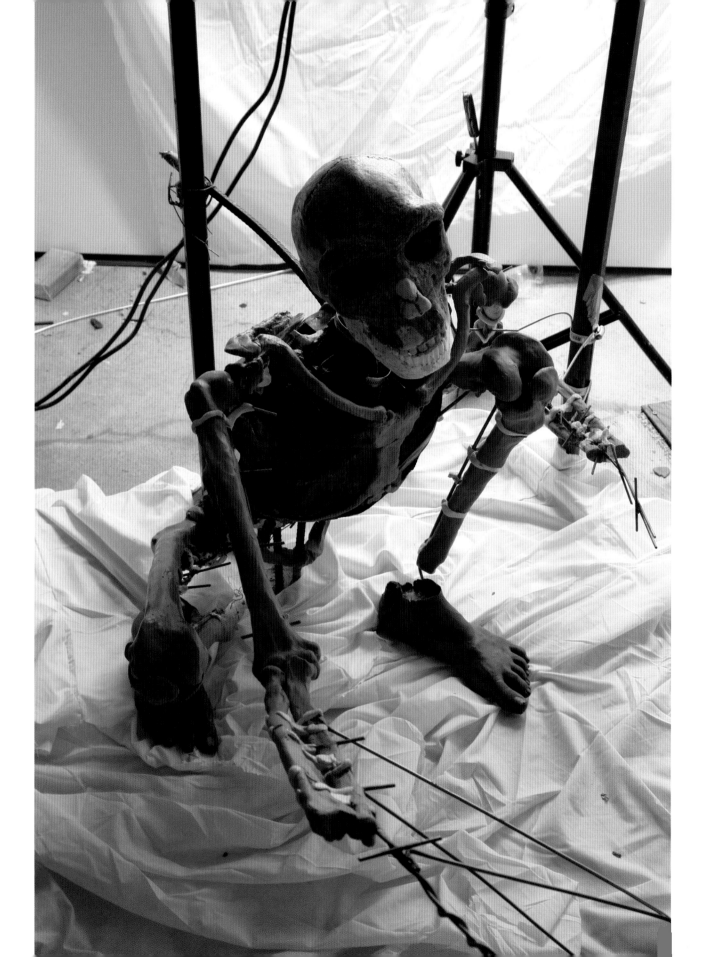

The length of the hand relative to other body elements cannot be accurately calculated for any specimen of *H. heidelbergensis*. Swiss anthropologist Adolph Schultz showed decades ago that the hand scales conservatively with the length of the arm bones in apes and humans.[3] I used a human ratio generated from Schultz's figures to calculate hand length from the length of the bones of the arm. The resulting hands were large. Intending to cast hands from a suitably sized modern person, I began looking for a model. With the first few friends I checked (those who knew me well enough to let me measure and potentially cast their hands) I found no match—they were all a little too small. It became thing number 427 on my list of things to do for the Smithsonian project: *find someone with suitably sized hands to cast for the H. heidelbergensis figure.* My quest remained unresolved for a while as I worked on other parts of the project. Then one night, as my family and I were eating at a local restaurant and I was thinking about other things, I suddenly became fixated on the waiter's hands as he put food on the table. They were quite large! I looked up at his face. I knew him! In fact we were once in a band together. Those hands had played bass to my drumming. Together we had once been the rhythm section of the Peter Novelli Blues Band. His hands turned out to be perfectly sized, and I asked him if I could immortalize them by putting them in the Smithsonian. He enthusiastically agreed, and I made a mold of them. With some alterations in posture (some finessing was necessary on the hands for all of the figures) they were incorporated into the figure.

Early on in the design of the *Homo heidelbergensis* figure, the hand not offering meat (the left hand) was planned to be cupped and holding a few berries. This was to acknowledge that, although plants are less visible in the archeological record, they are an important part of a hunting and gathering way of life, often making up a higher proportion of the diet than meat. Two years later, when the figure was being constructed, Rick Potts had forgotten this detail and, on seeing photos of the developing sculpture with cupped hand but still without berries, commented that he liked the cupped hand's unconscious position of receiving as a subtle acknowledgement of the two-way street that such giving involves. I was stunned. This was so much better than the nod-to-plants-in-the-diet message! It was, I felt, the perfect thing to indicate the symbolic act that was being represented here, an implied social reciprocity that was even better than the head's position, better than the body's forward lean, better than any other postural clue I had come up with for indicating how symbolic and human this offering was. My normal, more honest reaction in such a situation would have been to remind him of the old message, but I felt this one was so much better. I was almost holding my breath, afraid of losing this message if I was asked to put the berries back. You can't say a thing like this to an artist and not expect him to love it. I didn't say a word about the berries.

Clay and plastic left hand of the *H. heidelbergensis* figure.

Muscle markings on many of the bones known from heavier individuals of *H. heidelbergensis* are quite pronounced, and the larger bones from Kabwe are no exception. The thick walls of the limb bones complement this picture of great strength. I added well-developed musculature to the skeleton. Foot remains from Sima de los Huesos and from the Chinese site Jinniushan indicate that anatomical differences between the foot of *H. heidelbergensis* and that of modern humans are very subtle and would probably not be visible externally. My own feet were the right size for the skeleton, and I used casts of them for the figure, but I had to change one detail. There is no evidence that *H. heidelbergensis* individuals made clothing or foot coverings—no skin-processing tooth wear or stone awls. The feet of modern people who habitually go shoeless have a small gap between the great toe and the rest of the toes. I had made such a gap in the feet of the other figures, and I altered the feet accordingly for this one. They still, however, look like my feet. In the feet and hands of the Smithsonian's bronze *Homo heidelbergensis* figure, the rhythm section of the Peter Novelli Blues Band lives on.

Hand and foot of the bronze *H. heidelbergensis* figure.

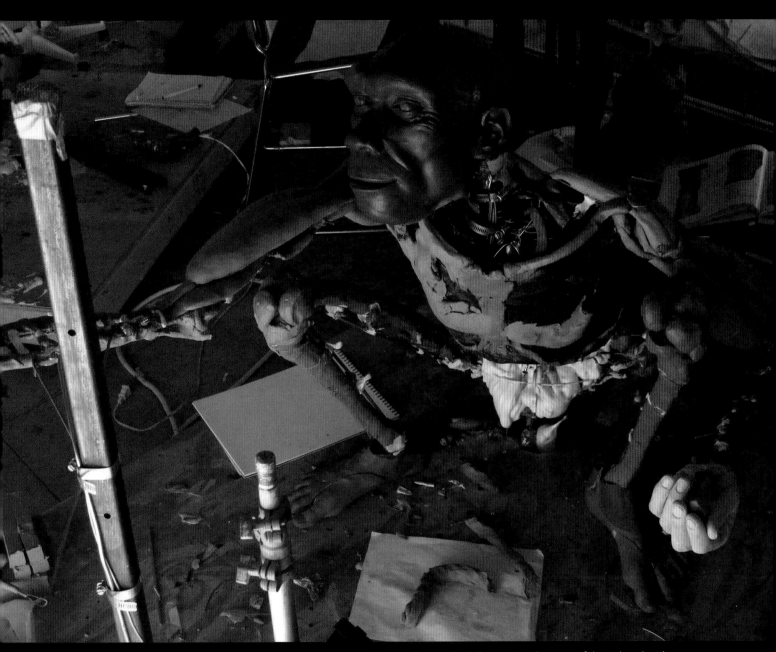

Composite skeleton of *Homo heidelbergensis* with a cast of the Kabwe head reconstruction, as well as hands and feet. The first muscles have been added.

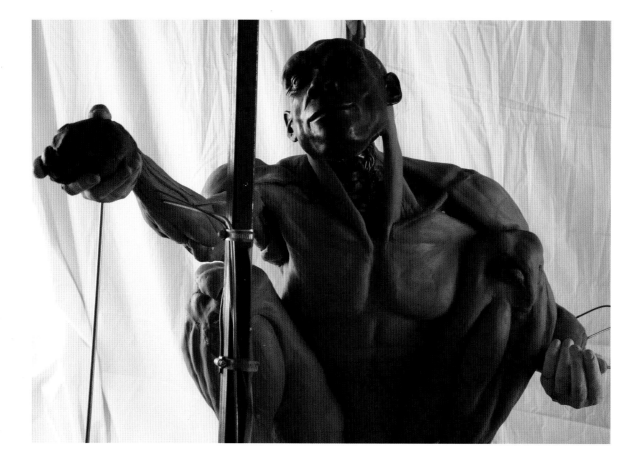

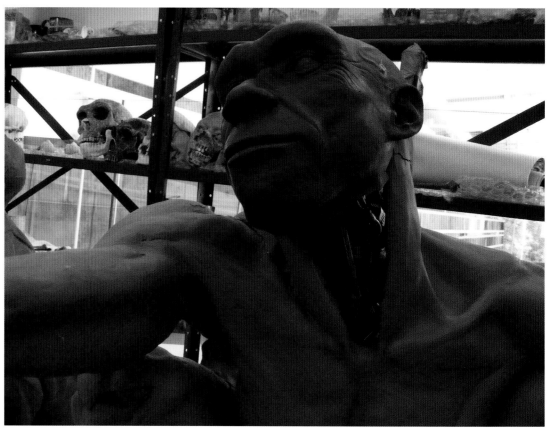

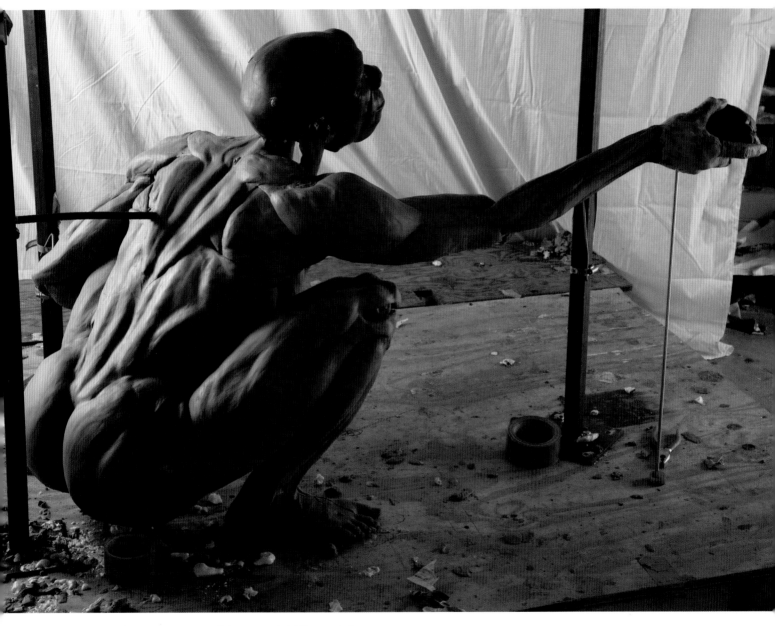

Muscular reconstruction of the *Homo heidelbergensis* figure.

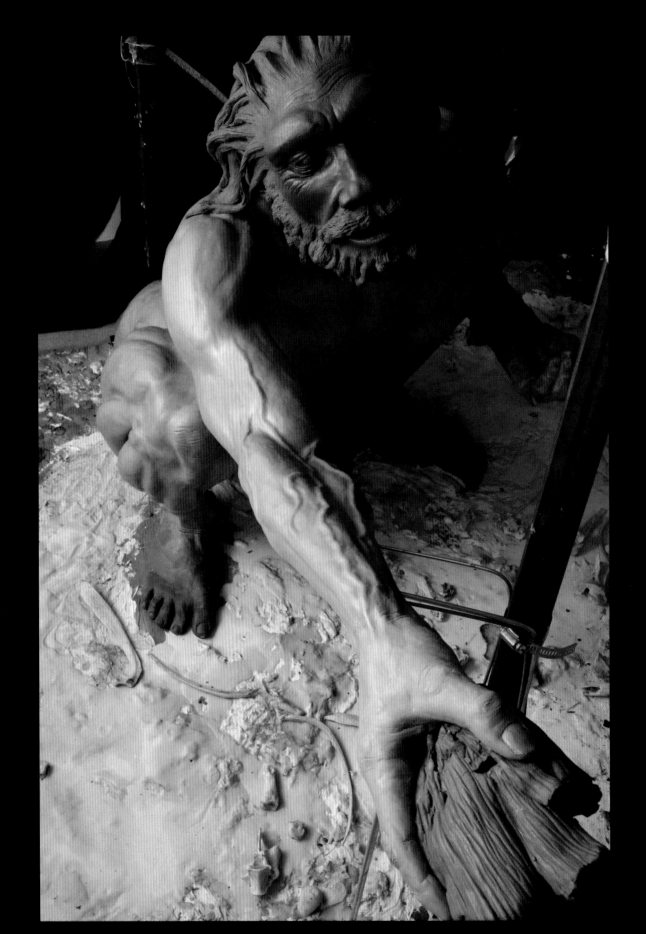

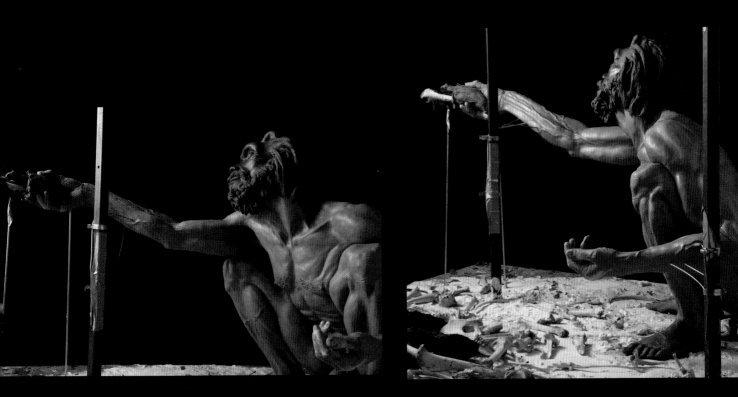

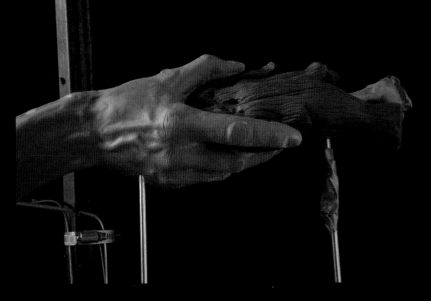

Final clay figure of
Homo heidelbergensis.

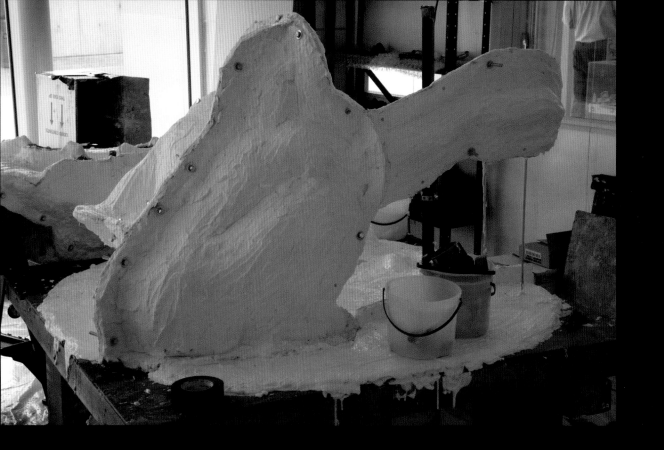

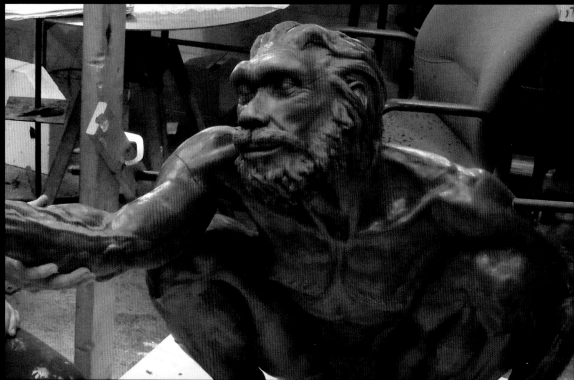

The two-part
(urethane and
plaster) mold of the
H. heidelbergensis
figure and the wax
casting made from
it.

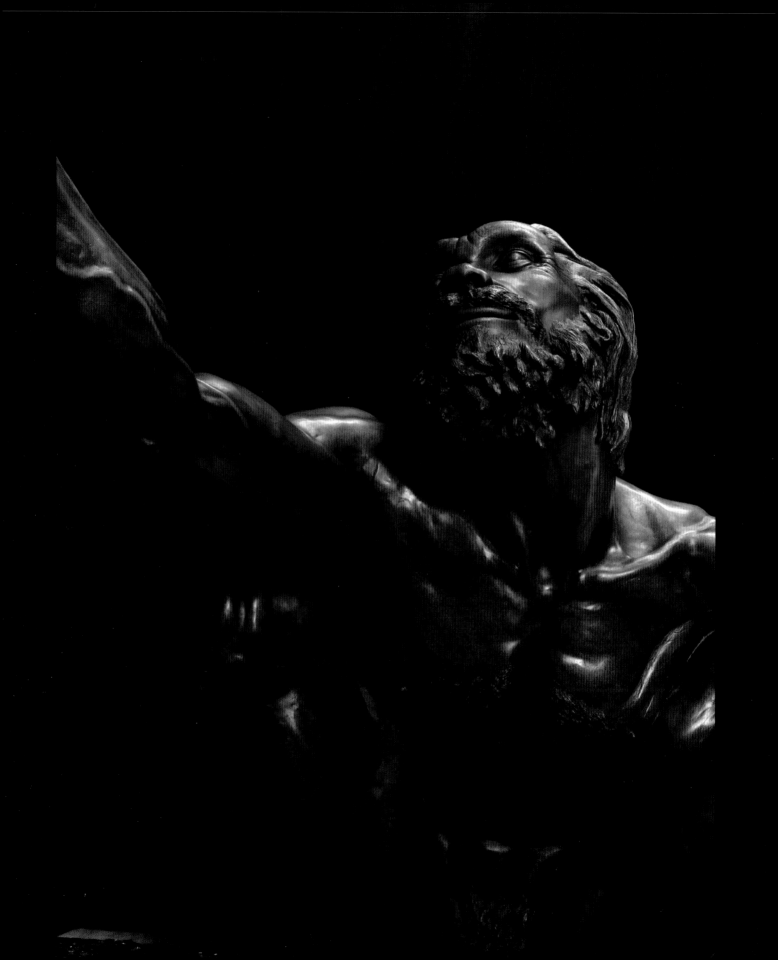

Bronze figure of *H. heidelbergensis.*

End Notes

To construct the setting for the figure, I created a hearth with casts of stones and burnt logs. I burned the logs with care, making sure to burn away any edges that bore the marks of modern tools. I was going for that patchy charcoal texture that is unmistakably identifiable as burnt wood. I then scattered a litter of bones around the hearth, as occurs at many sites. I wanted the figure's context to represent *H. heidelbergensis* as broadly as possible, so I needed bones of prey that would not be immediately identifiable as an inhabitant of one specific region or continent. Bones of European and Asian deer and African antelope have a very similar shape, so for my transcontinental artiodactyls (the order to which deer and antelope belong), I could use bones of either, as long as I stayed away from diagnostic

The bronze *H. heidelbergensis* figure in the Smithsonian hall with modern friend.

Accoutrements for the *H. heidelbergensis* figure. Charred logs are at left and scattered bones are at right.

parts such as complete skulls and mandibles. Careful scrutiny by osteologists (bone experts) would reveal the ones I used to be deer bones. If this choice, in conjunction with the figure's African proportions, ruins the sculpture's effect for a passing superobservant osteologist, I'm hoping this will constitute a very small percentage of visitors.

In our discussions about the *Homo heidelbergensis* figure, a number of nicknames spontaneously arose. For a while, some team members were referring to him as Heidi, but this always bothered me a little. When others began to call him Mr. Heid, it somehow seemed more appropriate. I think this is because, for me, this species has a dark side. While it is true that ritual defleshings or corpses dropped into a deep pit can be imagined in the most elevated of spiritual contexts, these can also be imagined as much darker behaviors as well (which are not necessarily any less symbolic).

If I approach the evidence as a scientist, I put no value judgments on these behaviors but interest myself only in what the evidence indicates

for the development of symbolic behavior. As an artist, I am aware of a lurking unease, and an ominous tone rings in the soundtrack of this part of the human movie (this tone is never again completely silenced). I may choose to depict this hominin pleasantly, but there is something here I don't quite trust. I can't escape the feeling that not far below the surface, there's something else, some darkness not quite seen. Although he is smiling and making every effort to appear pleasant, there is a lie here somewhere. This too would represent an aspect of complexly layered symbolic thought.

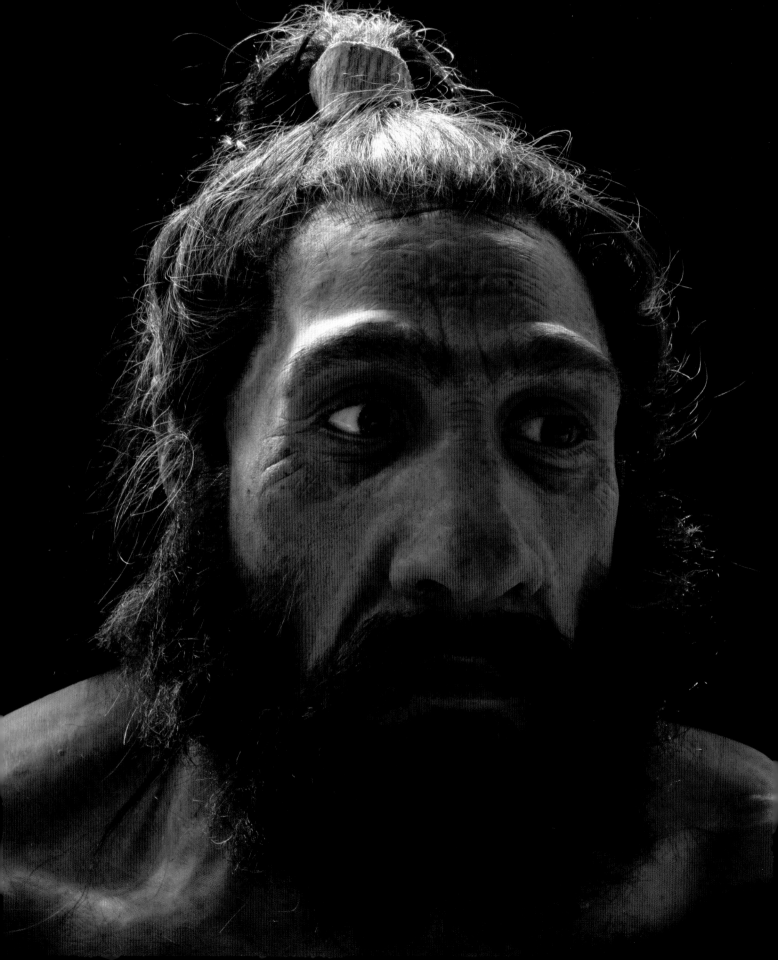

THE OTHER

Homo neanderthalensis (0.25 to 0.027 million years ago)

A New Hominin on the Landscape

The first two-thirds of human history is an African story. Hominins that lived during this time were, to various degrees, tropically adapted primates. When human groups expanded beyond Africa, perhaps two million years ago or just after, they encountered more intensely seasonal environments. Earth was at this time experiencing major oscillations in temperature, including cold periods that brought massive ice sheets across formerly temperate areas of Europe, Asia, and North America. Between these times of intense cold were warmer periods. The increased climatic variation brought new challenges for this unusual group of primates. How would they respond?

Human populations living in Europe during these times, beginning with their entrance perhaps 1.3 million years ago, were forced to ebb and flow with the ice. They were able to expand during the warmer interglacial periods, but when the cold returned, they either moved south or died out. During the first several major glacial advances, each lasting thousands of years, the cold areas of Europe were unoccupied by humans. Although natural selection on human populations to adapt to colder conditions must have been intense during these times, the first periods of cold came and went without producing hominins who could survive in the colder areas of Europe.

Late in this series of glacial advances and warmer periods, the human family brought forth a more potent evolutionary response to the cold. This was a kind of cold-adapted superhominin, a robust-bodied form that had a larger brain than any previous hominin, with cold-adapted physical features and a sophisticated culture that allowed them to survive in this harsh environment. These beings were physically very strong and were capable hunters who succeeded in becoming top predators within their ecosystems. These were the Neandertals, and their success story lasted for over two hundred millennia.

Since their discovery in the mid-1800s, Neandertals have fascinated us as a mysterious "other," an alternative kind of human being who lived during a long-past time period that overlapped with ours.

From the beginning, we have struggled to understand their differences from anatomically and culturally modern people. How different were they from us, and what do these differences mean? Were they human in the modern sense? Should they be included in our species? Perhaps the most poignant question of all is: What happened to them? We are justifiably a little uneasy as we ask this last question and ponder the possibilities, which may include a role for our kind.

Cave Man

What Neandertals were not is the cave man of popular culture. When the first Neandertal fossils were discovered, some argued that their unusual anatomy was due to some pathological condition, that perhaps rickets and "idiocy" could explain the unusual morphology. When more fossils were discovered, it became apparent to many that a pathological explanation required imagining the unlikely scenario of a widespread group of people who all suffered from the same mysterious malady, one which is unknown in our time.

A series of landmark studies by French paleontologist Marcellin Boule between 1911 and 1913 focused on the most complete Neandertal skeleton then known, from the French site of La Chapelle-aux-Saints. Boule's studies helped establish that there had once been a population of these beings, and that their peculiar anatomy was not the result of a pathological condition. He proposed that the La Chapelle-aux Saints individual would have stood more or less upright, but with bent knees and hips and a slouching posture, with head thrust forward.

The comments of contemporary anatomist Grafton Elliot Smith of the University of London sound a bit more like Monty Python than they do scientific writing. In his words, Boule's reconstruction painted "a clear-cut picture of the uncouth and repellent Neanderthal Man. His short, thick-set and coarsely-built body was carried in a half-stooping slouch upon short, powerful and half-flexed legs of peculiarly ungraceful form. His thick neck sloped forward from the broad shoulders to support the massive flattened head, which protruded forward, so as to form an unbroken curve of neck and back, in place of the alternation of curves which is one of the graces of the truly erect *Homo sapiens*. The heavy overhanging eyebrow-ridges and retreating forehead, the great coarse face with its large eye-sockets, broad nose and receding chin, combined to complete the picture of unattractiveness."

Ironically, what Boule failed to realize was that the skeleton he based many of his conclusions on *was* in fact heavily transformed by pathologies. There is evidence for arthritis up and down the La Chapelle-aux-Saints skeleton. Although Boule noticed the skeleton's arthritic condition, he failed to appreciate the degree of its influence on the anatomy and posture of the skeleton. Along with some misinterpretations and mistaken reconstructions of anatomy, this led him to his faulty picture of Neandertals.

Eventually, in the late 1950s, the severity of the effects of arthritis on the skeleton was finally appreciated and the mistaken interpretation was exposed. Today the slouching and the stooping are gone. These were robust, powerfully built

people with limbs at the short end of the modern spectrum, but their posture was as upright as that of living humans. Their brains were actually a little larger than modern averages, but since their estimated body weights were also a bit larger, relative brain size was the same as ours.

Apparently, however, the damage had been done. The image of the slouching, primitive, brutish "caveman" had caught the public imagination. This image is still with us today, from "cavemen" in insurance advertisements to Senator Ted Kennedy's characterization of President George W. Bush's federal court justice nominees as "Neanderthals." Apparently, some concepts are so compelling that they become habits that are hard to shake. If you are hiring actors to portray Neandertals, their first inclination is to slouch and drag their knuckles. You have to tell them *not* to shuffle and grunt. Sometimes they have trouble making the shift to a more "modern" Neandertal, and you can still see traces of this kind of behavior even in some recent television documentaries attempting serious portrayals of Neandertals.

The scientific pendulum has now swung the other way, and you occasionally hear the comment that a Neandertal, given a shave and dressed in a new suit, might go unnoticed on a New York subway. I think that's going too far. A robust individual with massive brow ridges and knee joints the size of cantaloupes would attract the attention of all but the most jaded New Yorkers. I would definitely notice. And I would invite him back to my lab for a photo shoot and face-casting party.

Factors That Shaped Neandertals

With *Homo erectus* we saw the first clear evidence that hominins were adapting to climate with body shape as we do. The long, comparatively lean body build evidenced by the Nariokotome boy's skeleton and by other likely *H. erectus* remains from east Africa was adapted to the heat of tropical environments with maximized surface area for a given body volume, allowing heat to be shed both by radiation and by the uniquely human evaporative cooling system, with enhanced sweat glands cooling the body.

Neandertals were shaped by the cold. Their skeletons show proportional adaptations that are in some ways the opposite of those seen in the Nariokotome boy's skeleton, in that they serve to minimize the surface area over which heat might be lost by a given body mass. These short-statured people had wide trunks and short distal limb segments (forearms and lower legs) like today's Inuit and Sami.[1] They also had large, barrel-shaped rib cages, with lungs that could pull in large volumes of air. Lung capacity and body mass are correlated in living humans, and Neandertals' more capacious lungs are thought to be related to the metabolic demands of maintaining a larger body and brain than those of the average modern human, and the increased oxygen demands of a physically active lifestyle.

Neandertal builds were stocky, with large joints and robust, thick-walled limb bones. These were bodies built to take punishment, and the common occurrence of multiple healed fractures in their skeletons provides a clue that underscores

this point. What were they doing that was so rough on their bodies? Some researchers have argued that Neandertals were engaging in close-range hunting of large mammals, and their banged-up skeletons may reflect such activities.

The robust Neandertal facial skeleton is a beautiful, natural work of art. It is different in many ways from the faces of modern people. What forces shaped this unique sculpture? Many of the distinctive features of the Neandertal face are thought to be related to two factors. One of these is the use of the mouth as a clamp or third hand. The front teeth in some Neandertal skulls show an unusual, beveled wear pattern similar to that of modern Inuit peoples who hold and process animal hides with their front teeth. The heavy brow ridges of Neandertals are thought by some to be a sort of shock absorber that dissipates the large forces generated by heavy use of the front teeth and transmitted through the robust face. The cheekbones do not face forward, but are oriented nearly toward the side, it has been argued, to better resist bending stresses from these forces.

The other factor that seems to have had a strong role in shaping the distinctive anatomy of the Neandertal face is adaptation to the cold. The large Neandertal mid-face projects forward, as if some master evolutionary sculptor placed a finger on the bridge of the nose and a thumb just below the mouth, and pulled the face forward. It has been noted that such mid-facial projection moves the nasal passages farther from arteries that supply the brain, minimizing their exposure to inhaled frigid air.

The prodigious, projecting Neandertal nose is a marvel of nature, and also a puzzle.

Explanations for its anatomy have ranged from the warming and humidifying of inhaled air to the *dissipation* of heat during strenuous activities, which might otherwise lead to sweating and the consequent risk of hypothermia in a cold environment. This last is difficult to square with the cold-adapted body proportions of Neandertals. Are we to imagine a being that is designed to conserve heat from the neck down, but to dissipate heat from the nose? One study has argued persuasively that the internal nasal cavities of Neandertals, when compared with those of living humans, fall out with those of people living today in colder climates. There continue to be occasional challenges to the idea of cold adaptation in Neandertals, and the subject obviously needs more work, but in many ways Neandertals seem to represent a tropical primate that has been retooled for survival in glacial environments.

Culture: Low Brows, High Brows, and the Neandertal Makeover

The scholarly literature on Neandertal cognition and culture sometimes has undertones of guilt. Some authors seem to dance around any direct assertion that Neandertals were cognitively or culturally our inferiors, even as they put forward evidence that would suggest this is true. Others are more direct in stating that Neandertal culture was less capable than that of modern humans. Still others argue that Neandertals were our equals, as human as we are. Part of the debate involves how best to explain why our kind survived while theirs became extinct, and there is a degree of survivor guilt in some of this

literature, especially about our possible role in the extinction of Neandertals.

The trouble started in Europe, where Neandertals were first discovered. It is difficult not to be impressed by the point in the European archeological record where the Mousterian cultures of Neandertals give way to Upper Paleolithic cultures in layers above them, long presumed to have been made entirely by anatomically modern humans. This great change in the archeological record, at about the time when modern humans first entered Europe, has been the strongest source of evidence used by those who argue for cognitive and cultural contrasts between Neandertals and modern humans.

In the early years of archeological research in Europe, it seemed that one of the stark differences was in evidence of symbolic behaviors. Body ornamentation, for which there was abundant evidence in the Upper Paleolithic, seemed not to be a feature of Mousterian culture. Paintings and music were unknown. Although Neandertals may have used pigments and buried their dead, grave goods, if that's what they were, were less elaborate. In contrast, an explosion of such creative behaviors occurred in the Upper Paleolithic. Suddenly there were intricate sculptures and beautiful cave paintings. (Pablo Picasso is said to have commented, upon emerging from the ancient art cave of Lascaux: "We have learned nothing in twelve thousand years.") The first known musical instruments, flutes made from bird bones and mammoth ivory, occurred in these cultural horizons. Burials became more elaborate and included grave goods such as carvings and pendants. Body ornamentation was

sophisticated and widespread. Neandertal symbolic behaviors seemed to be much less developed in comparison.

Contrasts between Mousterian and Upper Paleolithic technologies also seemed impressive. Upper Paleolithic peoples made a wider variety of tools from a broader range of materials. Their tools were, to modern eyes, more beautifully worked, often starting as long, graceful-looking blades of stone. Among tools of the Upper Paleolithic were compound tools, such as stone spear points which were hafted onto wooden spears, and delicate "microliths" (very small stone artifacts), both unknown to earlier studies of Mousterian technology. Upper Paleolithic tools included fine bone needles and bone awls. Neandertals, if they wore clothes at all, must have worn skins more loosely held together.

The invention of the atlatl, or spear thrower, during the Upper Paleolithic allowed anatomically and behaviorally modern hunters to hunt at greater distances. Neandertals, if they hunted at all, were thought to do so at close range, perhaps with only thrusting spears. Some authors denied Neandertals any kind of hunting at all, and suggested that their meat-eating consisted of scavenging carnivore kills. Some food resources, such as river salmon and marine animals, were present in Upper Paleolithic layers, but unknown in Mousterian contexts.

The behavioral pictures painted by this evidence for Mousterian and Upper Paleolithic behaviors seemed, in the early twentieth century, to match the physical pictures painted by early studies of Neandertals and Cro-Magnons (anatomically modern Europeans of the time). When

skeletal remains were found in association with Mousterian culture, they were Neandertals. Human remains were not found for all of the Upper Paleolithic cultures, but when they were, they were anatomically modern. It seemed like a clear-cut case: Neandertals, who created Mousterian culture, were replaced by modern humans, the creators of cultures of the Upper Paleolithic. The image of slouching, slow-witted, low-brow Neandertals creeping around Europe and scavenging for a living contrasted mightily with the picture of the upright, brilliantly creative, and intelligent Cro-Magnon highbrows with their superior technology and hunting prowess.

The plot thickened. First of all, the physical picture of Neandertals was given its major upgrade to the status of fully upright hominin. Then, when the first known hominin remains associated with one of the earliest Upper Paleolithic cultures (known as the Chatelperronian) were recovered, they turned out not to be anatomically modern as expected. They were Neandertals. Chatelperronian culture includes animal tooth pendants and other body ornaments, clear evidence for symbolic behavior.

Or was it? To some experts, the timing of this occurrence was suspicious: the Neandertal archeological record in Europe shows no body ornamentation for over 200,000 years and then, just at the point when moderns were first entering Europe, we suddenly see a culture associated with Neandertals that includes this feature and other new behaviors once thought to be the sole province of modern people. To some, this suggested a form of cultural diffusion: Neandertals were imitating the behavior of moderns, possibly

without grasping its meaning. Others suggested that Neandertals obtained body ornaments and modern-looking tools made by modern people by trading, stealing, or scavenging their abandoned camps. These scenarios preserve the idea that Neandertals did not (and perhaps could not) create symbolic objects on their own.

Recent discoveries have challenged this idea. At two sites in Spain, dated to a time when only Neandertals occupied the area, pierced seashells with traces of red and yellow ocher have been discovered. Other shells from the sites seem to have been used as paint cups. The sites have also yielded lumps of red ocher, brought in from source areas miles away. The discoverers of this evidence conclude that Neandertals had the same capacities for symbolism, imagination, and creativity that we have. Other sites representing Neandertal times have yielded bones, shells, and pieces of stone with zigzags or other abstract designs engraved in them, or with pigment stains. The German site of Oldisleben has yielded a bone engraved with a crude stick figure from layers thought to be 100,000 to 130,000 years old. This was long before the entrance of anatomically modern *Homo sapiens* into Europe. At some Neandertal sites, fossil shells have turned up far from their source areas, and seem to have been curated. Although it is difficult to tell whether their capacities were exactly the same as ours (perhaps unlikely given long periods of separate evolution, with a degree of isolation from each other), this evidence shows that Neandertals were capable of symbolic behavior, and to some extent challenges views that they became extinct because they were cognitively our inferiors.

Other Neandertal behaviors have been up-graded as well. Studies of animals they butchered often indicate that they had early access, instead of scavenging the remains of carnivore meals. The picture of scavenging Neandertals barely eking out a living in Ice Age Europe is now widely seen as hard to reconcile with their 200,000-year survival during this time of oscillating and sometimes harsh conditions. There is now good evidence that they were very capable hunters of small and large game, up to the largest size: bison, wooly rhino, and mammoth. They were often able to bring down impressive numbers of prime animals (healthy young adults). At some sites it is clear that they targeted a specific species. They were competent enough to specialize.

If not absolutely efficient in the sense of using every resource available, Neandertals' use of resources was nevertheless impressive. Once it was thought that the use of marine and freshwater resources was solely the province of anatomically modern humans. Recent finds have shown that Neandertals sometimes hunted dolphins and seals, and that they collected shellfish. Salmon is still rare at Neandertal sites.

Symmetrical wear on the bases of some Mousterian points and traces of tree resin and mineral adhesives have now clearly established that Neandertals made compound tools. The occasional occurrence of stone blade tools, bone tools, and microliths in European Mousterian contexts proves that these were not made by modern people alone. Many stone tools used by Neandertals have wear that indicates that they were used in woodworking, highlighting a facet of their technology that is otherwise not detectable

in the archeological record. Some wooden tools, though rare, have turned up. These include a spear and throwing sticks, and two potential wooden trays or shovels.

It now seems that Neandertals carried with them the capacity for a potent culture which complemented their cold-adapted physical features. This included the control of fire and apparently the ability to build shelters and make clothing. Stone awls and scrapers, thought to be for the purposes of perforating and working animal hides, occur in Neandertal-associated archeological contexts, adding to the evidence of hide processing from beveled tooth wear. Recurrent use of hearths, apparent post holes, and stones and bones that seem to have been used as weights for anchoring skins appear to indicate living structures at some sites.

Some evidence has been interpreted as showing a level of caring and support for the elderly and the handicapped that is especially at odds with a brutish or "caveman" image for Neandertals. Some Neandertal remains show injuries or a degree of debilitation that scholars have argued would have necessitated the care of others. There is debate about the comparative base: can apes and monkeys in the wild with similar disabilities survive for extended periods without help? The Neandertal evidence includes a mandible of an individual that, because of extensive tooth loss and bone damage, could not have chewed for at least six months prior to death. Another individual, an adult male known as Shanidar 1 from a cave site in Iraq, was extremely handicapped. He had a useless right arm, the humerus withered to a mere stick. His skull had healed fractures,

including a caved-in eye socket on the left side that probably held a blind eye. Bone fractures and significant arthritic damage to his joints would have further debilitated him. Other Neandertals show healed skull fractures, injuries so severe that, if they had occurred in a living person, they would have required care from others to heal.

Chris Ruff has deduced from the shape of the pelvic inlet in the male specimen known as Kebara 2 (extrapolated to female shape and size) that the birth process would have been difficult for Neandertal females, as it is for modern women, and would have required the second rotation of birthing. Milford Wolpoff has pointed out that a difficult birth process implies another facet of caring behavior: required assistance in childbirth. Caring behaviors implied for Neandertals should not be too surprising: we've already seen two examples of *Homo erectus* individuals whose survival depended on the care of others, showing that such behaviors are very ancient.

Remaining Differences in the Archeological Records of Neandertals and Anatomically Modern Humans

Despite new finds that appear to bring Neandertal culture closer to that of anatomically and culturally modern humans, their archeological signals are not identical. Moreover, there seem to be differences in how effective the two cultures were. Why did Neandertals disappear, while our species survived? Neandertals, with their large brains, physical strength, and hunting abilities which put them into the top predator positions in their food web, armed with both physical and cultural adaptations to the cold, would seem the

ultimate survivor, well adapted for glacial Europe. Their success story was already 200 millennia old in Europe when, at about 44,000 years ago, anatomically and behaviorally modern humans entered the continent. By 27,000 years ago Neandertals were extinct. Was their extinction and our survival largely a matter of chance? Or did cultural differences play a role?

The greater physical robusticity of Neandertals in comparison to anatomically modern humans implies to some that their culture was less capable of providing a buffer for their sometimes harsh environments. They have been characterized as solving problems with their bodies that modern humans would solve culturally, and this is perhaps underscored by the fact that Neandertals evolved arctic body proportions, while modern humans were able to enter and survive in glacial Europe with still-tropical body proportions, even penetrating farther north than Neandertals were able to do. What evidence remains in the archeological record concerning cultural differences that might help explain the apparent gap between the effectiveness of Neandertal culture and that of anatomically modern people?

Modern human cultures have a "ratcheting" effect in that they build on past progress and accumulate innovations. Previously incorporated innovations are recorded in the memories of the currently living as behavioral traditions. These can function as a platform that allows building on past achievements. Sometimes the process results in steady improvements in the way certain problems are handled. The culture evolves. Levels of complexity may increase, resulting in progressively more elaborate artifacts.

Cultural evolution allows much more rapid adjustments to a changing environment than does organic evolution. In some ways, evolving culture seems the ultimate adaptation to unpredictable, rapidly changing environmental conditions. This includes adjusting to varying conditions in a single place, but it also applies to adaptation to different environments encountered by human groups as they move into new lands, so it facilitates human population expansion and migration. To what extent does this kind of change characterize Neandertal cultures?

The archeological record for Neandertals shows cultural change through time in some regions, although it is slow by modern standards. Accumulation of innovations is also implied by evidence of different local traditions developing in different Neandertal groups. Their cultures could, to some degree, evolve and diversify. Social learning among Neandertals may have included teaching, where specific information is passed to another and the teacher adjusts the lesson to the progress of the learner. Some form of language may have played a role.

Recent studies have found that Neandertal cultures made fairly rapid adjustments to changing local conditions, varying patterns of resource use with changes in their environments. This was especially important during periods of wild and sometimes abrupt climate swings. Neandertals adapted their behavior to differences in resource availability, acting with foresight of alternative possibilities. There is evidence that Neandertal behavior was flexible enough to change toolmaking techniques to more stone-conserving methods when stone was scarce, including more extensive retouch and reuse of tools. Their subsistence strategies, tool types, and prey species shifted with seasons and environment. Any differences between such capabilities for flexible behavior in Neandertal culture and modern culture may be a matter of degree.

Although Neandertals have been shown to be capable of levels of symbolic behavior that include decoration of the body, evidence for body ornamentation is not common, and paintings and music are still unknown. Without widespread use of body ornamentation and art, Neandertal groups may not have been linked into larger social units such as those which commonly characterize modern peoples, united by common ideas and the artistic, ornamental, and musical symbols that represent them. So they may have lacked the advantages and buffers against risk that such a system can offer. As a result, gene pools may have been smaller, and innovations may have spread more slowly. Living in smaller isolated groups may have been a factor in limiting the spread of ideas.

In Europe there is still evidence of a broader use of available resources by moderns than by Neandertals, including more extensive use of bone and antler, and tapping into food resources that seem to be rarely utilized by Neandertals, such as the abundant salmon in nearby rivers. The Neandertals seem to have left virtually untouched some resources that were later used by Upper Paleolithic modern humans.

The archeological record still suggests a technological gap, perhaps best symbolized by the bone needles used by Upper Paleolithic modern

humans but absent in Mousterian cultures. This would have meant that the advantages of sewing tight seams in clothing and shelters to keep out the cold would not have been available to Neandertals. Some authors still see signs of a gap in stone tool technologies. One study finds anatomical evidence in the bones of the shoulder and arm suggesting that early anatomically modern people, by at least the time of middle Upper Paleolithic cultures, were making regular use of thrown projectiles, while Neandertals were not. The implication is that Neandertals were largely limited to hunting at close range, suggesting once again that early moderns were finding cultural solutions to problems that Neandertals solved physically by investing in more robust bodies.

Western Asia and the Modern Anatomy/Modern Culture Time Lag

Models attempting to explain the differential success of *Homo sapiens* over Neandertals must also take into account the archeological record from western Asia, which paints a different picture from the European story. Anatomically modern humans and Neandertals overlapped in western Asia for tens of thousands of years, beginning about 80,000 years ago, and produced very similar signatures in the archeological record, both of which are comparable to the Mousterian cultures associated with Neandertals in Europe. In other words, the arrival of modern anatomy in western Asia was not accompanied by the arrival of modern culture. In order to explain this apparent time lag, some have suggested that

"fully modern" language may not yet have been in place for these seemingly modern humans in western Asia who practiced a culture more like those of Europe's Neandertals. A proposed later shift in our lineage, perhaps 60,000–40,000 years ago, to a "fully modern" language or its unseen neurological underpinnings allows those supporting a modern culture/modern anatomy link to explain why the arrival of modern culture seems to lag behind the apparent transition to anatomical modernity (in other words, earlier seeming "moderns" were not actually fully anatomically modern in the neurological underpinnings of language).

Models suggesting a late arrival for fully modern language, which excludes Neandertals and their seemingly modern contemporaries in western Asia, have been based partly on the idea of a worldwide behavioral revolution among anatomically modern people between 60,000 and 40,000 years ago. This idea has begun to unravel as evidence for "modern" behaviors, such as the symbolic behaviors associated with *H. heidelbergensis,* is traced further back in time.

Efforts to show that Neandertals lack the vocal anatomy for spoken language have a long history. Research on the language capabilities of living great apes has shown that, although they cannot be taught to speak like humans, their use of gestural symbols can be more sophisticated. Based on this disjuncture and a degree of overlap in the neurological basis of hand movement and speech (discussed in chapter 5), some suggest the possibility that gestural language may have preceded spoken language. This has led some to

propose that if Neandertals lacked the ability to speak, perhaps they practiced gestural languages. This idea has been picked up by popular culture, as with the gesticulating Neandertals of Jean Auel's book *Clan of the Cave Bear* and the movie based on it.

Most of the anatomical work attempting to show that Neandertals lacked modern speech capabilities has been based on measurements indicating less flexed cranial bases in Neandertals, and on resulting reconstructions of vocal tract anatomy, some of which depict the hyoid bone and larynx higher in the throat than in modern adults. Many of these studies have not stood the test of time, and the discovery of the first-known Neandertal hyoid bone in 1983, which displays completely modern anatomy, led its discoverers to suggest modern speech capabilities for Neandertals. Study of DNA from the bones of Neandertals has shown that they possess the human form of some genes known to be related to language abilities.

Others argue that a less flexed cranial base in Neandertals implies, at the very least, that Neandertal speech, if it existed, was different from that of modern humans. One such author surprised me by finishing his talk at one of the annual physical anthropology meetings with a slide of a painting I had done of a Neandertal group, into which he had Photoshopped the image of deep-voiced pop singer Barry White. He concluded his talk with the sentence "Barry White would have been the tenor in the Neandertal choir."

Since the ability to speak involves the coordinated evolution of several anatomical systems including brain circuitry, a number of authors think that it must have evolved over a long time period. Neandertals appear late in human history, so many would guess that they practiced some form of language. The gestural theory of language origins is very much alive today, but there is currently no evidence to link a gestural language specifically to Neandertals.

At a conference in 2012, my graduate adviser, Dave Frayer, chaired a session on language origins. Evidence was presented by various researchers that Neandertal hearing was tuned to frequencies used in human speech, and that the modern shape of the Neandertal hyoid bone was related to modern speech abilities. Ralph Holloway of Columbia University reviewed evidence that brain circuitry related to language existed long before Neandertals, in specimens attributed to *H. heidelbergensis*. With a modern-looking transmitter and receiver, and a modern look to the circuitry that controls them, as Ralph said, "If it looks like a duck . . ." In a discussion of the link between handedness and language-related brain asymmetries, Dave showed that Neandertals were right-handers like us and summed up by saying, "I'll be bold. Neandertals spoke."

The timing of the arrival of "fully modern language" is difficult to pin down. Perhaps it was part of broader cultural changes, due to the ratcheting effect that modernized behavior in modern humans and, to some degree, Neandertals.

The Spirituality of Neandertals

There are scenes in the lives of great apes that are almost unbearable for their human observers to watch. A chimpanzee mother sometimes holds on to the corpse of her infant for weeks after its death. But this behavior is short-lived. There is no effort to preserve the corpse, no evidence that the mother believes the infant's essence continues in some way, and the corpse is eventually abandoned. The mother chimpanzee is completely powerless; she has no control in the face of the absolute finality of death.

This powerlessness appears to be an unacceptable condition for human beings. Most human groups have mythologies in which death is denied the power of absolute finality: an individual's story is thought to continue beyond his death. Some portion—an essence, spirit, or soul—survives beyond the death of the body. This often involves a spirit world, an afterlife, a heaven or hell, or a dreamtime. A spirit's successful navigation to such a world can be contingent upon observing the proper rituals. We have behavioral traditions for the "proper" way to treat a corpse: a proper burial, a proper mummification, or a proper ritual de-fleshing of the corpse. The suite of traditions concerning the correct way to respond to an individual's death often includes a component that will help the individual in some way in the afterlife or guide him to a spirit world. We have fears about the dividing line between life and death, and this suite of behaviors sometimes includes components to enforce the maintenance of this line, to make sure it is not violated.

Compelling stories endure. In many cultures, we recent humans sometimes indulge in telling ourselves frightening tales in a safe context, and we tell some of these stories again and again. The enduring stories of terror for westerners in our time, expressed in literature, campfire tales, and movies, are often about the violation of the proper line between life and death. Ghosts are spirits of the dead who are not at rest and perhaps have unresolved issues with the living. Vampires, zombies, and Frankenstein's monster all have a limited kind of existence (not one you would envy, the *Twilight* series notwithstanding) after death through some "unholy" practice: the reanimation of dead tissue, or an incessant thirst for human flesh or blood. These stories reach resolution only when the line between life and death is reenforced, and the individuals are returned to their proper place among the dead. The ghost's issues are resolved and its spirit is at rest. The monster is burned, the vampire is staked, the mummy is dust. The End.

At the French site of La Ferrassie, there are burials of seven Neandertals. Over one of them, a child's burial, a large slab of limestone had been placed. On its underside are eighteen pockmarks which have been carved into the rock, sixteen of them in pairs. Was this some kind of symbolic barrier? Were they afraid of something? Did the placement of this rock have something to do with preventing the line between life and death from being violated? We'll never know exactly what was in the minds of the Neandertals who buried this child (known as La Ferrassie 6), but the circumstances of this and other Neandertal burials force this question: Did they believe that some essence or soul of a person survives beyond death, to be

appeased, guarded against, or provided for in a journey to a spirit world?

As with almost every other aspect of Neandertal behavior, there has been debate about Neandertal burials. Were the remains buried intentionally? Does burial imply symbolic behavior or spiritual beliefs on the part of those doing the burying?

A change in the quality of preservation occurs at one point in the European fossil record, such that earlier fossil remains which are isolated or incomplete give way to articulated skeletons of Neandertals. The completeness of many Neandertal remains, without carnivore damage and with skeletal part frequencies that match those of recent cemetery samples, argues for burial, often in the absence of any evidence of rapid natural sedimentation agents that could result in such preservation. Many of the bodies were buried in what look like intentional more than random positions. Modern excavation techniques have confirmed unambiguous stratigraphic evidence of intentional burial of some of the more recently discovered Neandertal remains.

What about the symbolic implications of Neandertal burials? There are purported grave goods associated with Neandertal burials, but some scholars have offered alternative suggestions for what might be grave goods, or have suggested that, for example, grandfather was buried because he had begun to smell and might attract predators. One study revealed that roughly half of the Neandertal burials for which information was available contained well-made stone tools or the meatier bones of animals. The difficulty with grave goods often involves discerning what may be grave goods from background scatter: bone and stone litter that occurs in nonburial sediments.

Possible evidence of ritual treatment of the dead occurs at the Italian site of Grotta Guattari, where a Neandertal skull was reportedly found inside of a roughly circular arrangement of rocks. At Teshik-Tash Cave in Uzbekistan, a Neandertal child's skull was found surrounded by pairs of ibex horns.

Soil from one of the Neandertal burials deep in a cave at the Iraqi site of Shanidar contains very high concentrations of pollen, which suggest to some researchers that the man's corpse was laid on a bed of fir and pine boughs, and that seven species of colorful spring wildflowers were placed in large numbers into his grave. Alternative explanations have been suggested for the concentrations of pollen, involving bees or some other animal agent, or wind bringing pollen into the cave, but such high concentrations, as well as the discovery of 145 clusters of anthers uniquely found in this layer of the cave sediments alone, have been put forward as evidence that makes these explanations doubtful. If this does in fact represent a Neandertal flower burial it is unlikely that we will ever know its exact meaning, but it seems to hint at symbolic behavior that goes beyond practical considerations.

The use of pigments, especially red ocher, was apparently common among Neandertals. Red ocher is sometimes found in burials, and some experts have wondered whether this was done to restore the "blush of life" to a corpse. In historical times, red ocher has had a variety of associations, many of them connected with the power, spirit,

or blood of life. Perhaps something like this was in the minds of Neandertals who included it with their burial practices.

It is probably not appropriate to think of these practices as analogous to modern mortuary practices we see in the industrialized world, which restore the appearance of life, but have little spiritual meaning. In our highly modular modern lives, we appreciate the aesthetic of such mortuary practices (Doesn't he look natural?) without ascribing much symbolic significance beyond mere appearance. We separate the aesthetic from the spiritual. For the more highly integrated lives of tribal peoples, these aspects are often more intertwined. The common use of red ocher in Neandertal burials may have had a distinct spiritual meaning, beyond a mere gussying up of the corpse. Thinking of red ocher as merely lending the corpse an appearance of life is thinking like a twentieth- or twenty-first-century westerner. It may be more appropriate to imagine that, for these people, red ocher gave the appearance of life because it actually imparted some quality or essence of life to the dead.

The bones of Neandertals and of other animals are found mingled at some sites, with identical signs of the removal of meat and marrow. Most experts agree that this is good evidence of cannibalism, but there is debate about its meaning. We know from interrupted growth lines in the teeth of some Neandertals that they sometimes faced food shortages. Perhaps eating their dead was one way of coping, but to many experts this implied practice goes beyond mere survival. Among modern humans, such behaviors are often highly ritualized and symbolic. Even if a group resorts to cannibalism to fend off starvation, they may feel the need to ritualize it in order to make the behavior acceptable. Or to honor the dead as they are eaten.

Neandertal burials seem to imply an increased awareness of death. Do they indicate religious thinking such as belief in an afterlife? With current methods, we cannot know the exact meaning of Neandertal burials or the possible grave goods interred with them. But the circumstances of some burials, such as the flowers placed in the grave of the Shanidar Neandertal, startle us in that they make sense to us, despite the genetic, cultural, and temporal gulfs between us and Neandertals. We can imagine that spring wildflowers might have had meanings that had something to do with a symbolic life force, perhaps like the rejuvenation of life that the return of spring flowers represents to many modern people.

Putting It All Together: Early Modern and Neandertal History

Current evidence allows us to imagine the following scenario, which, if it is close to reality, is probably grossly oversimplified.[2] Key parts of this story may have occurred during times of more extreme climatic variation. Populations of *Homo heidelbergensis* in Europe and Africa evolved in different directions, perhaps with some gene flow moderating their isolation. European populations evolved into Neandertals about 250,000 years ago, while African populations evolved into anatomically moderns not long afterward. The capacities of early African moderns were

sculpted and honed by a time of extreme climate variations in parts of Africa between 135,000 and 75,000 years ago. The evidence of stone tools made in Africa during this time suggests that a diversity of behavioral traditions arose, and this gave people more options for dealing with the unpredictable. Meanwhile Neandertal populations in Europe specialized in adaptation to cold conditions both physically and culturally. Perhaps 80,000 years ago, they spread to western Asia, encountering anatomically modern humans who had arrived earlier. Their similar cultural signals in this time and place suggest that their cultures influenced each other.

Major waves of modern human populations expanded out of Africa and elsewhere between 60,000 and 15,000 years ago, reaching every continent except Antarctica and encountering a wide variety of habitats, further honing their adaptations to varying conditions. In some places they encountered other hominins that had arrived earlier. In other environments, no previous hominin had succeeded in adapting to local conditions.

Modern people entered Europe between 45,000 and 43,000 years ago. This occurred during a time of increasingly unstable climate, with replacements of fauna and flora that sometimes occurred within a single lifetime. Some Neandertal groups did adapt with shifts in tool types and prey, but they may not have been as good at this kind of quick change as the newcomers. There are signs in the archeological record that the cultures of modern people afforded them a competitive advantage. During the coldest times,

such as the period between 38,000 and 34,000 years ago when Neandertal populations may have contracted or moved farther south, modern people were able to stay in place and increase their population numbers, gaining a foothold that would not be relinquished when warmer conditions returned and Neandertal populations might have otherwise expanded north again.

The stone tools and shell beads of early modern people in Europe were sometimes made from materials from at least three hundred miles away. Some of this might reflect long-distance travel, but it has also been seen as evidence that groups of modern people were linked into larger social networks at this time. Widespread symbolic motifs may signify larger social institutions or clans, united by common religion or ideology. This may have been decisive in times of risk or disaster. It also enlarged the pool of potential mates and allowed greater sharing of technological innovations. With the larger networks that seem to characterize modern people, an idea is less likely to die out with the group that spawned it. Neandertals seem to have lacked such networks.

A spike in the longevity of individuals occurred in modern populations about 30,000 years ago, which would have allowed individuals more time to increase and disseminate their group's stores of knowledge, and to help raise and educate their grandchildren. By 28,000 years ago, Neandertal populations were reduced, confined to a few areas in Europe. Shortly thereafter the last Neandertals disappeared. But not without descendants. Recent genetic evidence,

from analysis of DNA found in Neandertal bones, suggests that, although interbreeding between the two lineages may not have been a widespread phenomenon, it was common enough so that many of us moderns are carrying around a few Neandertal genes. According to some, this is corroborated by the fossil evidence. Some late Neandertals look a little more like modern humans (for example, some had a more pronounced chin). And some early modern humans, such as a 24,500-year-old child's skeleton from a site in Portugal, show a number of Neandertal features. Technically, using a biological definition of a species that is based on the ability to interbreed, Neandertals belong to ours.

After surviving for over 200,000 years, Neandertals vanished from the earth. The fact that they did so only after modern humans entered Europe has led many to conclude that competition with our species was a factor. If so, the competitive balance must have been very close. If our kind had a decisive and extreme competitive edge, you might expect that Neandertals would have become extinct in only a few centuries. Instead, they survived contact with us in Europe for over 10,000 years.

The disappearance of Neandertal traits from the paleontological record may have been the result of a numbers game. Some experts argue that Neandertals did not actually become extinct but that, as Tulane University's Trent Holliday put it when we discussed what happened to them, "Their stream braided back into our own." The Neandertal gene pool may have been swamped by modern human genes from a combination of gene flow and incoming populations of anatomically modern people. Researchers have pointed out that estimated world population numbers for moderns are much larger than for Neandertals during their time of overlap, and this is likely to have been a factor influencing the dominant direction of gene flow.

Anything that gave early moderns in Europe a competitive advantage over Neandertals might have translated into higher reproductive rates. Estimates of daily energy requirements for each type of human have suggested that more energy may have been available for reproduction in modern populations, mostly because of their smaller estimated body mass (requiring less energy to maintain) and cultural solutions that may have enabled a reduction in energy expenditure. This does not mean they were mating more energetically than Neandertals, but they may have been able to put more energy into lowering infant mortality and increasing offspring survivorship. For example, nursing mothers may have had more energy available for milk production. Any of these factors could have translated into faster population growth among modern groups.

Some authors have suggested that it might have easily gone the other way and that Neandertals might just as well have been the ones who survived to contemplate their strange extinct cousins: ourselves. It may yet turn out that we out-survived them only by a very short time, a geological blink; we have currently occupied the planet for less time than the time span of Neandertal existence.

Characterizing Neandertals in Sculpture

In the team's discussions about what should be depicted in the Smithsonian Neandertal sculptures, several themes dominated. Cold adaptation was obviously important, including, if possible, both physical and cultural adaptations. This also seemed the best point in the series to address the theme of human social learning and cultural transmission, perhaps implying, if we could, both active teaching and imitation. Rick Potts thought this was best done with a mother and child, and we all agreed that it was important to address this fundamental bond—the foundation of our social behavior—somewhere in the series. I favored implying vocal communication of some sort (not necessarily a fully modern language), perhaps by sculpting the vocalist's mouth in an obvious "y" or "w" position. The anatomical cold adaptations would be evident, and one or both figures could be wearing clothing, addressing the theme of cultural adaptation to the cold.

Combining some of these themes, I envisioned a Neandertal child with his mother, who was obviously both gesturing and vocalizing. I could raise questions in the minds of museum visitors without taking on the presently impossible task of providing answers: To what degree could her communication be considered language? and How much of the meaning in her communication was conveyed by her gesturing relative to the vocal content? I spent some time on a drawing of a Neandertal woman in an expressive, gesticulating, almost dancelike, standing-on-one-leg pose, with her eyebrows raised in the manner of one who is speaking to a young child.

The drawing was awful. It looked like an overeager children's TV show host with an overly cutesy name—"Miz Bunny," or something similar. I couldn't stand to look at it, and I spare you, dear reader, from having to do so. Including it in this book would be as a blemish on what I hope is an otherwise beautiful face. Nobody on the team ever saw this drawing. I disliked it so intensely that I lost faith in the pose and stopped trying to promote the idea in discussions with the team.

Following Rick's suggestion, we began to focus more on clothing. The mother could be depicted not only wearing clothing, she could also be making clothing, perhaps using a scraper on a piece of hide. The likely destiny of the hide she is working on would be implied by the clothing she wears. The social learning component could be preserved by having the child watching her activity intensely.

Team member Kathleen Gordon pointed out that prehistoric females are often portrayed working at some kind of drudgery that is parallel to the work of women in historic times. There is less evidence for sharp divisions of labor in ancient times than in more recent times, and some experts have suggested that Neandertal women participated in what we think of as male activities, such as hunting. Maybe we could at least elevate her to something less repetitive and more creative than hide scraping, perhaps the slightly more dynamic job of perforating a hide with a stone awl. The rest of the team agreed that this would be a good change. I was enthusiastic; the promotion meant I could depict her doing something a

little more dramatic. I began to picture her effort. She is putting her back into perforating a hide, perhaps with her elbow raised, and there is a stream of tension and force flowing from shoulder into arm and hand, coming to a focal point in the stone awl she is wielding. At one point in my back-and-forth communication with the Smithsonian team, they sent photographs of Kathleen and Rick in the positions they were describing. These positions were later scrapped, but it was worth a lot to see Rick Potts as a baby Neandertal.

Inspired by photographs of a young chimpanzee sitting in its mother's lap, watching her as she uses a rock to crack open a nut, we at first put the Neandertal toddler in his mother's lap while she worked, holding the skin with one hand between extended thumb and index finger, and piercing it with an awl held in the other. But Kathleen feared that the child was dangerously close to powerful movements with a sharp object. "No caring mother would let her child do that," she objected. The design evolved. We took the child out of the mother's lap, putting it at one side, hand on his mother's shoulder as he watched the hide-piercing activity. This gave us the opportunity to include another element of inferred Neandertal behavior: that of using the mouth as a clamp. She could be depicted holding one end of the skin in her teeth, stretching it taut with one hand, and piercing it with the stone awl held by the other. This would have obscured the child when it was in her lap, but now we were free to pursue such a design.

The teeth had to look like beveled Neandertal teeth, and the hide had to be perfect—it had to have a texture that gave no room for alternative interpretations but instead instantly proclaimed: Hide. The tension in the hide had to be right also. I didn't want the museum visitor to wonder, even for a second, if she was engaged in some other oral activity, eating or whatever. I considered sculpting the whole arrangement, but a look at the calendar confirmed that I was living in the twenty-first century, when time frames given artists are never long. I hung a piece of bear skin, clamped at one end by a pair of Neandertal dentures I cast from one of the Neandertal skulls with beveled wear on the front teeth, and held taut at the other end by weights. I made a mold of the assemblage and cast it in urethane plastic. Later I inserted the teeth-with-hide assembly into the reconstructed Neandertal mother's mouth. We did have to make one sacrifice: with one end of the skin in her mouth, the mother could no longer be vocalizing. I felt the sacrifice was worth it and was happy to be able to depict so many Neandertal behaviors supported by direct evidence.

Taking the child out of his mother's lap offered an opportunity to include yet another evidence-based behavior in the sculpture. Faceted areas on the ankle end of the tibiae of many Neandertals match those found among modern populations that frequently rest in a squatting position. We scrapped the sitting pose in favor of a squatting position.

Something was still missing. The intimacy we needed between the mother and child did not seem to be there. And the teaching element seemed weak. Yes, the toddler was watching his mother's activity, but she was not encouraging him, not actively teaching him in a human way. We solved this by moving the toddler out in front of the mother, facing her so that they could have eye contact. This was so obviously what was needed that both Rick and I couldn't believe we'd taken this long to figure it out. Late in the process, in order to improve the social learning component, the toddler was given a scrap of skin and a quizzical tilt of the head as if unsure whether he should imitate his mother by putting it in his mouth. It followed naturally that the mother's expression should be one of love and encouragement, delight and even amusement at the child's tentative actions. We wanted to imply that she is not only making clothing; she is teaching him about the process. Teaching in a human way means that she is actively encouraging him to learn, and adjusting the lesson to his progress.

We considered making the Neandertal mother pregnant as well, to illustrate the human capacity to have offspring with overlapping

childhoods instead of being able to conceive only after an offspring is weaned, as in living apes. But we eventually rejected the idea. We were afraid that with so many issues, the vignette might explode.

Building Neandertals; Man, Woman, and Child

The Neandertal mother's body was reconstructed based on the fairly complete French female skeleton known as La Ferrassie II. The first step in the sculpture was to build a restored version of this skeleton over the metal armature. I had studied the skeleton at the Musée de l'Homme in Paris years earlier. It displays the cold-adapted proportions typical of other Neandertal skeletons, and the sturdy bones have well-marked muscle attachment sites that suggest that even adult female Neandertals were powerfully built. La Ferrassie II lacks a complete skull, so I added a probably female Neandertal skull known as La Quina 5 as a stand-in. As with the other figures, there came a shock! Suddenly it was looking at what it was doing! The sudden change caught me off guard, because this was actually the first of the hominin skeletons to receive a skull.

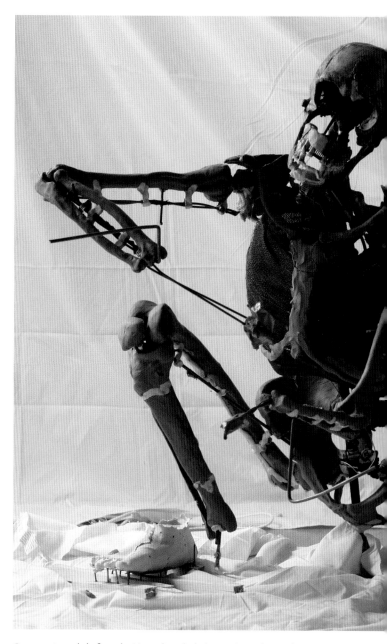

Composite adult female Neandertal skeleton, based mainly on the La Ferrassie II skeleton, with the La Quina 5 skull.

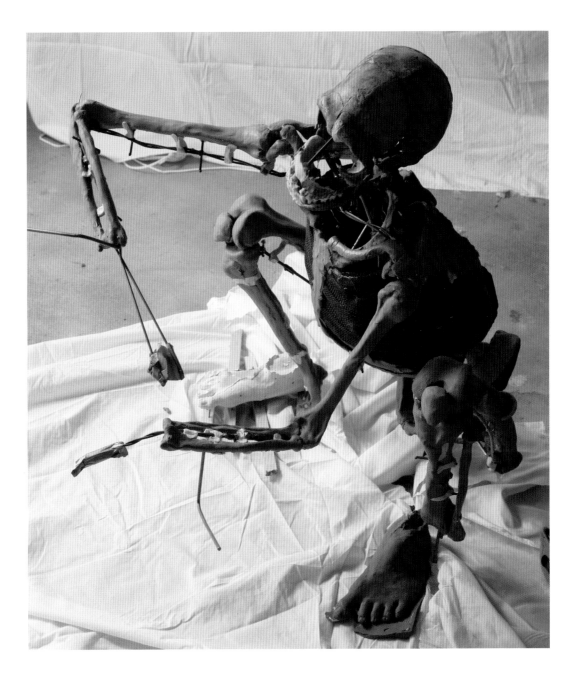

For the head reconstruction I used a more complete female Neandertal skull found at the Forbes' Quarry site in Gibraltar in 1848,[3] along with a modified version of the La Quina 5 mandible. The resulting head shows the big, projecting face, large brow ridges, swept-back cheeks, and prominent nose apparent in the skull's anatomy.

metacarpal shows exceptional development of the opponens pollicis muscle in the meaty area at the base of the thumb.

Other attachment sites confirm the presence of powerfully muscled areas near the base of the thumb, and on the opposite side of the palm. The bony gateposts of the carpal tunnel in the

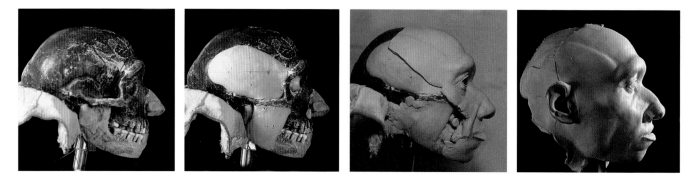

The head reconstruction for the female Neandertal figure was based on the fairly complete Gibraltar skull.

Casts of modern hands with moderate modifications, like those made for Lucy's and *P. boisei*'s hands, were not adequate for the Neandertal figure. I began with casts of modern hands, but by the time I had made all of the revisions necessary to represent the distinctive anatomy of Neandertal hands, they were almost entirely sculpted anew. This work was guided by the hand remains of La Ferrassie II and by other hand remains thought to belong to female Neandertals.

Neandertal hands had massive knuckles (Rodin would have loved them). Their fingers and thumbs ended in broad terminal pads, wider than those in average modern people. Proportions within the thumb are different in Neandertals than in those of moderns, with the terminal bone longer relative to the next bone nearer the wrist. Muscular differences are indicated as well. A crest with a scooped-out area on the first

wrists of Neandertals are large, indicating thick wrists and powerful flexors of the hand and fingers. The results of all of this for the figure were large, hammy hands, with thick fingers and thumbs. Looking at only the hands, a recent individual would have difficulty believing they belonged to a female.

Neandertal feet are especially broad. I found no close anatomical matches among living humans, and the feet for the figure were sculpted instead of cast, reconstructed from the comparatively complete La Ferrassie II foot remains.

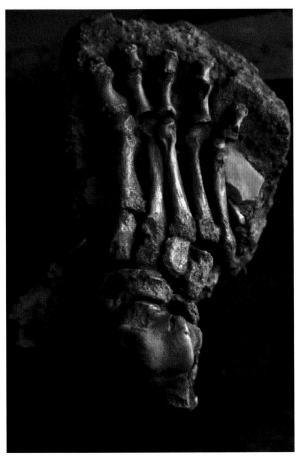

The La Ferrassie II foot skeleton, on which the foot reconstruction for the bronze figure was based (cast).

The reconstructed hands of the bronze Neandertal figure.

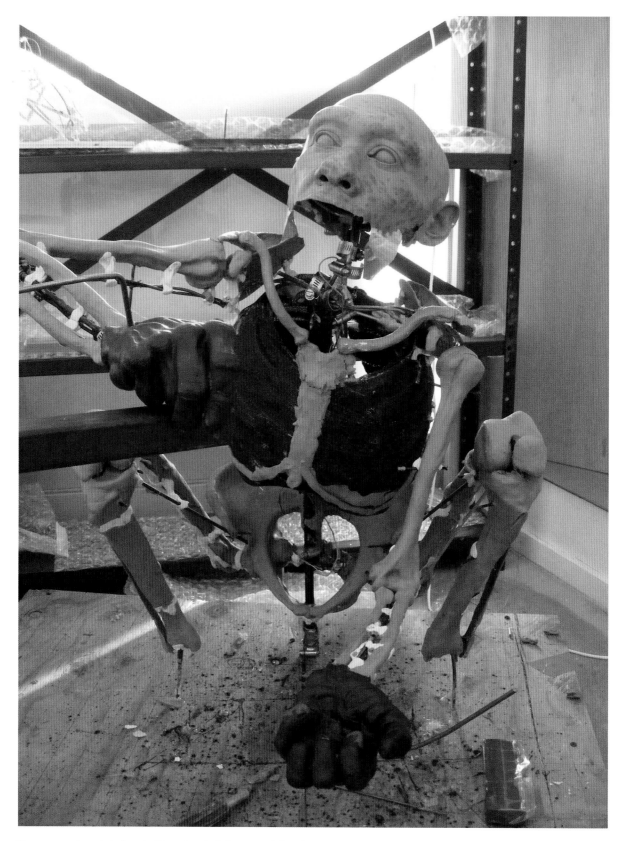

The composite adult female Neandertal skeleton, with hand reconstructions
and a partial cast of the head reconstruction.

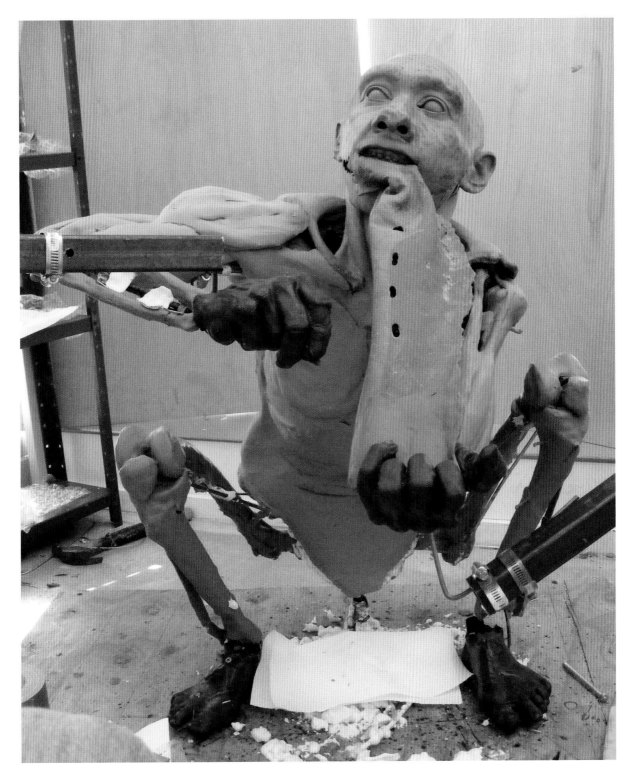

The hide and teeth for the Neandertal female were cast together as a unit, then installed
in the head and left hand of the figure. The first muscles have been added to the figure.

Muscles for the figure were based on muscle markings found on adult female Neandertal remains. These include some peculiarities that are different from modern human anatomy, such as an enlarged flange for the attachment of one of the muscles of the shoulder, the teres major muscle.

Just how muscular were Neandertals? I've been sometimes accused of making mine too muscle-bound. Critics are correct, I think, in their judgment that the most developed present-day bodybuilders represent extreme and artificial body forms, and should not be used as examples of what Neandertal builds were like. So why the muscle-bound look for Neandertals in some of my art? Building Neandertals involves the process of packing very athletic musculature onto short limb segments, and this gives them a muscle-bound look. And very athletic musculature is certainly what the bones indicate for Neandertals. Experts supporting substantially greater muscle mass in Neandertals than in modern humans have pointed out the extremely pronounced ridges and pits marking muscular attachment sites on their bones, suggesting

powerfully muscled bodies. Neandertal long bones are thick-walled in comparison to those of modern humans. Because bone is laid down in the cortex of limb bones in response to mechanical loading of force, those of Neandertals speak of heavy loading. These features, which are in the upper ranges for modern humans or beyond, suggest that average modern humans are not the best models for building Neandertal bodies. This is true for some of the other early hominins as well; when the bony evidence is considered, modern humans come out as the weaklings among hominins. Chris Ruff has found that Pleistocene *Homo* (including Neandertals) averages about 10 percent heavier than living humans. Given the common occurrence of indicators of nutritional stress among this ancient group, and their probably active lifestyles, their higher body weights are unlikely to include a large body fat component. Although male Neandertals probably had more muscular bodies, strongly marked muscle attachment sites in female skeletons suggest that they weren't far behind the males. My reconstruction of the body of La Ferrassie II resulted in a powerfully built woman.

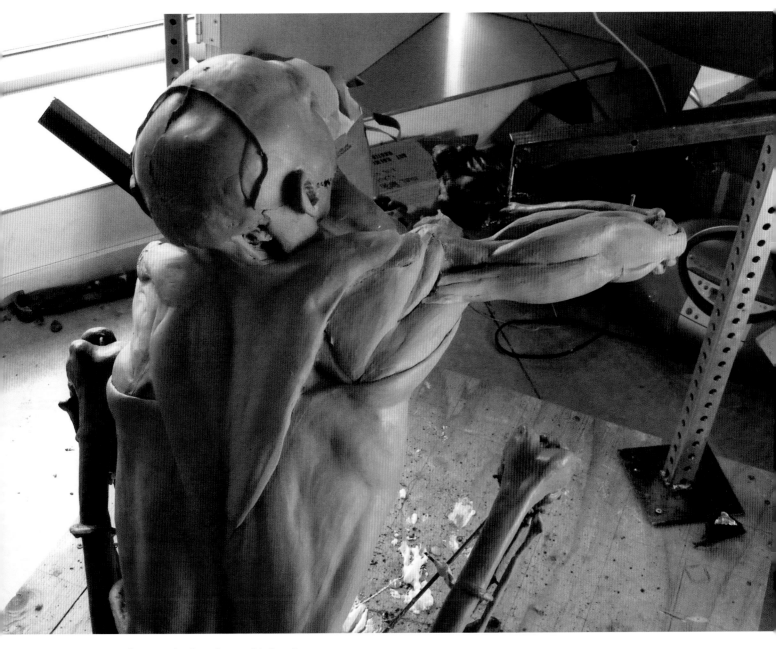

Here a few muscles have been added to the
composite female Neandertal skeleton.

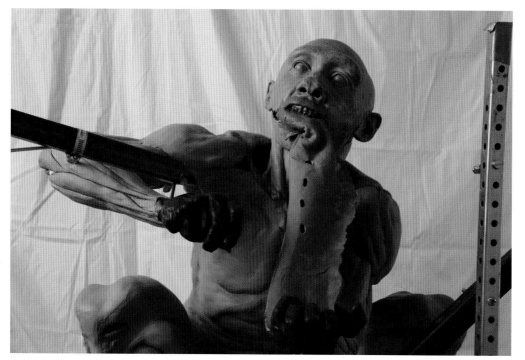

The fully muscled female Neandertal clay figure.

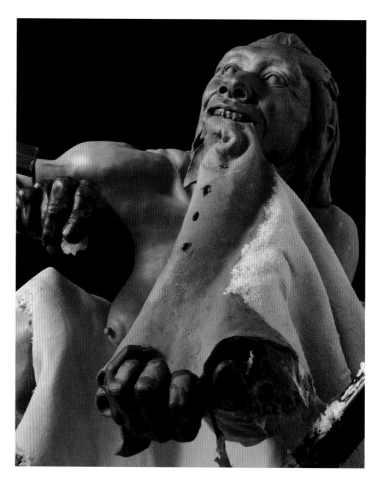

The final clay Neandertal figure, with animal skins.

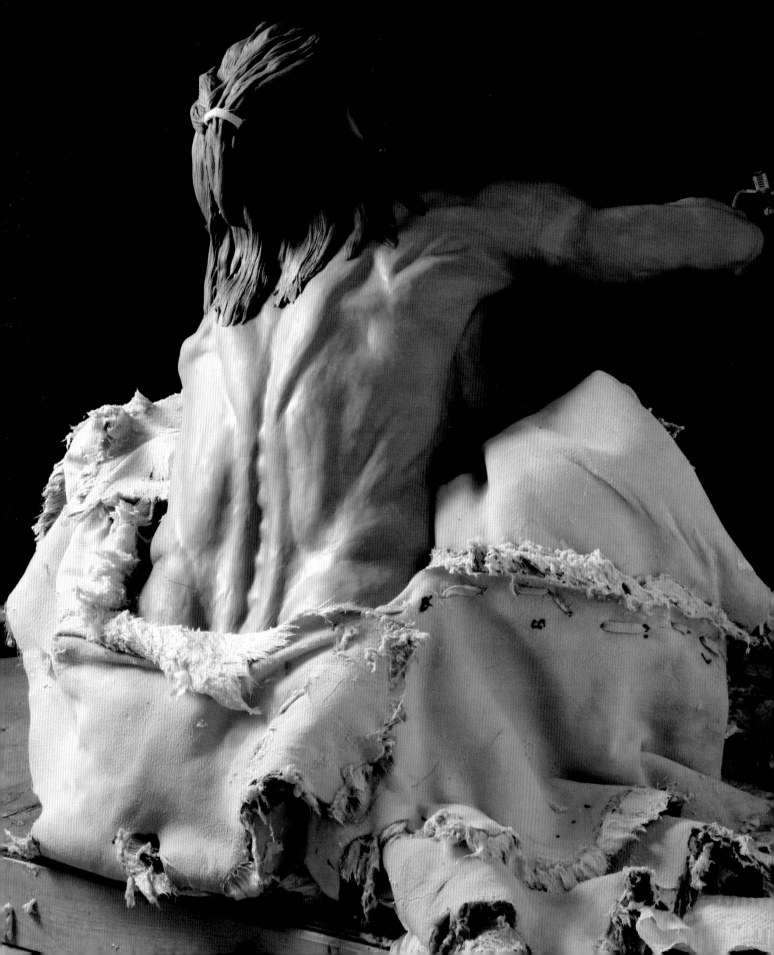

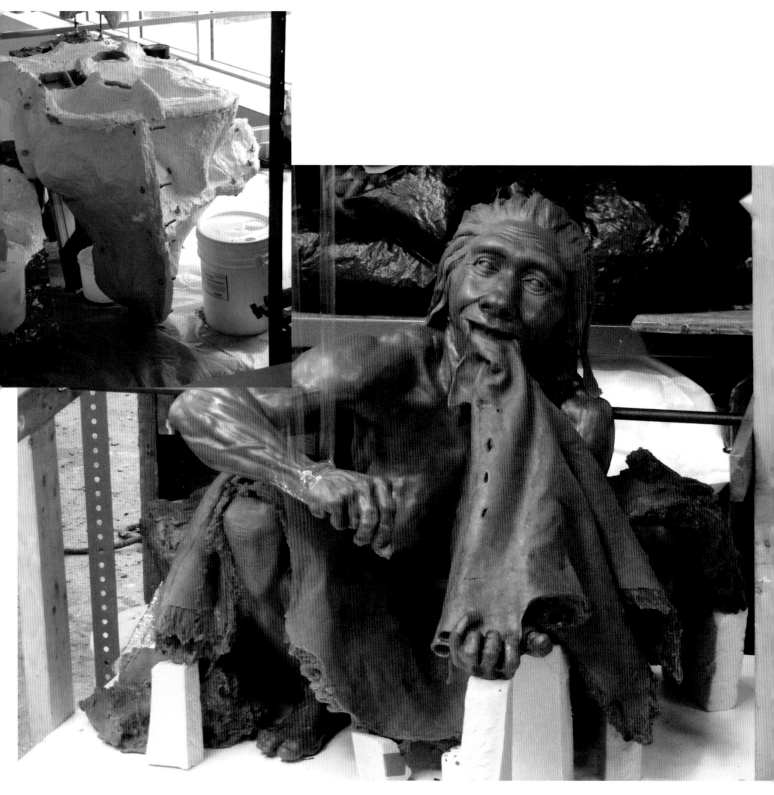

The two-part mold of the Neandertal figure is shown upside down (inset), as the final portion of the mold had to be made in this position. Also shown is the wax casting from the mold.

The toddler's body was to be reconstructed based on a skeleton from the site of Dederiyeh in what is now Syria, thought to be between 70,000 and 50,000 years old. This skeleton has a developmental age of about two years old. The skull is very fragmentary. Washington University's Erik Trinkaus, a Neandertal expert, helped out by lending a cast of a Neandertal child's skull from the site of Pech de l'Azé in France, thought to be of similar developmental age. This was used for the head reconstruction, with a few missing facial details filled in from the Dederiyeh skull and from a French skull, Roc de Marsal, thought to be that of a child between two and a half and four years old.

The Dederiyeh skeleton (cast) of a two-year-old Neandertal served as the basis for my sculpture of the bronze toddler.

The task of building the Neandertal toddler brought with it some special challenges. One of the issues was baby fat. Human babies are very pudgy, and in this they are very different from baby chimps and gorillas. Fat in human babies serves as a buffer against nutritional stresses during the process of growing a very large brain. Neandertal brains were, on average, a little larger than modern brains, so you might expect Neandertal babies to have a lot of fat like modern babies. There is evidence, however, that hungry times were fairly common among Neandertals. Years ago, I was in the process of drawing adult Neandertal body blueprints for the future Smithsonian hall and had asked Erik Trinkaus, who specializes in the study of Neandertals, to speculate about body fat levels. He pointed out that interrupted growth features, called hypoplasias, were fairly common in Neandertal teeth. These are indicators of nutritional stress. Coupled with evidence of very active lifestyles, this suggested to him that Neandertals in general would not have had much body fat. But I wondered now: what about the babies? With target adult brain sizes larger in Neandertals than in moderns, wouldn't baby fat seem a must?

I approached Erik again to ask him about this, and he recommended that I speak to one of his former students, then at the University of Central Florida, who studies the evolution of later humans (including Neandertals), especially growth and development, and adaptation to climate. Libby Cowgill was enthusiastic about helping with the Neandertal toddler. She agreed with my reasoning and suggested that there

might be thermoregulatory reasons to suspect fat in Neandertal babies as well. At the body size of an infant, surface area to volume ratios are much larger than in adults, so heat loss is a problem. This ancient cold-dwelling population did not enjoy the buffering effects of an advanced cold technology like that of modern Inuit, so a blanket of fat might have been more necessary. "If there was fat in Neandertal populations, this is where you'd find it," she told me. She also told me that very young human infants are not yet able to shiver, something I had not known.

Studies of the bones of Neandertal children convinced me that it might be a good idea to find a couple of big-boned, chunky modern toddlers of European extraction to be used as models. It wasn't that I wanted to duplicate their anatomy for the Dederiyeh Neandertal toddler, but I needed them as points of reference during the reconstruction. The building of a Neandertal child that was *less* robust than a chunky modern kid would probably not be consistent with the evidence, and I needed references to tell me just how robust a chunky modern kid is in various areas of the body.

So the search began for the right kind of modern child. This kind of thing isn't always easy. In the summer of 2009 I took a break from the Smithsonian project to go on a vacation with my family and two others at a nearby lake. On our second day, I saw a kid on the beach that looked perfect. It was a lucky find. I wanted to photograph him and I explained the project to his father, who was enthusiastic. His mother was not. I was permitted to photograph him, but his mom

never lost her look of suspicion, and the stats on him they had promised to send later never arrived. I never heard from them again.

A second toddler encounter started off on an even worse note. Through friends of friends I had heard of a Dutch-American two-year-old, named Bea, who might fit the bill, and I set up a photography session with her mother, Judy. I was working under somewhat strained circumstances, as the foundry's mold-making team was in town to mold all of the adult figures, and they had taken over both my home studio and my workplace at Ithaca's Museum of the Earth. In moving out of the museum space a couple of days before, I had moved a lot of material into my car. Among these were boxes of skull casts, partially completed facial reconstructions, and a wig I had used as a reference for hair texture. Not thinking about what this might look like to someone who didn't know me, I pulled into the driveway of Judy and Bea's home in a car that looked like it was full of body parts. Judy was in her front yard and greeted me with a big smile. Then her eyes drifted to the contents of my overstuffed car, and I saw the smile fade. Instantly, my inner voice of empathy gave me her likely thoughts: "Oh, here's Body Parts Man, come to visit my daughter."

It got better. I was able to reassure Judy that everything in my car was clay and plastic. Bea was perfect, hamming it up and enjoying the attention. She has a mischievous smile in most of the reference photos I shot that day. Photos of the two chunky modern toddlers helped greatly in quantifying the fleshing out of the Dederiyeh toddler's skeleton.

Bea, the modern two-year-old imp that served as a point of reference; a robust modern toddler.

My methods of predicting facial soft tissue for infants and toddlers are not as developed as for adults, having done much more anatomical research on adult apes and humans. Because my methods predict soft tissue variables for adult Neandertals that are similar to those of modern people, I took a shortcut and used facial soft tissue values from modern toddlers to flesh out the Neandertal toddler's face. "Bone Lady" Mary Manhein and research associate Ginnesse Listi of Louisiana State University helped out with unpublished data on facial soft tissue depths in the faces of living two- and three-year-old toddlers, measured by ultrasound.

I had a question about reconstructing a Neandertal this young which I could not answer before doing the work. Would this toddler be distinct enough from a modern toddler for the public to be able to see any difference? Juveniles of different primate species tend to look more similar than adults do, especially in the face and head. A study by Marcia Ponce de León and Christopher Zollikofer of the University of Zurich found that characteristics that distinguish the skulls of Neandertals from those of modern humans appear within the first few years of life. But this figure was at age two, and in any case I wasn't sure these skull traits would show in the fleshed-out form. Maybe it would just look like an everyday modern toddler to most eyes. As I reconstructed the head and face, building over the Pech de l'Azé skull, I began to see that some of the distinctive features of the Neandertal skull that appear at a very early age were showing subtly in the fleshed-out form. The long head with a projecting "bun" in the rear that characterizes the Pech skull is clearly visible in the final reconstruction. All three juvenile Neandertal skulls I worked from have chinless mandibles, and this too shows in the final bronze child. The "pulled-out" face and prominent nose

Stages in the reconstruction of the Pech de l'Azé child's head.

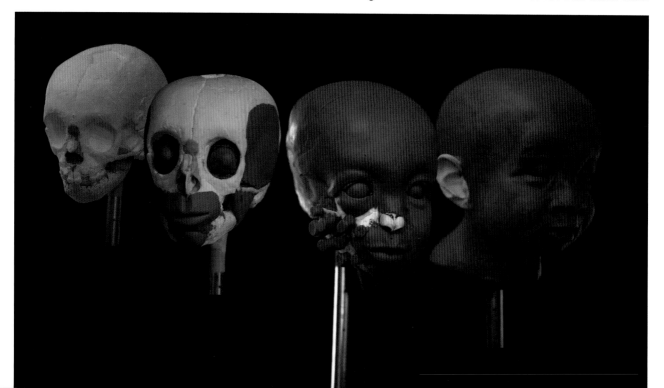

visible in the Pech skull and especially in the Roc de Marsal skull are also apparent in the toddler's fleshed-out face.

A casual eye could easily mistake the final bronze Neandertal toddler for a chunky but otherwise average-looking modern child. But for those who would look close, the face and head of this toddler are not average by modern standards. Although some of his features may be within the range of those of modern children, they depart from today's norms in ways that echo differences in skulls. Distinctive Neandertal features are visible in the fleshed-out forms of reasonably constructed Neandertals, even at this young age.

The Neandertal toddler reconstructed.

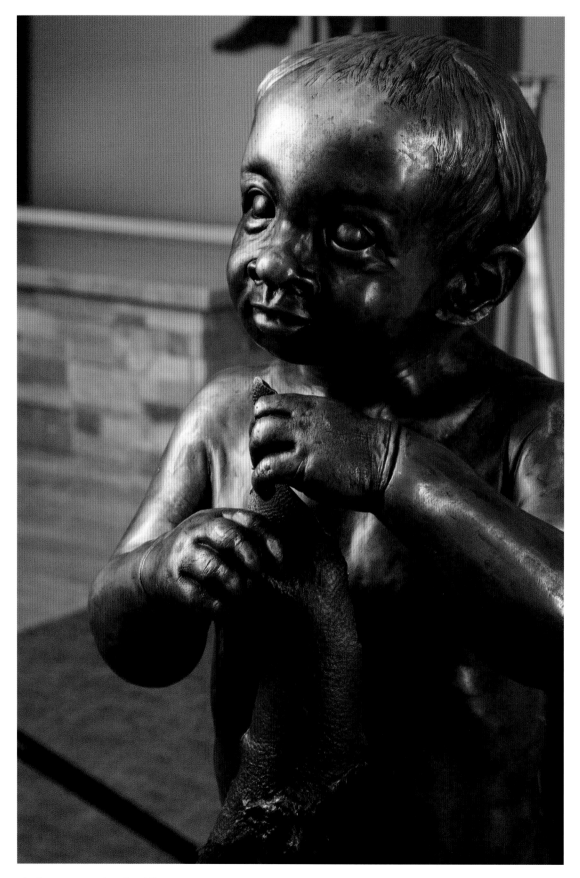

The bronze Neandertal toddler.

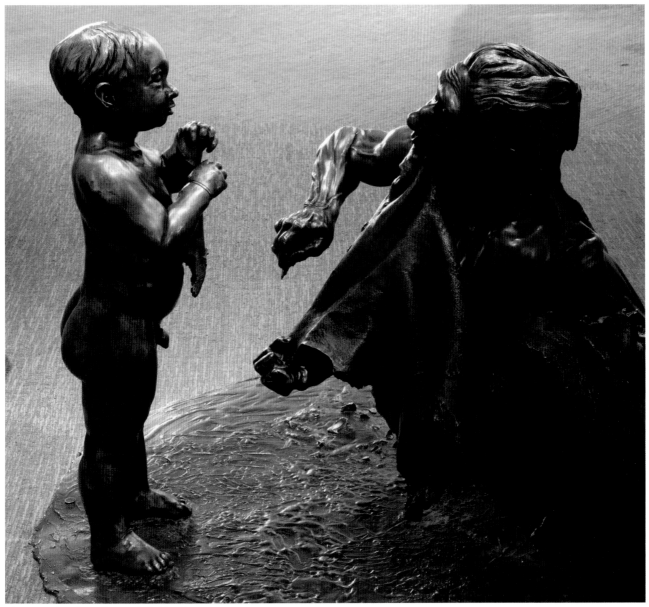

The Neandertal mother and child in bronze.

Later the bronze toddler was installed in the sculpted base opposite his mother, and for the first time they locked eyes. (They had been sculpted in different studios and at different times, so this was their first meeting.) There was instantly something there that had been absent moments before. A sort of magic empathy, goodwill, and love. Later, after the hall opened, I got reports from the Smithsonian staff that the sculpture was a "baby magnet."

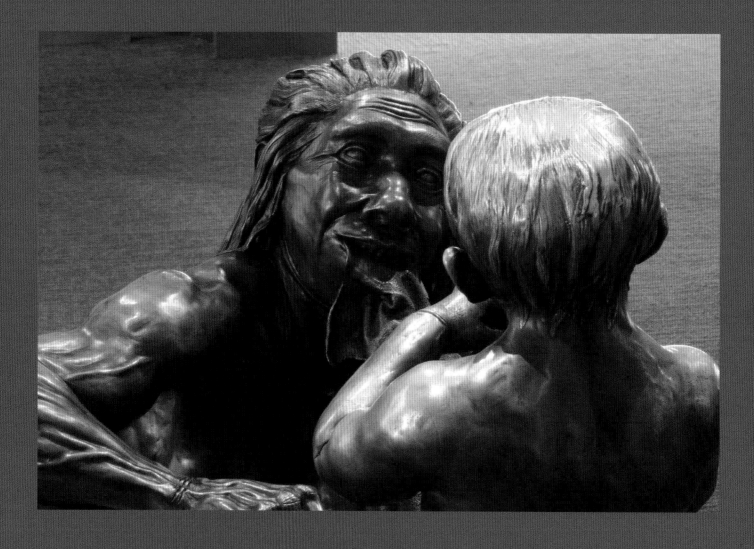

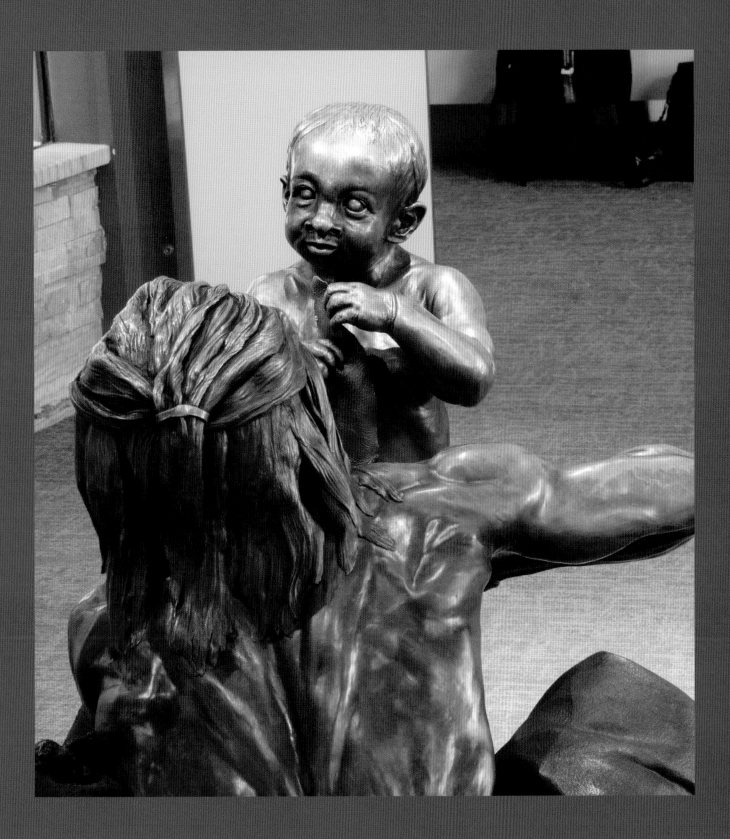

Bringing Back the Face of Shanidar 1

Similar features to those in the La Quina 5 and Gibraltar skulls are found in male form in the Neandertal skull known as Shanidar 1, who lived between 35,000 and 45,000 years ago in what is now Iraq. This was the basis of my Neandertal head reconstruction, made in silicone.

Working with the Shanidar 1 individual necessitated a decision early in the process. This individual had massive but healed injuries to his head and body. Among other injuries, he had sustained massive head trauma which had partially caved in his left eye socket. Reconstructing him in his injured state would have served as a talking point to museum visitors about the rough lives of Neandertals and the close-contact hunting they may have practiced. It would also have given the head the kind of character that is hard for a sculptor to resist (*As it is solely the power of character which makes for beauty in art, it often happens that the uglier a being is in nature . . .*). But I thought that it might detract from some of the subtler messages that could be communicated, and I wanted to show visitors what a Neandertal looked like, without the distracting disfigurement. So I healed the left eye socket of Shanidar 1, creating a mirror image of the intact right side, before I started the reconstruction.

The Shanidar 1 Neandertal skull (cast).

I thought the Neandertal head reconstruction offered some unique opportunities. Yes, the classic physical features typical of Neandertals are all there; the large brow ridges, the swept-back cheeks, and the large, pulled-out face with a broad, projecting nose. The themes of cold adaptation and heavy use of the mouth as a clamp were well represented, but I wanted something more. This is a behaviorally sophisticated kind of human and I hoped to get some of this into his face as well, with an expression that is pensive, and perhaps even a little sad. I wanted to portray a being with a complex inner life. As much as I like creating bronzes, this is probably too subtle an expression to be captured in bronze. It's not even perceptible from all viewing angles in this lifelike silicone sculpture. Intentional alterations to his physical appearance, such as a distinct hairstyle (I deliberately chose a non-Western hairstyle to distance him from the familiar) and a deerskin hair band with a lined design, hint that this complex being has symbolic levels to his thinking.

Stages in the reconstruction of the head of Shanidar 1. (Left photos by Chip Clark; courtesy of the Human Origins Program, Smithsonian Institution. Right photo and all reconstruction work by John Gurche)

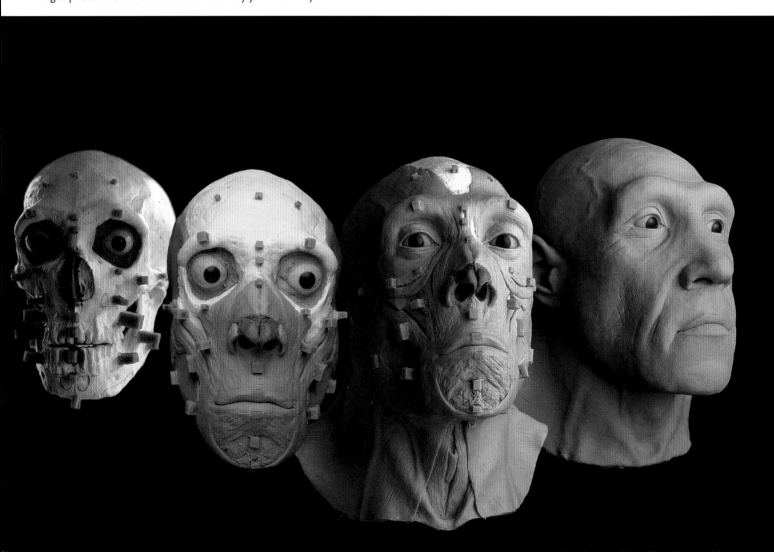

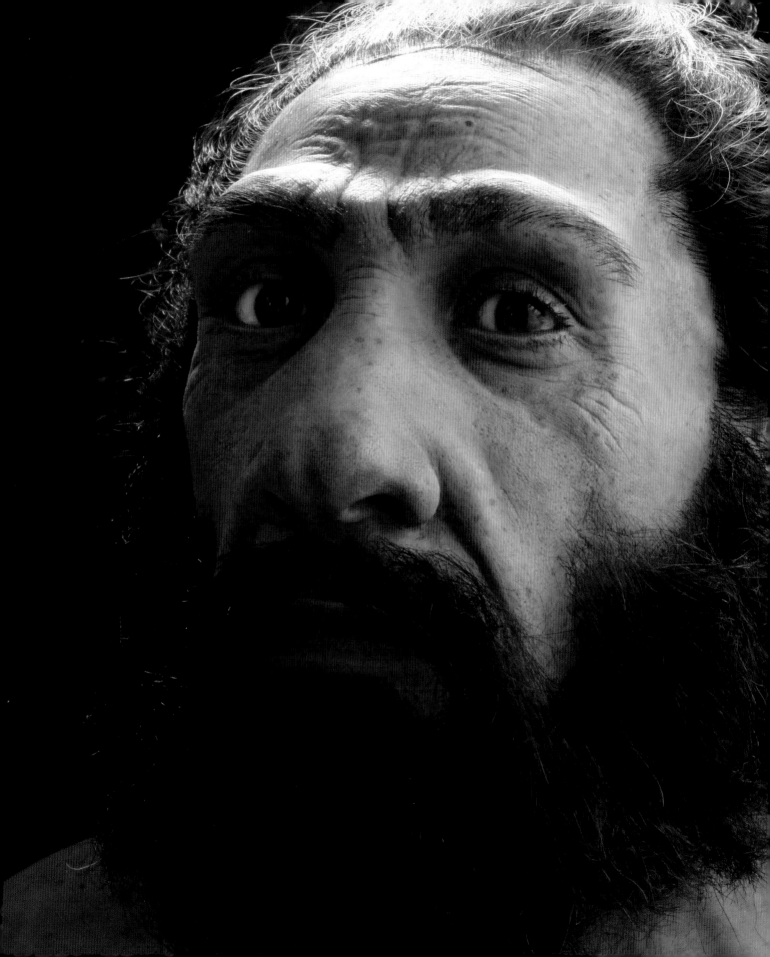

End Notes

Judy Kolkman visited the exhibit almost a year after it opened, and sent me photos of Bea, now towering over the Neandertal toddler. Concerning the Neandertal mother, she told me: "I was particularly struck by how immersed she was with her child. It was very effective." John Yellen later sent me a photo of his granddaughter, Nora Voldins, caressing the bronze toddler. During a Smithsonian visit a year and a half after the opening, I was able to confirm earlier reports by the staff that the bronze Neandertal toddler was indeed a baby magnet. I saw a toddler, about the same age as the Neandertal child, run toward it, then turn her head back to her parents, jabbing

Nora Voldins and bronze Neandertal playmate. (Photograph by John Yellen)

the air with her hand toward the bronze child, wordlessly gesturing toward the figure in unconscious affirmation of the gestural theory of the origin of language.

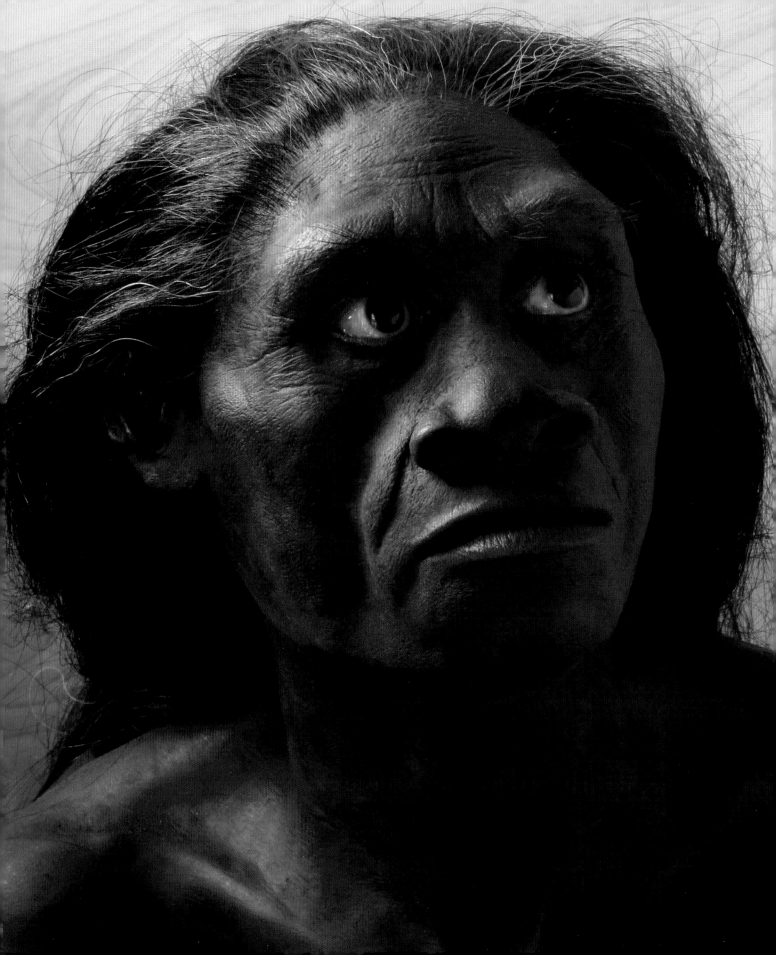

THE UNLIKELY SURVIVOR

Homo floresiensis (0.095 to 0.017 million years ago)

When Neandertals became extinct 27,000 years ago, we were left alone, the sole hominin species remaining on earth. Or so we thought. In mid-October 2004, I got a very surprising phone call. I had just finished working on a laborious project for *National Geographic*: three head reconstructions and a triple-page digital piece for an article on finds from the Georgian site of Dmanisi. I had been working seven days a week, often into the night, and I was ready for a rest. It was a beautiful autumn in Denver (where I was living), and I wanted to take long bike rides and play in the October sun with my kids, then five, seven, and nine years old.

The phone call was from *National Geographic's* Chris Sloan, senior art editor and the magazine's most knowledgeable connection with the paleosciences. He asked me if I was sitting down. He then told me that a diminutive, archaic-looking fossil hominid skeleton had been discovered on the Indonesian island of Flores. Its body size was tiny, the size of Lucy's, with a stature of about three and a half feet. Its brain volume was 380 cubic centimeters (later revised to 417 cubic centimeters), one of the smallest ever recorded for a hominin. Its kind had survived on the island until just 18,000 years ago (later this was revised to 17,000 years ago and it may be revised further). Would I be interested in reconstructing its face from the skull for the cover of their magazine? I couldn't speak. The idea of an archaic hominin with a seemingly primitive brain and body size turning up so far from Africa and so late in time was staggering. At each of the skeleton's amazing statistics, I simply smacked my hand on my worktable in astonishment. I wondered later what the archeologist in the next office thought was going on. After recovering my ability to breathe, I asked if I could call him back.

This was my introduction to the tiny hominin I came to call "Flo," perhaps the strangest branch of the human family tree. She would dominate my life for the next few months, and would never again be completely out of it. In the issue of the journal *Nature* that came out two weeks later her discoverers, a team of Indonesian and Australian scientists, described an odd mix of primitive features and more

The LB 1 ("Flo") skeleton of *Homo floresiensis.*
(Photo courtesy of Bill Jungers)

derived (more recently evolved) characteristics that she shared with members of the genus *Homo.* With australopiths such as Lucy, she shared primitive features such as her small brain and body size, her wide, flaring pelvic blades, the long neck of her femur, a large angle at the knee, and short legs. But she shared with *Homo* a flexed cranial base, a vertically short and not very projecting face, and thick walls of the skull, and she lacked the large, specialized jaws and chewing muscles of australopiths. Later discovery of her arm bones showed that, although her short legs gave her a Lucy-like ratio between humerus and femur, her forearm was relatively shorter, resembling that of tropically adapted populations of living *Homo sapiens* (including small-bodied populations). She had a long, low skull and a mandible without a chin, features which are seen in many early hominins, both australopith and *Homo,* but not commonly in modern humans.

An accompanying article described a surprisingly sophisticated archeological context for such a small-brained hominin. Cultural material included scatters of stone tools among the bones of a butchered dwarf elephant, evidence of the use of fire, and stone tools that were probably hafted to a wooden handle or shaft. And then there was the question of how the hominins got to Flores in the first place. Even during times of lowest sea levels, when it would have been possible to walk to Java, it would have required several water crossings, island-hopping up to fifteen miles, to reach Flores from mainland Asia. Before 4,000 years ago, when modern humans brought other species of mammals to the island, only two other kinds

of mammals had made the trip: rodents, which floated over accidentally on "rafts" of vegetation, and an extinct species of elephant, the modern relatives of which are good swimmers. Were Flo's ancestors technologically sophisticated enough to have made water craft?

What was Flo? Her discoverers proposed that the skeleton represented a new species of hominin that was probably a dwarfed descendant of *Homo erectus.* As reported by the authors, the cranium had a shape like that of *Homo erectus,* with a cranial vault that has its greatest breadth just behind the ear openings. The phenomenon of changes in body size, including dwarfing, in isolated island populations is well known in other lineages of mammals. There are dwarfed elephants, hippos, and buffalos, and the phenomenon is thought to be related to removal of both the means and the necessity for maintaining larger body size, in situations where there is both limited food and not many predators. Now that a dwarfed hominin had been discovered, one of the major messages seemed to be that evolution works on hominins similarly to the way it works on other mammals, and this can include island dwarfing. Flo was given a new species name by her discoverers: *Homo floresiensis.* Popular media called her "the hobbit."

Homo erectus made a convenient ancestor, as it is known to have existed in Indonesia for over a million years, perhaps until as recently as 100,000 years ago or less. Although Flo seemed more primitive in some ways than known specimens of *Homo erectus,* some scholars thought that some of her seemingly primitive features could

have been the effects of very small body size. Stone tools found decades ago on Flores attest to the arrival of hominins there by about 840,000 years ago, although their makers have yet to be discovered. The team thought it likely that these undiscovered hominins were Flo's ancestors. The only hominins known outside of Africa from that time period and earlier have been classified as *Homo erectus.* It seemed like a good match.

As is customary, the announcement met with controversy. Some thought that, rather than direct descent from a primitive hominin ancestor, pathologies could better explain Flo's small brain and body size, as well as other features of her skeleton. Brain size was a sticking point for many. As the Field Museum's Robert Martin explained in a comment in *Science* in early 2006, a reduction in body size from that estimated for *Homo erectus* to that of Flo would not alone account for a brain size as small as Flo's, if following the pattern seen in other mammalian lineages. To get to Flo's tiny brain size, the brain would have to reduce further. He and others thought Flo was more likely to be a modern human affected by severe pathologies such as microcephaly (a family of developmental abnormalities resulting in an unusually small brain). Some considered her a microcephalic pygmy.

Scholars from the lumpers school of thought stressed features suggesting genetic continuity between Flo and modern people living in her region today. They discussed Flo in light of possible pathologies and sided with those who considered her a pathological modern human instead of a new species representing an additional branch of

the human tree. Of course, pruning her branch simplifies the tree.

Most of these scholars considered it very unlikely that more individuals with size and morphology similar to Flo's would be found. The idea of an entire population of pathological individuals stretches credulity. The shaft of a radius found in older sediments and an additional tooth had been reported in the original article, but for many these were not conclusive indications of other individuals like Flo. "If I'm wrong about this," said Robert Martin to a National Public Radio interviewer, "I'll eat my hat." The next voice heard on the program was that of Australian researcher Mike Morwood, saying: "I'll just get the salt and pepper." Bones of several more small-bodied individuals had been found, including a second mandible, and some of the bones are smaller than Flo's corresponding elements.

No second skull has been announced to confirm the tiny brain size indicated by Flo's skull, and brain size continued to be a problem for some. This may be partly philosophical. A large brain is perhaps the number one hallmark of being human, and a look at the fossil and archeological records confirms a steady increase in brain size and a corresponding increase in behavioral sophistication over at least the past two million years. Can it ever work in reverse? Has it ever been advantageous to reduce brain size? We know that the brain is the most calorically expensive organ in the body. If body size in a population is reducing because of limited available calories, maybe the brain can reduce further, as long as it retains key organizational features. Some thought

that a hominin with a brain this small could not have made advanced tools, or hunted and controlled fire as the Flores hominins did.

Dean Falk, then of Florida State University, is an expert on brain evolution and endocranial casts (we first met her in chapter 2). In a 2005 article she and members of the original discovery team concluded that, although the brain of *H. floresiensis* was small, it showed evidence of expansion in some areas which are involved in higher cognitive processes such as planning. Dean and the team also found that Flo was not a pathological modern human. She concluded that the endocast of Flo's skull was not shaped like that of a pygmy or a microcephalic, but was closest in shape to that of *Homo erectus*. However, Dean and the team agreed with Robert Martin that Flo's brain was too small to be the result of typical dwarfing of *Homo erectus* (or *Homo sapiens*), and suggested an alternative hypothesis that *H. floresiensis* and *H. erectus* shared a small-bodied, small-brained, yet-unknown ancestor. In this scenario, dwarfing is not necessarily part of the picture at all.

Debate on this issue has continued through the years. As study of the bones of *H. floresiensis* branched out into other areas of the body, more evidence of primitive morphology was reported. In 2007, the Smithsonian's Matt Tocheri described the bones of Flo's wrist to a spellbound audience at the annual meeting of the American Association of Physical Anthropologists. "It's clear," he said. "The bones of the wrist retain morphology that is primitive for hominins." This has been followed by articles describing a mix of

primitive and humanlike morphology throughout the skeleton, published by a team that included Matt, Stony Brook University's Bill Jungers, and members of the original team. They concluded: "We have been unable to find this combination of ancient and more human-like features in either healthy or pathological modern humans, regardless of body size." A look at Flo's long foot skeleton is especially convincing, because it departs radically from modern anatomy.

Primitive features have now been reported for the cranium, mandible, brain, shoulder, limb bones, foot, hand, and pelvis. Debate about the remains' status as a primitive hominin vs. pathological modern human has nevertheless continued, sometimes heatedly. Presentations on *Homo floresiensis* play to packed audiences at professional meetings. "This must be a hobbit paper," said the American Museum of Natural History's Will Harcourt-Smith to a standing-room-only crowd when he took the microphone after a break during a session he was chairing at the annual American Association of Physical Anthropologists meetings in 2008. And indeed it was.

As these details emerge, the job of any person proposing that Flo is a pathological modern human has become increasingly difficult, as it now involves coming up with a pathology or pathologies that mimic primitive features in many areas of the body. As Dean Falk said during a talk at one of the yearly anthropology meetings: "If you can find a single pathology that mimics all of this primitive anatomy, you win, game over." For me, visual comparisons attempting to show similarities between Flo's anatomy and that of

microcephalic modern humans were never very convincing, even when the argument was restricted to comparisons of endocasts and skulls. In my view, nobody has succeeded in coming up with a pathology that produces, in a modern human, anything very close to the morphology seen in the Flores remains. "I think you guys can afford to be kind now," I told Bill Jungers after a particularly heated session in which one participant asked of another: "What color is the sky in your world?" It seemed to me that the scales of the argument had tipped so far in their direction that further rancor was unnecessary.

Finding Flo's Face

Despite the impossibly short time frame, I accepted the assignment from *National Geographic* to build a face for Flo. I was honored to have been given the job of figuring out what she looked like, and to participate in introducing her to the world. When the copy of Flo's skull which I was to work from arrived from *National Geographic,* I let my kids open the package.

"He's cute!" said one.

"And he's pink!" said another.

"*He* is a *she,*" I told them.

This was a high-tech model of Flo's skull. The original skull was too fragile to be molded and cast in the usual way, so this one was generated from CT scans of Flo's skull. It was translucent and beautiful. And it was indeed pink.

If it sounds like a rosy project, it was not. I had one month to do what normally takes me four months. Every few days, a *National Geographic* TV crew would come in and film the

progress. The insanity reached a high point during the weekend of Halloween. My wife, Patti, and I had long before agreed to take in the three children of some good friends for the weekend so they could attend a wedding in Boston. Then, just before the weekend, Patti had to leave town on a family emergency. With the extra kids I now had six children under my care. I could not stop working, except to cook, eat, and sleep a few hours. I had no time for extras. I did not have time to render my home camera-worthy for the *National Geographic* crew. If you look closely at the resulting TV program, titled *Tiny Humans: The "Hobbits" of Flores,* you can see out-of-focus clutter and Halloween decorations everywhere in the background.

I had had a little time to consider what facial expression I should give Flo while waiting for the package to arrive. In an exercise like this, the magazine cover symbolically becomes a magic window into time. The viewer is encouraged to believe, for a moment, that (s)he is looking through a portal into another time, and seeing an inhabitant of that time as it lived. This is the fiction we all participate in when a lifelike re-construction of an extinct hominin peers from a magazine page. Musing on the unspoken agreement to suspend disbelief that this requires, I thought: Why shouldn't it work in reverse? Why shouldn't we also indulge in the fiction that the portal works both ways, and that the ancient hominin can also see us?

I've been pleasantly haunted by this idea for a long time, and hints of it have shown up in my work before. In one painting, an adult hominin

in the foreground can sense our presence. He is wary and mistrustful; there's someone here, some presence felt, but he can't quite see it. The babies in the arms of their mothers further away, however, have no trouble seeing us, and they are reacting emotionally. In one of my paintings that takes place in the Cretaceous period, there is a glimmer in the eye of a dinosaur, a reflection of the photographer's flashbulb where no natural light source could be.

These are ways of playing with realism, of taking it a little bit further. If you think about it, it's no more absurd than executing a painting in a style that asks you to believe you are looking at a photograph of a dinosaur or an extinct hominin.

What expression would be fitting for Flo if she were able to see us? What would she have thought of our kind? I didn't have to think too hard about this one. We *Homo sapiens* do not have a good record when it comes to how we treat people different from ourselves. If she had any knowledge of our kind (and she may have, as modern humans were in the region during her time) we might have seemed to her like a race of violent giants. I thought her expression should be an uneasy one at the very least, maybe stopping just short of profoundly disturbed. Thinking further about it, I realized that this was not the first time that such an expression had appeared on the cover of *National Geographic*. One of the most famous covers of all time shows a green-eyed Afghani girl with an expression that speaks volumes about her experiences. She has seen too much. She is frightened and distrustful. This is exactly the kind of expression I was thinking of

for Flo. Could I pull it off? Could I get this kind of depth into Flo's eyes? In one sleep-deprived month? Only time would tell, but there wasn't much of it.

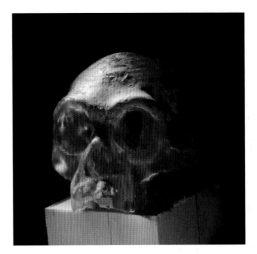

Flo's very reduced maxilla and mandible make an apelike muscularity around the mouth unlikely, and I reconstructed a reduced (which is to say humanlike) form for these muscles. Widely spaced temporal lines indicate that the temporal muscles were small. Her brow ridges are prominent for such a diminutive skull, forming double arches over the eye sockets; their form will be visible in the fleshed-out face, separated from the forehead by a slightly concave surface. The curve of bone that begins behind the brow ridges slopes back as it rises, and sports a midline prominence or peak on the upper frontal bone. These features, covered by a thin and nearly even layer of soft tissue, will be evident in the final face. The fleshed-out area below the mouth will be without a projecting chin, following the form of the mandible.[1] Flo's nose is, at this point, a crapshoot. The nasal bones on Flo's skull were sheared off when it was discovered, so it was impossible to determine the degree to which they projected. I've modeled the nose after that of *Homo erectus,* but this is a guess, and it was based partly on her proposed phylogenetic ancestry, a practice I like to avoid when I can. Now that this proposed ancestry has been called into question, I'm waiting, a little nervously, for a second skull to be found. If the nasal area is not as I've reconstructed it, I will have to change it in the Smithsonian sculptures. There may be a nose job in Flo's future.

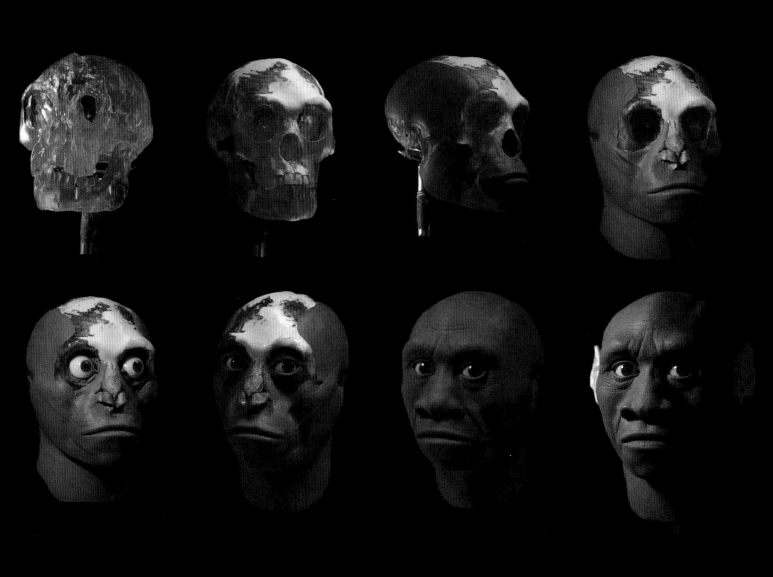

Stages in the reconstruction of Flo's head.

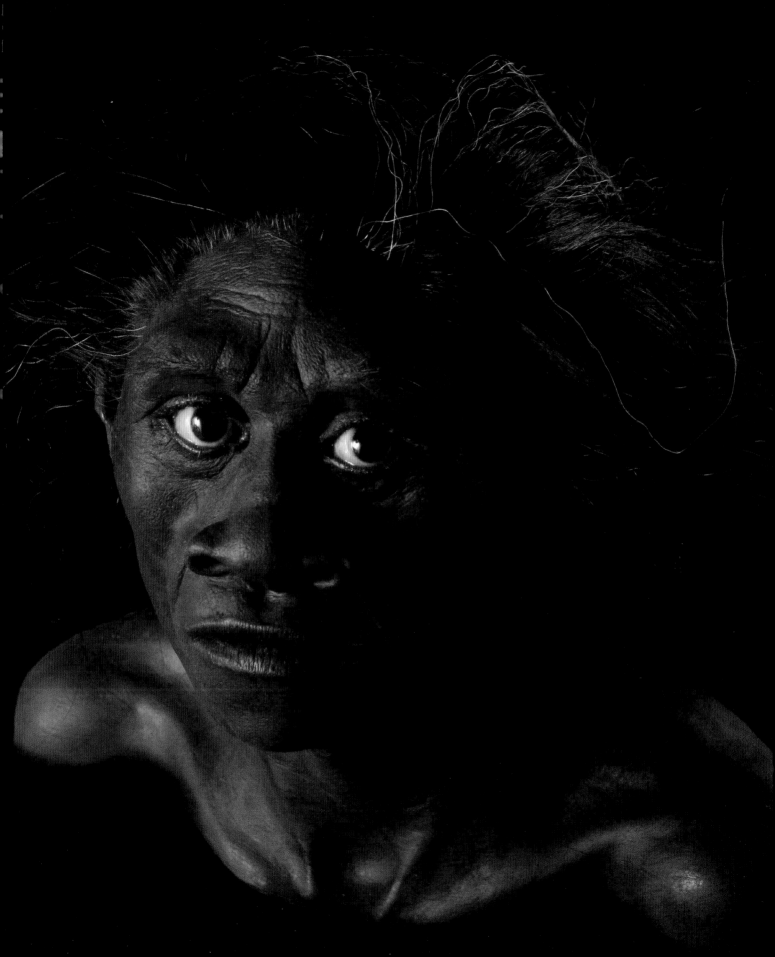

I was surprised in the end by how modern the finished reconstruction looked, even with the receding chin and small brain. It is partly because the small size of her braincase is hidden by her hair. But it is also because her face is tiny as well, so the skull lacks the primitive (to modern eyes) appearance of the face looking too large for the braincase which typifies australopiths (a disproportion which also is typical of microcephalics). I think it was this tiny face, along with the proportionally large eye sockets (which characterize most small mammals in comparison to their larger relatives), that my kids were having the "cute" response to. The *National Geographic* head reconstruction was duplicated, with a few upgrades to better realism (now that there was more time), for the new Smithsonian hall.

Vulnerability and Extinction

The Smithsonian team's thinking about what should be conveyed by the *H. floresiensis* figure and how to convey it centered around her vulnerability, both as a small hominin individual and as a species. It is thought that Flo's species was wiped out by a massive volcanic eruption, which belched clouds of hot ash and poisonous gas. Early ideas discussed by the team had her hiding behind something, perhaps a large rock.

"We can be a bit more poetic with this one," Rick said during one of our meetings. We had been discussing the poignant fact that this was our last evolutionary cousin to go, leaving our species alone on earth. He liked a sketch I had done of a hominin recoiling, with hands in a defensive position above the head. For me this had

been part of a more general exploration of ways of depicting aspects of the human (expanded to hominin) condition, but it might have special significance for Flo's species. Rick suggested that the figure could have a feeling of "trying to protect itself and having nowhere to hide, symbolic of its fate as a species; isolated and nowhere to go." We could make the defensive posture ambiguous enough to inspire questions and thinking about the various possibilities for what might be threatening her. I suggested implying motion by making the pose an unsustainable one. The team liked the idea.

We were comfortable building the plan for this sculpture around a question, one that fairly leaps out at you when you see the figure: From what is Flo recoiling? We wanted visitors to consider the possibilities. The two most likely answers we had in mind are: one of the giant Komodo dragons which are known to have existed on Flores at the time, and the volcanic ash cloud that may have terminated her species.

Both are meant to inspire thinking about the role of a hominin species (including ours) in its environmental context. The first answer brings with it the realization that the role of top predator cannot always be assumed for a member of a hominin species. They may also be prey. In the case of the ash cloud scenario, we wanted to inspire the realization that a human species can be terminated, and that our own continued presence on earth is not guaranteed.

Flo's Body Blueprint

As with the others, I began my work on the *Homo floresiensis* figure by creating a body

Drawings of potential poses for Flo.

blueprint, then a clay skeleton over an armature. Much of the information came from Flo's skeleton (also known as the LB1 skeleton), with a few gaps filled in from other specimens. At the time I began the figure, bones from a minimum of at least nine individuals had been recovered. Stony Brook University's Bill Jungers and the Smithsonian's Matt Tocheri, both working on a series of articles on the remains for *Nature,* were extremely helpful. Bill helped with body proportions and

with various details of the skeleton and their implications for soft tissue anatomy. Matt helped with details of the hand.

The body plan that emerged was unlike that of any other known hominin. Flo's pelvis has blades that flare out to the side, as in an australopithecine. Although the absence of a sacrum or a pubic bone makes it impossible to be certain about her pelvic breadth, it appears to be broad relative to its height. The highly angled knee at the end of her short femur (a combination seen in australopiths) provides another clue, as it would require a broader pelvis in a biped, which Flo assuredly was. Her wide pelvis gives her short trunk a broad, fireplug look.

Flo's clavicle is short, and her humerus lacks the twist found at the near end in modern humans, a combination also reported for the Nariokotome boy's skeleton and for remains from the Georgian site of Dmanisi, which have both been attributed to *Homo erectus*. As discussed in chapter 5, this would, with a normal modern human shoulder blade orientation, have the effect of orienting the arms and hands so that the palms and the plane of the elbow's hinge joint are turned outward. Since this position is considered less than optimal for toolmaking and using, it has led to the suggestion that the shoulder position in *Homo floresiensis* and *Homo erectus* was not the same as in modern humans, but was oriented so that the scapula is brought forward around the side of the rib cage and its joint for the humerus is more forward-facing. This would preserve elbow flexion in a front-to-back plane. I incorporated this shoulder position into the Flo sculpture, but as with the *Homo erectus* figure I have

a hedge, in case newer evidence doesn't support this work: both are in postures that would bring the shoulder joints forward even in a modern human.

A fairly complete scapula was recovered from another individual. I did not have a cast of it, and my first attempt at sculpting a scapula like it for Flo's skeleton from photographs had a very unusual look. I knew that the original was a weirdly shaped scapula, but I wanted to make sure that mine was the right kind of weird. Matt was kind enough to send me a three-dimensional image that was made from scans of the scapula, which I could spin in space and view from any angle on my computer, and this helped me get the anatomy right. Its unusual shape, in comparison to that of modern humans, affects the distribution of some of her back and shoulder muscles.

Flo combines a Lucy-like humerus-to-femur ratio with a *Homo*-like forearm-to-humerus ratio. As this is a combination previously unknown in the hominin record, it will give her a unique look. Matt helped me reconstruct Flo's hand skeleton. The hand skeleton from Flores is incomplete, but some proportional relationships reported decades ago by primatologist Adolph Schultz, which are identical in African apes and humans, allowed me to fill in some of the gaps.

Flo's feet are most startling of all, combining great length relative to the leg, little or no arch, and lateral toes which are much longer than the big toe, all primitive features for hominins. The metatarsals' robusticity sequence (order of metatarsals from least to most robust) is, however, like that of modern humans, as is the fully adducted big toe with a flat, humanlike joint at its base.

The team that has been writing on the Flores remains has concluded that features that have been proposed as endurance running features were absent in this species, and that the movements involved in walking and running would have been different from those of modern humans.

Although foot skeletal remains are largely unknown for *Homo erectus,* some researchers began to wonder: could such a primitive foot as Flo's be derived from *Homo erectus,* which, at least in African forms, is modern in so much of its post-cranial anatomy?

Flo's skeleton restored.

Flo's skeleton with a cast of the reconstructed head and portions of the musculature reconstructed.

The muscular reconstruction of Flo in clay.

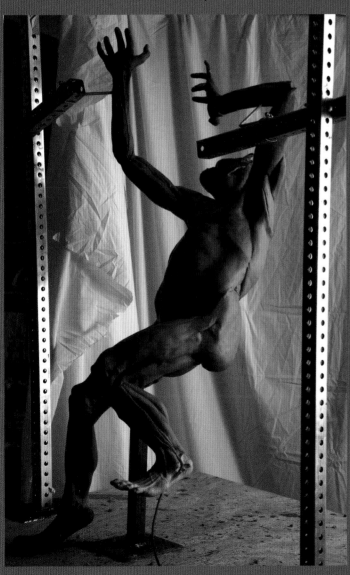

Courting the Impractical and the Absurd

The pose chosen for Flo is a tricky, difficult position. I think that the pose of the final bronze is a very powerful one, but it is dangerously close to some poses that are absolutely ridiculous. Change it a little, and you have something laughable. Tweak an arm this way or a leg that way and Flo is doing an interpretive dance. In fact the pose is so difficult that I was never able to get any of the present day human models I worked with to do it perfectly. I have a file full of near misses, and many of these photographs look very silly. Some resemble scenes from a bad 1950s science fiction movie. There is one exception. When I was experimenting with poses for Flo, I photographed myself in this pose, and one of these photos captures the pose beautifully. I needed to see what the various muscles were doing, so I did the photo shoot in my underwear. Later, but still early in the process, Rick and I were on the phone discussing the pose after I had sent him a drawing. He and the team needed to be convinced that the pose would work.

"Do you have some photographs of people in this pose?" he asked me.

"Well . . . only one," I answered. He promised to keep it confidential, and I e-mailed it to him. The image convinced him that the pose would work, but the rest of the team had to take our word for it. With any luck, it will never see the light of day.

During the time when we were working the pose out, I had a telephone conversation by speaker phone with the team in Rick's office.

Rick asked, "Will you please describe to the team what the *Homo floresiensis* figure is doing in this drawing?"

"Um . . . I think it's called the Hully Gully," I answered. After the laughter died down, Rick replied: "I think that perhaps we are revealing too much about the way we work together, John."

Late in the process of creating the sculpted figure of Flo, a crisis developed concerning the pose that almost caused me to scrap it and start over. I had been sending progress photos to the team as the sculpture progressed, and one batch set off alarm bells. Rick sent me an e-mail about it one night after midnight. The concerns were both perceptual and structural. The hominin had lost balance and was falling backward as planned, but as she became more fleshed out it appeared to Rick and Jenny Clark (also of the Smithsonian), and to Linda McNamara (of the design firm working on the hall) to be too extreme. Jenny thought it looked too much like a comedienne doing a pratfall, or slipping on a banana peel. Needless to say, this was not in harmony with our goals for the sculpture.

At the same time, there were structural and safety concerns. Project manager Junko Chinen had reviewed the latest progress shots of the sculpture with the Exhibits Department's chief of design, Mike Lawrence, and they felt that the degree of backward lean, which had not been as obvious in previous photos, was too extreme. Since the diminutive figure was leaning backward, there might be a temptation for kids to climb or hang on it.

In creating my "unsustainable pose," I had positioned the left foot off the ground and the

left leg somewhat flexed at the knee in reaction to the danger confronting Flo. This meant that the sculpture would be anchored only by the front of the right foot (the right heel was also off the ground, as the foot carried the tension of her recoil). There were concerns that a single anchor point might not hold. "I guess the question is," Rick put it in one e-mail, "how will the statue fare if, well . . . if a 250 lb teenager decides to lean full weight against the front of the statue, or pulls on the arms and head from behind?"

The central part of the armature inside of the fragile clay trunk of the figure was made of reinforced iron bar. It could not be changed without seriously damaging the figure. Putting the other foot on the ground would have been, to my mind, moving in the wrong direction. The pose would have become very unnatural. Maybe it was time to scrap the pose and begin again. I stopped the work and went into the house to make some coffee.

Halfway through my second cup, I began to see Jenny and Rick's point. I had to admit that it was too close to a falling pose, perhaps a pose of tripping over something behind her. Her fending arms could be interpreted as flying out during a loss of balance. Or, alternatively, as reaching for something. Or even, I thought to myself ruefully, as shooting a basketball. I never mentioned this impression to the team.

A number of conversations ensued, including discussions of starting over. We all kept our heads (I was probably the closest to losing mine), and gradually solutions emerged. To address the structural concerns, I needed to tilt the figure somehow so that it wasn't at such a radical angle

with the vertical. I solved this problem by tilting the sculpture-with-base and essentially building a new surface on which Flo would stand. It was tricky, because if I oriented her too vertically, she did look more like she was doing an interpretive dance, Hully Gully or otherwise. In order to increase the strength of the attachment at the base of the sculpture, I went back to an earlier plan to run a small metal bar, invisible from most angles, between the suspended left foot and a rock just beside the figure.

I reworked the position of the head and arms, and redid the facial expression, in order to highlight her gestures of avoidance. The left hand was moved to a more protective position near the face. The right hand was tilted farther back, into more of a fending-off gesture that excluded the possibility of reaching for something (or just having thrown a basketball). The head was turned a bit more, and the facial expression was altered to a tight-lipped wince, full of tension and fear, as if in expectation of a blow. I also felt that I needed to emphasize the quick movement of her recoil. I started to think about further implying a rapid turn of the head by putting the hair in motion. But first, I realized, I needed to speak with Nina.

Nina Jablonski is an anthropologist at Pennsylvania State University specializing in the study of skin and hair. She sees kinked and curly hair as adaptations that allow a trapped-air space between the scalp and the outer surface of the "do," so that the head is buffered from the effects of solar heating. This is usually a tropical adaptation, although not all tropical populations have it. Nina thought that a hairstyle that looked something like natural dreadlocks was a possibility for

an Indonesian hominin. I began to experiment with representing such a head of hair. I did not want it to look too modern or cultivated. I made casts of wigs and of my daughter Blythe's hair in the process, and one generous person donated his dreadlocks to the cause so I could experiment with them.

The best result came from sculpting the locks in negative space, by creating an irregular groove in a block of clay, and then incising lines in it with a needle. This could then be molded and cast in silicone or latex, duplicating the original clay groove. Clay could then be pushed into this groove, and the result was a nice, wild-looking tangle. The individual clay locks that resulted were each built around a stiff wire that was inserted individually into the scalp. This was a lot of work, for both me and the mold makers, who had to make individual molds for each lock. For me, it was very much worth the effort, and I love the aesthetic aspects of the flying dreadlocks and the way they convey the rapid turning away of the head. I can't speak for the mold makers.

I dragged guinea pigs from my village's coffee shop into my studio to get their impressions. They had no doubts that Flo was fending off something. They used adjectives like: "classical" and "biblical" in describing her pose. The process, as stressful as it was at the time, had only served to make Flo better.

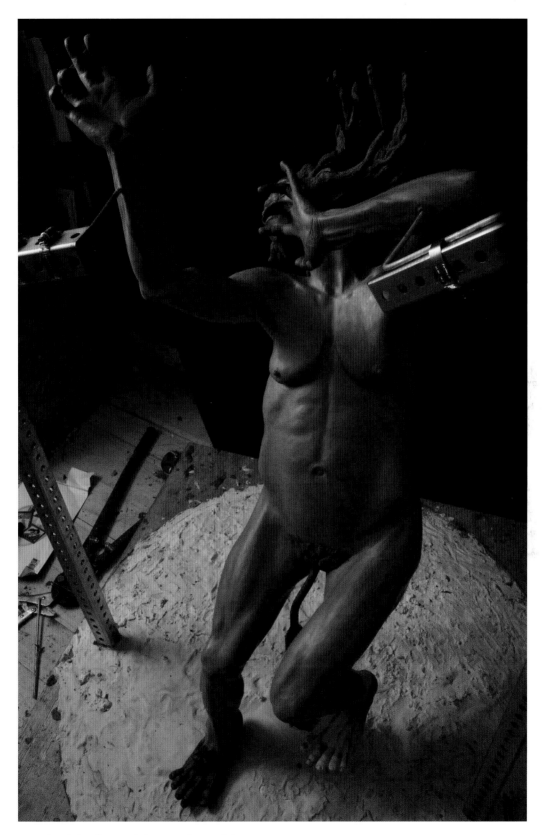

Completed clay figure of Flo, complete with hair in motion.

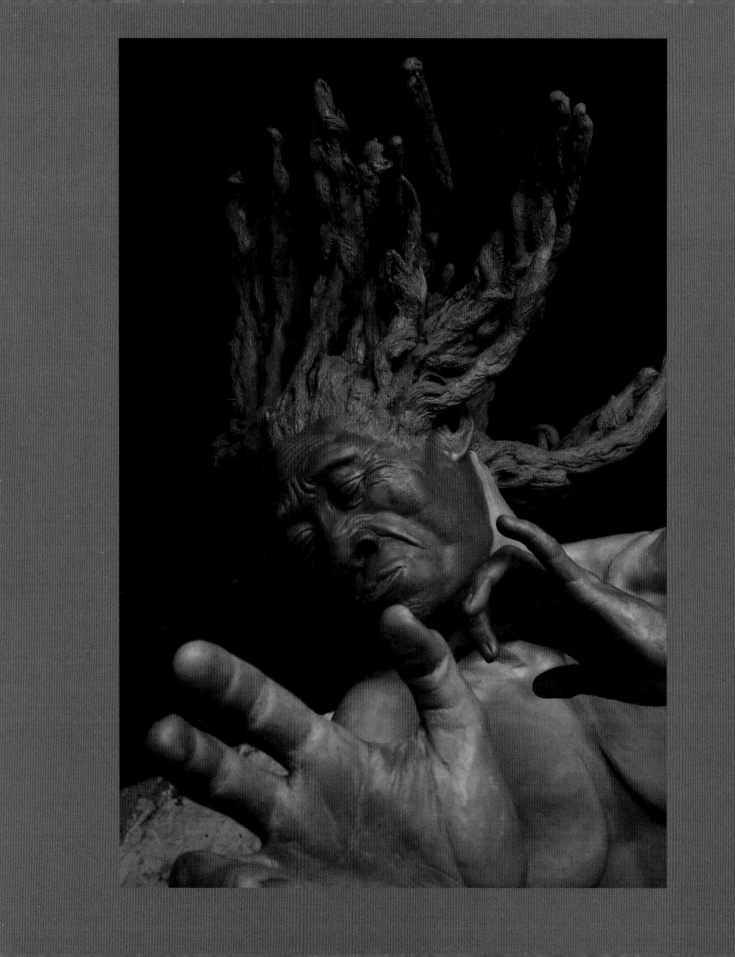

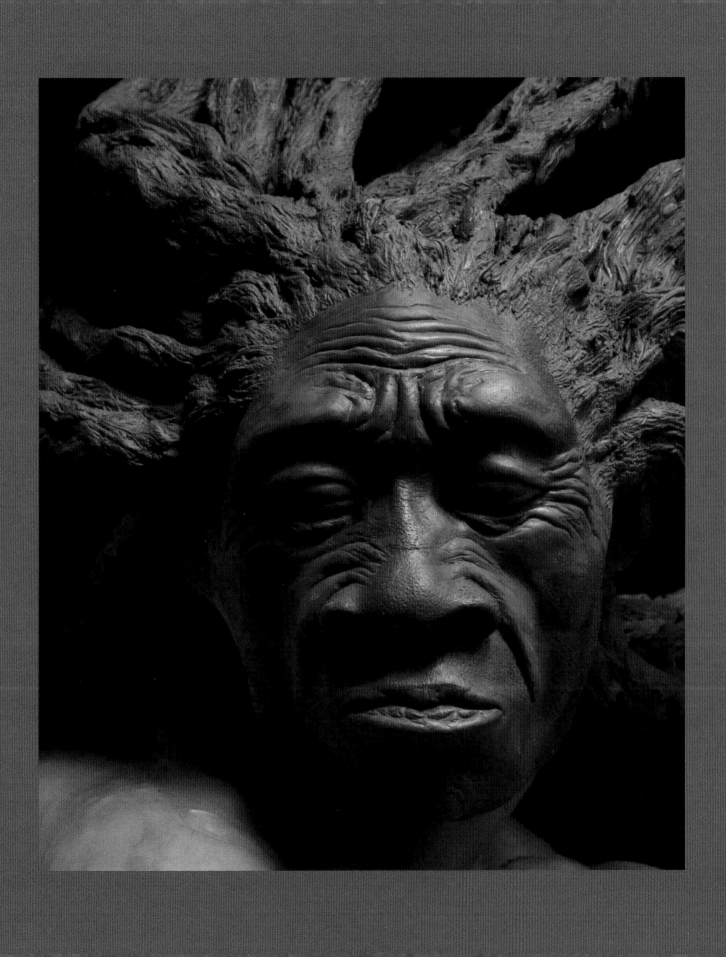

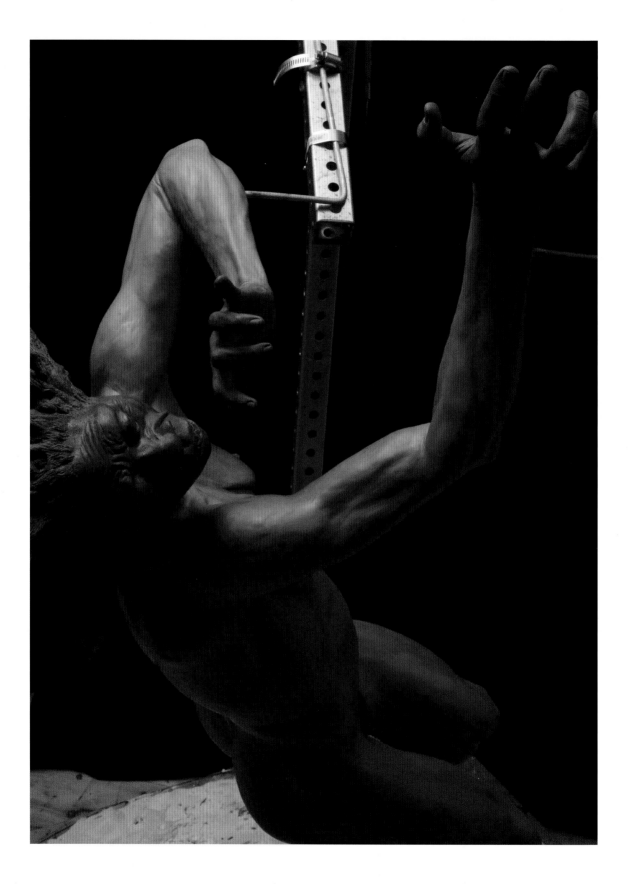

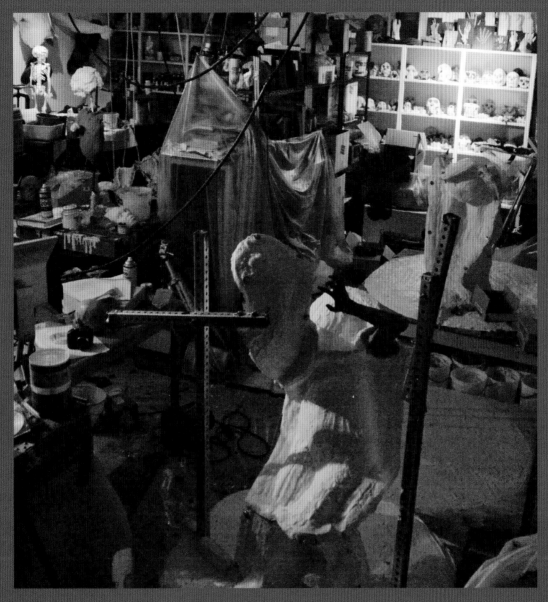

My home studio, showing a partially completed mold of Flo (foreground). Her
left arm and hand are not yet molded and are visible protruding from the mold.

Wax castings of Flo's body and head.

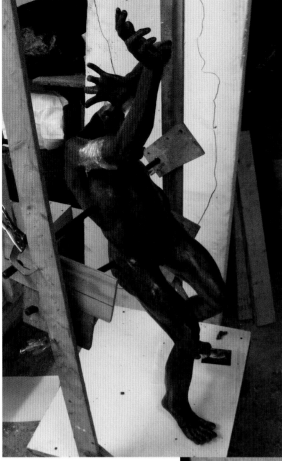

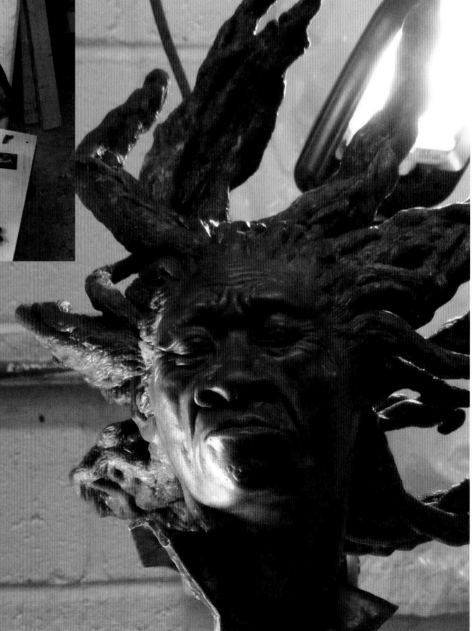

Meditation

If sculpting can be considered therapeutic, I had massive doses of therapy in 2007 through 2010. There is a lot of time for thinking while you are sculpting an entire body, even one as small as Flo's. The constant pushing, pulling, and smoothing of clay can be meditative, and it is easy to drift into a kind of waking dream. Some of the images that bubble up can be surprisingly appropriate to the work, and can offer new possibilities. They float up out of the darkness into plain view as if served up for your inspection by your subconscious mind. With *H. floresiensis,* there was a recurring theme of water—of large stretches of deep-blue ocean, with waves swelling and troughing. Deep water with no land in sight. The oceanic theme seemed important. Whatever her ancestry, the isolation provided by an island setting was important to her unique evolutionary path, and perhaps to the survival of her lineage while her ancestors elsewhere became extinct.

The arrival of hominins on Flores required crossing such water, even if the trip was made during times of maximum glaciation when sea levels were lower because so much water was locked up in the ice. Even during such times, Flores was separated from its neighbors by deep water. This has scientists considering between unlikely sounding scenarios. Was the crossing accidental? Did a group of hominins somehow get set adrift on a mat of floating trees or vegetation? A large enough group to found a population? Or is it possible that Flo's ancestors were technologically sophisticated enough to have mastered watercraft? Both of these scenarios have

an improbable ring, but one of them must be the true explanation. I began to wonder how I could incorporate this theme into the piece. The answer was literally under my feet.

My home studio is in the Finger Lakes region of upstate New York. We are surrounded here by an ocean of stone. These are limestones and shales initially laid down as ocean floor sediment about 380 million years ago. Everywhere in this stone, in creek beds, gorges, building sites, and sidewalks, are ripple marks, formed in the sediments by ocean currents. All I had to do for the obvious solution to hit me was take a walk from my front door, a hundred yards in any direction. Putting ripple marks into the stone planned for Flo's vignette would nicely hint at the oceanic theme which is connected with her presence on the island. I wanted to find a stone to work from with nice broad ripple marks that suggested the larger waves of an ocean rather than the small ripple marks of a stream.

I enlisted the help of my son, Loren, who is my partner in all things natural history, and it was he who found the stone I used. Loren found a rock with the perfect ripple marks for this purpose in a streambed a mile from our house, but it was the size of a car. We carried vats of silicone and urethane plastic to the site to make a mold and rigid "mother" mold, and I stirred in preweighed amounts of catalyst with a portable screw gun. Within several hours I had a cured mold I could use to make the chunk of stone to go with the Flo figure.

There were other thoughts that occurred to me while I worked on the *H. floresiensis* sculpture, and one of them began to hammer on me,

becoming so insistent that I began to think about including it in the piece. I'd rather not take all of the mystery out of the sculpture by explaining absolutely everything. As filmmaker Stanley Kubrick once said, the experience of seeing Leonardo's *Mona Lisa* would not be improved by adding a sign that said: "The lady is smiling because she is hiding a secret from her lover." I have said that there are two possibilities as to what Flo is reacting to in this sculpture. While I was at work, an obvious third possibility began to nag at me. After giving it much thought, I incorporated the idea into the piece. It's there in bronze, hard to find, but once you see it you can't avoid seeing it, and it adds another facet to Flo's story. Each of the hominin bronzes has at least one such secret.

The stone in Flo's environment, with ripple marks.

Flo in bronze.

End Notes

The mystery of *H. floresiensis* continued to deepen, even while I was at work on the Smithsonian sculpture of Flo. In early 2009, when 1.5-million-year-old footprints were reported from Kenya and attributed to *Homo erectus,* it had a profound effect on the question of Flo's ancestry, and added weight to the hypothesis Dean Falk and others had made earlier: that the size and morphology of Flo's brain and body could not be explained as a simple dwarfing of *Homo erectus.* If the newly discovered Kenyan footprints did in fact represent *Homo erectus,* they indicated that this species had an essentially modern foot, unlike the bizarrely primitive-looking foot of Flo's skeleton. Did something more primitive than *H. erectus,* perhaps with a very small brain and body, get out of Africa earlier than *H. erectus*'s celebrated exit 1.8 million years ago and eventually make it all the way to Flores? Scientists began seriously considering the possibility that an earlier form of *Homo* or even an australopith, with a small body and brain, a flaring pelvis, primitive limb proportions, and a primitive wrist and foot like that seen in Flo's skeleton, escaped Africa, made it into Asia, and eventually somehow rafted to Flores. This is a game changer for *Homo floresiensis* in many ways. Dwarfing of body and brain size, and a seeming reversion to more primitive body proportions, may not be part of the picture at all.

Then, in 2010, came a surprise. Primitive metatarsal proportions were reported for the Dmanisi remains, which have been considered by many a primitive stage of *Homo erectus.* Descent of Flo from such an ancestor would not require an evolutionary reversal in the proportions within the foot. But by this time, because such a relationship would still involve reversals in body proportions and size, and in other anatomical details, there were growing doubts about *H. floresiensis* being a descendant of any form of *Homo erectus.* The assumption that it took a larger-brained hominin at least as cognitively and technologically sophisticated as *Homo erectus* to make the journey out of Africa may be due for a fall. Likewise, the belief that humans were not able to leave Africa until they developed adaptations for long-distance travel, first seen as a package in *Homo erectus,* may also require revision. Increasingly, researchers are looking to a more primitive ancestor. The hunt for that ancestor is on.

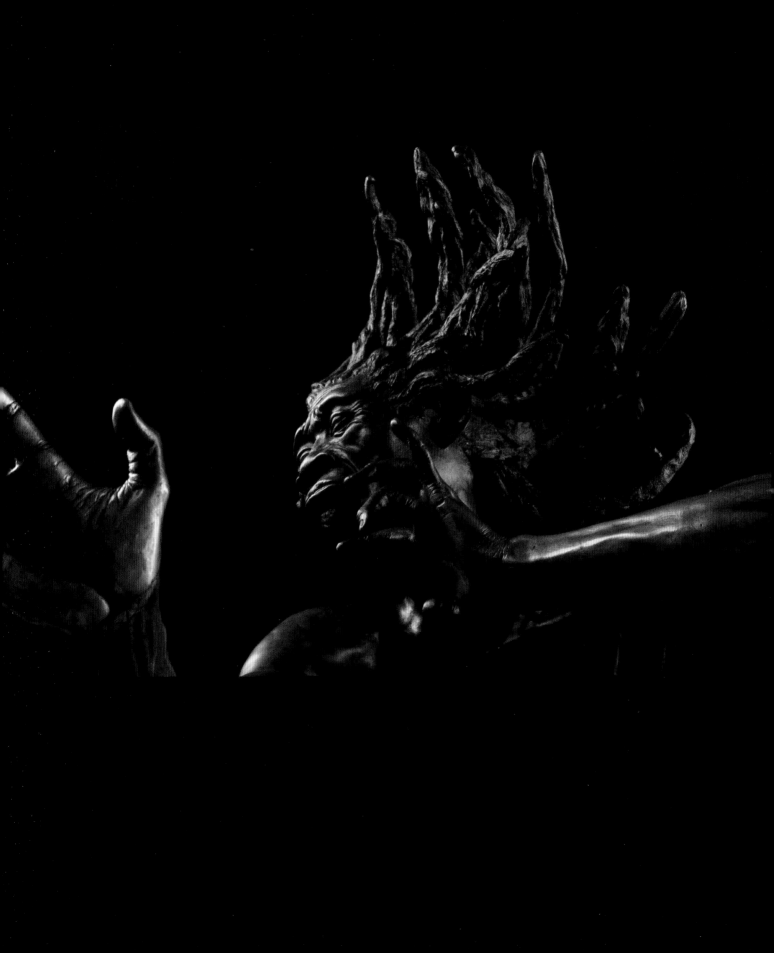

LINKED

Homo sapiens (0.2 million years ago–?)

At dawn, the collection of figures stands mute in the new hall, each a frozen snapshot in time, each representing a species now extinct. Their shapes have returned to the earth after long absences, but any appearance of life in these figures is belied by the material they are made of: an alloy of metal ores from the ground. By what conceivable natural process did these bodies, mimicking life in their shapes, make a reappearance on earth thousands to millions of years after their kind went extinct, in a metal that cannot sustain life?

Although these individual moments in human history have long passed, a curious circumstance has brought them back. A descendant in their distant future has looked back into time and used its survival-adapted cognitive powers to guess at their shapes and their daily lives. This is a species of hominin that lives in a symbolic world, spending day-to-day life navigating among phantoms of its own creation. It has reconstructed their bodies and placed them in a colossal shelter composed of idealized, geometrically patterned protective shells. When the earth's rotation brings the sun to a certain position in the sky, the silence will end, as masses of these descendants pour into the hall in a flood of color and sound. The colors represent the varied skin tones of a global species and the symbolic body coverings they wear. The sounds are nothing less than encoded thoughts, emitted in streams of sound. These hominins are linked, exchanging detailed information and states of mind.

By entering the new hall, this species becomes the final addition to the series of hominins here. Surrounding them all, fragments of thought are everywhere, fastened to walls in row upon row of black symbols and transmitted as sound from speakers. Other kinds of symbols abound here, including images and molded shapes. All of it relates to what this descendant has been able to puzzle out about its origins. The metallic shapes of ancestors are themselves among these symbols.

This curious descendant is you. You are not overwhelmed by the multiple streams of symbols surrounding you. After a lifetime being schooled in processing such symbols, you deftly shift your attention from one stream to the next, translating them effortlessly into thought. Through an ancestor's

sculpted figure, your mind builds a picture of a living ancestor. That ancient time is real, as real as today's. Art can function as a portal, allowing navigation from one plane to another. The capacity to do so is part of your heritage as the ultimate symbol-using primate, part of what allowed your species to survive as the sole hominin inheritors of earth.

Crossing the Gap

Some of the writings of William Golding deal with the everyday isolation of the individual and the immensity of the chasm that must be crossed when one individual attempts through language to communicate with another. Although his views of such attempts are not often positive ones, and his focus is on the immensity of the gap, for me this only serves to underscore the miracle of any means of crossing that gap, even imperfectly. When we get any sort of objective view on the fundamental isolation of the individual human mind, language is revealed as a wondrous mode of thought transfer linking individuals.

From Golding's 1959 novel *Free Fall:* "I am shut in a bone box and trying to fasten myself on the white paper. The [black] rivets join us together and yet for all the passion we share nothing but our sense of division . . ."

From the same novel:

We are dumb and blind yet we must see and speak. . . . It is the un-nameable, unfathomable, and invisible darkness that sits at the centre of him, always awake, . . . always thinking and feeling what you can never know it thinks and feels, that hopes hopelessly to understand and to be understood. Our loneliness is the loneliness not of the cell or the castaway; it is the loneliness of that dark thing that sees . . . by reflection, feels by remote control and hears only words phoned to it in a foreign tongue. To communicate is our passion and our despair.

With whom then?

You?

My darkness reaches out and fumbles at a typewriter with its tongs. Your darkness reaches out with your tongs and grasps a book. There are twenty modes of change, filter and translation between us. What an extravagant coincidence it would be if the exact quality, the translucent sweetness of her cheek, the very living curve of bone between the eyebrow and hair should survive the passage! How can you share the quality of my terror in the blacked-out cell when I can only remember it and not re-create it for myself? No. Not with you. Or only with you in part. For you were not there.

And who are you anyway? . . . Perhaps you found this book on a stall fifty years hence which is another now. The star's light reaches us millions of years after the star is gone, or so they say, and perhaps it is true.

When you watch a flock of starlings fly overhead, it's hard not to be captivated by the fluidity of their movement. The flock changes shape as one, flowing and pulsing amoeba-like. Individual birds seem connected somehow, joined into a single liquid entity as it flows around an obstacle.

How does the same nuance of directional change occur with what looks like simultaneity to beings controlled by fifty separate bird minds? What subtle communication links them all? Hair trigger reaction times and a deep compulsion to conform to the movements of others give the illusion of simultaneity and instantaneous telepathic communication between individuals.

With humans, it is not an illusion. Language is so fundamental in our everyday lives that it's especially difficult to stand back from it far enough to see it clearly. For a bit of objective distance, sit among a group of speakers of an unfamiliar language and watch the expressions as they come and go. You are cut off from the words' meanings and so pay more attention to what you are seeing. Here come the smiles again, fading in now simultaneously on each of their twelve faces as they respond to a speaker. They peak and begin to fade, then up again and *now:* breaking into laughter. Fading, fading, now gone—something like solemnity. Then coming up again, coming, and now laughter again. Riding on words, the emotions flow through the group. You are compelled to marvel at the magic of something that streams invisibly between them, causing similar emotional nuances to occur simultaneously in twelve human minds. Their minds are connected, and you begin to see language as the form of telepathy it is. In their unity of response, people linked by language are like starlings. In the nuances of the connections between their minds, humans go far beyond starlings or any other animal.

With language, humans externalize thought, so that it may cross the distance between individuals and then be internalized by others. The linkage begins in the darkness of an individual brain. A spark flashes into a minute tree of electrochemical fire, which immediately becomes a forest. This is experienced by the individual as a thought, representing units of perceived or imagined realities or relationships. Signals are sent to areas of the brain that assign words and organize them, according to unconsciously learned syntactical rules, into a sentence. These areas then send signals to brain regions controlling sound-making apparatus. An orchestra of over seventy individual muscles in the tongue, lips, chest, and throat coordinates to produce units of sound, and the original thought is on the wing, moving through air.

It is then apprehended by sound-sensing equipment operated by other nervous systems, and decoded and converted back into internal units of meaning very like the original thought of the sending nervous system. In this way, thoughts occurring in the mind of one individual can instantly be made to occur in the minds of others, with a kind of sound-mediated thought transfer.

Transmitted thoughts often have a purpose beyond the mere sending of information about the world. They may be transmitted to initiate further neural processing in the brains of the listeners: to cajole, threaten, or convince; to bend reality to the speaker's advantage. Manipulation of one's fellows has ancient roots among primates. Some of the living great apes are adept at politics and deception. Language allows these capabilities to be taken much further.

Linkages between individuals by language

are not static; they rapidly evolve, aided enormously by technology. As a result of technological facilitators of language such as writing and transmission by radio wave and electron, this linkage can occur across many miles and down through generations, enhancing cultural dissemination. Our species is now constructing and improving broad networks of intermediary technology to enhance links between millions of individual nervous systems at a rate that is breathtaking. As a result of electronic media and telecommunications, behavioral traditions can now develop on a global scale. The technology-assisted flow of language-encoded information has increased, and has literally resulted in revolutions. On an evolutionary timescale, writing, telecommunications, and the Internet all happened in the blink of an eye. What might happen in the next blink?

A Superorganism?

While Neandertals had been evolving in Europe, refining their physical and cultural specializations as a cold-adapted hominin, with a culture that allowed them to accommodate, to a degree, to changing conditions, *Homo erectus* hung on in portions of Asia after becoming extinct elsewhere. A tiny descendant of very ancient hominins survived on a small island in Indonesia. Meanwhile, something new had been evolving in Africa, an organism that represented the most potent yet of adaptive responses to earth's varying climates. This life form consisted of a web of intimately interconnected nervous systems, and it can be seen as a new level of organization for life on earth. This is modern *Homo sapiens,* with very large individual brains linked

by symbolic behaviors that include language in its modern form.[1]

The sequence:

- simple cell (prokaryote)
- complex cell (eukaryote, with a nucleus and other organelles derived from the incorporation of prokaryotic symbionts within a host cell)
- multicellular organism

can be viewed as a nested series (each category containing the previous one, in Russian doll fashion) of increasing levels of organization for earth's life. Each level represents an organism which emerged from the linkage of multiple individuals from the preceding level. Human society, as some biologists have suggested, exhibits a number of the qualities that have been used to define an organism, and some scientists see it as approaching the next level, a kind of superorganism composed of linked multicellular individuals.

Language bridges the gap between nervous systems, linking individuals in a way never before seen on earth, so that they resemble in some ways the individual cells of a multicellular organism. Increased communication between individual "cells" is one of the ways in which human society is like an organism. Increasingly, the experiences of one become the experiences of many. Individuals are embedded together in a matrix of shared experience and culture.

In a complex multicellular organism, a single cell cannot survive in isolation, cut off from the support system of the whole organism. With human societies, each individual "cell" may be isolated for short time periods. Total isolation for

longer periods seriously compromises the health of the individual mind. This would apply, to a degree, to individuals of many social species, but it has special meaning for humans. The human brain is so dependent on its linkage by language to other brains that it cannot develop normally without it. Experience is packaged, filtered, and funneled into the developing brain by language, and it actually determines which neurons will proliferate and which will be trimmed as the brain grows. So the circuitry of the brain is literally a product of experience, and much of its experience is mediated by its linkage through language with a larger network of brains.

Some of the comparisons that have been made between an organism and human society apply especially well to global society. The human superorganism has complex analogues to the circulatory and lymphatic systems of other organisms. Its nervous system is global and includes nonvisible channels such as microwave and radio wave transmission. Its sense organs have been technologically augmented, penetrating into invisible portions of the electromagnetic spectrum, and have been extended into microscopic realms and the depths of oceanic abysses, and to distant portions of the galaxy.

The power of language-linked minds has resulted in stunning technological advances. No single person knew how to send an intelligent robotic probe to explore the surface of Mars on its own for several years. This goal was accomplished by an aggregate of thousands of language-linked minds. The establishment of many human institutions, such as governments, religious institutions, and economic systems, has required huge amounts of mind-sharing, possible only through language.

Our machines and tools cannot be excluded from the human superorganism. We are obligate technology users. Even if you are not a hominin fitted with devices to correct defects in sight, hearing, or heart rate, you are dependent on a vast array of technologies to warm and shelter you, and to cultivate, package, and deliver your food, and most likely you engage daily in a thousand other technology-dependent activities. The technological material portions of the human superorganism might be considered in some ways analogous to the nonliving portions of other organisms—the silica encasing of a diatom or the calcium carbonate shell of an oyster.

Networks United by Symbols

Modern behaviors, once thought to have emerged over a few tens of millennia in a worldwide behavioral "revolution," have more recently been shown to have deeper roots, going back in some cases to the time of *H. heidelbergensis* (or, in the parlance of the lumpers, archaic *Homo sapiens*), so the transition can no longer be fairly characterized as an abrupt one. But some experts argue that the full collection of archeological signals that characterize later *Homo sapiens* is unlike that of earlier forms, suggesting that although earlier hominins may have practiced some behaviors we think of as modern, the entire package we consider modern was not yet in place until later versions of our species.

Like the minds of more archaic hominins, the individual minds of modern *Homo sapiens* build internal models of the external world, and

are capable of self-awareness, introspective theorizing about the mental states of others, and the use of symbols. But evidence suggests that modern *Homo sapiens* individuals experience a more richly symbolic world than those suggested by the evidence for more archaic hominins. This is a world inhabited by apparitions and gods. Among modern groups, huge amounts of energy and time are devoted to unseen worlds and invisible beings. Modern humans dedicate a great deal of effort to activities that seem unrelated to reproduction or resource acquisition, such as praying, painting, sculpting, games, and creating music. Who, if they had been watching developments from afar, would have picked this vision-questing, invisible being–worshipping species as the one most likely to be the sole inheritor of earth?

The success of modern *Homo sapiens* seems to have been due in part to the degree to which individuals are socially linked. Evidence suggests that in Upper Paleolithic Europe this kind of human was connected in larger networks over unprecedented stretches of space, a complex regional social entity, closer to adapting to the varied landscape as a single, variable unit. Some of the very behaviors that make these humans seem unlikely inheritors of the earth appear to have contributed to this. This group may have been the first to include among those they considered "their people" individuals whom they have never met. As with recent humans, part of an individual's identity was tied by symbols to that of a larger group. The human tendency to conform, to belong, resulted in behavioral traditions and belief systems that spanned vast areas, taking in larger amounts of people than could have known

one another. Their beliefs (including religious beliefs) and cultural traditions were encoded physically in symbolic objects that would be recognized at great distances, and by total strangers. In modern groups, contingency plans are sometimes encoded in religious mythologies so that, as with the characters of a particular myth, an inland group may approach a shore-based group in a time of need, even if they've never met. Their symbols will be recognized. They will be aided or taken in. As long as they're good Catholics. Or people of the fox tooth pendant.

Symbolic behaviors such as the creation of music and images help establish and maintain group identity, and are thought to have been very much a part of maintaining these complex social networks. Unseen worlds and invisible gods have immense uniting power for modern humans, and these are made visible through art, translated into powerful symbols that can be accessed by large networks of people, helping to reinforce their bonds. Some Upper Paleolithic art motifs— for example, leaping animals with distended bellies, and female figurines with exaggerated breasts and vulvas—are found in sites over a large area, suggesting common mythologies with symbols that reinforced group identities over vast areas. Today it is common for group identities to be global.

Symbolic behaviors that may have begun with *H. heidelbergensis* evolved into the modern range of symbolic behaviors in later *H. sapiens*. The use of symbols allowed modern humans to expand social networks, reducing risk (especially important in climatically uncertain times) with reciprocal obligations, and providing a larger pool from

which to select mates. Information exchange is an important part of this picture, and innovations would have been less likely to die out as they might with smaller, more isolated groups that apparently typified the social lives of Neandertals and other archaic hominins. Extensive trade, religious, and mate exchange networks may have arrived only with later *H. sapiens.*

The modern humans who entered Europe were not as physically cold-adapted or as robust as Neandertals. Apparently they didn't need to be. Their more flexible, more rapidly evolving culture provided a better buffer against their sometimes harsh environments. There is evidence that they were supremely adapted to environmental variability. They entered Ice Age Europe while still retaining tropical body proportions, and penetrated farther north than the Neandertals were able to. Their bodies had become more delicately built, and their teeth and facial skeletons were smaller, apparently because their cultural solutions to problems spared them the need to invest in more robust bodies.

Humanity is an organism that emerged on earth during times of extreme climatic instability. There were sometimes wild oscillations of cold and warm, wet and dry, and life on earth was subjected to intense selection (evolutionary) pressures. Sometimes climatic trends reversed direction quickly, so that a successful specialist during one climatic phase was suddenly at a disadvantage in the next. Hominins responded by evolving an increased capacity for culture, a potent new way to adjust to the caprices of environmental change. Those hominin species that specialized in any one environment or resource

tended to become extinct. Paradoxically, specializing in culture allowed some hominins to become the ultimate generalists. Evolutionary success in the hominin family seems linked to adaptability to varied environments. Modern *Homo sapiens,* linked into large networks and cognitively capable of producing a flexible, rapidly evolving culture, appears to be the most adaptable of them all. Their populations have swarmed the globe and their numbers have soared into the billions.

Human Culture

Culture was once thought to be the exclusive domain of humans. As we get to better understand our closest living relatives, the chimpanzees, they have provided challenges to claims of human uniqueness by exhibiting behaviors once thought to be solely the province of humans. In a 1999 article in *Nature,* a large team of prominent primatologists argued persuasively that chimpanzees have culture in the sense of behavioral traditions. Different chimpanzee groups each have their own way of practicing socially learned behaviors, including styles of greeting and patterns of tool use.

This is not to say that chimpanzee culture is identical to human culture. We have already discussed some of the ways modern human culture seems to be unique, even among hominins. And it is obvious that human culture and chimpanzee culture have produced very different results.

One reason for this is the "ratcheting" effect in human cultures, where innovations become fixed as mainstream behaviors in a human group and can then serve as a platform for the addition of further invention. Over time the culture

accumulates innovations and evolves. This can have the result of increasing complexity in technology and social systems. Chimpanzee cultures seem to lack this quality.

Language is key to this process. It greatly facilitates social learning by active teaching, including the specifics of behavioral traditions and powerful memes. Many human behaviors cannot be learned without language-encoded instructions. An innovation that is the result of neurological processes in one brain can rapidly spread to others, enhancing the speed of cultural evolution.

Human teaching involves demonstration, explanation, and adjusting the lesson to the learner's progress. The learner may use language to indicate specific portions of the lesson that are difficult for him. The learner's cognitive capacities come into play, including evaluation of alternative methods, with faithful imitation of those judged to be most successful. Language-aided teaching allows fewer weak links in the chain of behavioral transmission, and plays a role in "fixing" the specifics of a behavioral tradition, and in limiting "drift" in ideas and information.

Memory and its technological augmentations have a role in the fixing of behavioral traditions, facilitating the ratcheting effect. Innovations that have become behavioral traditions are recorded in the memories of the currently living, or in external memory such as writing or digital electronic storage. These technological forms of extrasomatic memory allow memories to spread well beyond the reach of those who created them, allowing input from individuals never met: the distant and the dead. This can then serve as a

base from which to move forward, as in Newton's "standing on the shoulders of giants." In reality, of course, there were no "giants" larger than Newton. He stood on the shoulders of a tall stack of people of various intellectual statures, most of them more modest than his own.

The results to date of the ratcheting effect for cultures of *Homo sapiens* have been stunning. Differences between Upper Paleolithic tool kits of bone, antler, and stone implements and today's technologies, which include particle accelerators, computers, and space vehicles, are not the result of differences in the brains of their makers. There is no evidence for differences in size or organization of the brains behind these two technologies, so they are thought to have been created by the same basic human brain. Technological evolution from stone tool to microchip is the result of the ratcheting effect of evolving human culture, and has occurred over a short stretch of human history, the last 40,000 years of a 6-million-year epic.

The ratcheting effect is speeding up. In *A Connecticut Yankee in King Arthur's Court,* Mark Twain's time-traveling protagonist from the year 1889 imagines what would happen if he described the technology of his day to his sixth-century companion. "If I had told [my companion] I had seen a wagon, uninfluenced by enchantment, spin along at fifty miles an hour; had seen a man, unequipped with magic powers, get into a basket and soar out of sight among the clouds; and had listened, without any necromancer's help, to the conversation of a person who was several hundred miles away, [she] would . . . have supposed me to be crazy." Imagine

this same protagonist getting a look at technology of today—our Internet and spacecraft. Our machines are evolving much faster than we do, which is why, while we have a physical resemblance to *Homo erectus* of a million years ago, our nanotechnology and intelligent machines bear little resemblance to the hand axe that was the height of technology at that time.

Science fiction writer Arthur C. Clarke has argued that a technology that is sufficiently advanced beyond our own would be, to our eyes, "indistinguishable from magic." Within the past several hundred years, the technology practiced by humans at any one point in time would certainly have had elements of magic for someone living a century earlier. Technological evolution is accelerating at such a rate that this time period is now less than a century. In fact the "magic" may now occur within a single generation. Several years ago my son received a Christmas gift of a globe that could be invisibly suspended in air by electromagnets above and below it. Before seeing it, I hadn't known that was possible. Today routine, even mundane aspects of life—how we navigate to a destination or store pictures—involve extreme technologies that border on the incredible, and that few of us understand well enough to explain in detail.

✳ ✳ ✳

So what are we? A symbolic animal? Earth's most adaptable mammal? A global, technology-wielding primate? A superorganism? A weed species headed for a cliff?

All of these descriptions have elements of truth. We are a small portion of the universe that has awakened. A scatter of atoms that once existed in the vast swirling cloud of dust and gas that preceded our solar system are now the atoms of which you yourself are composed, organized in such a way as to be aware. As Alan Watts once said, we are "an aperture through which the universe is looking at and exploring itself." We are, of course, the outlandish descendant described at the end of chapter one: a large network of enormous individual brains, linked by the sound-mediated telepathy of language.

We are a social species that is capable of caring and empathy, and also of cruelty and torture. It is rare for a human group to be free of war for any length of time. We engage in suicidal behaviors such as the fouling of resources we need for survival. Occasionally we use our technological prowess to destroy hundreds of thousands of our own kind at a single stroke.

Ecologically, we inhabit all of earth's habitats, including short-term occupations of the harshest deserts, iciest continents, and tallest mountains. Through humans, earth's life has sent its pseudopods outside earth's atmosphere and as far as its moon, and has propelled technological extensions of itself beyond the borders of the solar system. Humans have made brief forays into space and into the ocean's abysses, diving-bell spiderlike, in technologically sustained bubbles of habitable environment.

We are the authors of the newest, most powerful version of cultural evolution. With our linked minds and our rapidly evolving culture, we move mountains and change the planetary climates. We share some characteristics of a "weed" or "pioneer" species, which often uses up or destroys the resources upon which it depends before

moving on to other habitats. One important
difference is that, as a global species, we have no
other habitat to which we can move. Our soaring
population numbers have greatly amplified the
effects of our activities, and our footprint on the
earth is large. Our activities have now altered or
affected 83 percent of the land's surface on earth
(excluding oceans and polar icecaps). We change
the chemistry of oceans and the atmosphere. We
liberate carbon stored underground and warm
the planet. We poke holes in the ozone layer and
replace natural ecosystems with simpler, low-
diversity ecosystems, with ourselves at the top of
the food web. We are the creators of earth's sixth
large-scale (or mass) extinction (the fifth included
the extinction of dinosaurs). We do these things
before we fully understand their effects, and
our cultural capacities are now experiencing a
runaway acceleration in the sense that our powers
have, for the moment, outpaced our power to
control their more damaging effects. We have
emerged during times of increased environmen-
tal instability and have become creators of further
increases in environmental instability. As a result
of our own activities, we are likely to experience
rates of environmental change beyond any our
lineage has faced before. Our origin was not inev-
itable, and our survival is by no means a given.

Chapter 10

ENDINGS

My hand reaches for the knob of my studio door as it has done thousands of times before. I put the key into the lock and am instantly struck by the feeling that I am trespassing, disturbing a quiet place. The words come floating up out of my darkness: "a dead man's realm." I have a strong impression that the hand on the doorknob is not my own, but that of someone else, using this same key to enter the now-cobwebbed studio after I am gone. Perhaps my things are still in there, now covered with dust. I close my eyes and say to myself: not yet.

In November 2009, four months before the opening of the new Smithsonian hall, I was diagnosed with a malignant brain tumor. An intense headache during a cardiac stress test had sent me to the emergency room, where scans indicated a ping-pong-ball-sized mass in my right cerebellum. I was very lucky to catch it early, before it became symptomatic. Allowed to advance, it would have caused problems with balance and coordination, faculties which I use in, among other things, making art. These kinds of symptoms had so far not shown themselves. Eventually, the tumor would have killed me.

My wife, Patti, and I started interviewing surgeons. I met a brilliant, quirky brain surgeon at Johns Hopkins named Gary Gallia, who began every sentence with a pause, as if to gear down his thoughts for consumption by us normals. The interview proceeded pretty unemotionally until he found out I was a sculptor. At the mention of this a light seemed to come into his eyes. He was suddenly aware of the profound consequences the quality of his work would have for my life. He became our surgeon of choice.

The surgery went very well. It took about seven hours. I was out of the hospital in a little over forty-eight hours—the closest one can come, I think, to out-patient brain surgery. This was followed a little later by a six-and-a-half-week course of radiation therapy. During this time, I continued working on the last piece to be installed in the new hall before it opened. This was the Lucy figure, for which

something like a million individual hairs had to be implanted over her entire body. All bets were off, of course, regarding my finishing the piece in time for the opening. My usual ability to pour on the steam in a pinch was then missing; I had no steam. But it helped to keep working, to have something to focus on every day besides how awful I felt. My wife and family were incredibly supportive, even to the extent of suppressing fears about the future when in my presence.

With the help of my assistant, Bryan Root, I finished the Lucy figure on the same day the course of radiation treatments ended. This was a week before the Smithsonian hall was to open. I was still too sick to attempt the six-hour drive to Washington, D.C., but an extremely kind friend, Fred Bonn, offered to drive me and the Lucy figure to Washington. Patti came down for the new hall's opening celebration the following week, and it was a life-affirming time for me—of triumph in difficult circumstances, and of seeing old and dear friends.

The brain tumor turned out to be of a rare kind, which meant that no one could give me a solid idea of what the future might hold regarding the chance of a recurrence or how much more time I might expect to remain alive. For all of the negative aspects of this experience, there have been some positive effects too, especially with some of the perspectives it has engendered.

Living through this has changed the way I experience life. Oh, it isn't always true; I can still fall into the old ruts. But quite often I will experience a moment as if I had just been granted a return from being dead a long time, hanging in the void, perhaps wishing to return to a moment

of life, any moment, and see color, hear a human voice, breathe. And then, by some miracle, I'm there, immersed in a living moment. Maybe I'm in the process of getting a speeding ticket, as I did just this afternoon. The officer has taken my driver's license and registration and returned to his car. The police car's flashing lights are an intense red, someone is talking on the radio, and there I am, in that bubble of experience. I breathe, I am alive. The moment comes complete with smell, taste, and touch; a crystalline whole. If I choose to take all of this for granted, I can select an alternative stream of thought, in which I worry about how much the ticket will cost, etc. No doubt I will eventually do this, but it's clear to me that it is a choice and, for now, I can put it aside.

Some of these new perspectives have to do with a sharpened sense of the placement of my finite life within larger temporal contexts. The present now seems less like an endpoint of all that has come before, and becomes a moving midpoint, gobbling up the uncertainties of the future and converting them to the certainties of the past. I now find it easier to visualize times when I am no longer here, and have a sharper sense of my life as a finite segment within a much larger time stream: the past and future of human history. As a product of evolution, I am a work in progress, a snapshot of a process still in motion.

I lived on earth during a time of wonder and discovery.

I lived during a time when we were still learning about the basics of the phenomenon we are part of: organic life. We had, just a century and a half earlier, discovered that it evolves. We

were less sure about how it originated. This was during a time when we had only one volume in the library; we had yet to discover life on other worlds. We did not understand life well enough to synthesize it.

I lived at a time when we understood that the human family had evolved from a species of ape, but before we had identified that species. I lived before we had found all of the species in the human family tree. More than half of the hominin species known at the time of my death were discovered during my lifetime.

During my lifetime, the entire human genome was sequenced for the first time, as well as those of our closest living relatives. We were just at the beginning of our understanding of how genes work. We had begun, through breeding programs and later through the manipulation of genes, to guide the evolution of select species of other organisms. Attempts at exerting any control over our own evolutionary trajectory had been sporadic and ethically problematic.

I lived after my lineage learned a degree of control over stone, bone, wood, fire, metals, organic and inorganic chemicals, plastics, subatomic particles, and high-energy radiation. We had just begun to tinker with genes. We had yet to achieve any significant control over space, time, or gravitation. Our mastery of many elements and compounds was at a primitive stage in that it did not include dealing with or even fully understanding their effects on our health and that of the rest of the biosphere. When we discovered that portion of the electromagnetic spectrum we now refer to as radiation, we had so little understanding of it that radioactive thorium was

thought to be health-giving, and was included in laxatives and toothpastes. As a child, I remember putting my foot into an unsupervised X-ray machine, fully available for public use in the lobby of a shoe store, to see the bones of my foot. Many types of energy and materials were used in my time before their health effects were known, and my generation has sometimes been called "the poisoned generation." We had yet to understand how to live with our technology in a way that could go on indefinitely. We were in a primitive industrial phase, and it just about killed us. It did kill many of us.

Members of my species were obligate technology users and we employed technology in nearly all of our activities. Some of us had machines implanted to keep our hearts beating, our joints mobile, and our arteries open. Other technologies became like an extended body, external to our own. Some of our thinkers predicted that we will someday merge more completely with our technology, including the downloading of individual human minds into computers or their descendants. In my time, although our basic biological processes were often assisted by technology, we still reproduced, ate, and eliminated wastes like other mammals.

By the time of my birth, our technologies were evolving much faster than us. During my lifetime, technologies arose that made possible the construction of massive worldwide information networks.

I lived 350 million years after my ancestors' invasion of the land, and during the time of the first penetration into the space beyond earth's atmosphere.

I lived at a time when the stars in our galaxy were still visible from many places on the earth's surface. This was during the early days in our understanding of the universe. When my father was a child, it was discovered that the universe was expanding. After the birth of my first child, but before the birth of my last, we discovered that the expansion was accelerating. This was theoretically attributed to something we called dark energy, but we had no idea what it is, other than that most of the universe must be composed of it.

My ancestors became good at colonizing new environments, expanding their niche beyond forests and lakeshores. With technology, they were able to move beyond their home continent, and in my time, my kind inhabited all of the habitats and continents on my planet. My species had traveled to our planet's moon for short periods, but we had yet to colonize other worlds. In my time, plans were under way for the first short visits to our planetary neighbors. Our machines had preceded us there.

When I was alive, we did not yet know whether we represented a rare phenomenon or a common one in our universe. During my lifetime, the first planets outside of our solar system were discovered, and it was demonstrated that planets orbited many of the stars in our galaxy. We still did not know whether life was common or unique to earth. We understood even less about whether there might be qualities such as consciousness or intelligence on other worlds.

At the time in which I lived, my species had achieved a degree of thought transfer, but it required encoding thought into patterns of light or sound waves, to be decoded by the receiving individual. There were no other, more direct, forms.

In my time, language seemed a finished product, a completed bridge between people. We agreed that it developed from simpler forms of communication, but most of us did not view it as still evolving, largely because of a failure of the imagination; we could not imagine what is as far beyond language as language is beyond the communication systems of other animals. Similarly, the human mind was widely viewed as a finished product, mostly because we had trouble imagining something that was as far beyond us as we are beyond our nearest relatives.

I lived at a time when each human experienced a single, isolated self, a quiet central darkness that was a vortex for the reception of direct sensory experiences of just one body. We had developed technologies that allowed us to experience limited versions of the sensory experiences of others, and our shared thought through language had moved somewhat beyond the complete isolation of other animals. But for each of us, experience was still a singularity. We had merged with each other only up to a point. Each of us felt the dichotomy: the we and the I.

I am more like a wave than a stone, in that atoms flow into me and out of me, but my shape is maintained. These atoms belong to the universe at large, and are temporarily organized into a human shape for only a brief time. The heavier atoms I've borrowed from the universe were forged in the cataclysmic explosions of supernovae more than five billion years ago. These eventually fell together, along with much other material. By five billion years ago, the atoms

which now make up my body and brain were widely dispersed in a rotating disk of rock and ice rubble just before its central mass ignited and became our sun. By what conceivable organizing process could these scattered particles be brought together into a shape that could ponder its origins? That, of course, is the subject of much of this book.

❋ ❋ ❋

Bringing the human narrative to the present day does not bring us to the end of the story. It is more like watching a movie of condensed human history during which the film breaks. Things were just getting to an exciting/terrifying point and we are dying to know: What will happen next? How will the story end? Cultural and technological developments in the last few seconds of the film had sped up to a frenetic pace just before the break and we wonder what we will see in the next few seconds, once the film is repaired. Keeping pace with humanity's rapidly expanding cultural capabilities were the destructive aspects of human activities, and we wonder: Will some form of human life or its technological/organic descendants survive to inhabit the earth and its neighbors for as small a blink of geologic time as an additional tenth of a million years? If we manage to get control of our deadly powers before it is too late, may we hope for longer?

We are the last man standing, the inheritors of earth. But we are poor inheritors if we, with a *boisei*-like, shortsighted focus on what can be pulled from the ground today, cut the last living branch off of the human tree. We have the dust of yesterday sifting through our fingers and the light of the cosmos in our eyes. Will we trip

ourselves up on our way to the stars? To cover two possibilities for the human future, I have here provided two alternative endings. You may choose whichever ending you prefer. This choice parallels the choices we all must make in our own lives.

Ending 1

The eventual fate of all known hominin species except *Homo sapiens* has been extinction. We tend to congratulate ourselves because we've managed to outlast all other hominin species, but it is important to realize that it was not by our longevity as a species that we did so; most well-known hominin species are known to have lasted much longer than our mere 200,000 years. Some scholars feel that there was an element of chance in our becoming the sole surviving species. Genetic data indicates that *Homo sapiens* was brought to the brink of extinction at some point within the past 100,000 years. Anyone watching from afar at that point in time might have bet on another species (two, and possibly three, other hominin species shared the planet with us at that time), as most likely to outlast others. Our cultural capacities do not represent a guarantee of our species' survival.

Previous experiments in being human have shown that those species that follow a narrow path of adaptation, such as the cold adaptations of Neandertals or the specialized chewing anatomy of *Paranthropus boisei,* eventually became extinct. The survivors were those with diverse capabilities, that could keep more options open when conditions changed. The vast majority of current *Homo sapiens'* worldwide food consumption is

now limited to a few species, mostly the seeds of cultivated grasses (rice, corn, and wheat) and a few of their consumers. Under human control, population numbers for these domesticated species have increased dramatically worldwide, while the numbers for their relatives in the wild have declined. As Rick Potts has pointed out, this certainly represents a narrowed path for humans, and is likely to constrain our future options.

In addition, *Homo sapiens* has a record of behaviors that are not sustainable in the long term. Neandertal activities have been characterized by some investigators as culturally conservative, with low impact adaptations that maintained low population densities and put little stress on the environment. The record for modern humans upon their arrival in the same areas has been characterized as higher impact. An example of this contrast is provided by evidence that, despite competing for some of the same resources, Neandertals and cave bears coexisted for tens of thousands of years, during which time their populations seemed to be in a state of dynamic equilibrium. Upon their arrival, modern humans hunted cave bears more intensively, and competed with them for living sites. After a period of co-occurrence with the newly arrived modern humans, cave bears became extinct. This behavioral aspect, seen in the ancient record of modern people 30,000 years ago in western Europe, is not unique to that time and place. Modern humans have been implicated in major faunal extinctions around the world.

This record seems to prefigure the behavior of our species today, which is amplified by our enormous population numbers. The consumption of resources and destruction of habitats at unsustainable rates seem to be habits we have difficulty shaking. These behaviors are more characteristic of a "weed" species that moves into an area, reproduces quickly, uses up resources, and moves on to other habitats, than they are of the practices of more stable late succession species (also known as climax species). The late succession species that eventually follow weed species are characterized by more sustainable practices and a longer tenure. Weed species are generally short-lived phenomena. Our weedlike behaviors are now being carried out on a global scale. At present we have no new habitats to move on to; earth is our only home. Unless we can make the switch to sustainable behaviors more like those of a climax species, our species is likely, from an ecological perspective, to be a short-lived phenomenon (weedlike ecological "strategies" are, of course, not conscious in most species; many are practiced by plants). An outside observer watching the progress of life on earth might have expected that when earth's life finally produced a form that was self-aware and intelligent, it might realize that its behavior must become sustainable if it was to endure, and that perhaps it would use its ingenuity and technological capacities to make a shift in the direction of the practices of late succession species, in it for the long haul. As of yet this does not describe our behavior.

As we gobble up resources, destroy habitats, and spread our wastes, we engender rates of extinction of our fellow earthlings that are so rapid that they are considered by many scientists to represent earth's sixth mass extinction, comparable

to that which ended the dinosaurs' reign. We know that the current activities of humanity cannot be sustained over the thousands of centuries it might take to give rise to an organic descendant species or even the handful of centuries it might take to give rise to an evolving population of self-reproducing technological descendants. Can we change these behaviors in time? Are our talents for agility in responding to unpredictable changes in conditions enough to save us from the accelerating negative effects of our activities? With any reasonable look at present day trends and their projection into the very near future (a mere blink on an evolutionary timescale), the more relevant question might be: *Are* we curbing these tendencies? The time is now. The human future is a very large IF.

The speed of development of technologies designed to kill on ever more massive scales is also not encouraging. How long a period of geological time can a worldwide species with nuclear arsenals and stockpiles of biological weapons survive?

In Ending 1, *Homo sapiens* does not survive. We retain the characteristics we share with "weed" species right to the end, or perhaps we turn our course too late, and our unsustainable practices are, in the end, not sustained. Like most "weed" species, humanity turns out to be a short-lived phenomenon. It becomes extinct with no descendants or technological heirs. It is brought down with many other species in the sixth mass extinction it authored. Earth's life survives. After a brief decimation from human activities, it rebounds enthusiastically with an explosion of adaptive responses to the conditions in which humans left the planet. This has happened before.

Whether the insult was caused by a collision with an asteroid, volcanic activity, or poisonous pollutants generated by life itself, the insult has been followed by an exuberant adaptive radiation of new forms that could withstand or even benefit from changed conditions. Earth and its life will survive the human insult.

A few human artifacts will survive in near-pristine condition. Those few we have sent out of the solar system will escape the ravages of the earth's restless surface and the sun's high-speed charged particles. Some of these space vehicles carry images and sounds meant to convey impressions of the lives of the species that made them long before. These are complete with maps of the cosmos indicating where, relative to the location of various pulsars (pulsating neutron stars), their makers once lived. If anyone from elsewhere ever visits earth, our time will be represented by a thin layer of plastic in the geological record, laced with heavy metals and exotic hydrocarbons. And by the numerous fossils of a very few species: a single global primate and the organisms that, for a brief time, sustained it.

Ending 2

If our lineage does manage to survive our current difficulties, what would the human future look like? It is likely that if we were able to visit a time only a short hop into the future in geologic time, say 100,000 years from now, we would not see human beings as they are today. By almost any measure, change in the human sphere is accelerating, and any reasonable extension of current trends on graphs charting the paths of human culture becomes a steep climb

and then a vertical line long before that time. Given that what we would find in this future era would no longer be what we consider human, what kind of organism might descend from humanity and its technology?

Human activities have now altered the ways in which evolution works on the human species. These effects are likely to increase, and this may both close off evolutionary paths and open new ones. New evolutionary paths may involve more human control over our evolution and further integrations of technology and organic life. Our technologies are evolving at much faster rates than we are, and such future integrations may reach a point where organic materials represent the weak link in the system.

Even within the short life spans of people alive today, humans have become more integrated and interdependent, and networks have become more global. Where are these trends headed? If the degree to which we can access the experiences of other individuals is increasing, we might ask: What would it be like if you could more directly experience and process another's sensory experiences? Studies of conjoined twins whose brains are connected provide some interesting data, suggesting a reduction or blurring of the boundary between their individual selves. When one drinks, the other feels the sensation of liquid pouring down her throat. Visual stimulation of one individual's eyes produces activity in both brains. Both twins seem to be able to experience what the other is sensing. In one case, the parents of brain-conjoined twins suspect that each twin can choose to look through the eyes of the other. In imagining possible human futures,

we might try to imagine the results if boundaries between individuals are further reduced or erased. The integration of sensory information from more than one individual's sense organs would require profound cognitive changes. The origin of humans from the apes of seven million years ago has demonstrated that evolution is capable of producing profound cognitive changes. Some primatologists consider the possibility that we are moving toward a species-wide unit, a kind of global organism. If we extrapolate past and present trends in the linkage of individuals far beyond that of today, the results are both spectacular and terrifying. Many science fiction authors have speculated about how such a merger might come about. As with other feats of mere human imagination (origins myths, for example), their tales will likely pale in comparison to the real story as it unfolds. If we allow it to.

Cognitive capacities have been increasing steadily in our own lineage for the past two million years. There is no reason at this arbitrary point in time to suspect that the human brain and mind have arrived at the top of the cognitive ladder, that this is it, we have arrived at the upper limit of what is possible. As with brains of other animals, the human brain has limitations. It is not some wide-open receptacle for perceiving and processing absolute reality. Like the brains of other animals, the human brain functions as a limited conduit for channeling selected filtered aspects of the external world. There is room for improvement. In fact, there is no scientific reason to think that there are not hypothetical levels of cognitive ability as far beyond ours as ours is beyond a snail's.

To end this book on a hopeful note, ending 2 assumes that humans somehow get through the difficult time we're in, and that the human lineage does not suffer an abrupt truncation in the near geologic or historical future. Perhaps very soon we will be able to make changes so that human activities become sustainable after all. Changes in our lineage are rapid in this scenario, and soon outpace our current imaginings of what we might become.

Who are you? We beings from your future are using every method we can devise to bring you into focus and answer this question. We want to know you, to see your face, even to experience the world through your senses. We measure you. We generate long chains of numbers, images, and symbols in our effort to understand you. Past events leave residues you have not yet dreamed of. Past moments can be partially accessed, and, in a limited way, we can unfold them and study them.

We sift through the debris you cast off, trying to understand the way you lived. We hold the tools that you made and feel a connection to you. Did you give a thought to the distant future of the artifact you were making? Could you have imagined that it would last for uncountable years, outlasting even your home planet?

We would so like to know about your life, what you think about when you gaze into a starry night sky. Do you wonder about your people's future, about whether there will be heirs to inherit your world and your ways? We can answer: Yes, for we are they.

Our ways are different now. If you could meet us, how unimaginably strange we would seem to you. We and our technology are more closely connected than in your time. And we as individuals are linked in ways you cannot dream of. If you could see us without fear, you might grasp in some way the geometries of our lives.

We look through your eyes and ponder what you saw. We trace your neural pathways in our attempts to learn about your thoughts. We can see that in some ways you are like us. In other ways, you are still very much like the animals that came before you, and you conduct the affairs of your lives and your world as an animal would. If we could experience your thoughts, would they be those of an uncomprehending animal? We have found signs of your consciousness, and in this mirror of awareness, we think we see a bit of ourselves. We view ourselves as part of a larger evolutionary stream of ancestors and descendants, of which you are also a part. We cannot help feeling a powerful kinship with you. You are, after all, our physical and symbolic link to the rest of creation.

NOTES

Chapter 1. Beginnings

1. No research reporting the discovery of postcranial bones for *Sahelanthropus* has been officially published, although an ex–team member has recounted the discovery of a primate femur that may have been associated with the skull. Photographs of the bone have turned up on John Hawks's blog, among other places.

2. Concepts such as adaptive plateaus or grades are used by some anthropologists to group related species with similar adaptations into broader categories. Others argue against such usage, making a case that each extinct species, if and when it becomes better known, may represent its own plateau. To some paleoanthropologists, the use of adaptive plateaus implies higher and lower grades, implying an outmoded concept of evolution as progress.

3. Among the apelike features apparent in the foot skeleton of *Ardipithecus ramidus* are some subtler features that are argued by the discovery team to be related to a primitive form of bipedalism.

4. In 1940 primatologist Adolph Schultz demonstrated that eye volume relative to the volume of the orbit (eye socket) is variable between species, and that in general the eyeball tends to account for a smaller percentage of eye socket volume in primates of larger body size. This relationship is too variable, both within and among species, to allow reliable prediction of eyeball size. However, some of the linear measurements of the eye socket perform more consistently as predictors of eyeball diameter in African apes and humans, especially if only adult specimens are used.

5. This measure is taken from maxillofrontale (the point where the anterior lacrimal crest crosses the frontomaxillary suture) to frontomalare orbitale (the point where the orbital rim crosses the frontozygomatic suture). I will call this measurement mf-fmo.

The mean eyeball diameter/mf-fmo ratios are: Homo sapiens (n=a sample of 2 individuals): 0.61; Pan troglodytes (n=1): 0.64; Pan paniscus (n=2): 0.63; Gorilla gorilla (n=2): 0.55; Pongo pygmaeus (n=3): 0.57. Further work is under way to test whether this relationship holds for larger samples.

6. Every year at Halloween, my friends and I build a haunted house in our village of Trumansburg, New York. Our village is one of those rare places where Halloween is still alive in a form similar to the way it was when I was a child, and the streets thronged with kids. I am in charge of making the inhabitants for the house, and eyeballs that are defective in some way are, of course, just right for them.

7. I scored mouth corner position by giving the back border of the upper canine a value of 0, and counted each tooth as a unit, so that the center of upper third premolar (equivalent to the upper first bicuspid in dentist's terms) would be 0.5, its back border would be 1.0, etc. Male African apes (all three species, n=5) averaged 1.65, with a range of 1.50–2.00. Female African apes (all three species, n=4) averaged 0.74, with a range of 0.09–1.25.

8. Means in centimeters for African apes the author has measured are as follows: maximum height of the ear in *Pan paniscus*=6.4 (n=2), *Pan troglodytes*=7.3 (n=2), *Gorilla gorilla*=6.8 (n=4). Means for seven human populations (those which included members of both sexes) reported by anthropologist Rudolf Martin in 1914 range from 6.0 to 6.6.

Chapter 2. Walkers and Climbers

1. Efforts to determine the forearm/upper arm relationship in Lucy and other australopiths have been

hampered by the incompleteness of fossil skeletons. Until the MH2 skeleton (*Australopithecus sediba*) from the South African site of Malapa was discovered, no adult australopith had been recovered with a complete humerus and complete radius or ulna. More fragmentary remains have yielded estimates that are suggestive of longer-than-human forearms relative to the length of the upper arm in *A. afarensis* and its proposed ancestors *Ardipithecus ramidus* and *Australopithecus anamensis*, as well as *Australopithecus africanus*, *Paranthropus boisei*, and a partial skeleton from the Ethiopian site of Bouri, which may represent *Australopithecus garhi*.

2. Some researchers have argued that factors other than upper body strength for climbing are reflected in the robustly marked muscle attachment sites in large australopith arm bones. These might include the use of tools or hammerstones. Others suggest that what we are seeing is what might be expected in an arboreal species that has lost grasping function in the lower limb: a compensation in the powerfully muscled upper limb.

3. Cut marked bones of hoofed mammals from between 3.2 and 4 million years ago have been reported, but the evidence is contested and no stone tools of this age have been found. In some cases cut marks are difficult to distinguish from trampling marks by hoofed mammals.

4. Known tool use for wild bonobos is limited.

5. This may be at least partly due to a shortening of the fingers.

6. Bone tools have been found at the South African site of Swartkrans in deposits from which the only hominin known is *Paranthropus robustus*, and they have been discovered in association with this species at Drimolen, also in South Africa.

7. This specimen, A.L. 58-22, preserves a portion of the lower maxilla that allows it to be oriented properly in relation to the A.L. 444-2 reconstruction.

8. The placement of this feature early in human evolution is speculative, and some would put it much later in human history. Anthropologist and science writer Pat Shipman, for example, wonders whether it might have been timed with later improvements in communication ability such as language.

9. There is variation in this feature within species, with some overlap between the patterns seen in *A. afarensis* individuals and later australopiths.

10. The two segments are: the projecting, convex contour of the upper jaw above the incisors, and the bone bearing the canine roots, which merges evenly,

moving up the face, with the bone of the lateral margin of the nasal opening just above it.

11. Since I completed my reconstruction of Lucy's thorax, publications on newer finds of australopiths have found evidence for an apelike upper thorax for *Australopithecus sediba*, and a humanlike upper thorax for a recently published partial skeleton thought to represent an adult male *Australopithecus afarensis*.

12. Trunk length as used by Adolph Schultz is measured from the point known as Symphysion, the uppermost point on the junction between the two pubic bones, to Supersternale, in the notch above the breast bone.

13. The prediction of Lucy's trunk length from the Sts 14 ratio is a bit larger, probably because it is based on a trunk built with six lumbar vertebrae, and its use for Lucy would assume the same for her, whereas all ten of the modern humans I measured had only five. Because factors affecting spine length/trunk length ratios, such as spinal curvatures and the number of lumbar vertebrae, are likely in Lucy to be more like those of Sts 14 than like modern humans, I thought it more appropriate to use the trunk length predicted by Sts 14's "probable" ratio for Lucy.

14. The australopiths for which we can reconstruct pelves are relatively wider-bodied (relative to both stature and the length of the trunk) than humans. Both Lucy and the Sts 14 female have significantly broader pelves relative to the trunk lengths estimated from their preserved vertebrae than those in modern females. Separate reconstructions of the presumably male Stw 431 pelvis (attributed to *A. africanus*) by Ron Clarke and me have resulted in pelves that are wider relative to trunk length, as predicted by the preserved trunk vertebrae, than in modern males.

15. For example, the flange on the lower humerus for the attachment of the brachio-radialis muscle in Lucy and other *A. afarensis* specimens extends a bit further up the humerus than is typical for living humans.

16. This strongly angled knee is related to her short legs and the need to position the knee and lower leg close to the midline for efficient bipedal locomotion. The femur has a shorter distance over which to reach the midline, so it is more angled relative to the horizontal plane of the upper tibia upon which it rests.

17. A similar form is seen in M. pectoralis major in gorillas. In chimpanzees, the lower border of pectoralis major, separating it from the large abdominal component of the muscle, is less discernible exteriorly, but when visible it often takes this form.

Chapter 3. The Impossible Discovery

1. Estimates of sexual dimorphism in body size are greater for these two species than that found in living humans, although they are somewhat less for *A. africanus* than for *A. afarensis*.

2. If *A. africanus* should prove to be ancestral to *Paranthropus robustus*, the genus *Paranthropus* would become polyphyletic (with two lineages of robust australopiths arising independently from nonrobust ancestors) and would cease to be a valid genus. This is because there is a broad consensus that the 2.5-million-year-old "Black Skull" represents the ancestor of *Paranthropus boisei*, to the exclusion of *A. africanus*. Some experts already consider the genus *Paranthropus* to be invalid for this reason and include *robustus* and *boisei* in the genus *Australopithecus*.

3. Evolution does not have goals, so this should not be taken as a process which is somehow striving toward humanity. The evidence indicates only that some evolutionary trends, which took place in the proposed *afarensis*–*africanus* transition, continued after the time of *A. africanus*. Long-term trends reflect continued selection, not progress toward a future end.

4. As discussed in chapter 2, the distal phalanx of the thumb in *A. afarensis* already had a broader tip than in chimpanzees, and it fits within the range of living humans in this feature. Only a single distal phalanx of the thumb is known for each of these species, but in this comparison (for what it's worth) the *A. africanus* specimen has a broader tip than the *A. afarensis* specimen.

Chapter 4. The Paradoxical Specialist

1. There are some who argue that the robust australopiths have a better claim to be closely related to *Homo* than other, nonrobust australopiths such as *A. africanus* and *A. garhi*, both of which have been championed by others as likely ancestors to *Homo*. Acceptance of the proposed *Homo*-like features of the *africanus*-like *A. sediba* would weaken such an argument and point instead to *A. africanus* as a more likely ancestor of *Homo*. Any way we draw the tree, there are some features of *Homo* that evolved independently in some of the australopiths.

Interlude. Transitional Hominins and the Origin of Homo

1. I did draw up a body blueprint for adult female *Homo habilis*, on which other flat art in the hall is based.

2. The University of Zurich's Peter Schmid's work on one of the *A. sediba* skeletons, which preserves the most complete adult shoulder girdle in the early record, indicates that the shoulders were held in a high position. He makes a convincing case that the orientation is constrained by ligamentous attachments identifiable in the fossil.

3. The tips of the fingers (but not the thumbs) are narrow in *A. afarensis*. They are broader and more humanlike in the later species *A. sediba*.

4. Some would argue that this situation arose at an earlier point in human evolution. Debate notwithstanding, there is consensus that it was in place by the time of *Homo erectus*.

5. No species of nonhuman great ape, however, is as firmly committed to or as profoundly shaped by bipedal locomotion as are the australopiths.

6. New hominin species that appeared during this time period include *Australopithecus garhi* and one lineage of hyper-robust australopith, represented at first by fossils attributed to *P. Aethiopicus*. The oldest fossils attributed to *Homo* appear at the end of this period.

7. Stone tool cut marks have recently been proposed for bones 3.4 million years old, found at the Ethiopian site of Dikika, but no tools have been found and this evidence is debated.

8. Relative brain size is marginally higher among australopiths than among living or fossil apes.

9. It has been pointed out that *H. rudolfensis* may have undergone body size increases that lessen the effect in terms of relative brain size.

10. Those scholars who prefer dividing the hominin record into fewer species ("lumpers") in a simpler family tree lump this group into *Homo habilis* with members of the other group, which then becomes a highly variable species: *Homo habilis* in the broad sense.

11. The evidence for tall *Homo erectus* females, and for modern body proportions in the species, are discussed in chapter 5.

12. Virginia Morell gives a detailed account of the lives of the Leakeys in her book *Ancestral Passions*.

13. In *A. sediba*, the ilium has a more sigmoid (s-shaped) crest atop it than in other australopiths, and a deep hollow for the origin of the gluteus medius muscle. Although retaining some *Australopithecus* features, a number of other reported details of the pelvis are *Homo*-like. The team points out that two previously proposed explanations for the origin of some

of these *Homo*-like features must now be abandoned. Pelvic adaptations for the birthing of larger-brained babies cannot be a valid explanation for features seen in this small-brained species. And the team sees evidence in the hand and foot skeletons of arboreal behavior, so they also eliminate another popular explanation for some of these features: the abandonment of the trees. They say that the functional implications are unclear but may be related to "changes in exploitation of the terrestrial environment," which may mean locomotor differences or the exploitation of different habitats. It is also possible that some of these changes relate to changes in gut size or to thermoregulatory changes, perhaps a narrowing of the body to a more linear build for heat dissipation.

14. Similarly, earlier populations of *Homo habilis,* not those occurring latest in time, must have given rise to *Homo erectus* in any reasonable ancestor-descendant scheme for the two species.

Chapter 5. The Traveler

1. Attribution of these bones as the right and left first metacarpals of the Nariokotome boy's skeleton are regarded by Alan Walker and Richard Leakey as probable but not certain.

2. This scenario and other ideas about the *Homo erectus* adaptive niche were later challenged by the discoverers of the Gona pelvis (see discussion later in this chapter). Chris Ruff and others have pointed out the difficulties that arise if the Gona pelvis is included in *Homo erectus,* and consider its taxonomic attribution uncertain. If the Gona pelvis does turn out to belong to *Homo erectus,* or if newer fossils show that *Homo erectus* females had a larger birth canal than that extrapolated from the Nariokotome boy's reconstructed pelvis, this and many other ideas about the adaptive niche of this species will have to be revised.

3. Most but not all experts agree that KNM-ER 3733 is female.

4. Research published in 2010 confirmed that metatarsals 3, 4, and 5 of the Dmanisi foot are longer in relation to metatarsal 1 than they are in modern humans, and that the Dmanisi foot is more like those of apes in these proportions. This finding may influence arguments about whether the material from Dmanisi should be included within *Homo erectus* or not.

Chapter 6. A Symbolic Animal

1. Traces of what may be cannibalism go back to early times. Cut-marked human bones were discovered scattered among similarly cut-marked bones of butchered animals in layers about 800,000 years old at the Spanish site of Gran Dolina. One skull from Sterkfontein (Stw 53) that may be older than two million years is reported to have cut marks on its upper jaw near the attachment site for the masseter muscle. It is not known whether these represent instances of ritual or symbolic behaviors.

2. It is possible that fairly complete skeletons of *H. heidelbergensis* are mixed with the bones of at least thirty other individuals at the rich site of Sima de los Huesos, but, if so, nobody has proposed a definitive method of sorting them into individual skeletons.

3. The ratio of hand length to summed humerus length + radius length is the same in humans and gorillas. Chimpanzees have somewhat longer hands relative to the length of their arm bones.

Chapter 7. The Other

1. The Sami people were formerly referred to as Lapps.

2. Nearly all aspects of this scenario are debated.

3. The Gibraltar skull was actually discovered before the Neander Valley (in Germany) specimen from which this type of human gets its name.

Chapter 8. The Unlikely Survivor

1. Although the lower jaw does not have a projecting chin, a reduction in the muscle ringing the mouth could raise its lower border (as it does in modern humans in comparison to its position in great apes), and this might create a soft tissue crease or a change of planes where the lower border of M. Orbicularis Oris meets the uppermost fibers of M. mentalis, as it does in living humans. This might give the appearance of delineating a chinlike area even without a bony prominence in this location.

Chapter 9. Linked

1. The degree to which earlier hominin species can be characterized this way is debated.

GLOSSARY

A.L. 333 site. Locality at Hadar, Ethiopia, which has produced a large assemblage of bones attributed to *Australopithecus afarensis*.

Acheulean tradition. Stone tool culture characterized by bifacial hand axes and cleavers, practiced by hominins between 1.65 and 0.1 million years ago.

adaptation. Heritable change that fits an organism to its environment.

adaptive plateau. Broad grouping of related organisms with similar adaptations.

allometry. Difference in shape due to size difference.

altricial. Offspring that are born at a relatively immature state of development, usually requiring intensive care from parent(s).

anterior. Front.

anterior nasal spine. Projection of bone at the base of the nasal aperture in humans, in the midline. It is the most anterior attachment point on the maxillae for the cartilaginous nasal septum.

area 131. Site in the Koobi Fora region of northeast Kenya, east of Lake Turkana. The KNM-ER 1470 skull, attributed by some to *Homo rudolfensis*, was discovered there, along with several leg bones.

artiodactyls. Order of even-toed hoofed mammals.

atlas. Uppermost vertebra of the neck, which articulates with the skull.

auditory meatus. External ear opening of the skull.

australopith (also australopithecine). Informal name for members of the genera *Australopithecus* and *Paranthropus*.

Australopithecus. Genus of early hominins named by Raymond Dart in 1925 and characterized by adaptations for bipedal walking and, to various degrees, by specializations of the teeth and jaws thought to be related to the processing of hard or abrasive foods.

bauplan. When used in relation to organisms, a body plan or blueprint.

biface. Stone tool from which flakes have been removed on both sides.

bipedalism. Practice of walking on two legs. (A biped is one that uses this style of locomotion.)

black skull. Nickname for skull KNM-WT 17,000, discovered by Alan Walker in 1985 and attributed to *Paranthropus aethiopicus*.

bonobo. Common name for *Pan paniscus*, formerly referred to as the pygmy chimp.

brachioradialis muscle. Muscle of the arm originating on the lateral portion of the distal humerus and inserting on the distal radius.

Broca's area. Area of the human left frontal lobe that has figured into language origins debates. Positron emission tomographic (PET) scans have shown that this area is involved in motor sequencing of both muscles of the hands and muscles used in speech.

Brodman's area 10. The most anterior part of the frontal lobe of the cerebrum, important in higher cognitive functions such as modeling future possibilities and multitasking.

bush baby. African prosimian primate (prosimians constitute a group of primates that includes lemurs, lorises, tarsiers, and a number of extinct species, and is distinct from monkeys, apes, and humans).

canine tooth. Occupies the position in the tooth row between the incisors and the premolars, in both upper and lower jaws. Its form and size are different in humans from those of other great apes, and it has played a role in the determination of hominin status for ancient fossils.

carpal bones. Bones of the wrist.

carpal tunnel. Tunnel on the palm side of the wrist, composed of the carpal (wrist) bones and a fibrous band of tissue. The tendons of the long flexors of the fingers pass though the carpal tunnel.

cartilaginous nasal septum. Cartilage separating the nose and nasal cavity into halves. Attaches to the anterior nasal spine of the maxillae in humans.

cerebral cortex. Outermost part of the upper brain, involved in sensory and cognitive processes.

cervical vertebrae. Bones of the neck.

clade. A group that includes all of the descendants of a common ancestor.

clavicle. Collar bone.

cleaver. Biface that is sharp along a linear edge, as opposed to a point.

confrontational scavenging. Style of scavenging carcasses that involves appropriating another predator's kill.

counterrotation of the upper body. Rotation of the upper body during human walking and running in a direction opposite to the rotation of the lower body.

cranium. Skull, not including the mandible.

crepuscular. Active during dawn and twilight hours.

cultural evolution. Change in socially learned behavioral traditions.

dental arcade. Curving row of the teeth, U-shaped in some great apes and parabola-shaped in living humans and some extinct hominins.

derived. Newly evolved. Derived anatomy shared by organisms can be used to argue for a close relationship between them, as opposed to primitive anatomy, which can be inherited from a distant ancestor in two or more descendants that are no longer closely related.

diastema. Gap between adjacent teeth, usually to accommodate a projecting canine tooth from the opposing jaw.

distal. Farthest from the trunk or center.

ecogeographic adaptation. Theory predicting that variation in human body form will follow variation in climatic zones, maximizing surface area for a given volume in climates where heat stress is a problem, and minimizing surface area per volume where heat loss is problematic.

eukaryotic cell. Complex cell, with a nucleus and organelles, thought to have originated from the incorporation of prokaryotic symbionts into a host cell. Some single-celled forms, and all organized multicellular forms (fungi, plants, and animals), have eukaryotic cells.

expensive tissue hypothesis. Predicts that increases in metabolically expensive tissues such as brains will be accompanied by a reduction in other systems to balance metabolic demands.

extrasomatic. Outside of the body. Stone tools have sometimes been considered extrasomatic teeth. Cultural evolution might be considered extrasomatic evolution.

feedback loop. A circuit that "feeds back" some of a system's output to its input, so that the output is augmented or altered.

femoral neck. Portion of the femur connecting the spherical head with the shaft.

femur. Thigh bone.

fibula. Smaller of the two bones of the lower leg or shin, located lateral to the tibia.

foramen magnum. Hole through which the spinal cord enters the base or rear of the skull.

frontal bone. Bone of the skull that forms the forehead and the upper eye sockets.

frontal process of the maxilla. Portion of the maxilla that contacts the frontal bone, and is positioned just lateral to the nasal bones.

genus (pl. genera). Group of closely related species. This is the level of taxonomic classification above the species, and it can contain one or more species. This is the "first name" of a species designation (such as *Homo* for *Homo sapiens*). Some definitions also require a common adaptive zone, grade, or plateau.

gestural theory of language origins. Any of a group of theories that posits a strong gestural component to early language.

Gigantopithecus. Genus of extinct Asian ape named for a number of very large teeth and jaws.

gluteal muscles. Muscles of the hip, consisting of gluteus minimus, gluteus medius, and gluteus maximus. These muscles are important in bipedal locomotion.

great apes. Group that includes orangutans, gorillas, chimpanzees, bonobos, and hominins. There is currently debate about whether some of the features they share were inherited from common ancestors or evolved independently.

great toe. Big toe.

greater alar cartilage. Paired cartilage making up the substructure of the bulbous tip of the nose. (Also called greater nasal cartilage or simply alar cartilage.)

Hadar. Ethiopian site where Lucy was found, as well as other important specimens attributed to *Australopithecus afarensis*.

hand axe. Bifacially flaked, teardrop-shaped stone tool. This is the most characteristic type of stone tool in the Acheulean tradition.

head of the femur. Spherical portion of the thigh bone that articulates with the pelvis at the hip joint.

hominin. Member of the tribe *Hominini*, consisting of all animals more closely related to humans than to chimpanzees.

Homo. Genus to which living humans belong, along with related species going back to either just before or just after two million years ago, depending on one's

perspective on which specimens should be considered the earliest members of the genus.

humerus (pl. humeri). Upper arm bone.

hypoplasia. Line or irregularity in a tooth that reflects an interruption in nutrition or some other disruption of enamel formation.

ilium. Uppermost of the three paired bones of the pelvis, forming the "blades" of the pelvis.

incisor tooth. One of several broad cutting teeth at the front of the upper and lower jaws. Humans and apes have eight incisors.

inguinal ligament. Fibrous band of connective tissue that runs from the anterior superior spine of the ilium to the pubic bone. It forms the lower lateral border of three layers of abdominal muscle which attach to it, and demarcates the abdomen in relation to the thigh.

insertion (of a muscle). Muscle's attachment site farthest from the body's center.

intervertebral disk. Fibrocartilaginous disk between vertebrae, providing the spine with elasticity and shock absorption.

KBS tuff. Deposit of volcanic ash dated to 1.8–1.9 million years ago. It is named after a site discovered by paleontologist Kay Behrensmeyer and it has been important in the dating of some important hominin fossils.

Kenyanthropus. Genus of hominin named by Meave Leakey and her colleagues in 2001 for the KNM-WT 40000 cranium and an upper jaw with similar form.

Koobi Fora. Hominin site in northern Kenya east of Lake Turkana.

lateral. To the side.

latissimus dorsi. Major muscle of the back originating on the crest of the ilium and the spinous processes of the lower vertebrae, and inserting on the humerus.

ligament. Band of fibrous connective tissue linking two or more bones.

lumbar vertebra. Element of the lower spine.

lumpers. Those who subscribe to a classification scheme in which the fossil record for a group (for example, hominins) is divided into fewer species, resulting in a simpler phylogenetic (family) tree.

lunate sulcus. Curved fissure toward the rear of the cerebrum that approximates the anterior border of the primary visual cortex.

mandible. Lower jaw.

manubrium. Uppermost segment of the breastbone.

masseter muscle. Major chewing muscle of the jaw. It originates on the zygomatic arch, and inserts on the ramus (the more vertical non-tooth-bearing part) of the mandible.

matrix. Surrounding substance in which something is embedded, as in the rock matrix which encapsulates a fossil.

maxilla (plural maxillae). Upper jaw.

meme. Idea or unit of socially learned behavior, the spread of which, it is sometimes argued, is governed by processes similar to natural selection.

meningeal tissues. Three membranes that surround and cushion the brain.

mentalis muscle. Muscle of facial expression originating on the front of the mandible and inserting into the facial skin. This muscle lifts the skin of the chin and "rumples" it in some facial expressions.

metacarpals. Bones of the palm, articulated with the bones of the wrist at their proximal ends and with the bones of the fingers at their distal ends.

metatarsals. Bones of the foot, articulated with the bones of the arch at their proximal ends and with the toe bones at their distal ends.

microcephaly. Any of a number of developmental pathologies that result in abnormally small brains.

mirror neurons. Neurons in the brain which are active not only when initiating an action, but when observing another individual performing the same action.

molars. Grinding teeth at the back of the jaws. Humans and apes have twelve molars.

morphology. Form.

mother mold. Rigid outer portion of a mold.

Nariokotome boy. Fossil *Homo erectus* skeleton with the museum number KNM-WT 15,000.

nasal cartilage. Any of the cartilages that, with the nasal bones, form the substructure of the nose.

nasal cavity. Opening in the skull for the nose.

natural selection. Differential survival of some traits and the genes they are based on over their alternatives.

occipital bone. Bone of the skull at its rear and base.

ocher. Highly pigmented earth or sediment.

Olduvai Gorge. Tanzanian early hominin site made famous by Leakeys.

orbicularis oris muscle. Muscle ringing the mouth.

orbit. Eye socket.

origin (of a muscle). Muscle's attachment site closest to the body's center.

osteologist. Bone expert.

Paranthropus. Genus of hominin characterized by large jaws and chewing teeth and by robust skulls with pronounced markings at the attachment sites of chewing muscles.

parietal association cortex. Area of the cerebral cortex approximately under the parietal bones, which integrates input from primary sensory areas of the brain.

parietal bone. Paired bone of the upper posterior skull.

pectoralis major muscle. Large muscle of the chest originating on the collarbone, breastbone, and rib cartilages, and inserting on the upper arm bone.

perikyma (pl. perikymata). Incremental growth lines in tooth enamel that can be counted (like tree rings) and used to estimate the period of formation of a tooth.

periosteum. Tough, vascularized membrane which surrounds a bone, and to which muscles attach.

persistence hunting. Method of hunting that employs the hunter's capacity for endurance in pursuing prey to the point of exhaustion.

petalia. Asymmetrical enlargement or protrusion of a lobe of the brain.

phalanx (pl. phalanges). Finger or toe bone.

postcranial. Pertaining to the skeleton excluding the skull; bones behind or below the head.

posterior. Back.

power grip. Family of strong grips executed between the fingers and the palm of the hand, with the thumb acting as a brace. A squeeze grip used in holding a hammer and a spherical grip used in holding a baseball are examples.

precision grip. Any grip involving the tip of the thumb and one or more fingers. These are important in the making of stone tools.

premolar. Teeth between the canine and molar teeth; in dentist's terms, a bicuspid. Humans and apes have eight premolars.

prokaryotic cell. Simple cell, without a nucleus, as in a bacterial cell.

proximal. Closest to the trunk.

pubic bone. One of the three paired bones of the pelvis. This pair comes together at the pubic symphysis in the anterior pelvis.

pulsar. Pulsating neutron star.

radius. One of the two bones of the forearm, this bone is articulated with bones of the wrist. Movement of this bone rotates the hand.

resorption. Wasting of bone, such as that occurring when tooth loss decreases forces passing through the tooth-bearing portions of the upper or lower jaw.

sagittal crest. Midline crest at the top or back of the skull, which anchors the temporalis muscles.

scapula. Shoulder blade.

Scheuermann's kyphosis. Condition characterized by abnormal bone growth in the vertebrae, thought to be related to strenuous or acrobatic activity.

sclera. Tough, fibrous outer envelope of tissue enclosing the eyeball except for the cornea. It's referred to as the "whites of the eyes" in humans, and is variously pigmented in other primates.

sexual dimorphism. Difference in form or size according to gender (other than differences in reproductive anatomy).

sexual selection. Effects of differential mating choices on the evolution of the target gender. A classic example of the results is the form of the male peacock's tail feathers.

sigmoid crest (of the ilium). An S-shaped crest atop the ilium in humans and some other hominins.

splitters. Those who subscribe to a classification scheme in which the fossil record for a group (for example, hominins) is divided into many species.

sternum. Breastbone.

temporal lines. Ridges of bone that mark the origin of the temporalis muscle and its covering of fascia on the skull.

temporalis muscle. Chewing muscle one can feel moving at the temple during chewing. Its origin is at the temporal lines or on the sagittal crest of the skull, if one is present, and its insertion is on the front of the ramus (the more vertical non-tooth-bearing part) of the mandible.

teres major muscle. Muscle of the shoulder, with its origin on the lower shoulder blade and its insertion on the upper arm bone.

thoracic vertebrae. Rib-bearing bones of the spine.

thorax. Chest or rib cage.

tibia. Largest bone of the lower leg or shin.

ulna. One of two bones of the forearm, articulating in a hinge joint with the humerus.

variability selection. Form of natural selection that favors adaptability.

viscera. Internal organs.

volcanic tuff. Rock or sediment composed of consolidated volcanic ash.

Zinjanthropus boisei. Genus and species named by Louis Leakey for the OH 5 specimen his wife, Mary, discovered in 1959, and similar fossils. The species is now considered to be included in the genus *Paranthropus.* This is often referred to as a hyper-robust australopith.

zygomatic arch. Arch of bone at the side of the skull, composed of portions of the temporal bone and the zygomatic bone.

zygomatic bone. Bone of the cheek.

BIBLIOGRAPHY

Ahern JCM. 2005. *Foramen magnum position in Pan troglodytes, Plio-Pleistocene hominids, and recent Homo sapiens: Implications for recognizing the earliest hominids.* Am J Phys Anthropol 127: 267–76.

Aiello LC, and Collard M. 2001. *Our newest oldest ancestor?* Nature 410: 526–27.

Aiello LC, and Dean C. 1990. *An introduction to human evolutionary anatomy.* London: Academic.

Aiello LC, and Key C. 2002. *Energetic consequences of being a Homo erectus female.* Am J Hum Biol 14: 551–65.

Aiello LC, and Wheeler P. 1995. *The expensive tissue hypothesis: The brain and digestive system in human and primate evolution.* Curr Anthropol 36: 199–221.

Alba DM, Moyà-Solà S, and Köhler M. 2003. *Morphological affinities of the Australopithecus afarensis hand on the basis of manual proportions and relative thumb length.* J Hum Evol 44: 225–54.

Alemseged Z, Spoor F, Kimbel WH, Bobe R, Geraads D, Reed D, and Wynn JG. 2006. *A juvenile early hominin skeleton from Dikika, Ethiopia.* Nature 443: 296–301.

Antón SC. 2003. *Natural history of Homo erectus.* Yearb Phys Anthropol 46: 126–70.

Argue D, Donlon D, Groves C, and Wright R. 2006. *Homo floresiensis: Microcephalic, pygmoid, Australopithecus or Homo?* J Hum Evol 51: 360–74.

Arsuaga JL, Bermúdez de Castro JM, and Carbonell E. 1997. Special issue on the Sima de los Huesos hominids and site. J Hum Evol 33: 105–421.

Arsuaga JL, Lorenzo C, Carretero, JM, Gracia A, Martínez I, García N, Bermúdez de Castro JM, and Carbonell E. 1999. *A complete human pelvis from the Middle Pleistocene of Spain.* Nature 399: 255–58.

Arsuaga JL, Martinez I, and Gracia A. 1999. *The human cranial remains from Gran Dolina Lower Pleistocene site.* J Hum Evol 37: 431–57.

Asfaw B, Gilbert WH, Beyene Y, Hart WK, Renne P, WoldeGabriel G, et al. 2002. *Remains of Homo erectus from Bouri, Middle Awash, Ethiopia.* Nature 416: 317–20.

Asfaw B, White T, Lovejoy O, Latimer B, Simpson S, and Suwa G. 1999. *Australopithecus garhi: A new species of early hominid from Ethiopia.* Science 284: 629–35.

Balter M. 2010. *Candidate human ancestor from South Africa sparks praise and debate.* Science 328: 154.

Balter M, and Gibbons A. 2000. *A glimpse of humans' first journey out of Africa.* Science 288: 948–50.

———. 2002. *Were "little people" the first to venture out of Africa?* Science 297: 26–27. (D2700 from Dmanisi)

Bass WM. 2005. *Human Osteology: A laboratory and field Manual.* 5th ed. Columbia: Missouri Archaeological Society.

Begun DR. 2004. *The earliest hominins: Is less more?* Science 303: 1478–80.

Behrensmeyer K, Harmon EH, and Kimbel WH. 2003. *Environmental context and taphonomy of the first family hominid locality, Hadar, Ethiopia.* J Vert Paleo 3: 33A.

Bennet MR, Harris JWK, Richmond BG, Braun DR, Mbua E, Kiura P, Olago D, Kibunjia M, Omuombo C, Behrensmayer AK, Huddart D, and Gonzalez S. 2009. *Early hominin foot morphology based on 1.5-million-year-old footprints from Ileret, Kenya.* Science 323: 1197–1201.

Berger LR, de Ruiter DJ, Churchill SE, Schmid P, Carlson KJ, Dirks PHGM, and Kibii JM. 2010. *Australopithecus sediba: A new species of Homo-like Australopith from South Africa.* Science 328: 195–204.

Berger T, and Trinkaus E. 1995. *Patterns of trauma among the Neandertals.* J Archaeol Sci 22: 841–52.

Bermúdez de Castro JM, Arsuaga J, Carbonell E, Rosas A, Martinez I, and Mosquera M. 1997. *A hominid from the Lower Pleistocene of Atapuerca, Spain: Possible ancestor to Neandertals and modern humans.* Science 276: 1392–95.

Biegert J, and Maurer R. 1972. *Rumpfskelettlänge, Allometrien und Körperproportionen bei catarrhinen Primaten.* Folia Primatol 17: 142–56.

Blumenschine RJ, Peters CR, Masao FT, Clarke RJ, Deino A, Hay RL, et al. 2003. *Late Pliocene Homo and*

hominid land use from western Olduvai Gorge, Tanzania. Science 299: 1217–21.

Bobe R, and Behrensmeyer AK. 2004. *The expansion of grassland systems in Africa in relation to mammalian evolution and the origin of the genus Homo.* Palaeogeogr Palaeocl 207: 399–420.

Bonnefille R, Potts R, Chalié F, Jolly D, and Peyron O. 2004. *High-resolution vegetation and climate change associated with Pliocene Australopithecus afarensis.* Proc Natl Acad Sci USA 101: 12125–29.

Boule M. 1911–13. *L'homme fossile de La Chapelle-aux-Saints.* Ann Paleontol 6: 111–72; 7: 21–56, 85–192; 8: 1–70.

Bower B. 2002. *Care-worn fossils: Bones reopen controversy about ancient assistance.* Science News. November 23, 2002.

Bramble DM, and Lieberman DE. 2004. *Endurance running and the evolution of Homo.* Nature 432: 345–52.

Brown B, Brown FH, and Walker A. 2001. *New hominids from the Lake Turkana basin, Kenya.* J Hum Evol 41: 29–44.

Brown FH, Harris JM, Leakey RE, and Walker AC. 1985. *Early Homo erectus skeleton from West Lake Turkana.* Nature 316: 788–92.

Brown P, Sutikna T, Morwood MJ, Soejono RP, Jatmiko, Saptomo EW, and Due RA. 2004. *A new small-bodied hominin from the Late Pleistocene of Flores, Indonesia.* Nature 431: 1055–61.

Brunet M, Guy F, Pilbeam D, Lieberman DE, Likius A, Mackaye HT, Ponce de León MS, Zollikofer CPE, and Vignaud P. 2005. *New material of the earliest hominid from the Upper Miocene of Chad.* Nature 434: 752–55.

Brunet M, Guy F, Pilbeam D, Mackaye HT, Likius A, Ahounta D, Beauvilain A, Blondel C, Bocherens H, Boisserie JR, De Bonis L, Coppens Y, Dejax J, Denys C, Duringer P, Eisenmann VR, Fanone G, Fronty P, Geraads D, Lehmann T, Lihoreau F, Louchart A, Mahamat A, Merceron G, Mouchelin G, Otero O, Campomanes PP, Ponce de León MP, Rage JC, Sapanet M, Schuster M, Sudre J, Tassy P, Valentin X, Vignaud P, Viriot L, Zazze A, and Zellikefer C. 2002. *A new hominid from the Upper Miocene of Chad, Central Africa.* Nature 418: 145–51.

Brunet M, et al. 2002. *Sahelanthropus or "Sahelpithecus"?* (Reply). Nature 419: 582.

Bush ME, Lovejoy CO, Johanson DC, and Coppens Y. 1982. *Hominid carpal, metacarpal, and phalangeal bones recovered from the Hadar formation: 1974–1977 collections.* Am J Phys Anthropol 57: 651–77.

Carbonell E, Bermúdez de Castro JM, Arsuaga JL, Díez JC, Rosas A, Cuenca-Bescós G, Sala R, Mosquera M, and Rodriguez XP. 1995. *Lower Pleistocene hominids and artifacts from Atapuerca-TD6 (Spain).* Science 269: 826–30.

Carbonell E, Cáceres I, Lozano M, Saladié P, Rosell J, Lorenzo C, Vallverdú J, Huguet R, Canals T, and Bermúdez de Castro JM. 2010. *Cultural cannibalism as a paleoeconomic system in the European Lower Pleistocene.* Curr Anthropol 51: 539–49.

Carlson KJ, Stout D, Jashashvili T, de Ruiter D, Tafforeau P, Carlson K, and Berger, LR. 2011. *The endocast of MH1, Australopithecus sediba.* Science 333: 1402–7.

Chase PG, and Dibble H. 1987. *Middle Paleolithic symbolism: A review of current evidence and interpretations.* J Anthropol Archaeol 6 (3): 263–96.

Choi CQ. 2010. *Heavy brows, high art?: Newly unearthed painted shells show Neandertals were Homo sapiens's mental equals.* Sci Am. January 8, 2010.

Clarke RJ, and Tobias PV. 1995. *Sterkfontein member 2 foot bones of the oldest South African hominid.* Science 269: 521–24.

Coffing KE. 1998. *The metacarpals of Australopithecus afarensis: Locomotor and behavioral implications of cross-sectional geometry.* PhD diss. Johns Hopkins University, Baltimore, MD.

Coffing K, Feibel C, Leakey M, and Walker A. 1994. *4-million-year-old hominids from East Lake Turkana, Kenya.* Am J Phys Anthropol 93: 55–65.

Collard M, and Wood B. 2001. *Homoplasy and the early hominid masticatory system: Inferences from analyses of extant hominoids and papionins.* J Hum Evol 41: 167–194.

Conard NJ, and Richter J, eds. 2011. *Neanderthal lifeways, subsistence and technology: One hundred and fifty years of Neanderthal study.* New York: Springer.

Constantino P, and Wood B. 2007. *The evolution of Zinjanthropus boisei.* Evol Anthropol 16: 49–62.

Cook DC, Buikstra JE, DeRousseau CJ, and Johanson DC. 1983. *Vertebral pathology in the Afar Australopithecines.* Am J Phys Anthropol 60: 83–101.

Coolidge FL, and Wynn T. 2009. *The rise of Homo sapiens.* Malden, MA: Wiley-Blackwell.

Dart R. 1925. *Australopithecus africanus. The man-ape of South Africa.* Nature 115: 195–99.

Darwin C. 1871. *The descent of man.* London: John Murray.

Dawson JE, and Trinkaus E. 1997. *Vertebral osteoarthritis of the La Chapelle-aux-Saints 1 Neanderthal.* J Archaeol Sci 24: 1015–21.

DeSilva JM. 2009. *Functional morphology of the ankle and the likelihood of climbing in early hominins.* Proc Natl Acad Sci USA 106: 6567–72.

Dirks PGHM, Kibii JM, Kuhn BF, Steininger C, Churchill SE, Kramers JD, Pickering R, Farber DL, Mériaux A-S, Herries AIR, King GCP, and Berger LR. 2010. *Geological setting and age of Australopithecus sediba from Southern Africa.* Science 328: 205–8.

Dodo Y, Kondo O, Muhensen S, and Akazawa T. 1998.

Anatomy of the Neandertal infant skeleton from Dederi-yeh Cave, Syria. In Akazawa T, Aoki K, and Bar-Yosef O, eds., 323–38. *Neandertals and modern humans in Western Asia.* New York: Plenum.

Domínguez-Rodrigo M, Pickering TR, Semaw S, and Rogers MJ. 2005. *Cutmarked bones from Pliocene archaeological sites at Gona, Afar, Ethiopia: Implications for the functions of the world's oldest stone tools.* J Hum Evol 48: 109–21.

Drapeau MSM. 2008. *Articular morphology of the proximal ulna in extant and fossil hominoids and hominins.* J Hum Evol 55: 86–102.

Drapeau MSM, and Ward CV. 2007. *Forelimb segment length proportions in extant hominoids and Australopithecus afarensis.* Am J Phys Anthropol 132: 327–43.

Drapeau MSM, Ward CV, Kimbel WH, Johanson DC, and Rak Y. 2005. *Associated cranial and forelimb remains attributed to Australopithecus afarensis from Hadar, Ethiopia.* J Hum Evol 48: 593–642.

Duarte C, Maurício J, Pettitt PB, Souto P, Trinkaus E, van der Plicht H, and Zilhão J. 1999. *The early Upper Paleolithic human skeleton from the Abrigo do Lagar Velho (Portugal) and modern human emergence in Iberia.* Proc Natl Acad Sci USA 96: 7604–9.

Falk D. 1980. *A reanalysis of the South African australo-pithecine natural endocasts.* Am J Phys Anthropol 53: 525–39.

———. 1983. *The Taung endocast: A reply to Holloway.* Am J Phys Anthropol 60: 479–89.

———. 1985. *Hadar AL 162–28 endocast as evidence that brain enlargement preceded cortical reorganization in hominid evolution.* Nature 313: 45–47.

———. 1990. *Brain evolution of Homo: The radiator theory.* Behav. Brain Sci. 13: 333–81.

———. 2009. *The natural endocast of Taung (Australo-pithecus africanus): Insights from the unpublished papers of Raymond Dart.* Yearb Phys Anthropol 52: 49–65.

———. 2012. *Hominin paleoneurology: Where are we now?* Prog Brain Res 195: 225–72.

Falk D, Hildebolt C, Smith K, Morwood MJ, Sutikna T, Brown P, Jatmiko, Saptomo E, Wayhu E, Brunsden B, and Prior F. 2005. *The Brain of LB1, Homo floresiensis.* Science 308: 242–45.

———. 2005. *Response to Comment on "The brain of LB1, Homo floresiensis."* Science 14 (October): 236.

Falk D, et al. 2007. *Brain shape in human microcephalics and Homo floresiensis.* Proc Natl Acad Sci USA 104: 2513–18.

Falk D, Hildebolt C, Smith K, Morwood MJ, Sutikna T, Saptomo EW, and Prior F. 2009. *LB1's virtual endocast, microcephale and hominin brain evolution.* J Hum Evol 57 (5): 597–607.

Falk D, Redmond JC, Guyer J, Conroy C, Recheis W, Weber GW, and Seidler H. 2000. *Early hominid brain evolution: A new look at old endocasts.* J Hum Evol 38: 695–717.

Fransiscus RG, and Trinkaus E. 1988. *Nasal morphology and the emergence of Homo erectus.* Am J Phys Anthropol 75: 517–27.

Gabunia L, Vekua A, Swisher CC III, Ferring R, Justus A, Nioradze M, et al. 2000. *Earliest Pleistocene hominid cranial remains from Dmanisi, Republic of Georgia: Taxonomy, geological setting, and age.* Science 288: 1019–25.

Galik K, Senut B, Pickford M, Gommery D, Treil J, Kuperavage AJ, and Eckhardt RB. 2004. *External and internal morphology of the BAR 1002' 00 Orrorin tugen-ensis femur.* Science 305: 1450–53.

Gerasimov MM. 1971. *The face finder.* Philadelphia: Lippincott.

Gibbons A. 2009. *A new kind of ancestor: Ardipithecus unveiled.* Science 326: 36–50.

Gordon AD, Green DJ, and Richmond BG. 2008. *Strong postcranial size dimorphism in Australopithecus afarensis: Results from two new resampling methods for multivariate data sets with missing data.* Am J Phys Anthropol 135: 311–28.

Grausz HM, Leakey RE, Walker AC, and Ward CV. 1988. *Associated cranial and postcranial bones of* Australo-pithecus boisei, In Grine FE, ed., 127–32. *Evolutionary history of the "robust" australopithecines.* New York: Aldine de Gruyter.

Green DJ, Gordon AD, and Richmond BG. 2007. *Limb-size proportions in Australopithecus afarensis and Aus-tralopithecus africanus.* J Hum Evol 52: 187–200.

Gregory WK, ed. 1950. *The anatomy of the gorilla: The studies of Henry Cushier Raven.* New York: Columbia University Press.

Grine FE. 1986. *Dental evidence for dietary differences in Australopithecus and Paranthropus.* J Hum Evol 15: 783–822.

Grine FE, and Kay RF. 1988. *Early hominid diets from quantitative image analysis of dental microwear.* Nature 333: 765–68.

Guy F, Lieberman DE, Pilbeam D, Ponce de León M, Likius A, Mackaye HT, Vignaud P, Zollikofer C, and Brunet M. 2005. *Morphological affinities of the Sahel-anthropus tchadensis (Late Miocene hominid from Chad) cranium.* Proc Natl Acad Sci 102: 18836–41.

Haeusler MF. 2001. *New insights into the locomotion of Australopithecus africanus: Implications of the partial skeleton of Stw 431 (Sterkfontein, South Africa).* PhD diss., University of Zurich.

Haeusler M, Martelli SA, and Boeni T. 2002. *Vertebrae numbers of the early hominid lumbar spine.* J Hum Evol 43: 621–43.

Haeusler M, and McHenry H. 2004. *Body proportions of Homo habilis reviewed.* J Hum Evol 46: 433–65.

Haile-Selassie Y. 2001. *Late Miocene hominids from the Middle Awash, Ethiopia.* Nature 412: 178–81.

Haile-Selassie Y, et al. 2010. *New hominid fossils from Woranso-Mille (Central Afar, Ethiopia) and taxonomy of early Australopithecus.* Am J Phys Anthropol 141: 406–17.

Hanebrink JR. 2006. *Datum is only skin deep: In vivo measurements of facial tissue thickness in chimpanzees.* Master's thesis, Louisiana State University, Baton Rouge, LA.

Hartwig-Scherer S, and Martin RD. 1991. *Was "Lucy" more human than her "child"? Observations on early hominid postcranial skeletons.* J Hum Evol 21: 439–49.

Hatley T, and Kappelman J. 1980. *Bears, pigs, and Plio-Pleistocene hominids: A case for the exploitation of belowground food resources.* Hum Ecol 8: 371–87.

Heinrich RE, Rose MD, Leakey RE, and Walker AC. 1993. *Hominid radius from the Middle Pliocene of Lake Turkana, Kenya.* Am J Phys Anthropol 92: 139–48.

Heiple KG, and Lovejoy CO. 1971. *The distal femoral anatomy of Australopithecus.* Am J Phys Anthropol 35: 75–84.

Henshilwood CS, and Marean CW. 2003. *The origin of modern human behavior: Critique of the models and their test implications.* Curr Anthropol 44: 627–51.

Hernandez-Aguilar RA, Moore J, and Pickering TR. 2007. *Savanna chimpanzees use tools to harvest the underground storage organs of plants.* Proc Natl Acad Sci 104: 19210–13.

Hill A, Ward S, Deino A, and Curtis G. 1992. *Earliest Homo.* Nature 355: 719–22.

Hill RS, and Walsh CA. 2005. *Molecular insights into human brain evolution.* Nature 437: 64–67.

Holloway RL. 1970. *Australopithecine endocast (Taung specimen, 1924): A new volume determination.* Science 168: 966–68.

———. 1981. *Revisiting the South African Taung Australopithecine endocast: The position of the lunate sulcus as determined by the stereoplotting technique.* Am J Phys Anthropol 56: 43–58.

———. 1983. *Cerebral brain endocast pattern of Australopithecus afarensis hominid.* Nature 303: 420–22.

Holloway RL, Broadfield DC, and Yuan MS. 2004. *The human fossil record. Vol 3. Brain endocasts: The paleoneurological evidence.* Hoboken, NJ: Wiley.

Holloway RL, and Kimbel WH. 1986. *Endocast morphology of Hadar hominid AL 162-28.* Nature 321: 536–37.

Holton NE, and Franciscus RG. 2008. *The paradox of a wide nasal aperture in cold-adapted Neandertals: A causal assessment.* J Hum Evol 55 (6): 942–51.

Hood BM, Willen JD, and Driver J. 1998. *Adult's eyes trigger shifts of visual attention in human infants.* Infant Behav Dev 21: 466.

Hublin J, Spoor F, Braun M, Zonneveld F, and Condemi S. 1996. *A late neanderthal associated with Upper Paleolithic artifacts.* Nature 381: 224–26.

Jacob T, Indriati E, Soejono RP, Hsü K, Frayer DW, et al. 2006. *Pygmoid Australomelanesian Homo sapiens skeletal remains from Liang Bua, Flores: Population affinities and pathological abnormalities.* Proc Nat Acad Sci 103: 13421–26.

Johanson DC. 1980. *A provisional interpretation of the Hadar hominids.* Proc 8th Pan-Afr Congr Prehist Quat Studies, 157–68.

Johanson DC, and Coppens Y. 1976. *A preliminary anatomical diagnosis of the first Plio/Pleistocene hominid discoveries in the Central Afar, Ethiopia.* Am J Phys Anthropol 45: 217–34.

Johanson DC, and Edey MA. 1981. *Lucy: The beginnings of humankind.* New York: Simon and Schuster.

Johanson DC, Lovejoy CO, Kimbel WH, White TD, Ward SC, Bush ME, Latimer BM, and Coppens Y. 1982. *Morphology of the Pliocene partial hominid skeleton (A.L. 288-1) from the Hadar formation.* Am J Phys Anthropol 57: 403–51.

Johanson DC, Masao FT, Eck GG, White TD, Walter RC, Kimbel WH, Asfaw B, Manega P, Ndessokia P, and Suwa G. 1987. *New partial skeleton of Homo habilis skeleton from Olduvai Gorge, Tanzania.* Nature 327: 205–9.

Johanson DC, and Taieb M. 1976. *Plio-Pleistocene hominid discoveries in Hadar, Ethiopia.* Nature 260: 293–97.

Johanson DC, and White TD. 1979. *A systematic assessment of early African hominids.* Science 203: 321–30.

Johanson DC, White TD, and Coppens Y. 1978. *A new species of the genus* Australopithecus *(primates: Hominidae) from the Pliocene of Eastern Africa.* Kirtlandia 28: 2–14.

Jungers WL. 1982. *Lucy's limbs: Skeletal allometry and locomotion in Australopithecus afarensis.* Nature 297: 676–78.

———. 1988. *Lucy's length: Stature reconstruction in Australopithecus afarensis (A.L. 288-1) with implications for other small-bodied hominids.* Am J Phys Anthropol 76: 227–32.

———. 1988. *Relative joint size and hominid locomotor adaptations with implications for the evolution of hominid bipedalism.* J Hum Evol 17: 247–65.

Jungers WL, Harcourt-Smith WEH, Wunderlich RE, Tocheri MW, Larson SG, Sutikna T, Awe RD, and Morwood MJ. 2009. *The foot of Homo floresiensis.* Nature 459: 81–84.

Jungers WL, Larson SG, Harcourt-Smith W, Morwood MJ, Sutikna T, Awe RD, and Djubiantono T. 2008. *Descriptions of the lower limb skeleton of Homo floresiensis.* J Hum Evol 57 (5): 538–54.

Jungers WL, and Stern JT. 1983. *Body proportion, skeletal*

allometry and locomotion in the Hadar hominids—
A reply. J Hum Evol 12: 673–84.

Kibii JM, Churchill SE, Schmid P, Carlson KJ, Reed ND, de Ruiter DJ, and Berger L. 2011. *A partial pelvis of Australopithecus sediba.* Science 333: 1407–11.

Kibii JM, and Clarke RJ. 2003. *A reconstruction of the Stw 431 Australopithecus pelvis based on newly discovered fragments.* S Afr J Sci 99: 225–26.

Kimbel WH, and Delezene LK. 2009. *"Lucy" redux: A review of research on Australopithecus afarensis.* Yearb Phys Anthropol 52: 2–48.

Kimbel WH, Johanson DC, and Rak Y. 1994. *The first skull and other new discoveries of Australopithecus afarensis at Hadar, Ethiopia.* Nature 368: 449–51.

Kimbel WH, Lockwood CA, Ward CV, Leakey MG, Rak Y, and Johanson DC. 2006. *Was Australopithecus anamensis ancestral to A. afarensis? A case of anagenesis in the hominin fossil record.* J Hum Evol 51: 134–52.

Kimbel WH, Rak Y, and Johanson DC. 2004. *The skull of Australopithecus afarensis.* New York: Oxford University Press.

Kimbel WH, Walter RC, Johanson DC, Reed KE, Aronson JL, Assefa Z, et al. 1996. *Late Pliocene Homo and Oldowan tools from the Hadar formation (Kada Hadar member), Ethiopia.* J Hum Evol 31: 549–61.

Kimbel WH, and White TD. 1988. *A revised reconstruction of the adult skull of Australopithecus afarensis.* J Hum Evol 17: 545–50.

Kimbel WH, White TD, and Johanson DC. 1984. *Cranial morphology of Australopithecus afarensis: A comparative study based on a composite reconstruction of the adult skull.* Am J Phys Anthropol 64: 337–88.

Kirk EC. 2006. *Effects of activity pattern on eye size and orbital aperture size in primates.* J Hum Evol 51: 159–70.

Kivell TL, Kibii JM, Churchill SE, Schmid P, and Berger LR. 2011. *Australopithecus sediba hand demonstrates mosaic evolution of locomotor and manipulative abilities.* Science 333: 1411–17.

Klein RG. 1999. *The human career.* Chicago: University of Chicago Press.

Krogman WM. 1962. *The human skeleton in forensic medicine.* Springfield, IL: Charles C. Thomas.

Lahr MM, and Foley R. 2004. *Human evolution writ small.* Nature 431: 1043–44.

Lalueza-Fox C, Römpler H, Caramelli D, Stäubert C, Catalano G, Hughes D, Rohland N, Pilli E, Longo L, Condemi S, de la Rasilla M, Fortea J, Rosas A, Stoneking M, Schöneberg T, Bertranpetit J, and Hofreiter M. 2007. *A melanocortin 1 receptor allele suggests varying pigmentation among Neanderthals.* Science 318: 1453–55.

Larson SG. 2007. *Evolutionary transformation of the hominin shoulder.* Evol Anthropol 16: 172–87.

Larson SG, et al. 2007. *Homo floresiensis and the evolution of the hominin shoulder.* J Hum Evol 53: 718–31.

Larson SG, Jungers WL, Tocheri MW, Orr CM, Morwood MJ, Sutikna T, Awe RD, and Djubiantono T. 2009. *Descriptions of the upper limb skeleton of Homo floresiensis.* J Hum Evol 57 (5): 555–70.

Latimer B. 1983. *The anterior foot skeleton of Australopithecus afarensis.* Am J Phys Anthropol 60: 217.

———. 1991. *Locomotor adaptations in Australopithecus afarensis: The issue of arboreality.* In Senut B, and Coppens Y, eds., 169–76. *Origine(s) de la bipédie chez les hominidés.* Paris: CNRS.

Latimer B, and Lovejoy CO. 1989. *The calcaneus of Australopithecus afarensis and its implications for the evolution of bipedality.* Am J Phys Anthropol 78: 369–86.

———. 1990. *Hallucal tarsometatarsal joint in Australopithecus afarensis.* Am J Phys Anthropol 82: 125–33.

———. 1990. *Metatarsophalangeal joints of Australopithecus afarensis.* Am J Phys Anthropol 83: 13–23.

Latimer BM, Lovejoy CO, Johanson DC, and Coppens Y. 1982. *Hominid tarsal, metatarsal and phalangeal bones recovered from the Hadar formation: 1974–1977 collections.* Am J Phys Anthropol 57: 701–19.

Latimer B, and Ohman JC. 2001. *Axial dysplasia in Homo erectus.* J Hum Evol 40: A12.

Latimer B, Ohman JC, and Lovejoy CO. 1987. *Talocrual joint in African hominoids: Implications for Australopithecus afarensis.* Am J Phys Anthropol 74: 155–75.

Leakey LSB. 1959. *A new fossil skull from Olduvai.* Nature 184: 491–93.

———. 1960. *Recent discoveries at Olduvai gorge.* Nature 188: 1050–52.

———. 1961. *New finds at Olduvai gorge.* Nature 189: 649–50.

Leakey LSB, Tobias PV, and Napier JR. 1964. *A new species of the genus Homo from Olduvai gorge.* Nature 202: 7–9.

Leakey MD. 1979. *3.6 million years old-footprints in the ashes of time.* Natl Geo 155: 446–57.

Leakey MD, and Hay RL. 1979. *Pliocene footprints in the Laetolil beds at Laetoli, northern Tanzania.* Nature 278: 317–23.

Leakey MG, Feibel CS, McDougall I, and Walker A. 1995. *New four-million-year-old hominid species from Kanapoi and Allia Bay, Kenya.* Nature 376: 565–71.

Leakey MG, Feibel CS, McDougall I, Ward C, and Walker A. 1998. *New specimens and confirmation of an early age for Australopithecus anamensis.* Nature 393: 62–66.

Leakey MG, Spoor F, Brown FH, Gathogo PN, Kiarie C, Leakey LN, and McDougall I. 2001. *New hominin genus from eastern Africa shows diverse middle Pliocene lineages.* Nature 410: 433–40.

Leakey REF. 1973. *Evidence for an advanced*

Plio-Pleistocene hominid from East Rudolf, Kenya. Nature 242: 447–50.

———. 1974. *Further evidence of lower Pleistocene hominids from East Rudolf, North Kenya, 1973.* Nature 248: 653–56.

Leakey REF, and Walker AC. 1976. *Australopithecus, Homo erectus and single species hypothesis.* Nature 261: 572–74.

LeGros Clark WE. 1951. *Hominid characters of the australopithecine dentition.* J R Anthropol Inst G 80 (1–2): 37–54.

———. 1964. *The fossil evidence for human evolution.* 2d ed. Chicago: University of Chicago Press.

Leonard WR, and Robertson ML. 1997. *Comparative primate energetics and hominid evolution.* Am J Phys Anthropol 102: 265–81.

Lewin R. 1987. *Bones of contention: Controversies in the search for human origins.* Chicago: University of Chicago Press.

Lieberman DE. 2001. *Another face in our family tree.* Nature 410: 419–20.

Lockwood CA, Richmond BG, Jungers WL, and Kimbel WH. 1996. *Randomization procedures and sexual dimorphism in Australopithecus afarensis.* J Hum Evol 31: 537–48.

Lockwood CA, and Tobias PV. 1999. *A large male hominin cranium from Sterkfontein, South Africa, and the status of Australopithecus africanus.* J Hum Evol 36: 637–85.

Lontcho F. 2000. *Georgia Homo erectus crania.* Archaeology 53 (1): 22–31.

Lordkipanidze D, Jashashvili T, Vekua A, Ponce de León M, Zollikofer CPE, Rightmire GP, Pontzer H, Ferring R, Oms O, Tappen M, Bukhsianidze M, Agusti J, Kahlke R, Kiladze G, Martinez-Navarro B, Mouskhelishvili A, Nioradze M, and Rook L. 2007. *Postcranial evidence from early Homo from Dmanisi, Georgia.* Nature 449: 305–10.

Lordkipanidze D, Vekua A, Ferring R, Rightmire GP, Agusti J, Kiladze G, Mouskhelishvili A, Nioradze M, Ponce de León M, Tappen M, and Zollikofer, C. 2005. *The earliest toothless skull.* Nature 434: 717–18.

Lovejoy CO. 1988. *Evolution of human walking.* Sci Am 256: 118–25.

———. 2005. *The natural history of human gait and posture. Part 1. Spine and pelvis.* Gait Posture 21: 95–112.

———. 2005. *The natural history of human gait and posture. Part 2. Hip and thigh.* Gait Posture 21: 113–24.

———. 2007. *The natural history of human gait and posture. Part 3. The knee.* Gait Posture 25: 325–41.

———. 2009. *Reexamining human origins in light of Ardipithecus ramidus.* Science 326: 74, 74e1–74e8.

Lovejoy CO, et al. 2009. *Careful climbing in the Miocene: The forelimbs of Ardipithecus ramidus and humans are primitive.* Science 326: 70e1–70e8.

Lovejoy CO, et al. 2009. *The pelvis and femur of Ardipithecus ramidus: The emergence of upright walking.* Science 326 (71): 71e1–71e6.

Lovejoy CO, and Heiple KG. 1970. *A reconstruction of the femur of Australopithecus africanus.* Am J Phys Anthropol 32: 33–40.

Lovejoy CO, Heiple KG, and Burstein AH. 1973. *The gait of Australopithecus.* Am J Phys Anthropol 38: 757–79.

Lovejoy CO, Johanson DC, and Coppens Y. 1982. *Elements of the axial skeleton recovered from the Hadar formation: 1974–1977 collections.* Am J Phys Anthropol 57: 631–35.

———. 1982. *Hominid lower limb bones recovered from the Hadar formation: 1974–1977 collections.* Am J Phys Anthropol 57: 679–700.

———. 1982. *Hominid upper limb bones recovered from the Hadar formation: 1974–1977 collections.* Am J Phys Anthropol 57: 637–49.

Lovejoy CO, Suwa G, Simpson SW, Matternes JH, and White TD. 2009. *The great divides: Ardipithecus ramidus reveals the postcrania of our last common ancestors with African apes.* Science 326: 100–6.

Martin R. 1928. *Lehrbuch der anthropologie in systematischer Darstellung.* 2d ed. Jena, Germany: Fischer.

Martinez I, Rosa L, Arsuaga J-L, Jarabo P, Quam R, Lorenzo C, Gracia A, Carretero J-M, Bermúdez de Castro JM, and Carbonell E. 2004. *Auditory capacities in Middle Pleistocene humans from the Sierra de Atapuerca in Spain.* Proc Natl Acad Sci 101: 9976–81.

Marzke MW. 1983. *Joint functions and grips of the Australopithecus afarensis hand, with special reference to the region of the capitate.* J Hum Evol 12: 197–211.

———. 1997. *Precision grips, hand morphology, and tools.* Am J Phys Anthropol 102 (1): 91–110.

Marzke MW, and Marzke RF. 1987. *The third metacarpal styloid process in humans: Origin and function.* Am J Phys Anthropol 73: 415–31.

Marzke MW, and Shackley MS. 1986. *Hominid hand use in the Pleistocene: Evidence from experimental archaeology and comparative morphology.* J Hum Evol 15: 439–60.

Marzke MW, Wullstein KL, and Viegas SF. 1992. *Evolution of the power ("squeeze") grip and its morphological correlates in hominids.* Am J Phys Anthropol 89: 283–98.

Matterness J. 1981. In Johanson DC, and Edey ME. *Lucy: The beginnings of humankind.* St Albans, UK: Granada.

McBrearty S, and Brooks AS. 2000. *The revolution that wasn't: A new interpretation of the origin of modern human behavior.* J Hum Evol 39 (5): 453–563.

McHenry HM. 1986. *The 1st bipeds: A comparison of the A. afarensis and A. africanus postcranium and*

implications for the evolution of bipedalism. J Hum Evol 15: 177–91.

———. 1991. *Femoral lengths and staure in Plio-Pleistocene hominids.* Am J Phys Anthropol 85 (2): 149–58.

———. 1992. *Body size and proportions in early hominids.* Am J Phys Anthropol 87: 407–31.

———. 1992. *How big were early hominids?* Evol Anthropol 1: 15–19.

McHenry HM, and Berger LR. 1998. *Body proportions in Australopithecus afarensis and A. africanus and the origin of the genus Homo.* J Hum Evol 35: 1–22.

———. 1998. *Limb lengths in Australopithecus and the origin of the genus Homo.* S Afr J Sci 94: 447–50.

McHenry HM, and Coffing K. 2000. *Transformations in body and mind.* Annu Rev Anthropol 29: 125–46.

McHenry HM, and Jones AL. 2006. *Hallucial convergence in early hominids.* J Hum Evol 50: 534–39.

Morwood MJ, Brown P, Jatmiko, Sutikna T, Saptomo EW, Westaway KE, Due RA, Roberts RG, Maeda T, Wasisto S, and Djubiantono T. 2005. *Further evidence for small-bodied hominins from the Late Pleistocene of Flores, Indonesia.* Nature 437: 1012–17.

Morwood MJ, O'Sullivan PB, Aziz F, and Raza, A. 1998. *Fission-track age of stone tools and fossils on the east Indonesian island of Flores.* Nature 392: 173–76.

Morwood M, Soejono RP, Roberts RG, Sutikna T, Turney CSM, Westaway KE, et al. 2004. *Archaeology and age of a new hominin from Flores in eastern Indonesia.* Nature 431: 1087–91.

Mounier A, Marchal F, and Condemi S. 2009. *Is Homo heidelbergensis a distinct species? New insight on the Mauer mandible.* J Hum Evol 56: 219–46.

Niinimäki S. 2012. *The relationship between musculoskeletal stress markers and biomechanical properties of the humeral diaphysis.* Am J Phys Anthropol 47 (4): 618–28.

Ohman JC, Krochta TJ, Lovejoy CO, Mensforth RP, and Latimer B. 1997. *Cortical bone distribution in the femoral neck of hominoids: Implications for the locomotion of Australopithecus afarensis.* Am J Phys Anthropol 104: 117–31.

Partridge TC, Granger DE, Caffee MW, and Clarke RJ. 2003. *Lower Pliocene hominid remains from Sterkfontein.* Science 300: 607–12.

Pickering R, Dirks PHGM, Zubair J, de Ruiter DJ, Churchill SE, Herries AIR, Woodhead JD, Hellstrom JC, and Berger LR. 2011. *Australopithecus sediba at 1.977 Ma and Implications for the Origins of the Genus Homo.* Science 333: 1421–23.

Pickford M, and Senut B. 2001. *"Millennium ancestor," a 6-million-year-old bipedal hominid from Kenya: Recent discoveries push back human origins by 1.5 million years.* S Afr J Sci 97: 22–32.

Pickford M, Senut B, Gommery D, and Treil J. 2002. *Bipedalism in* Orrorin tugenensis *revealed by its femora.* C R Palevol 4: 191–203.

Plavcan JM. 2000. *Inferring social behavior from sexual dimorphism in the fossil record.* J Hum Evol 39: 327–44.

Plavcan JM, Lockwood CA, Kimbel WH, Lague MR, and Harmon EH. 2005. *Sexual dimorphism in Australopithecus afarensis revisited: How strong is the case for a human-like pattern of dimorphism?* J Hum Evol 48: 313–20.

Plavcan JM, and Van Schaik CP. 1997. *Interpreting hominid behavior on the basis of sexual dimorphism.* J Hum Evol 32: 345–74.

Pontzer H, Rolian C, Rightmire GP, Jashashvili T, Ponce de León M, Lordkipanidze D, and Zollikofer CPE. 2010. *Locomotor anatomy and biomechanics of the Dmanisi hominins.* J Hum Evol 58: 492–504.

Potts R. 1988. *Early Hominid activities at Olduvai.* New York: Aldine de Gruyter.

———. 1996. *Humanity's descent: The consequences of ecological instability.* New York: Morrow.

Potts R, Behrensmeyer AK, Deino A, Ditchfield P, and Clark J. 2004. *Small mid-Pleistocene hominin associated with East African Acheulean technology.* Science 305: 75–78.

Potze S, and Thackeray JF. 2010. *Temporal lines and open sutures revealed on cranial bone adhering to matrix associated with Sts 5 ("Mrs. Ples"), Sterkfontein. South Africa.* J Hum Evol 58: 533–35.

Prag J, and Neave R. 1997. *Making faces: Using forensic and archaeological evidence.* London: British Museum Press.

Rak Y. 1983. *The australopithecine face.* New York: Academic.

Reno PL, DeGusta D, Serrat MA, Meindl RS, White TD, Eckhardt RB, Kuperavage AJ, Galik K, and Lovejoy CO. 2005. *Plio-Pleistocene hominid limb proportions.* Curr Anthropol 46: 575–88.

Reno PL, Meindl RS, McCollum MA, and Lovejoy CO. 2003. *Sexual dimorphism in Australopithecus afarensis was similar to that of modern humans.* Proc Natl Acad Sci USA 100: 9404–9.

———. 2005. *The case is unchanged and remains robust: Australopithecus afarensis exhibits only moderate skeletal dimorphism. A reply to Plavcan et al. (2005).* J Hum Evol 49: 279–88.

Richmond BG, Aiello LC, and Wood B. 2002. *Early hominin limb proportions.* J Hum Evol 43: 529–48.

Richmond BG, Begun DR, and Strait DS. 2001. *Origin of human bipedalism: The knuckle-walking hypothesis revisited.* Yrbk Phys Anthropol 44: 70–105.

Richmond BG, and Jungers WL. 2008. *Orrorin tugenensis femoral morphology and the evolution of hominin bipedalism.* Science 319: 1662–65.

Richmond BG, and Strait DS. 2000. *Evidence that humans*

evolved from a knuckle-walking ancestor. Nature 404: 382–85.

Ricklan DE. 1987. *Functional anatomy of the hand of Australopithecus africanus.* J Hum Evol 16: 643–64.

———. 1990. *The precision grip in Australopithecus africanus: Anatomical and behavioral correlates.* In Sperber GH, ed., 171–83. *From apes to angels: Essays in anthropology in honor of Phillip V. Tobias.* New York: Wiley-Liss.

Rightmire GP. 1998. *Human evolution in the Middle Pleistocene: The role of Homo heidelbergensis.* Evol Anthropol 6: 218–27.

———. 2004. *Brain size and encephalization in Early to Mid-Pleistocene Homo.* Am J Phys Anthropol 124: 109–23.

Rightmire GP, Lordkipanidze D, and Vekua A. 2006. *Anatomical descriptions, comparative studies and evolutionary significance of the hominin skulls from Dmanisi, Republic of Georgia.* J Hum Evol 50: 115–41.

Robinson JT. 1972. *Early hominid posture and locomotion.* Chicago: The University of Chicago Press.

Rosenberg KR, Zune L, and Ruff CB. 2009. *Body size, body proportions, and encephalization in a Middle Pleistocene archaic human from northern China.* Proc Natl Acad Sci USA 103: 3552–56.

Ross CF, and Kirk CE. 2007. *Evolution of eye size and shape in primates.* J Hum Evol 52 (3): 294–313.

Ruff CB. 1994. *Morphological adaptation to climate in modern and fossil humans.* Yrbk Phys Anthropol 37: 65–107.

———. 1995. *Biomechanics of the hip and birth in early Homo.* Am J Phys Anthropol 98 (4): 527–74.

———. 2009. *Relative limb strength and locomotion in Homo habilis.* Am J Phys Anthropol 138: 90–100.

———. 2010. *Body size and body shape in early hominins: Implications of the Gona pelvis.* J Hum Evol 58 (2): 166–78.

Ruff CB, et al. 1998. In Strasser E, ed., 449–69. *Primate locomotion: Recent advances.* New York: Plenum.

Ruff CB, Trinkaus E, and Holliday TW. 1997. *Body mass and encephalization in Pleistocene Homo.* Nature 387: 173–76.

Ruff CB, Trinkaus E, Walker A, and Larsen CS. 1993. *Postcranial robusticity in Homo. I. Temporal trends and mechanical interpretation.* Am J Phys Anthropol 91: 21–53.

Russon AE, and Begun DR, eds. 2004. *The evolution of thought: Evolutionary origins of great ape intelligence.* Cambridge: Cambridge University Press.

Ryan AS, and Johanson DC. 1989. *Anterior dental microwear in Australopithecus afarensis: Comparisons with human and nonhuman primates.* J Hum Evol 18: 235–68.

Schmid P. 1983. *Eine Rekonstruktion des skelettes von A.L.*

288-1 *(Hadar) und deren Konsequenzen.* Folia Primatol. 40: 283–306.

———. 2004. *Functional interpretation of the Laetoli footprints.* In Meldrum DJ, and Hilton CE, eds., 50–52. *From biped to strider: The emergence of modern human walking, running, and resource transport.* New York: Kluwer.

Schmitt D, and Churchill S. 2003. *Experimental evidence concerning spear use in Neandertals and early modern humans.* J Archaeol Sci 30: 103–14.

Schoetensack O. 1908. *Der Unterkiefer des Homo heidelbergensis aus den Sanden von Mauer bei Heidelberg.* Leipzig: Wilhelm Engelmann.

Schultz AH. 1940. *The size of the orbit and of the eye in primates.* Am J Phys Anthropol 26: 389–408.

———. 1969. *The life of primates.* New York: Universe.

Scott RS, Ungar PS, Bergstrom TS, Brown CA, Grine FE, Teaford MF, and Walker A. 2005. *Dental microwear texture analysis reflects diets of living primates and fossil hominins.* Nature 436: 693–95.

Semaw S, et al. 2003. *2.6-million-year-old stone tools and associated bones from OGS-6 and OGS-7, Gona, Afar, Ethiopia.* J Hum Evol 45: 169–77.

Semaw S, Renne R, Harris JWK, Feibel CS, Bernor RL, Fessaha N, and Mowbray K. 1997. *2.5-million-year-old stone tools from Gona, Ethiopia.* Nature 385: 333–35.

Senju A, and Csibra G. 2008. *Gaze following in human infants depends on communicative signals.* Curr Biol 18 (9): 668–71.

Senut B, Pickford M, Gommery D, Mein P, Cheboi K, and Coppens Y. 2001. *First hominid from the Miocene (Lukeino formation, Kenya).* C R Acad Sci IIa 332: 137–44.

Shipman P. 2008. *Separating "us" from "them": Neanderthal and modern human behavior.* Proc Natl Acad Sci USA 105: 14241–42.

Shipman P, and Walker A. 1989. *The costs of becoming a predator.* J Hum Evol 18: 373–92.

Simpson SW, Quade J, Levin NE, Butler R, Dupont-Nivet G, Everett M, and Semaw S. 2008. *A female Homo erectus pelvis from Gona, Ethiopia.* Science 322: 1089–92.

Soressi M, and D'Errico F. 2007. *Pigments, gravures, parures: Les comportements symboliques controversés des Néandertaliens.* In *Les Néandertaliens: Biologie et cultures,* 297–309. Document préhistoriques 23. Paris: Éditions du CTHS.

Spoor F, Leakey MG, Gathogo PN, Brown FH, Antón SC, McDougall I, Kiarie C, Manthi FK, and Leakey LN. 2007. *Implications of new early Homo fossils from Ileret, east of Lake Turkana, Kenya.* Nature 448: 688–91.

Spoor F, Wood B, and Zonneveld F. 1994. *Implications of*

early hominid labyrinthine morphology for evolution of human bipedal locomotion. Nature 369: 645–48.

Stern JT. 2000. *Climbing to the top: A personal memoir of Australopithecus afarensis.* Evol Anthropol 9: 113–33.

Stern JT, and Susman RL. 1983. *The locomotor anatomy of Australopithecus afarensis.* Am J Phys Anthropol 60: 279–317.

———. 1991. *"Total morphological pattern" versus the "magic trait": Conflicting approaches to the study of early hominid bipedalism.* In: Senut B, and Coppens Y, eds., 99–111. *Origine(s) de la bipédie chez les Hominidés.* Paris: CNRS.

Strait DS, Weber GW, Neubauer S, Chalk J, Richmond BG, Lucas PW, Spencer MA, Schrein C, Dechow PC, Ross CF, Grosse IR, Wright BW, Constantino P, Wood BA, Lawn B, Hylander WL, Wang Q, Byron C, Slice DE, and Smith AL. 2009. *The feeding biomechanics and dietary ecology of Australopithecus africanus.* Proc Natl Acad Sci USA 106: 2124–29.

Stringer CB, Finlayson JC, Barton RNE, Fernández-Jalvo Y, Cáceres I, Sabin RC, Rhodes EJ, Currant AP, Rodríguez-Vidal J, Giles-Pacheco F, and Riquelme-Cantal JA. 2008. *Neanderthal exploitation of marine mammals in Gibraltar.* Proc Natl Acad Sci USA 105: 14319–24.

Stringer CB, Trinkaus E, Roberts MB, Parfitt SA, and Macphail RI. 1998. *The Middle Pleistocene human tibia from Boxgrove.* J Hum Evol 34: 509–47.

Susman RL. 1988. *Hand of Paranthropus robustus from Member 1, Swartkrans: Fossil evidence for tool behavior.* Science 240: 781–84.

———. 1994. *Fossil evidence for early hominid tool use.* Science 265: 1570–73.

———. 1998. *Hand function and tool behavior in early hominids.* J Hum Evol 35: 23–46.

Susman RL, Stern JT, and Jungers WL. 1984. *Arboreality and bipedality in the Hadar hominids.* Folia Primatol 43: 113–56.

———. 1985. *Locomotor adaptations in the Hadar hominids.* In Delson E, ed., 184–92. *Ancestors: The hard evidence.* New York: Liss.

Swindler DR, and Wood CD. 1973. *An atlas of primate gross anatomy: Baboon, chimpanzee and man.* Seattle: University of Washington Press.

Swisher CC III, Rink WJ, Anton SC, Schwarcz HP, Curtis G, Supryo A, and Widiasmoro. 1996. *Latest Homo erectus of Java: Potential contemporaneity with Homo sapiens in southeast Asia.* Science 274: 1870–74.

Tardieu C, and Damsin JP. 1997. *Evolution of the angle of obliquity of the femoral diaphysis during growth: Correlations.* Surg Radiol Anat 19: 91–97.

Tattersall I. 1993. *The human odyssey: Four million years of human evolution.* New York: Prentice Hall.

Teaford MF. 2007. *What do we know and not know about dental microwear and diet?* In Ungar PS, ed., 106–32. *Evolution of the human diet: The known, the unknown, and the unknowable.* New York: Oxford University Press.

Teaford MF, and Ungar PS. 2000. *Diet and the evolution of the earliest human ancestors.* Proc Natl Acad Sci USA 97: 13506–11.

Teaford MF, Ungar PS, and Grine FE. 2002. *Paleontological evidence for the diets of African Plio-Pleistocene hominins with special reference to early Homo.* In Ungar PS, and Teaford MF, eds., 143–66. *Human diet: Its origin and evolution.* Westport, CT: Bergin and Garvey.

Thorpe SKS, Holder RL, and Crompton RH. 2007. *Origin of human bipedalism as an adaptation for locomotion on flexible branches.* Science 316: 1328–31.

Tobias PV. 1967. *Olduvai Gorge. Volume 2: The cranium and maxillary dentition of Australopithecus (Zinjanthropus) boisei.* Cambridge: Cambridge University Press.

———. 1980. *"Australopithecus afarensis" and A. africanus: Critique and an alternative hypothesis.* Palaeont Afr 23: 1–17.

———. 1991. *Olduvai Gorge. Volume 4: The skulls, endocasts and teeth of Homo habilis.* Cambridge: Cambridge University Press.

Tocheri MW, Orr CM, Jacofsky MC, and Marzke MW. 2008. *The evolutionary history of the hominin hand since the last common ancestor of Pan and Homo.* J Anat 212: 544–62.

Tocheri MW, Orr CM, Larson SG, Sutikna T, Jatmiko, Saptomo EW, Due RA, Djubiantono T, Morwood MJ, and Jungers WL. 2007. *The primitive wrist of Homo floresiensis and its implications for hominin evolution.* Science 317: 1743–45.

Tomasello M, Hare B, Lehmann H, and Call J. 2007. *Reliance on head versus eyes in the gaze following of great apes and human infants: The cooperative eye hypothesis.* J Hum Evol 52 (3): 231–346.

Trinkaus E. 1983. *The Shanidar Neanderthals.* New York: Academic.

———. 1985. *Pathology and the posture of the La Chappelle-aux-Saints Neanderthal.* A J Phys Anthropol 67: 19–41.

———. 2009. *The human tibia from Broken Hill, Kabwe, Zambia.* PaleoAnthropology 2009: 145–65.

Trinkaus E, Churchill SE, and Ruff CB. 1994. *Postcranial robusticity in Homo II: Humeral bilateral asymmetry and bone plasticity.* Am J Phys Anthropol 93: 1–34.

Trinkaus E, and Shipman P. 1993. *The Neanderthals: Changing the image of mankind.* New York: Knopf.

Tuttle RH, Webb DM, and Baksh M. 1991. *Laetoli toes and Australopithecus afarensis.* Hum Evol 6: 193–200.

Ungar PS. 1996. *Relationship of incisor size to diet and anterior tooth use in sympatric Sumatran anthropoids.* Am J Primatol 38: 145–56.

———. 2004. *Dental topography and diets of Australopithecus afarensis and early Homo.* J Hum Evol 46: 605–22.

———. 2007. *Dental topography and human evolution: With comments on the diets of Australopithecus africanus and Paranthropus robustus.* In Bailey S, and Hublin JJ, eds., 321–44. *Dental perspectives on human evolution: State of the art research in dental anthropology.* New York: Springer-Verlag.

———. 2011. *Dental evidence for the diets of Plio-Pleistocene hominins.* Am J Phys Anthropol Yearb S 53 (v146): 47–62.

Ungar PS, and Grine FE. 1991. *Incisor size and wear in Australopithecus africanus and Paranthropus robustus.* J Hum Evol 20: 313–40.

Ungar PS, Grine FE, and Teaford MF. 2006. *Diet in early Homo: A review of the evidence and a new model of adaptive versatility.* Annu Rev Anthropol 35: 209–28.

———. 2008. *Dental microwear and diet of the Plio-Pleistocene hominin Paranthropus boisei.* PLOS One 3: 1–6.

Ungar PS, Grine FE, Teaford MF, and El-Zaatari S. 2006. *Dental microwear and diets of African early Homo.* J Hum Evol 50: 78–95.

Ungar PS, Scott RS, Grine FE, and Teaford MF. 2010. *Molar microwear textures and the diets of Australopithecus anamensis and Australopithecus afarensis.* Phil Trans R Soc B 365: 3345–54.

Vekua A, Lordkipanidze D, Rightmire GP, Agusti J, Ferring R, Maisuradze G, et al. 2002. *A new skull of early Homo from Dmanisi, Georgia.* Science 297: 85–89.

Vrba ES. 1979. *A new study of the scapula of Australopithecus africanus from Sterkfontein.* Am J Phys Anthropol 51: 117–29.

———. 1995. *Paleoclimate and evolution, with emphasis on human origins.* New Haven: Yale University Press. 385–424.

Walker A. 1973. *New Australopithecus femora from East Rudolf, Kenya.* J Hum Evol 2: 545–55.

Walker AC, and Leakey RE. 1988. *The evolution of Australopithecus boisei.* In Grine FE, ed., 247–58. *Evolutionary history of the "robust" australopithecines.* New York: de Gruyter.

Walker AC, and Leakey REF, eds. 1993. *The Nariokotome Homo erectus skeleton.* Cambridge, MA: Harvard University Press.

Walker A, and Shipman P. 1996. *The wisdom of the bones: In search of human origins.* New York: Knopf.

Walker A, Zimmerman M, and Leakey R. 1982. *A possible case of hypervitaminosis A in Homo erectus.* Nature 296: 248–50.

Wallace IJ, et al. 2008. *The bipedalism of the Dmanisi hominins: Pidgeon-toed early Homo?* Am J Phys Anthropol 136: 375–78.

Ward CV. 2002. *Interpreting the posture and locomotion of Australopithecus afarensis: Where do we stand?* Yrbk Phys Anthropol 45: 185–215.

Ward C, Leakey M, and Walker A. 1999. *The new hominid species Australopithecus anamensis.* Evol Anthropol 7: 197–205.

———. 2001. *Morphology of Australopithecus anamensis from Kanapoi and Allia Bay, Kenya.* J Hum Evol 41: 255–368.

Ward CV, Plavcan JM, and Manthi FK. 2010. *Anterior dental evolution in the Australopithecus anamensis–afarensis lineage.* Phil Trans R Soc B 365: 3333–44.

Weber J, Czarnetzki A, and Pusch C. 2005. *Comment on "The brain of LB1, Homo floresiensis."* Science 310 (5746): 236.

Wheeler PE. 1991. *The thermoregulatory advantages of hominid bipedalism in open equatorial environments: The contribution of increased convective heat loss and cutaneous evaporative cooling.* J Hum Evol 21: 107–15.

White TD. 1991. *Human Osteology.* San Diego, CA: Academic.

———. 2003. *Early hominids: Diversity or distortion?* Science 299: 1994–97.

White TD, Asfaw B, Beyene Y, Hailie-Selassie Y, Lovejoy CO, Suwa G, and WoldeGabriel G. 2009. *Ardipithecus ramidus and the paleobiology of early hominids.* Science 326: 75–86.

White TD, Johanson DC, and Kimbel WH. 1981. *Australopithecus africanus: Its phyletic position reconsidered.* S Afr J Sci 77: 445–70.

White TD, and Suwa G. 1987. *Hominid footprints at Laetoli: Facts and interpretations.* Am J Phys Anthropol 72: 485–514.

White TD, Suwa G, and Asfaw B. 1994. *Australopithecus ramidus: A new species of early hominid from Aramis, Ethiopia.* Nature 371: 306–12.

White TD, WoldeGabriel G, Asfaw B, Ambrose S, Beyene Y, Bernor RL, Boisserie JR, Currie B, Gilbert H, Haile-Selassie Y, Hart WK, Hlusko LJ, Howell FC, Kono RT, Lehmann T, Louchart A, Lovejoy CO, Renne PR, Saegusa H, Vrba E, Wesselman H, and Suwa G. 2006. *Asa Issie, Aramis and the origin of Australopithecus.* Nature 440: 883–89.

Wilkinson C. 2004. *Forensic facial reconstruction.* Manchester, UK: Manchester University Press.

Wolpoff MH. 1983. *Lucy's little legs.* J Hum Evol 12: 443–53.

———. 1996. *Human evolution.* New York: McGraw-Hill.

———. 1999. *Paleoanthropology.* 2d ed. New York: McGraw-Hill.

Wolpoff MH, Hawks J, Senut B, Pickford M, and Ahern J. 2006. *An ape or the ape: Is the Toumaï cranium TM 266 a hominid?* PaleoAnthropology 2006: 36–50.

Wolpoff M, Senut B, Pickford M, and Hawks J. 2002. *Sahelanthropus or "Sahelpithecus"?* Nature 419: 581–82.

Wong K. 2010. *Fossils of our family.* Sci Am, June 2010.

———. 2010. *Spectacular South African skeletons reveal new species from murky period of human evolution.* Sci Am, April 8, 2010.

Wood BA. 1976. *Remains attributable to Homo in the East Rudolf succession.* In Coppens Y, Howell FC, Isaac GL, and Leakey REF, eds., 490–506. *Earliest man and environments in the Lake Rudolf Basin.* Chicago: University of Chicago Press.

———. 2002. *Hominid revelations from Chad.* Nature 418: 133–35.

———. 2006. *Palaeoanthropology: A precious little bundle.* Nature 443: 296–301.

Wood B, and Collard M. 1999. *The changing face of genus Homo.* Evol Anthropol 8: 195–207.

———. 1999. *The human genus.* Science 284: 65–71.

Wood B, and Constantino P. 2007. *Paranthropus boisei: Fifty years of evidence and analysis.* Yrbk Phys Anthrop 50: 106–32.

Wood B, and Harrison H. 2011. *The evolutionary context of the first hominins.* Nature 470: 347–52.

Zihlman AL, and Brunker L. 1979. *Hominid bipedalism: Then and now.* Yearb Phys Anthropol 22: 132–62.

Zipfel B, DeSilva JM, Kidd RS, Carlson KJ, Churchill SE, and Berger LR. 2011. *The foot and ankle of Australopithecus sediba.* Science 333: 1417–20.

Zollikofer CPE, Ponce de León MS, Lieberman DE, Guy F, Pilbeam D, Likius A, Mackaye HT, Vignaud P, and Brunet M. 2005. *Virtual cranial reconstruction of Sahelanthropus tchadensis.* Nature 434: 755–59.

INDEX

Page numbers in *italics* refer to illustrations.

Acheulean tradition, 125, 197
adaptive plateau, 11–12
aesthetics, xi, 196, 197
Aiello, Leslie, 95, 121, 150
A.L. 333 site, 33, 35, 38
Alemseged, Zeresenay, 37
allometric differences, 54
altriciality, 150, 165
American Association of Physical Anthropologists, 78, 136, 137, 139, 167, 268, 269
ankles, 130, 131, 141
antelope, 118, 154–55, 162
Antidorcas recki, 155, 185
Anton, Mauricio, 185
apes: bipedalism among, 13, 122; birth of, 39; birth spacing in, 79; brow ridge of, 9; competition among, 12; cranial capacity of, 14; digestive tract of, 94–95; facial muscles of, 48, 50; facial skin of, 25; foramen magnum of, 10; human resemblance to, 13; jaws of, 135; metacarpal walls of, 36; nose of, 81–82, 121; pelvis of, 34;

Sahelanthropus resemblance to, 8, 9, 10, 14; skull of, 7, 14, 22; species of, 16; teeth of, 7, 11, 19; thumbs of, 93
arborealism. *See* tree dwelling
Ardipithecus kadabba, 11, 40, 90
Ardipithecus ramidus, 12, 42, 44, 142
arms, 35, 59, 78, 93–94
art, 3, 302
arthritis, 220
artiodactyls, 216
asteroids, 315
atlas (vertebra), 20
atlatl, 223, 228
auditory meatus, 22
Auel, Jean, 229
Australopithecus afarensis, 13, 31–66, 78, 83, 94, *114*, 129, 135, 136; cranial capacity of, 39, 66, 76; heel bone of, 141; jaws of, 8, 26, 43, 45, 50; mandible of, 26; metacarpal walls of, 36; neck muscles of, 48; nose of, 49, 50, 121; origin of, 44; sagittal crest of, 18, 45; sexual dimorphism in, 73, 75; skull of, 22, 44–45, 79; teeth of, 8, 43, 44, 76; temporalis muscles of, 47; thorax of, 53; thumbs of, 42, 93; tooth wear in, 90

Australopithecus africanus, 55, 69–83, 89, 90, 121; *Australopithecus sediba* likened to, 140, 142
Australopithecus anamensis, 44, 48
Australopithecus garhi, 118
Australopithecus sediba, 78, 90, *114*, 126, 137–42
awls, 223, 225
axes, 125, 151, 152, 183, 197–98

baboon, 24, 69
balance, 37, 116
beads, 233
Behrekhat Ram, Golan Heights, 194
Behrensmeyer, Kay, 133, 155
Berger, Lee, 137–38, 139, 140
Berger, Mathew, 137
bicuspids. *See* premolars
bifaces, 197
Bilzingsleben, Germany, 194
biostratigraphy, 134
bipedalism, xii, 12, 31, 78, 94; angled knees and, 32, 276; among apes, 13, 122; balance and, 116; brain size increase vs., 150; climbing vs., 35–36, 37–38, 115; Darwin's view of, 72; disputed evidence of, 11;